Modern Art and the Object

Ellen H. Johnson

Modern Art and the Object

A century of changing attitudes

with 109 illustrations

Icon Editions

HARPER & ROW, PUBLISHERS

New York, Hagerstown, San Francisco, London

*For my sister Elva, who saw me through school
during the Great Depression and has never ceased
to encourage me in my work*

ISBN *0–06–433425–2*

LIBRARY OF CONGRESS CATALOG CARD NUMBER *76–20394*

77 78 79 80 81 10 9 8 7 6 5 4 3 2

Contents

Acknowledgments

To all of the artists whose names appear in these pages and to the numerous colleagues in the academic, museum and commercial art world, as well as to the thousands of students, who, for a quarter of a century or more, have wittingly and unwittingly contributed to this study of the problematic relationship between art and the object, I am very grateful. My particular thanks go to Nikos Stangos, an author's dream of what an editor should be, who first proposed that I write a book on modern art, with a selection of my papers as its nucleus, and who has sensitively directed the project.

The major essay, introducing and developing the theme and its complex variations during the past hundred years, was the main piece written for this publication. Some of the articles have appeared previously in the *Allen Memorial Art Museum Bulletin*, which has a very special and limited audience. Its editor during those years, Laurine Mack Bongiorno, deserves highest praise and thanks for her exact and delicate scrutinizing of every word published between its pages. The amount of revision which the reprinted essays have undergone varies considerably, but in no case are the original ideas and content altered or modified; thus the date of first publication for each is significant.

The necessary freeing of my time was made possible by a Senior Fellowship from the National Endowment for the Humanities and grants in aid of research from Oberlin College. Among the many individuals to whom I am especially grateful for their insights and assistance over the years are my friends and associates Chloe Hamilton Young, Hedy Bäcklin-Landman, Susan Corliss, Jane Kleinberg, Ricardo Barreto and, above all, Athena Tacha Spear, to whose critical comments and informed, stimulating thinking my writing of the past decade is particularly indebted.

The author and the publisher acknowledge permission from the following magazines and journals to reproduce here some material previously published (an essay's title as first published is given in brackets): *Allen Memorial Art*

Museum Bulletin, Oberlin College, 'Cézanne and a Pine Tree' (1963), 'John Marin's Vision of Nature' ('John Marin, 1870–1953'; 1955), 'On the Role of the Object in Analytic Cubism' (1955), 'Diebenkorn's *Woman by a Large Window*' (1958), 'Is Beauty Dead?' (1963), 'Mathematics and the New Abstraction: Hinman, Poons and Williams' (1965; reprinted in *Art News* as 'Three New, Cool, Bright Imagists') and 'Towards the Indeterminate' ('Three Young Americans: Krueger, Nauman, Saret'; 1968); *Art Quarterly*, 'A Nineteenth-century American Nature Painter: John F. Kensett' ('Kensett Revisited'; 1957); *Studio International*, 'Jackson Pollock and Nature' (1973); *Arts Magazine*, 'Arcadia Enclosed: The Boxes of Joseph Cornell' (1965) and 'Giant 3-Way Plug' (1971; reprinted in the *Allen Memorial Art Museum Bulletin*); *Art International*, 'The Living Object' (1963), 'The Poetry of Everywhere' ('Oldenburg's Poetics: Analogues, Metamorphoses and Sources'; 1970) and 'Cast from Life' ('The Sculpture of George Segal'; 1964); *Art and Literature*, 'Art about Art: Jim Dine and Jasper Johns' (1965); *Canadian Art*, 'The Image Duplicators: Lichtenstein, Rauschenberg, Warhol' (1966); and *Art and Artists*, 'Style as Object' ('The Lichtenstein Paradox'; 1968). 'Cézanne's Truth' is based on *Paul Cézanne*, which was published in *The Masters* series (1967); 'American Attitudes towards Art and Experience' is excerpted and revised from the catalogue essay, 'Continuity in Modern American Art', for the United States contribution (organized by the author) to the First India Triennale of Contemporary World Art, New Delhi, 1968.

Preface

This publication is devoted to a reexamination of modern art from the point of view of the artist's approach to the object. The first essay chronicles the complex, changing relationship between art and the object over the past hundred years; it is a relationship which, like nature – or art itself for that matter – has no precise beginnings or endings, only a constantly shifting emphasis, advancing and receding, like the waves of the sea, always the same but never alike. This kind of fundamental organicism has determined the total structure of the book, as one thing grows out of another, holding its past and its future within itself. Cézanne's obsessive, full stressing of *both* nature and art throws a bridge from the faithful representation of the object in nineteenth-century painting to cubist and subsequent abstraction's freedom from the object. Picasso's indebtedness to Cézanne in his subjugation of the object is indisputable. However, it is not only formally that Picasso considered himself Cézanne's son, but also in the auto-biographical expressiveness which asserts itself even in his most rigorously analytic cubist phase. He made that clear when he said that Cézanne wouldn't have interested him at all if he had not been the suffering human being that he was. In the mid-twentieth century, Jackson Pollock is akin to both earlier masters as he passionately identifies himself with his work; 'I *am* nature' also means 'I am the form I create'. Certainly Cézanne's as well as Pollock's painting is, like most art, to some extent *about* art; but such artists as Lichtenstein, Johns and Dine stress that aspect of their work more obviously. One might even propose, not altogether frivolously, that Cézanne's insistence on the importance of the painter's mind anticipates conceptual art. These instances of inter-relationship, of a giving and taking kinship, and of a flexible continuity have been cited to exemplify the kind of organic order into which the contents of the book have been disposed.

Ellen H. Johnson
Oberlin, August 1974

1 Modern Art and the Object from Nineteenth-century Nature Painting to Conceptual Art

Art criticism, like politics, is plagued by words which mean different things to different people in different places at different times. When the contemporary American artist Mel Bochner says, 'In the early 'sixties the formula was "art = object",' the word 'object' is different in meaning and reference from what it was for Picasso, for whom it meant the source object in the visual world which served as the point of departure for art's inventions. He told Zervos, 'There is no abstract art. You must always start with something. Afterwards you can remove all traces of reality. There's no danger then, anyway, because the idea of the object will have left an indelible mark.'[1] Picasso meant by 'object' more what Kandinsky had in mind when he called his abstract painting 'non-objective', whereas Bochner was referring to the paintings and constructions of such artists as Frank Stella, Robert Morris and Sol Lewitt as objects. The whole problem is more a question of what is the object, than of what an object is; or one might say it is more a question of where than of what. Is it something 'out there' in the external world (a river, a mountain, a haystack); or is it something 'in here' (either the artist's personal vision and his emotional reaction to the external world, or the work of art turned in on itself, focusing on its own properties and processes); or is it something having no visible substance and/or no direct cause-effect relationship to physical reality (a philosophic proposition or similar idea)?

Thus, in considering modern art from naturalism to conceptualism, we speak first of the object as that part of the external world which served as the departure point, the subject matter, for the work of art. Then gradually we switch, with the artist, to thinking about the object as the work of art itself, a tangible thing among things, which 'lives its own life', to use Picasso's well-worn phrase. Perhaps less familiar is a statement he made to Françoise Gilot: 'One of the fundamental points about cubism is this: not only did we try to displace reality; reality was no longer in the object. Reality was in the painting.'[2] Finally, we encounter the widely held contemporary stance that the art object has sunk to the level of a commodity and it is to be spurned by artists. So, the object is dead;

but long live the object! Because of course these artists stake out new territory and their new object (meaning either subject-matter or work of art or a combination of both) may be anything from a mathematical theorem to the life cycle of an ant. Throughout all the enormously varied ramifications of the basic usages of 'object', there runs, moreover, a hint of its signifying 'purpose'. A further variant on the use of the word is hardly relevant to the present study, but should at least be mentioned: the object as a matter-of-fact thing, i.e. as the result of an 'objective' as opposed to a 'subjective' approach. This is what Claes Oldenburg meant when he said that in his happenings he treated the actors and the audience as objects, or what Rainer Crone had in mind when he wrote that in Andy Warhol's Jackie Kennedy portraits 'the emotions of mourning become object'.[3]

The entire gamut of modern art can be viewed from the vantage point of the artist's attitude towards the object, an examination which should throw some light on the larger problem of how the modern artist chooses to interweave art and reality and, ultimately, of what constitutes reality for him. In this first chapter, the broad outlines of such an investigation are sketched in; and in the essays which follow, some particular areas of the problematic relationship between art and object are explored in greater detail.

It hardly needs saying that no movement or individual is concerned exclusively with any one phase of that relationship; rather, it is a matter of degree and emphasis. At the risk of falsifying through over-simplification in pursuit of clarity, I shall trace major strains of emphasis as they wind in and out of art history from Cézanne and John F. Kensett in the second half of the nineteenth century to Chuck Close and Mel Bochner in the second half of the twentieth century.

In late nineteenth-century nature painting one can detect three major emphases which will appear and reappear in numerous guises up to the present: 1) faithful representation of the visual appearance of the object, i.e. illusionistic or what Duchamp called 'retinal' art (the impressionists, Cézanne and that great body of landscape painters here represented by the American, Kensett); 2) revealing and underscoring the materials and process of painting, the art in art (the impressionists, Cézanne, Seurat); 3) exaggeration and departure from verisimilitude to express feelings or ideas (van Gogh, Munch, Gauguin, Seurat, Cézanne). The fact that Cézanne's name appears in all three categories, and most of the others in two, clearly points up the dangers and inadequacies of such classifications; but I hope it does not invalidate the attempt to find or make some paths through a very rich and tightly-packed forest of activity. The two essays on Cézanne demonstrate how his art fulfils the multiple requirements for the artist which he himself posited: 'There are two things in the painter: the eye and the brain. The two must co-operate; one must work for the development of both, but as a painter: of the eye through the outlook on nature, of the brain through the logic of organized sensations which provide the means of expression.'[4]

And again, 'One is neither too scrupulous nor too sincere nor too sub-missive to nature; but one is more or less master of one's model and, above all, of the means of expression. Get to the heart of what is before you and continue to express yourself as logically as possible.'[5] Vision, idea, creativity, feeling are conjoined. Cézanne delineates the structure of his source objects so exactly that one can locate almost the very spot where he set up his easel in painting each of his numerous studies of Mont Sainte-Victoire (1); one can recognize a particular pine tree when it reappears in several pictures, and even propose the date of a watercolour on the basis of the tree's growth. At the same time, his paintings and drawings are as much objects as the mountain and tree are; but the painted object (oil, watercolour) and the object painted (mountain, tree) vie with each other for dominance. The tension resulting from this conflict adds resonance to the pictorial dynamism animating the relationship of every last little brush-stroke to the extremely complex, quietly vibrant whole. Literally hundreds of small opposing forces are brought into equilibrium; but the equilibrium and quietude of Cézanne's paintings are different in kind from Kensett's. The latter's pictures, like Monet's (2) and most other nineteenth-century nature painting, are more passive in total structure and in detail. Kensett's idyllic, optimistic landscapes (66) are utterly without tension; you feel no sharp craggy bones in his mountains, no treacherous currents in his rivers and lakes, and even the Atlantic stills its surf for him. One might say that neither did Cézanne paint turbulent seas; however, it is not the *depiction* of motion, but the interactivity of the pictorial elements which animates his painting – *qua* painting, not *qua* nature. Kensett's love for nature is more peaceful and he is more acquiescent towards her, whereas Cézanne was never in such easy harmony with nature, art and himself. While he worshipped nature, he insisted on being 'master of one's model'; he knew that he was a significant, inventive and courageous artist, but he was never satisfied. In his last year he wondered if he would ever 'realize the dream of art that I have been pursuing all my life'.[6] Cézanne's magnificent struggle and his self-doubt meant almost as much as his revolutionary art did to many of his followers. Even Picasso, who said, 'Bien sûr!' Cézanne was his 'father',[7] declared, 'It's not what the artist *does* that counts, but what he is. Cézanne would never have interested me a bit if he had lived and thought like Jacques Emile Blanche, even if the apple he painted had been ten times as beautiful. What forces our interest is Cézanne's anxiety – that's Cézanne's lesson. . . .'[8] While Cézanne's inventions undermined the integrity of the object in relation to other objects and to its environment, and thus readied the ground for the cubist's more pronounced subjugation of the object, still he steadfastly cherished its identity. Cézanne upset the whole applecart, but he hung onto the individual apple; Picasso and Braque (3) let that slip too, as they (first separately and then together) worked out the kind of formal analysis and vocabulary which came to be called cubism. Here the painting and the process of its constructing shatter the individual object to bits; but the source object, unlike Humpty-

Dumpty, *can* be put together again (see 'On the Role of the Object in Analytic Cubism', pp. 97–110). Not so in total abstraction, which inevitably and very rapidly evolved from the cubist premises.

Although there will probably never be a definitive solution to the problem of who is the rightful contender for the honour of having painted the first abstract picture, there is no question that by 1912–13 pictures with no recognizable objects had been painted by such diverse artists as Kupka, Kandinsky, Larionov, Balla, Malevich, Picabia, Delaunay, Morgan Russell and Mondrian, among the most conspicuous. Their created objects were not referential to any objects other than themselves – ostensibly. 'Symbol snatchers', as Arshile Gorky called iconographical investigators, have identified several of Kandinsky's shapes (4) and paint gestures as signs for lightning, mountains, horses and riders, etc. And it is well known that Mondrian's exquisitely balanced horizontal and vertical compositions began with series of studies of trees and church façades and the rhythmic beat of water against the pier at Scheveningen (5). There are very few first generation abstractions as completely 'pure' as Malevich's daringly reduced squares (6), and even they are not exclusively self-referential, but have a distinct, almost programmatic relation to the Russian political and social ideal as well as a profoundly emotive significance. He called his art suprematism, he said, to signify 'the supremacy of pure feeling in creative art. . . . In the year 1913, in my desperate attempt to free art from the ballast of objectivity, I took refuge in the square form and exhibited a picture which consisted of nothing more than a black square on a white field. . . . This was no empty square . . . but rather the feeling of non-objectivity.'[9] Geometric reduction wholly and *purely* rational served as the vehicle for mystic revelation for other artists besides Malevich, most notably Mondrian who sought to create what he designated as 'pure reality' by pruning painting to strictly right-angled relationships in dead-centre colours (red, blue, yellow, black and white). As much a preacher as van Gogh had been, Mondrian charged his paintings with a social as well as a theosophical spiritual message. In 1931 he wrote, 'When "art" is thrown into the "abyss", its real content will remain. Art will be transformed, it will be realized first in our physical surroundings, later in society . . . in our whole life, which will then become "truly human".'[10] Another student of theosophy, Kandinsky, in his numerous writings (beginning with *Concerning the Spiritual in Art*, first published in 1912) professed a similar Utopian intent for his diametrically different non-objective art with spontaneous, eruptive lines and splashes of colour shooting out in violently opposing directions. (When he returned to Russia at the time of the revolution, his work became considerably more controlled-looking). In 1916 he wrote:

When will the question of form no longer replace the question of art? When will one really understand that art does not come from form, but form from art . . . and that form without content is a sin against the spirit? . . . The only

stand toward art which is creative demands . . . that one surrender oneself to the personal resonance of the artist, that one entrust oneself to him. . . . Then a new world . . . opens up for the spectator. He journeys into a new land of the spirit where his life will be enriched. This country, which the artist is compelled to show his fellow men and which, despite all and defying all, he must embody, is created . . . not for the artist's sake but solely for the spectator's, because the artist is the slave of humanity.[11]

Exploring the meaning of abstract art is not so peripheral to our particular subject as it may seem. Aside from exemplifying the switch from external object to the work of art as an object in itself, there is pertinence in the fact that this early abstraction admittedly and consciously did, in its *content*, allude to something other than itself, whereas most of the new abstract art of the 1960s (which falls within the same strain in the context of this essay) firmly abjures such allusions.

In 1965 Donald Judd (7), writing on Lee Bontecou's work (8), considered it as an example of the scale, economy and oneness of the new American art which he characterized as 'pragmatic, immediate and exclusive. Rather than inducing idealization and generalization and being allusive, it excludes. The work asserts its own existence, form and power. It becomes an object in its own right.'[12] While Judd's historic 'Specific Objects' article (published in *Arts Yearbook 8*, 1965, but written about a year earlier) is primarily concerned with three-dimensional art, he also refers to the new painting as sharing the desired 'specific, aggressive and powerful character', which derives largely from the fact that 'the thing as a whole, its quality as a whole, is what is interesting . . . the shape, image, colour and surface are single and not partial and scattered.' These qualities are apparent not only in the strictly geometric work of such artists as himself, Robert Morris (9), Sol LeWitt, Frank Stella, Kenneth Noland and Will Insley, but also in the fluorescent light pieces of Dan Flavin, in Richard Smith's canvas constructions, in Lee Bontecou's cloth over metal reliefs and the clothing, food and home items of Claes Oldenburg (10) in which the image corresponds with – actually creates – the shape of the object. Among the notable 1950s precursors of the 1960s image/object structures are Jasper Johns's flags (11), which were especially important for Stella, Insley and a whole host of shaped canvas painters, including Charles Hinman and Neil Williams (see 'Mathematics and the New Abstraction' (pp. 196–201) and 'American Attitudes towards Art and Experience' (pp. 125–121), in which some of the issues raised by the art and attitudes of many of these artists, including Judd and Morris, are touched upon). One of the major 'specific object' makers, Robert Morris, told David Sylvester, 'The reason I don't title them is that I don't think the work is about allusions. And I think titles always are. And I think the work is very much about *that* thing there in the space, quite literally. And titles seem to me always to have some allusion to what the thing isn't, and that's why I avoid titles.'[13]

Morris's comment brings to mind the name of a little magazine, *It is*, published briefly in New York in the late '50s; one also recalls that from about 1948 to 1951 several of the major abstract expressionists assigned numbers to their paintings instead of titling them, thus emphasizing the autonomy of the painted object. But they never adhered to a programme of excluding extra-pictorial meaning; on the contrary, they continued to uphold the principles set forth in the famous 1943 letter to the *New York Times* prepared by Mark Rothko, Adolph Gottlieb and Barnett Newman, in which they proclaimed, 'There is no such thing as good painting about nothing.' For the rest of their lives, Rothko and Newman produced abstract work which for countless observers supports another contention expressed in that letter, 'Only that subject matter is valid which is tragic and timeless.' Most 'minimalists' (as Morris, Judd, LeWitt, Andre, etc. are commonly, but annoyingly, called) would insist that such concerns are extrinsic to the art object itself. In a 1971 interview Judd asserted, 'I wanted to get rid of all those extraneous meanings – connections to things that didn't mean anything to the art.'[14]

However, such disavowals on the artists' part cannot prevent the observer from responding as deeply and explicitly as he chooses to, or can, to the minimalists' severely stripped-down, monumental constructions. Basic in form, direct and clear in concept: either one piece (a triangle, rectangle or L by Morris), or the same unit repeated a number of times (Andre's row of bricks on the floor (13), or a simple progression (Judd's horizontal wall and floor pieces; 7, 76), or a more involved group of permutations (LeWitt's forty-nine cubes; 58), these bold new works take their point of departure from principles operating or implicit in the art of such immediate predecessors as Newman, Reinhardt, Rothko (12) or the earlier precursor Malevich – and of course Brancusi.

While Brancusi's sculpture has been of the greatest importance for such artists as Andre and Morris, it is, I feel, fundamentally different from major American art since the Second World War in some respects. Brancusi's work tends to retain a more intimate, human scale, and (except for the extraordinarily advanced *Endless Column* (14), which repeats the same unit to a height of ninety-six feet, and implies indefinite extension) it evidences careful 'relational' adjustments, i.e. the kind of subtle balancing which makes the *Bird in Space* such a *living* image and a symbol of aspiration. Moreover, Brancusi's work has a lovingly hand-made, beautifully crafted quality. Even the rough, unfinished-looking bases, which he sometimes regarded as sculptures, are 'crafted', though partly by nature's hands. In any case, all of his work looks as though it were made by an artist, not a machine. Another, and profound, difference from most minimalists is that Brancusi's art consciously celebrates human spiritual values, as is clear from the photographs that he took of his work, one of which catches the light on the highly polished bronze *Bird in Space* in such a way that the physical object is totally dematerialized – the body is transformed into pure

light, pure spirit, like the Christ in Rembrandt's drawing of *The Supper at Emmaus*. (I am thinking particularly of the one attributed to him in the Fitzwilliam Museum, Cambridge.)

Probably the flattest statement of the minimalists' neutral attitude (evidenced even in the absolutely flat surfaces of both their two- and three-dimensional art) was made by Frank Stella in 1966:

> I always get into arguments with people who want to retain the old values in painting – the humanistic values that they always find on the canvas.
> My painting is based on the fact that only what can be seen there *is* there. It really is an object. . . . All I want anyone to get out of my paintings, and all I ever get out of them, is the fact that you can see the whole idea without any confusion. . . . What you see is what you see.[15]

Stella's painting follows strict correspondence between interior image and exterior shape. His idea is basically quite simple – clear and direct as a total concept and in the structure of each picture. In the 1959 black paintings the movement of the white lines conforms to the edges, i.e. he took his leads straight from the traditional rectangular format. Many earlier artists had reinforced or reiterated, in their images, the vertical-horizontal nature of the support; but Stella simply covered the surface with lines uniformly distant from each other into such strictly rectilinear patterns as concentric rectangles, diamonds or triangles. Then, as though he asked himself: 'What's so inviolate about the outer edge?', he let the movement of the lines actually *determine* the exterior configuration, and continued doing so in all his paintings from 1960 to 1965 (except for some mitred and concentric squares which return to the black pictures in basic pattern, but which are executed in bright colours, extremely flatly applied with machine-precise edges). First after the black paintings came the aluminium series (15) in which the lines are allowed to notch the edges. These initial, only slightly 'shaped canvases' are followed by a series of copper-coloured paintings in such right-angled conformations as a broad L, a T, a U, a zig-zag and a Greek cross. Next come polygons in purple metallic paint whose concentric lines leave widely open centres to the hexagon, trapezoid, rhomboid etc. shapes; then red, green and smoky-blue metallic-coloured chevrons forming trapezoids, parallelograms, stars or crosses, and the notched Vs, thrusting vectors, of the series which Stella termed the 'running V' or 'flying wedge' pictures. Robert Rosenblum's reference to this last type as a 'symbol for abstract, mechanized speed'[16] openly contradicts the artist's intention, but that is only one of many instances when the observer gets a great deal more out of what's there than would presumably please Stella and other artists who, by the late '50s, had had more than enough of the abstract expressionist soul-searching and soul-finding as extolled by such critics as Harold Rosenberg. In 1966, the parallel stripes which had served as the basis of all Stella's imagery from 1959 to 1965 gave way to a series of irregular polychrome polygons. While there is interaction

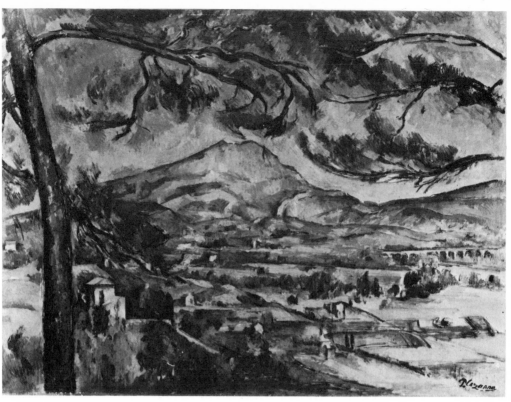

1 PAUL CÉZANNE *Mont Sainte-Victoire c.* 1887

2 CLAUDE MONET *Haystack at Sunset near Giverny* 1891

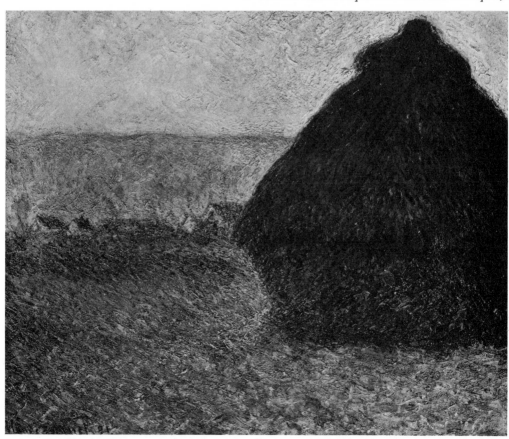

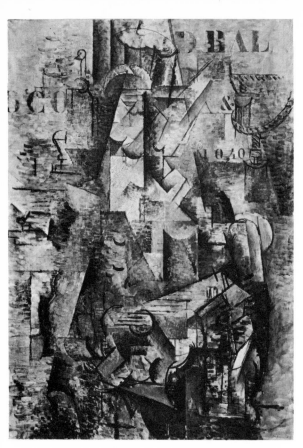

3 GEORGES BRAQUE *The Portuguese* 1911

4 WASSILY KANDINSKY *Skizze 160A* 1912

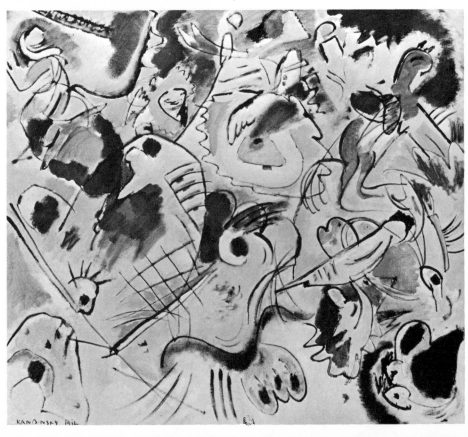

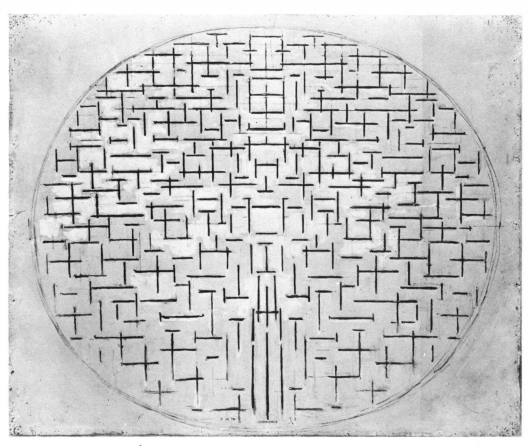

5 PIET MONDRIAN *Pier and Ocean* 1914

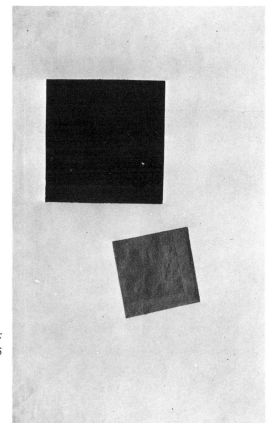

6 KASIMIR MALEVICH *Suprematist Composition:*
 Red Square and Black Square 1914 or 1915

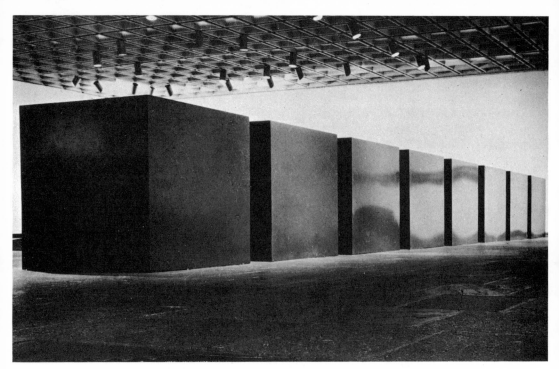

7 DONALD JUDD *Untitled* 1967

8 LEE BONTECOU *Untitled* 1961

9 ROBERT MORRIS *Columns* 1961

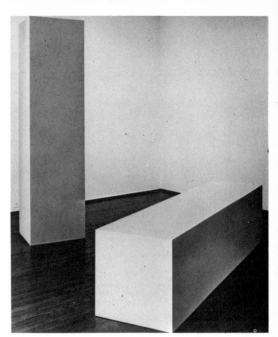

10 CLAES OLDENBURG *Cash Register* 1961

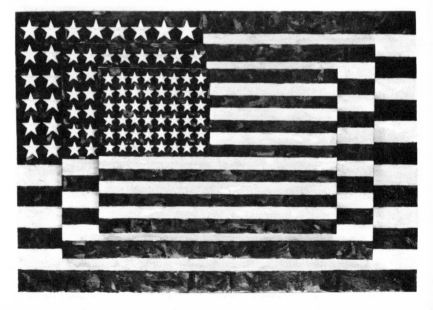

11 JASPER JOHNS
Three Flags 1958

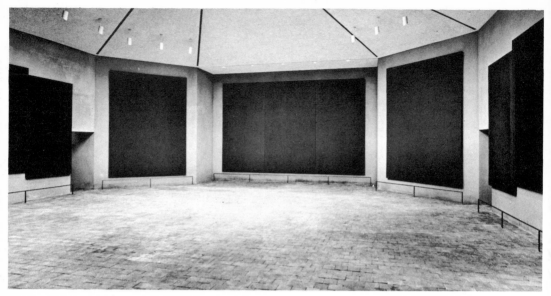

12 MARK ROTHKO The Rothko Chapel dedicated 1971

13 CARL ANDRE *Lever* 1966

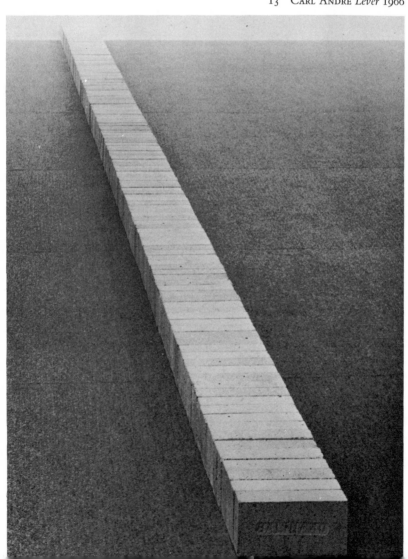

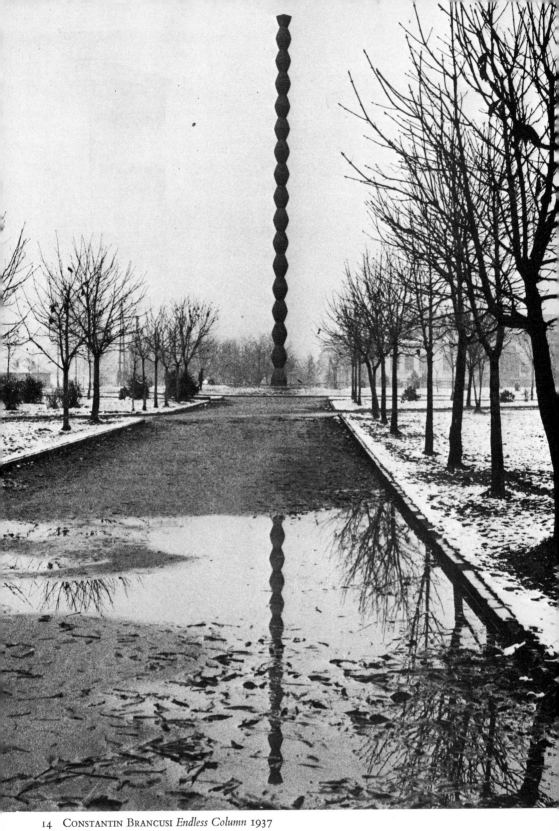

14 CONSTANTIN BRANCUSI *Endless Column* 1937

15 FRANK STELLA *Six Mile Bottom* 1960

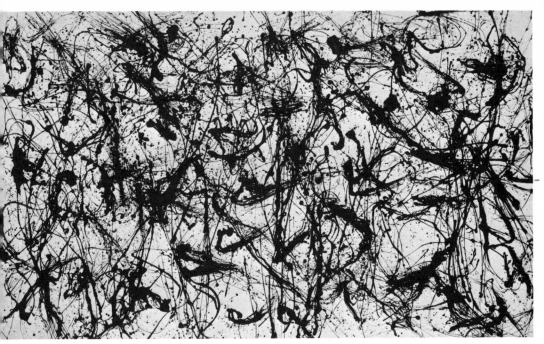

16 JACKSON POLLOCK *Number 32* 1950

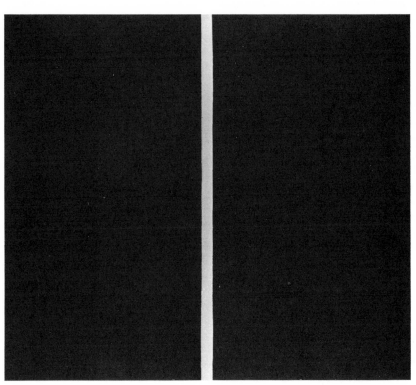

17 BARNETT NEWMAN *Onement IV* 1949

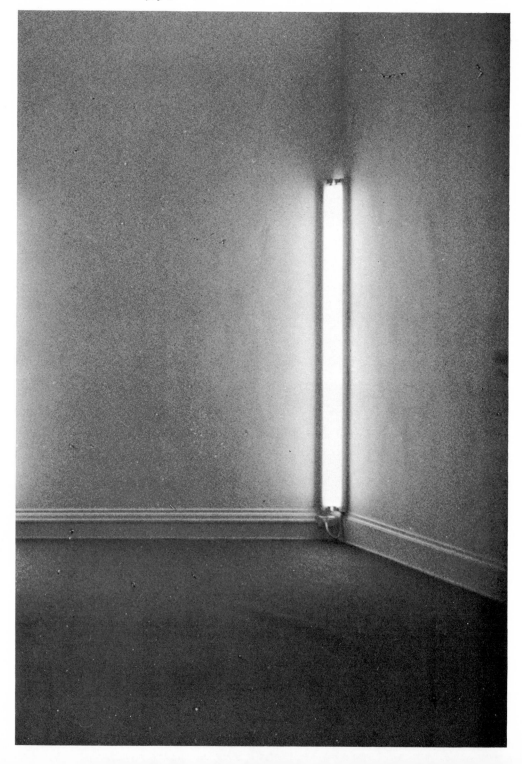

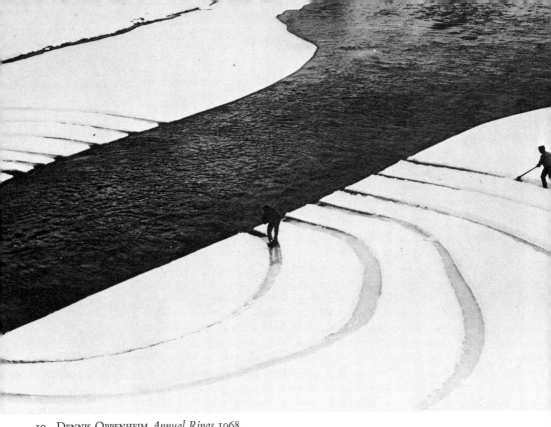

19 DENNIS OPPENHEIM *Annual Rings* 1968

20 MEL BOCHNER *Range* 1975

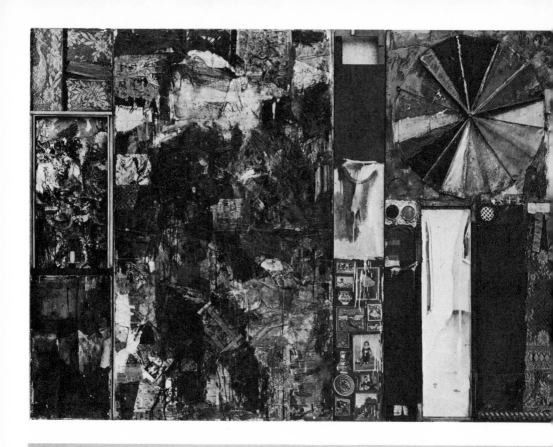

black bathroom #2

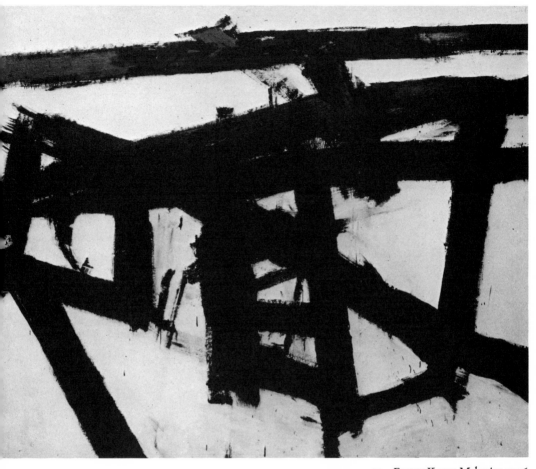

23 FRANZ KLINE *Mahoning* 1956

< 21 ROBERT RAUSCHENBERG *Charlene* 1954

< 22 JIM DINE *Black Bathroom No. 2* 1962

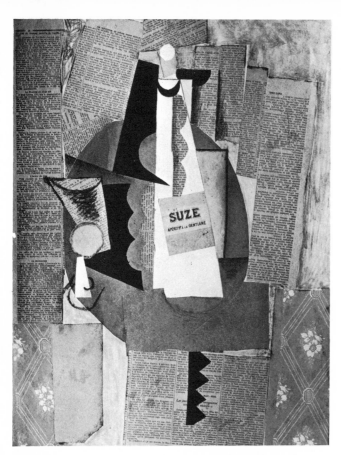

24 PABLO PICASSO *La Suze* 1912–13

25 GEORGES BRAQUE *The Clarinet* 1913

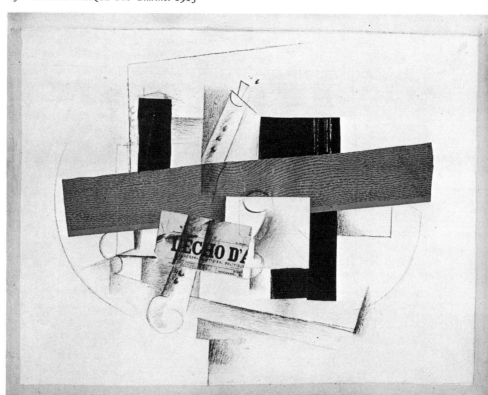

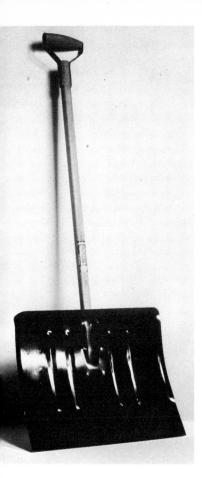

26 MARCEL DUCHAMP *In Advance of the Broken Arm*
1915 (original lost; second version
obtained by Duchamp 1945)

27 KURT SCHWITTERS
Hanover Merzbau 1925
(destroyed)

28 JAMES ROSENQUIST *Painting for the American Negro* 1962–3

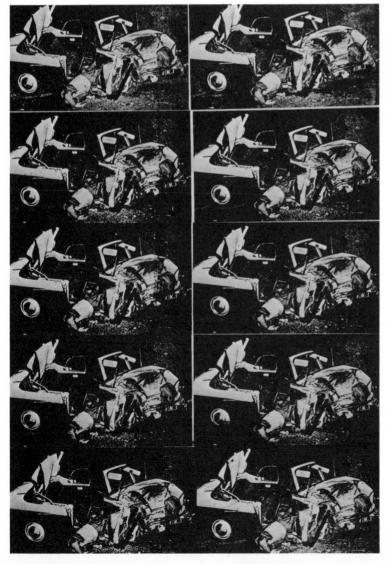

29 ANDY WARHOL
Green Disaster No. 2
1963

between the shape of the canvas and the pattern painted on it in the irregular polygons and in the subsequent, dazzlingly-coloured protractor series, still the movement of line is no longer the actual determinant of shape in Stella's painted objects. That it had been the design, the drawing, which determined the configuration of the support in the earlier work is not only visually apparent but is supported in a statement by the artist himself to William Rubin, 'I don't think of the perimeter as such . . . when I see the outline of the picture I see the interior drawing with it. In other words I see a line drawing of the idea. I never see just a cut-out of the shape.'[17]

I have spent a considerable amount of time on Stella as the master *par excellence* of the shaped canvas, because such structures underscore heavily the existence of the painting as an object and because minimal sculpture is closely allied to Stella's painting, or even in some cases indebted to it, and because the power he gives to line as the basic generator of his work connects it with that of Jackson Pollock and Barnett Newman. (The idea could be carried back, but only generally speaking, to the Futurist 'lines of force', Klee's 'going for a walk with a line', and the veering directions of parallel lines van Gogh used as one means of expressing what he called 'the struggle for life'.) In Pollock's most personal painting (16), however, it is line alone which charges those swaying fields of energy, and it is with *line* that Newman 'declares space' (17), the phrase by which he indicated that he was not representing space, but actually creating it.[18] And he did so with a single breath-taking 'zip'. Newman's orange line cutting right down the centre of a red-brown field in *Onement I*, 1949, was as daring, and as seminal, as Malevich's black square on a white ground. The two artists, one Russian and the other an American whose parents came from Lomza in Russian Poland, are further comparable in that their radical reductivism puts their art at the service of values extrinsic to it. Although Malevich sought specifically to further the social ideals of his political position, whereas Newman's thrust is religious (primarily poetic analogies with ancient Judaic myths of creation, etc.), those implications of their work are secondary to its central concern, namely that its abstract content be *experienced*. Such art makes special demands on the spectator; one must forget everything else – put everything else aside as the artist had done – and allow oneself to *feel* the void, to experience the reality of nothingness and of that sudden streak of energy which quickens nothing into being. To call Newman an abstract expressionist is no misnomer. Although his painted line is absolutely straight and as inorganic as a mathematical equation, it is *fundamentally* no less expressive and personally felt than Pollock's or van Gogh's. Among the more recent unexpected uses of line are Dan Flavin's fluorescent light fixtures (which may seem like Duchamp's 'ready-mades', but actually have far more to do with Newman as art and idea; 18), Dennis Oppenheim's paths on ice (19) and Mel Bochner's numbers (20). Although concealed, line is still at work in Larry Poons's circles and ellipses moving through large fields of colour (101), and in the chicken-wire and plaster pieces by Claes Oldenburg

(84). Although Oldenburg is totally committed to common objects, he, in distinction to several of the other artists carelessly grouped together as 'Pop', almost never incorporates actual objects (only in some small studies where he uses cigarette butts, three-way plugs, a clothes-peg). Rather, he *makes* objects which have the intensity that ordinary things possess when they are isolated from their normal surroundings or robbed of their function.

In the early 1950s, Robert Rauschenberg had begun to attach real things to his paintings (a stuffed goat in a rubber tyre like a ballet-skirt, an umbrella, a cushion, a rooster, etc.; 21). Except for printed matter, principally sports and other news images, Rauschenberg's objects seem to have come from attics and junk piles, whereas Jim Dine, one of his numerous followers, got his tools, bathroom fixtures and such objects straight from hardware and plumbing shops (22). But there is an equally personal flavour to the objects selected by Jim Dine, Jasper Johns, Roy Lichtenstein, James Rosenquist, Tom Wesselmann and other major 1960s common-object artists, each of whom is decidedly individual aesthetically, iconographically and art historically. In much of his work, Lichtenstein deals specifically with earlier art styles; Dine's sink functions, not only emotively as a naked, unshielded object, but also visually, like a slashing stroke of white against black in a Franz Kline painting (23); and there are in Rauschenberg's combines reminiscences of cubist pictorial structure in spite of their other differences from cubist collage, which is of course the cradle of object art.

While analytic cubist painting emphasized the supremacy of the created object by subjugating the source object to it, and thus prepared the way for totally non-objective painting, cubism also ironically set the stage, in its collage phase beginning in 1912, for the eventual elimination of the created object. The bits of reality from 'out there' (fragments of newspaper, labels, rope, etc.) which Picasso (24) and Braque (25) combined with oilpaints in their pictures, brought so much of *their* life into what Picasso referred to as the life of the forms that the step from cubist collage to Duchamp's hat-rack, shovel (26), urinal, etc. which he designated 'ready-mades' (and which become art objects simply by virtue of their being selected by an artist) was not such a fantastic stride as it seemed during and immediately after the First World War – and as it still continues to seem for many people.

A casual comment by Rauschenberg became a cornerstone of 1960s criticism; he said he was operating in the gap between art and life.[19] The attempts on the part of artists to narrow that gap, by bringing everyday life into art's theories, concerns, materials and processes, can be traced back through a long course of art history, taking on increased urgency throughout the nineteenth century and our own century of constantly shifting values. The Dada shattering of traditional values, graphic evidence of the cultural and political changes signalized by the First World War, took many different forms and degrees, although generally speaking the basic destructiveness was intended, as Duchamp later recalled, to be a sweeping out process.[20] The musician Edgard Varèse expressed the same idea

(in a talk given during a symposium on art and music at Bennington) in 1955: 'Radical changes in music written today are considered not evolutionary, but dangerous and destructive. And they are. Dangerous to inertia and destructive of habits.'[21] The range within Dada is evident, for example, in comparing the objects of Kurt Schwitters with those of Duchamp. The former's collage paintings and constructions, his *Merzbau* (an environmental maze of niches and caves filled with physical mementoes of his family and friends – fingernail clippings, cigarette ashes, a bottle of urine; 27), his proposed *Merz* theatre (which would have incorporated an amazing assortment of sights, sounds, smells, anticipating the 1960s happenings) and his *Ursonate* (a 35 minute vocal sound poem, with no words) do bring life into art while dissolving the barriers between the two realities. However, in spite of the immensely generative effect Duchamp's act of selecting the ready-mades has had on subsequent art, it remains an intellectual gesture. While it devastatingly proclaims the anti-traditional art position that anything the artist says is art *is* art, it is exclusively involved with an *art* issue, and it demonstrates that the narrower the gap between art and life, the deeper it is. To most people, a shovel is a shovel; only those who are supposed to 'know' could call it an art object.

A slightly different ironical twist was encountered by the Pop artists in relation to their public. Since they incorporated or imitated the most ubiquitous, everyday objects, they thus, theoretically, made their work more accessible; but at first even art critics found it difficult to separate their art objects from their source objects. Even now, I suspect, to the uninitiated, Oldenburg's sculptures are still food (86) and clothing (84), and Lichtenstein's paintings are comics (94), Rosenquist's are billboards (28) and Warhol's are news photographs (29). Although these artists take their subjects from already abstracted images (such as advertising art), they are presenting the appearance of the object 'out there' as surely as Kensett had done, or as the photo-realists of the 1970s are doing. While the latter use photographs, as many nineteenth-century artists had done, they do so very differently. Most of the new photo-realism is *about* photography, as much Pop art was about advertising. Chuck Close's colossal portraits (30) are more about putting into paint the appearance of the black-and-white and colour photographic and reproductive processes than they are about the persons represented. His concerns, and those of many other photo-realists, like the British-born Malcolm Morley, who was already precisely copying coloured photographs (31) in the early '60s, are in many ways closer to those of modernist abstract painters than to nineteenth-century representational artists, or even to the American precisionists of the 1920s. The means usurps the subject; and that is still not easy to see because of the ironical way in which it happens. But anyone can see that Picasso's *Glass of Absinthe* (68) and Schwitters's collages, unlike Duchamp's ready-mades or 'rectified' ready-mades, *look* like art objects. Even the *Merzbau* is a construction, a free-form, open-ended cubist sculptural building.

In Schwitters's constructions and in the enigmatic, contradictory Surrealist work of the 1930s such as Magritte's *The Therapeutic* (32) or Meret Oppenheim's historic fur-covered teacup and saucer (33), or in Cornell's pure poetic boxes (34), the found objects are *responsible* for the character of the work. In cubist collage, on the other hand, the *objet trouvé* keeps only some of its presence while it is being used as a material like paint or charcoal. In the 1950s, when Rauschenberg put found objects together with paint again, they remained much more themselves than they had done in cubist collage and much more amalgamated with painting than in Dada or surrealist objects. The surrealist artist acts as a kind of medium, releasing the mysterious power of things. The appeal of surrealism for the American 'myth makers' (Rothko, Newman, Pollock, etc.) of the 1940s lay in that area, as well as in its emphasis on ritual and primitivizing and on what Pollock spoke of as its 'freeing of the subconscious'. Pollock identifies his inner self so closely with his activity as a painter that one might say he abolishes the distinction between subject and object. Figuratively speaking, the action, the acted upon and the actor become one.

Happenings, which had their high point in New York in the early '60s and dwindled in impact as they increased in popularity, are a direct outgrowth of this attitude. From being a pictorial record of an act, the art object easily became the act itself. In this and other areas where the art object ceases to be a portable *thing*, I have veered slightly away from the initial theoretical bent of this essay to a more specific and even, to some extent, historical analysis. My reason for doing so is that recent departures from the traditional object are extraordinarily numerous, complex, more in need of introductory explication than the work of Cézanne, Picasso, or the Pop artists, and less fully covered in the following essays.

Involving the spectator directly in the art work, as happenings often do, is another phase of the historic levelling-out process which, like the dissolution of the barriers between the separate arts and between art and life, makes unexpected companionships. Pollock, who joins hands with Dada in this respect, would have been startled, to say the least, at some of the art educed from ideas implicit in his work and attitude. Allan Kaprow's article, 'The Legacy of Jackson Pollock', published in 1958, is a brilliant prophecy of the new art unconsciously generated and sanctioned by Pollock. He writes that Pollock

> . . . left us at the point where we must become preoccupied with, and even dazzled by, the space and objects of our everyday life, either our bodies, clothes, rooms, or, if need be, the vastness of Forty-Second Street. Not satisfied with the *suggestion* through paint of our other senses, we shall utilize the specific substances of sight, sound, movements, people, odors, touch. Objects of every sort are materials for the new art: paint, chairs, food, electric and neon lights, smoke, water, old socks, a dog, movies, a thousand other things which will be discovered by the present generation of artists. Not only

will these bold creators show us, as if for the first time, the world we have always had about us, but ignored, but they will disclose entirely unheard of happenings and events, found in garbage cans, police files, hotel lobbies, seen in store windows and on the streets, and sensed in dreams and horrible accidents. An odor of crushed strawberries, a letter from a friend or a billboard selling Draino [*sic*]; three taps on the front door, a scratch, a sigh or a voice lecturing endlessly, a blinding staccato flash, a bowler hat – all will become materials for this new concrete art.

The young artist of today need no longer say 'I am a painter' or 'a poet' or 'a dancer'. He is simply an 'artist'. All of life will be open to him. He will discover out of ordinary things the meaning of ordinariness. He will not try to make them extraordinary. Only their real meaning will be stated. But out of nothing he will devise the extraordinary and then maybe nothingness as well. People will be delighted or horrified, critics will be confused or amused but these, I am sure, will be the alchemies of the 1960s.[22]

Claes Oldenburg, who declared his debt to the abstract expressionist master in vivid language ('I feel as if Pollock is sitting on my shoulder or rather crouching in my pants!'),[23] had been affected by Kaprow's essay when he wrote his famous

I am for an art that does something other than sit on its ass in a museum. I am for an art that grows up not knowing it is art at all. . . . I am for an art that involves itself with everyday crap and still comes out on top. . . . I am for an art that comes out of a chimney like black hair and scatters in the sky. I am for an art that spills out of an old man's purse when he is bounced off a passing fender. I am for the art out of a doggy's mouth, falling five floors from the roof. I am for an art that a kid licks, after peeling away the wrapper. I am for an art that joggles like everyone's knees on a bus. . . . I am for an art that unfolds like a map, that you can squeeze like your sweety's arm, or kiss, like a pet dog. . . . I am for the art of red and white gasoline pumps and blinking biscuit signs. . . . I am for the art of underwear and the art of taxi-cabs. . . .'[24]

But Oldenburg's happenings (87) were very different from Kaprow's, as is indicated even by the term 'performances', which he preferred to call his Ray Gun Theater pieces. While chance and the extemporizing of his performers created considerable variation in what happened, still Oldenburg did have a kind of script, and the observer very definitely felt the artist's presence and his profligate richness in the visual as well as experiential character of the work. Kaprow's pieces, on the other hand, tended to be stricter, less abundant, and usually kept closer to actual events which he designated as happenings. Indeed there were as many varieties of happenings as there were artists presenting them. The German, Joseph Beuys, one of the most important and earliest artists in this field, calls such pieces as his famous *How to Explain Paintings to a Dead Hare* (35) 'actions', thus underlining with Teutonic certitude the fact that the object has

become the act. Other artists loosely grouped together in the international Fluxus association include several Americans, especially George Brecht, who has yet to have a major show in a US museum. A few of his Duchamp-inspired arrangements were exhibited in some of the early '60s group shows; but those objects (such as a stool with a bag of oranges on it) are somewhat less pertinent to our investigation than some other aspects of his work, particularly his mail art. As early as 1961 Brecht began sending out such cards as the following:

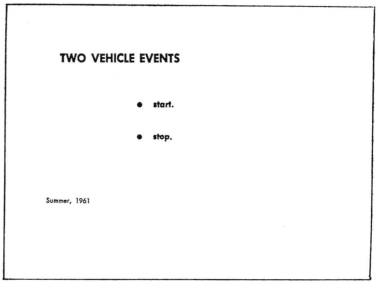

TWO VEHICLE EVENTS

● start.

● stop.

Summer, 1961

Fig.1 GEORGE BRECHT *Two Vehicle Events* 1961

Fig.2 GEORGE BRECHT *Two Exercises* 1961

TWO EXERCISES

Consider an object. Call what is not the object "other."

EXERCISE: Add to the object, from the "other," another object, to form a new object and a new "other."
Repeat until there is no more "other."

EXERCISE: Take a part from the object and add it to the "other," to form a new object and a new "other."
Repeat until there is no more object.

Fall, 1961

The major and most consistent exponent of correspondence as the object is another American, Ray Johnson, who spends twelve to fifteen hours a day at his work-table, writing, pasting, labelling, xeroxing his art. He too has had more official recognition in Europe than at home, although, unlike Brecht, he has always lived in the States. In April 1973 he wrote a letter to the obituary section of the *New York Times* announcing the death of the 'New York Corraspondence [*sic*] School', which has since been replaced by a variety of sobriquets including 'Buddha University' and 'The Dead Pan Club'. Johnson's mailings are usually in the form of his highly individual collages, which the recipient is frequently requested to add something to and send on to a designated person.[25] In this way Ray Johnson and George Brecht and, more recently, a great many others who are mailing out their art (from Gilbert and George's *Pink Elephants* to Eleanor Antin's antic *100 Boots* postcards; 36) extend the object-act to the observer, and even to several unwitting participants – those workers who process and deliver the mails.

Other recent production in a related genre includes body sculpture or 'performance art', street art and events, earthworks and process art. Some critics and artists place this whole area of activity within the category of conceptual art, which owes so much to Duchamp, frequently via John Cage, as it extols 'visual indifference' (Duchamp's phrase) and chance rationally planned-for, extends the boundaries of art and gets rid of the buyable, sellable object. These historic tendencies were given added impetus by the resistance, which steadily increased during the affluent '60s, to the production of art objects as commodities for sale (thought by many only to feed the vanity and fill the pockets of the rich) and by the disenchantment with the entire gallery-museum-journalism system. Numerous artists of this persuasion left the galleries and studios to produce their art in dance-halls and restaurants, in the forest, the desert and the street. But, ironically, the heartfelt opposition to élitism which prompted many of these artists succeeded in producing even more élitist art. When Walter de Maria draws mile-long chalk lines in the Mojave Desert and Michael Heizer displaces 200,000 tons of the Virgin River Mesa, Nevada (37), it is often thought that they are trying to subvert the establishment while simply moving the gallery or museum out of doors, thereby increasing the size of the showplace but pitifully reducing the size of the audience. A common reaction is: how many people can hire a helicopter to look at a line in the desert or a cut in the rock? However, the majestic visual power of such remote works can be *felt* in one's imagination from published descriptions and photographs. What is sometimes interpreted as the artist's arrogance towards nature is more than matched by that of the patron ('collector', as he is designated in several publications illustrating these and other earthworks). In 1969 Robert Scull stated, 'I've collected art for the last ten years because I love it and I want to own it. It ennobled me and my surroundings. But things have changed with the discovery of Heizer's work. My walls used to be my gallery. Now the vast open spaces have become my gallery.'[26]

Although Carl Andre's own 'post-studio' art (his term) has seldom taken the form of earthworks (a notable exception was the 580 foot long *Joint*, made up of 183 bales of hay), his concept of 'sculpture as place' is one of the roots of earth art. Andre defined place as 'an area within an environment, which has been altered in such a way as to make the general environment more conspicuous. Everything is an environment, but a place is related particularly to both the general qualities of the environment and the particular qualities of the work which has been done.'[27] So 'sculpture as place' (which is to say the art object as place) means what happens to the environment out there when the artist does something to part of it. The conditions of the specific location determine, or at the very least strongly affect, the choice and placement of materials; there would be no work without the place.

Within such a concept, it was an easy step from the studio and gallery location to the outdoor site. Moreover, the boldly simplified, unambiguous, monumentally scaled structures of the minimalists called for an outdoor location. As Dennis Oppenheim said, 'Minimal art made people look at minimal forms. The best minimal forms were outside the gallery.'[28] Earth art is also related to the way in which Andre, Oldenburg, Judd and Morris among others had, in the early '60s, placed their boldly simplified, unambiguous sculptures directly on the floor. Especially prophetic were Andre's separated identical units laid down in a lateral extension (13), hugging the ground like a Frank Lloyd Wright house. Andre says, 'All I am doing is putting Brancusi's *Endless Column* (14) on the ground instead of in the air.'[29] But that change from a predominantly upward thrust to a flat, horizontal extension is highly significant in its cultural as well as aesthetic implications – a levelling-down tendency.

Earth works constitute one phase of the broader category of process art. In such examples as Richard Long's removal of daisy heads to form a twenty-foot long cross in a meadow, called *England* (38), 1968, and Jan Dibbets's 6×6 foot turf shaped into a *Grass Roll*, 1967, process becomes the art object. Robert Morris, one of the initiators in the States of the open, indeterminate kind of work which first earned the 'process' designation, wrote of 'making process not behind the scenes but the very substance of the work'.[30] A factor of major importance in process art is the role played by gravity, whether it be in materials with no fixed form of their own, such as vinyl, rope, latex and chicken-wire as used by such artists as Oldenburg (39), Eva Hesse (41), Robert Rohm and Bruce Nauman, or whether it be in solid materials such as lead, steel and wood. Gravity and process combine dramatically in Richard Serra's powerful, monumentally scaled works of flung or precariously balanced lead and of huge California logs positioned as they fell during the act of sawing, as in *Log Measure: Sawing Five Fir Trees* (40). Although Robert Morris is particularly identified with cut-felt sculpture, Richard Serra and Alan Saret had also made pieces in similar spineless materials (leather and rubber) in 1967; and Joseph Beuys, whose work Morris saw in Germany, had used felt several years earlier, but most often

as corner pieces or to cover objects, not to hang like paintings, as Morris's did at first. The *process* of the felt's cutting and the way it takes its own form in the hanging and changes from one state to another are the very 'substance of the work'; it, like the process of picking the heads off the daisies, or the dye changing the waters of the Caribbean to magenta in a work by Dennis Oppenheim, is the object itself.

In some respects, earth art is both conceptual and perceptual, that is, it is perceptual for the person(s) actually doing it or seeing it; but for the rest of us it can only exist in our minds – unless the experience is shared graphically, as is certainly the case with Robert Smithson's extraordinarily evocative film, a work of art in its own right, about the *Spiral Jetty* (42) which he built out into the Great Salt Lake, Utah. As the record of a spectacularly beautiful event, it would be difficult to surpass the film made of Christo raising his 200,000 square foot, bright orange *Valley Curtain* (43) across a 1,250 foot span at Rifle, Colorado. The art object was not the curtain, but the process, the event and the preparation for it and in fact the entire *history* of it, so that the ordinary activities of many persons become part of the art object. Christo makes his art of their daily life; the film makes this concept clear and involves the spectator emotively.

Most of the time, however, the photographs or films are only documentary evidence and in no sense works of art themselves, although they are too frequently so misapprehended when they are framed, exhibited and sold. This, like many other troubling discrepancies between the artists' stance and reality, results from the brute fact that, for the artist to live, money has to change hands somehow, although there have been several noble attempts to circumvent that problem. Among the few successful solutions are Tom Marioni's Museum of Conceptual Art, for several years operating on a shoe-string in a bare loft in San Francisco, where art-minded people can meet and talk and occasionally give performances; the numerous activities of Seth Siegelaub, a non-dealing dealer organizing non-exhibited exhibitions, like his 1969 *One Month*, for which he assigned a specific date in March to each of 31 artists whom he invited to send him verbal information regarding the 'work' they planned to 'contribute' to the exhibition, their replies, or blank pages for the non-replies, being published as the catalogue; or John Gibson's efforts to help artists realize their earth or other grand projects by trying to get commissions from collectors or patrons. The Fernsehgalerie Gerry Schum, Cologne, which commissions artists' films for German television, frankly admits the financial problem and their solution to it. Schum explained in 1969: 'The TV gallery exists only in a series of transmissions. . . . One of our ideas is communication of art instead of possession of art objects. . . . This conception made it necessary to find a new system to pay the artists and to cover the expenses for the realization of art projects for the TV show. Our solution is that we sell the right of publication, a kind of copyright, to the TV station.'[31] As Lucy Lippard pointed out, the Art & Project 'gallery', Amsterdam, is usually just its *Bulletin*.

In spite of these and other interesting attempts to bypass it, the traditional kind of gallery arrangement remains the most viable one for most artists. It has even served as the subject of several conceptual works, among them Walter de Maria's piece consisting of photographs of six dealers, and three adjectives describing each of them, together with this statement, 'MY DEALERS The following six people have represented me and my work to the outside world in the ten years of my professional career. RICHARD BELLAMY, PAULA COOPER, ARNE EKSTROM, NICHOLAS WILDER, HEINER FRIEDRICH, VIRGINIA DWAN. I would like to thank them, for our past association and for representing me here, for I do not like to be photographed.'[32] Does one reject the gallery system by embracing it fully, by making dealing itself the subject and the object? Is it an ironical gesture, or a straight acknowledgment of the system, or a clever idea for a work? Since dealers 'represent' an artist, why not have them literally represent him or her? De Maria does not show his physical appearance, but he reveals other aspects of his person in his relationship with his dealers and in his personal interpretation and reactions to them, as evidenced in his three-word characterizations of them. The extremely varied and significant role played by the major contemporary dealers, not only economically but in every aspect of the artist's relation to his public (and even to himself as an artist in extreme cases), needs the attention of a just, sensitive and totally disinterested historian. Perhaps the curator's role should also be evaluated, particularly when, as sometimes happens, it almost seems as though vanity had been the motivation. This results most probably from the difficulty of striking a balance between a fresh, stimulating show and one wherein the exhibition itself becomes the art object; the curator, the artist; and the exhibited works, the material.

The severely criticized gallery and museum establishment is not about to crumble when it is still being used by several of the strictest conceptual artists, i.e. the art-language group – those who insist that art is not visual; it is idea, information. But why, if art is not something to be looked at, do they put their words, too often boring, ill-digested liftings from currently fashionable philosophy or sociology, on exhibition in museums and galleries? Is it because the idea, like Duchamp's shovel, cannot be art outside the art context? Lawrence Weiner declared, 'I don't see how you can differentiate poetry from art without the proper information. First you might see it as a poem, but with the correct information, you would accept it as it is intended.'[33] In the words of Joseph Kosuth, American editor of *Art-Language*:

In so far as visual experiences, indeed aesthetic experiences, are capable of existence separate from the art, the condition of art in aesthetic or formalist art is exactly that discussion or consideration of concepts as examined in the functioning of a particular predicate in an art proposition. To restate: the only possible functioning as art aesthetic painting or sculpture is capable of, is the engagement or inquiry around its presentation within an art proposition.

Without the discussion it is 'experience' pure and simple. It only becomes 'art' when it is brought within the realm of an art context (like any other material used within art).[34]

Douglas Huebler's succinct statement, 'The world is full of objects, more or less interesting; I do not wish to add any more,'[35] could be paraphrased, 'The world is full of information, more or less interesting; so why add any more?' Often information is given straight like a weather report (with the difference that almost everybody has some personal interest in the weather) or words are used to show how words are used, disdaining what they are used for. Much linguistic-based art is about how we think, not what we think, about how we perceive, not what we perceive. Victor Burgin says, 'Some recent art . . . has tended to take its essential form in message rather than in materials;'[36] however, it seems to me that these artists *are* interested in materials. They are interested in the words which are their materials, but not in words as physical entities (the way 'sonorous', for example, sounds full-bodied and reverberating), nor in words as conductors of emotional, associational responses (e.g. the way D. H. Lawrence uses 'dark'), but in the way words *function*. Once more, the art object is process. Burgin himself says:

> Perception is a continuum, a precipitation of event fragments decaying in time, above all a *process*. . . . Vertical structuring, based in hermetic, historically given concepts of art and its cultural role, has given way to a laterally proliferating complex of activities that are united only in their common definition as products of artistic *behavior*. This situation in art is the corollary of a general reduction in the credibility of institutions.[37]

In the light of such ideas, it is behind the times to persist in looking for the *avant-garde*, as many critics still do. The whole idea of 'advancing' belongs to a more optimistic age. Modern man is a sandcrab, moving sideways instead of straight ahead; he doesn't advance, he shifts.

Certainly not all conceptual art in which the object has become language or information or theory is dry pedagogy. The work of such artists as Hans Haacke, John Baldessari, Steve Kaltenbach (44), Daniel Buren, Iain Baxter, Robert Barry, Agnes Denes and Lawrence Weiner, for example, does not merit Carl Andre's condemnation, 'If abstract art is art as its own content, then conceptual art is pure content without art.'[38] While conceptual art is truly abstraction (a concept is without physicality), it may deal with, imply or evoke physical facts, sensations, states, which may be more or less visually oriented. Some of the best of it is almost as rigorous in rejecting everything that is not art, and as totally dedicated to what *is* art, as Ad Reinhardt was – surely one of the greatest conceptual artists, *avant la lettre*.

Robert Barry declares, 'In my work the language itself isn't the art. . . . I use language as a sign to indicate that there is art, the direction in which the art is, and to prepare someone for the art. . . . Art is about man himself. . . . It is about

myself, about the world around me. And it is also about things that I don't know, about using the unknown.'[39] Much conceptual art supports Bochner's contention that '. . . it remains specifically impossible to abandon visibility, to speak, as it were, only with the mental voice.'[40] The fact that it is equally impossible to separate oneself from one's body is the basis of the large branch of conceptual art known as performance or body sculpture.

Although all of Yves Klein's work antedates the use of any such terms, most of it underscores the conceptual orientation of subsequent body/performance art. His *Anthropometrics* (45) presented in Paris in 1960 combined advanced music and a happening to make a painting on canvas. While twenty musicians played his *Monotone Symphony*, three nude females smeared their bodies with paint and rolled or dragged each other or pressed themselves upon the canvas, as directed by the artist. As Manet's *Déjeuner sur l'herbe* had done, *Anthropometrics* takes a traditional theme and genre – a monumental nude composition in oil paint – and puts it into a contemporary, shockingly actual life situation. Klein's body performance action painting comments upon, while it demonstrates, the action painter's non-traditional materials, methods and tools (here a 'living brush'), the commitment to gesture and ritual, the physical involvement and existential identification with the act of painting on a *conceptual* level (he only directed the nudes to paint his *Anthropometrics*; no paint touched his own elegantly clad body). The conceptual bent of Klein's art was signalized a dozen years before when he is said to have 'signed' his name to the sky as his part of the world, which he, Arman and Pascal divided among themselves. In 1959 Klein lectured at the Sorbonne on 'The Evolution of Art Toward the Immaterial' and released his first 'immaterial pictorial sensitivity zones', throwing into the Seine the gold leaf purchased by the buyer, who simultaneously burns his receipt for 'the material value correspondent to the immaterial acquired'. Through 'this act of integration of the work with himself', the spectator ('the buyer') becomes an essential part of the art object.[41] In 1960 Klein published his *Journal d'un seul jour*, illustrated by a photograph of himself (again in evening clothes) jumping from the second floor of a building and flying out over the street, with the caption, '*Le peintre de l'espace se jette dans le vide*'.[42] The Italian Piero Manzoni, like Klein, devised work of prophetic import within a tragically short lifetime, especially in such proclamation type gestures (both from 1961) as exhibiting a can labelled, and professedly containing, 'Artist's Shit', and signing his name on a nude body, thus making 'living sculpture'.

Comparable concerns motivated the work of a good many artists during the 1960s and early '70s. Curiously, the more global-minded one became in political and social sympathies throughout that period, the more one sought to develop awareness of one's own individual self and to explore every nuance of one's personal experience. The artist – his body, his activity, his thoughts, his perceptions, his relation to society, to the spectator, the dealer, etc. – become the art object. Such works range from Bruce Nauman's sculptures cast from parts of his

body, such as his *From Hand to Mouth* (104), recalling Jasper Johns's *Target with Plaster Casts* (46), and his corridors altering one's physical and aural perceptions of space, and Morris's key work, the 1963 *I-Box* (47) whose door is shaped like an I, which when opened reveals a photograph of the artist's nude body, to Vito Acconci's *Seed Bed*, 1973, wherein the spectator walks on a raised section of the floor, knowing (or being told) that underneath his feet, the hidden artist is masturbating – an extreme example of the artist's relation to the spectator becoming the art object.

Most of Acconci's other work and a great deal of body sculpture or performance art altogether involves self-violence: Terry Fox's *Cellar Event*, in which he smashed a burning light-bulb and broke the windows with a knife while the flying glass cut his face and wrist; Barry le Va's *Velocity Piece* (the artist rushing back and forth across a room, hurling his bleeding body against the wall for as long as he could move – 1 hour and 43 minutes); Chris Burden's *Movie on the Way Down* (an unforgettable image lasting only 1½ minutes, of the artist's nude body hanging upside down from a rope tied to his feet, holding in his hands a movie camera, photographing the process even as he crashed to the floor when the rope was cut by someone hidden in the high rafters; 48). But the ultimate in self-mutilation was Rudolf Schwarzkogler's amputating his own penis inch by inch, one of several such acts transgressing the line between art and madness which led to his death at the age of twenty-nine.

In a more pleasant vein, the ritual of eating and drinking has been the object of many performance pieces from Spoerri's dinners served at the 'Restaurant de la Galerie J' in 1963 to Tom Marioni's solitary drinking of a case of beer. The latter, and the majority of performance works, are either recorded, i.e. documented, on film or actually executed *as* film or videotape art. There is an enormous amount of work done in this category, ranging from Dan Graham's works in which, as he says, 'The camera may or may not be read as extension of the body ('s identity)', to William Wegman's deadpan, witty and lovable photographs and videotapes with his dog, Man Ray (49). Graham describes his *Two Correlated Rotations*, 1969:

> Two performers/filmmakers hold their cameras so viewfinders are direct extensions of their eye and visual fields. They walk in a counter-spiral to each other, the outside performer moving outward while the other walks inside towards the center. . . . The two films are projected simultaneously at right angles to each other. . . . The spectator rotates his neck to see frontally one or the other image. . . . The filmmakers are, to the spectator's apprehension of the projected images, each other's subjects (observed) as they are simultaneously each other's objects (observers). . . . The spectator is part of a three-way relation between the attention of the performers and the attention of his perception.[43]

Speaking of his dog, Wegman says:

> In a way he's like an object. You can look at him and say, how am I going to
> use you, whereas you can't with a person. . . . Maybe I was always trying to
> animate objects, maybe I wanted to make them come to life in some way in
> my work. And Man Ray already had that tension, that potential of becoming
> more than he was. . . . Once I thought I heard him say, 'Will you be needing
> me today, Bill?'[44]

Man Ray is like an extension of Wegman's own totally engaging self.

But in regard to the art object as the artist's self, Andy Warhol (50) remains
the prime example. In the 1960s, in his glittering Factory perfumed by all the
beautiful flowers surrounding him, he became an art object of mythic propor-
tions. Probably no other artist's studio activities have been made so public, and
yet we know more about even Mondrian's interior world than we do about
Warhol's. The reason is that 'Andy Warhol' is a carefully planned and executed
aesthetic entity, and the very secrecy about the real Andy Warhol is a major
factor in it, even though it may be partly unconscious (he was the way he is long
before the image was established). Making the artist's life the art object is not an
unexpected development when one remembers how the artist's biography is
just as effective as monetary value in drawing crowds to van Gogh, Gauguin and
Rembrandt exhibitions. Moreover, Andy Warhol, his films, the live perform-
ances of the Velvet Underground and his entire entourage vividly expressed the
attractive decadence and other not altogether negative values of the '60s drug
and rock scene. One should also realize that Warhol has always been a movie
addict, and his unquestioned importance as an innovator rests in his films and
silk-screen paintings (29). Both are two-dimensional *image* arts; and both are
second-hand images made in large part by a machine 'interfered with' as little as
possible by the artist. Irony abounds: making films with no editing or writing
a novel, *a*, simply by recording conversation in the Factory, should, on the face
of it, be very real. But how real is that isolated life, and who goes around looking
exclusively at sections of a sleeping man's body for eight or more hours? What
studied artistry in that concentration! Violent death in motor accidents (29), or
the electric chair, or by suicide, becomes unreal by repeating over and over
again, often in artificial colours, the silk-screen print of a newspaper photograph;
they are thrice removed from reality. Warhol remarked once, a good many
years ago, that he used to be afraid of death, but seeing it repeated all the time
made it unimportant. (Since the attempt on his life in 1968, however, his
attitude has changed: 'Having been dead once, I shouldn't feel fear. But I am
afraid. I don't understand why.'[45]) To a generation brought up on films and
television, has reality become confused with the picture of it? Fed constantly on
the endlessly duplicated, multiplied image of reality, is it surprising that an
artist should take his cue from the reflections or shadow of a thing, rather than its
substance? The fact that someone else now makes Warhol's films, just as a

stand-in has often made his public appearances, adds a conclusive touch to the masterful Warhol art object.

The way Andy Warhol lives his life becomes the art object; with the sculptors Gilbert and George, the reverse is the case: they become the art object and live its life (51). They actually *are* singing, walking, sitting, dancing, drinking sculptures. They carry the self-identifying implications of van Gogh's and Pollock's art to an extreme realization; but they do so with the nostalgic grace and purity of a Watteau painting come to life.

At the opening of *Dokumenta 5* in 1972, Joseph Beuys, the German counterpart of France's Yves Klein in terms of germinal importance, sat, wearing the battered old felt hat that has become something of himself, signing his name to plastic bags imprinted with one of his social-democratic manifestos. He was just as much a work of art as Duane Hanson's disorientatingly convincing *trompe-l'œil* sculpture, *Artist Seated* (52), exhibited in another part of the show. Beuys has ever more sharply focused his efforts onto two phases of his richly varied creativity: his teaching and his democratic political activism, which ultimately become fused into the single object which his dedication constitutes. In 1969 he declared, 'To be a teacher is my greatest work of art. . . . Man really is not free in many respects. He is dependent on his social circumstances, but he is free in his thinking, and here is the point of origin of sculpture. . . . My theory depends on the fact that every human being is an artist. I have to encounter him when he is free, when he is thinking.'[46] Art is one of the last strongholds of freedom. It offers us *freedom* – and we give it so little.

Beuys's activity exemplifies in part a final major branch of conceptual art, namely, that based on a variety of systems – biological, political, economic, social or mathematical. In the late eighteenth century, on the threshold of the modern age, Wright of Derby painted scientific demonstrations; now such demonstrations are exhibited *as* the art work (for example, Alan Sonfist's birds moving in response to the changes of heat and air currents, or Newton Harrison's extremely complex *Survival Pieces* (53, 54), including the *Portable Fish Farm* which caused such an outcry when it was shown at the Hayward Gallery in London together with other Los Angeles art in 1971). When the intermediate stage, i.e. the painting of the phenomenon, is eliminated, the subject becomes object. Such is also the case with Athena Tacha's 1968-9 *Phaenomena* sculptures (55) and subsequent films which include *Burning, Specific Gravity 1.18, Dripping,* etc. She as well as several other artists take their point of departure and, in Hans Haacke's case, even form and content, from sociology and its key tool, the questionnaire. Another of the several artists who have made works in the questionnaire format is Agnes Denes, whose art (56) based on a wide spectrum of science – biology, physics, astronomy, chemistry, psychology – is extraordinarily ambitious and sometimes, curiously, almost mystical. Using the idea of advertising because, as he said, he 'wanted to become a legend', Stephen Kaltenbach put ads in *Artforum* like 'Build a Reputation', 'Tell a Lie'.

But it is the mathematical branch of systems as the art object which has probably attracted most proponents, including Mel Bochner, in such demonstration pieces as *Meditation on the Theorem of Pythagoras* (57), and Sol LeWitt, who is generally regarded as the first master of conceptual art. His sculptures (almost exclusively white) which are constructed in sets running through numerous permutations in the placement of the same or similar elements, such as *49 3 Part Variations on 3 Different Kinds of Cubes* (58), are rigorously intellectual, but at the same time strangely sensuous and even touching in their austere purity. His *Paragraphs* (1967) and *Sentences* (1969) *on Conceptual Art*, which are almost as revered as Duchamp's dicta, likewise deal in contradiction: 'Conceptual artists are mystics rather than rationalists. They leap to conclusions that logic cannot reach. . . . If words are used, and they proceed from ideas about art, then they are art and not literature.' From this last statement, one would hardly expect the following, 'These sentences comment on art, but are not art.' While LeWitt says, 'Ideas alone can be works of art; they are in a chain of development that may eventually find some form. All ideas need not be made physical,'[47] he surely would also agree with Robert Smithson's statement, 'There is no escape from matter. There is no escape from the physical nor is there any escape from the mind. The two are in a constant collision course.'[48] The impact of that collision is felt in the work of all modern artists from Cézanne to Bochner, however varied their attitude toward the object.

30 CHUCK CLOSE *Phil* 1969

31 MALCOLM MORLEY *S.S. 'Amsterdam' Entering Rotterdam* 1966

32 RENÉ MAGRITTE *The Therapeutic* 1967

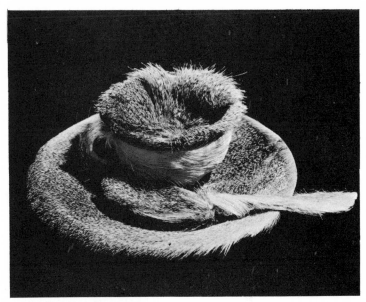

33 MERET OPPENHEIM *Objet*
(Le Déjeuner en fourrure) 1936

34 JOSEPH CORNELL
Taglioni's Jewel Casket 1940

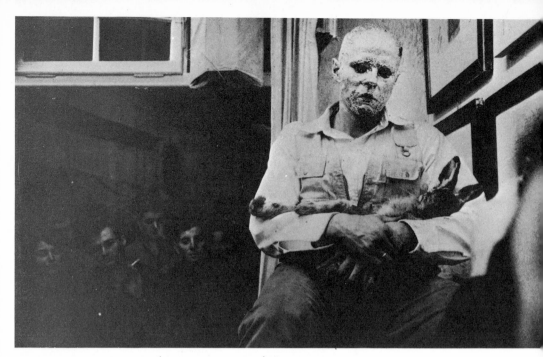

35 JOSEPH BEUYS *How to Explain Paintings to a Dead Hare* 1965

36 ELEANOR ANTIN *100 Boots on the Way to Church* 1971

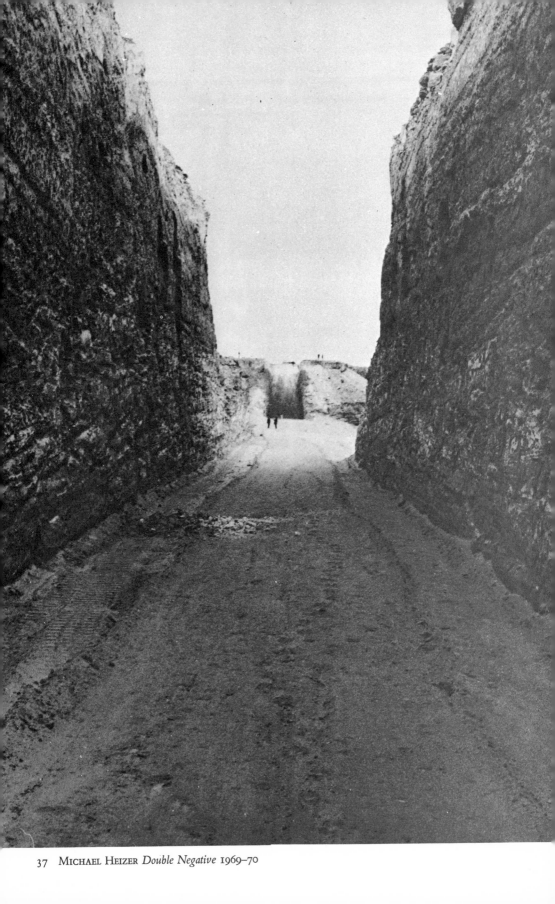

37 MICHAEL HEIZER *Double Negative* 1969–70

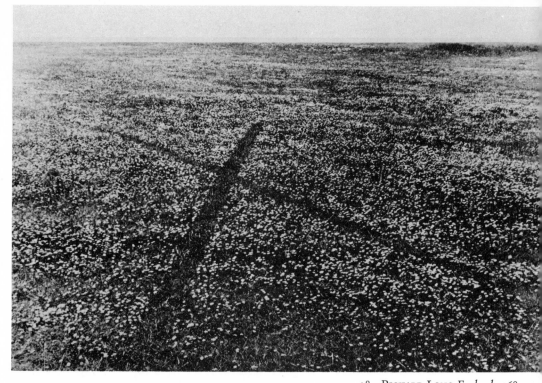

38 RICHARD LONG *England* 1968

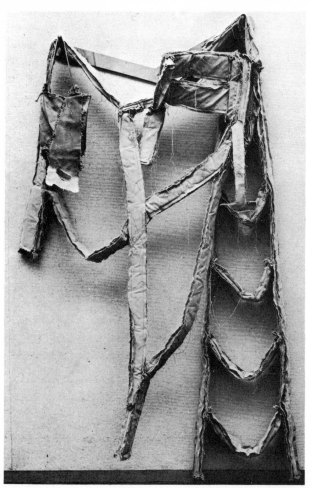

39 CLAES OLDENBERG *Soft Ladder,
Hammer, Saw and Bucket* 1967

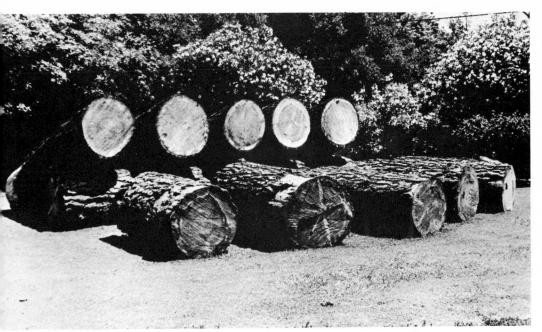

40 RICHARD SERRA *Log Measure: Sawing Five Fir Trees* 1970

41 EVA HESSE *Right After* 1969

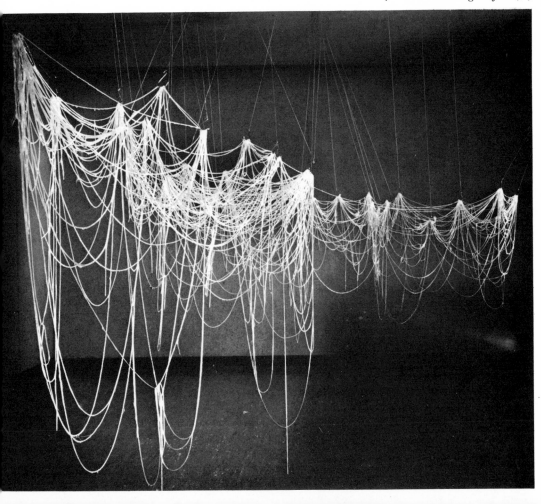

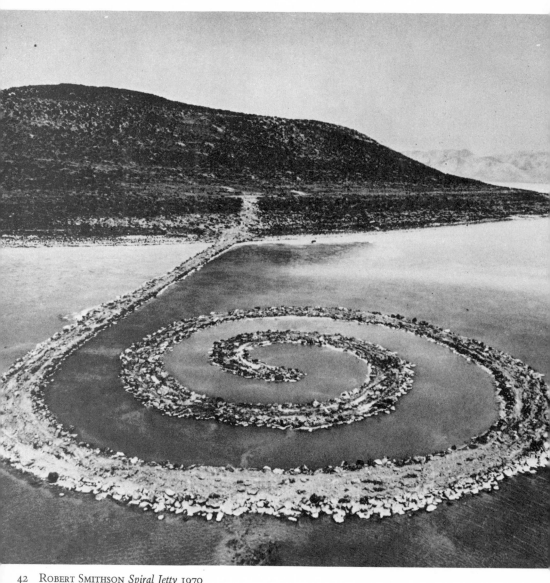

42 ROBERT SMITHSON *Spiral Jetty* 1970

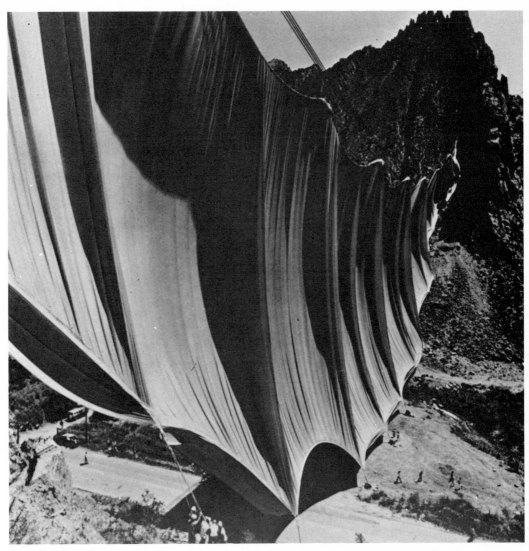

43 CHRISTO *Valley Curtain* 1970–72

44 STEVE KALTENBACH *Personal Appearance: Eye-disguise* 1969

45 YVES KLEIN *Anthropometrics* 1960

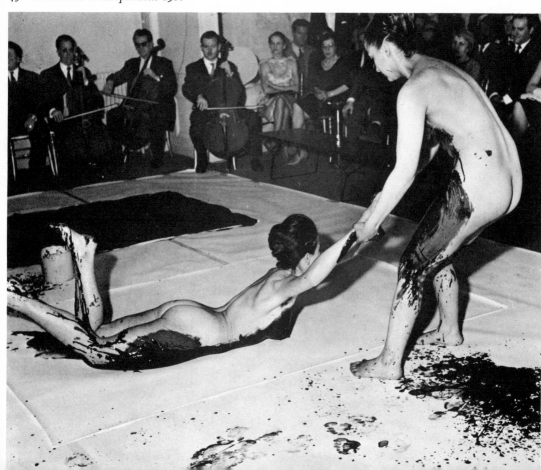

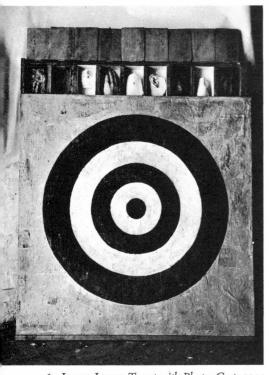

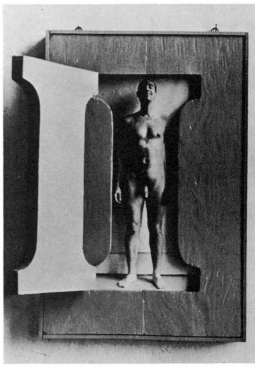

46 JASPER JOHNS *Target with Plaster Casts* 1955 47 ROBERT MORRIS *I-Box* 1963

48 CHRIS BURDEN
Movie on the Way Down 1973

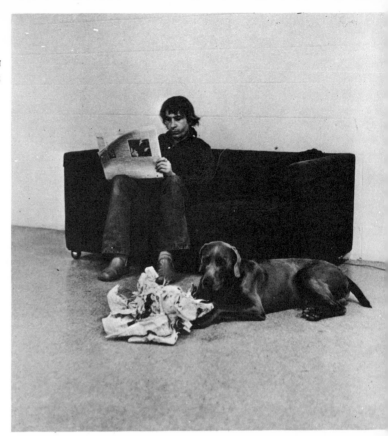

49 WILLIAM WEGMAN
Reading Newspaper 1973

50 Andy Warhol
at the Factory 1966.
Left to right:
Benadetta Barzini,
a friend, Warhol,
Lou Reed, Sterling
Morrison

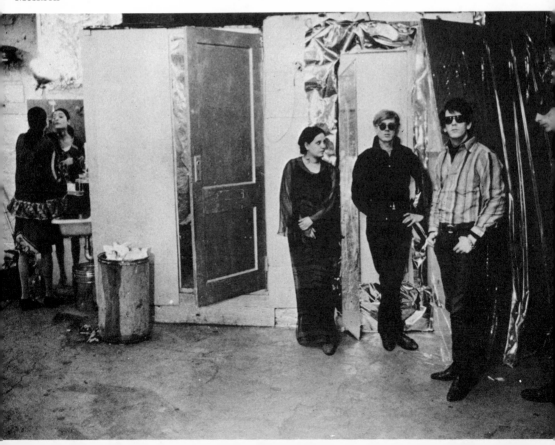

51 Gilbert and George
Singing Sculpture 1971

52 DUANE HANSON
Artist Seated (Mike) 1971

53 NEWTON HARRISON *Portable Orchard: Survival Piece No. 5* 1972

54 NEWTON HARRISON *Drawing for Portable Orchard* 1972

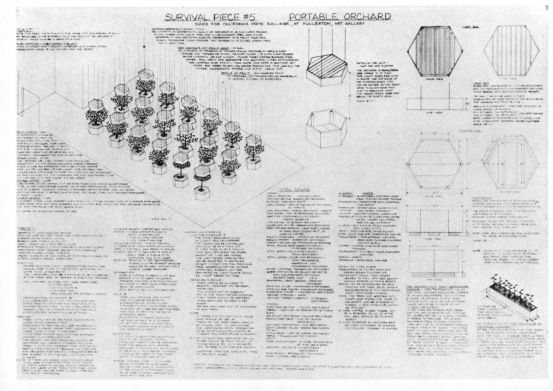

55 ATHENA TACHA *Dripping* 1969

56 AGNES DENES
Dialectic Triangulation:
A Visual Philosophy 1970

57 MEL BOCHNER *Meditation on the Theorem of Pythagoras* 1972

58 SOL LEWITT *49 3-part Variations on 3 Different Kinds of Cubes* 1968

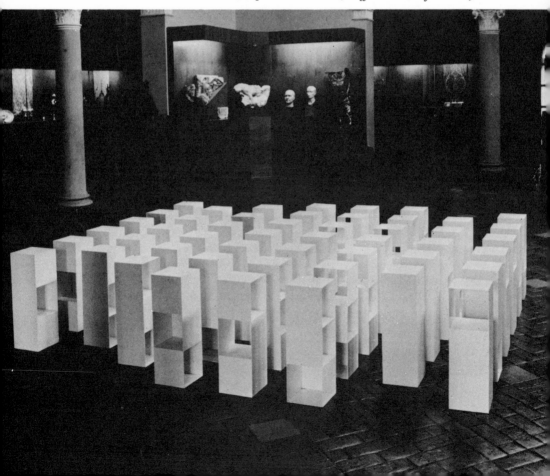

2 The Object Painted and the Painted Object in Quiet Collision

Cézanne's Truth

I owe you the truth in painting. CÉZANNE

Cézanne's never-ending humble and heroic search for truth is the moral condition of his art and a primary source of its greatness. His truth, like Wordsworth's, is the truth of art 'in the keeping of the senses'. In his faithfulness both to nature and to art, his synthesis of minute visual sensation with a grandeur of formal construction, Cézanne stands alone. Austere and difficult of access as his work may be on first encounter, prolonged contemplation slowly reveals his delicate exactitude and the depth of his feeling for nature, which to him meant 'man, woman, and still-life' as well as landscape.

Although Cézanne almost never dated his paintings and it is difficult to assign dates to them with precision, certain crucial changes serve to divide his work into a few fairly distinct phases. The early paintings, of the 1860s, are violent expressions of his dark, tortured imagination, his unfulfilled eroticism, and the anxieties springing from the repressive hand of his father and from his own despair of realizing the grandeur of his dreams. Such themes as the temptation of St Anthony, rape, murder and even the portraits, picnics, landscapes, still lifes and the translations from other art, are painted with brutal power. They can also be as astonishingly elegant as the *Still Life with Black Clock* (Stavros S. Niarchos, Paris). Crude and even grotesque as the youthful paintings have appeared to some critics, they are monumental pre-expressionist images whose dramatic contrasts of black and white intensify the red, blue or green areas and whose dense surfaces, tempestuously built up with the brush and knife, harken back to Goya and herald de Kooning. Clearly Cézanne's early painting owes much to Delacroix, and its heavy, sensuous paint even exceeds that of another of his masters, Courbet.

This *couillarde* technique, as Cézanne termed it, was abandoned in his impressionist phase, which began in about 1872 when he made the first of several visits to Auvers and Pontoise. Here, in close association with Pissarro, he learned to relate his painting more to the evidence of his eyes and to register what he saw by means of short, separate strokes of fresh colour. That this shift in direction from interior to exterior vision was of decisive importance in developing

65

what he called his 'own means of expression' was attested to when, exhibiting in Aix a few years before he died, he designated himself 'pupil of Pissarro'.

Although none of the *plein air* painters examined the relationship between colour and light more exhaustively than did Cézanne, his analysis never led him to abandon the full volume of objects and the firmly constructed space which he admired in the art of the past. These qualities are apparent in his earliest impressionist paintings, notably *The House of the Hanged Man* (c. 1873), in the Louvre, Paris, as well as in the work from the end of the decade, such as *The Château of Médan*, in Glasgow Art Gallery and Museum, where the foliage and even its reflection in the Seine are as substantially constructed as the buildings. During the next few years he placed the little parallel blocks of paint with ever-increasing exactitude to record his sensations of colour, volume and space, as they moved, series after series, in changing directions corresponding to and enforcing the structure and growth of the object and its directional force in the painting. Indeed, in several of the paintings from the early 1880s, he modelled volumes and thrust them out into space as securely as though he were chiselling them from rock. One would think that Cézanne might have been a sculptor, were it not that his mighty forms and the space they occupy are built up by means of colour in subtle inter-action.

Later in the 1880s Cézanne had gained sufficient command of his *petites sensations* to be able to relax a little the stern regimenting of the colour strokes. The looser, thinner and more open painting of *Mont Sainte-Victoire* (1) brings an expansive space which allows the forms to breathe more easily. The mass of the mountain is constructed by subtle modulations of colour, from blue to violet to pink to orange to ochre to green. Each variation in colour creates a different indentation or projection of the form, which corresponds so precisely to the actual contours of the mountain that one can identify the exact angle from which each of the more than sixty pictures of Mont Sainte-Victoire was made. The fact that Cézanne could represent exactly the form of objects is of no importance in itself; but it is significant that he wanted to, and did, maintain the identity of individual objects at the same time as he adjusted and bent them to his creative will. In this particular painting he has made the fork of the garden wall echo the slant of the fields which fan out from the house, and he has brought into rhythmic accord the arcs and angles of the branches of the tree, the mountain and the valley.

The pine branches, stretching gloriously out into space, set in motion a series of curves which roll through the mountain and down into the valley where the angular counterpoint grows stronger. He has almost completely dispensed with the texture of objects in favour of the unifying texture of the paint. In the valley the distinction between green and orange-ochre induces a sensation of different locations in space. At the same time, these green and orange planes are decisively shaped in relation to the rectangular format of the picture and, even though they are slanting rectangles moving in zig-zag directions to suggest the extension of

the valley, they are also flat, conforming to the essential nature of the picture plane. Moreover, the green planes tend to move back while the recurring orange-ochre areas come forward and the colour intensity, unlike that in traditional illusionist painting, diminishes very little, if at all, in the distance. By these and far more carefully contemplated means, the illusion of space and volume is firmly presented – and as firmly denied. The represented reality gives way to the created reality; but Cézanne never conceals the tension between the two in his insistence on the truth of both. Already here, in the 1880s, he laid down that premise of his art on which so much of twentieth-century art has been built.

Cézanne's insistence on the truth of feeling was no less strongly maintained. However, the emotions expressed, in keeping with the complexity and contradictions of his nature, his mind and his work, are neither simple nor single. In the *Mont Sainte-Victoire* painting, tranquil and buoyant as it is, one senses something of 'the struggle for life' which van Gogh found in the 'living being' of trees; but trying to put words to such feelings is so hopeless that one can only conclude, as Cézanne did, 'it is better to feel them'.

Cézanne's painting is born of the senses and addresses itself directly to them. Looking at this picture of Mont Sainte-Victoire from Montbriant on his brother-in-law's estate 'Bellevue', one experiences again the sensation of the clear, dry air and burning sun of Provence and the trees whipping in the wind; and one vividly recalls the green fields and the orange earth which, from miles away, can be seen to move up into the blue and violet rock of the mountain. But Cézanne's art is also born of what he called 'the logic of organized sensations'. He is reported to have said that he wanted 'to make of impressionism something as solid and enduring as the art of the museums' and that the kind of 'classic' effect which he sought was 'Poussin remade entirely after nature'. Comparing Cézanne's painting with that of Poussin, one recognizes a similar reasoning at work in the monumental simplification, the elimination of the fortuitous, the geometric decisiveness of forms and the precisely calculated distances between them. These are among the elements which contribute to the grave serenity which pervades the painting of both masters. However, Cézanne weds this idealism with the scientific materialism to which the impressionists adhered more closely. Using their analytical method of perceptual painting, he created his profoundly intellectual and universal 'ideal of art' not outside but within and from the framework of specific observation. To many of his contemporary critics, Cézanne seemed to be the great destroyer of the classical tradition. In reality, as we now see, he, like Seurat, was one of its great restorers. There were, however, a few critics who responded to the classical quality of his work. Georges Rivière, as early as 1877, called Cézanne 'a Greek of the great period' and those who ridiculed his work 'barbarians criticizing the Parthenon'.

In his still-life paintings, Cézanne achieved a similar harmony between the perception of nature and the logic of form. The painted apples, bottles, flowers,

bread and even tablecloths appear as everlasting and unmoving as his mountain. One does not expect to find a still life of ordinary objects so monumental and grave as *The Basket of Apples* (59) unquestionably is. This quietude, however, is like T. S. Eliot's 'At the still point of the turning world'. The individual objects move, shift, expand and contract as though they lived a life of their own in a magical world.

The problem of representing three-dimensional objects in space on a two-dimensional surface is as old as painting; but Cézanne's solution to that problem fundamentally questions the concept of space which for centuries had prevailed in western art. According to the laws of linear perspective formulated in the Renaissance, all the objects in a picture are represented as though seen from a single, fixed, static point. Cézanne, subjecting objects to the demands of their pictorial relationships, introduced multiple and moving view-points. In *The Basket of Apples*, the biscuits appear as though seen from the left and above as well as *en face*. The top two biscuits are suspended beyond their support, curiously increasing the sensation of their amplitude of form. The oval of the plate is squared off like the biscuits, relating these shapes to other oval and rectangular forms; the basket and its handle, the apples and the colour planes which model them are pulled towards the shape of the picture itself in a complex oval–rectangle counterpoint. The left side of the table is completely flat, not viewed from any single position; it gives pictorial but no conceivable physical support for the swelling basket of fruit, within which the scale of the apples changes considerably. By enlarging, simplifying and flattening forms towards the outer parts of the composition, Cézanne accentuates, by contrast, the fuller volumes and more quickly changing colours, shapes and lines in the central parts (a compositional arrangement often followed in cubist paintings). The left edges of the table do not correspond to those on the right; these discrepancies set up a pictorial tug-of-war concealed by the cloth and the bottle and basket. (The cubists would remove the cloth.) We *feel* these tensions and we feel the slanting bottle straining away from the axes of the biscuits. Through this empathy we experience the life and evolution of the picture, and we marvel at the miraculously quiet but vibrant equilibrium which Cézanne creates from the conflicting forces in the still-life.

In compelling the objects 'to put up with', in Picasso's phrase, the pictorial life which the artist assigns to them, Cézanne prepared the way for the cubist fragmentation of the object and its eventual elimination in abstract painting. At the same time, while impelling our perception of the painting as painting, he heightens illusion. Cézanne's departures from traditional perspective more nearly approximate the way in which we actually see with successive, shifting focus than does the Renaissance 'rationalization of sight', as perspective has been called. His slow and deliberate painting presents the experience of space in time – not the moment of the impressionists, but time itself – as duration. The tensions and continuous interweavings between space and surface, volume and plane,

near and far, create a fluctuating and dynamic relativity which suggests a parallel with modern concepts of time/space as an entity, neither any longer separate and independent from each other.

But apart from these implications of Cézanne's work there is its sheer beauty. The *Still Life with Plaster Cupid,* in the Courtauld Institute Galleries, London, is a perfect harmony of consonant and dissonant elements, of related and opposing colour and of pointed shapes and swinging curves. The complex and daring zig-zag rhythm up and back into space reaches its climax in the expanded apple shape suspended breathlessly over the upward sweeping tilt of the floor. The qualities of objects are modified in accordance with the demands of the painting: the canvas behind the cupid curves to receive and conform to its forms; the section of another painting on the upper right is treated like a piece of relief sculpture; the green foreground apple forces the plate to give way to its coloured shape; objects throw green, blue, red or violet transparent shadows; the freely moving line strikes an accent here, a full contour there, and sometimes forms the object in complete independence from it. This fresh and beautiful still life is 'about' art: an actual cast of a piece of baroque sculpture, a painting of another piece of sculpture, a canvas with no visible composition on it, the back of at least one more canvas leaning against the wall, and a section of a painted still life, whose cascading drapery spills out over the 'real' table. The new reality of painting which Cézanne creates transcends and shatters the traditional distinctions between real and unreal or the different levels of reality.

One might say that the *Still Life with Apples and Oranges,* in the Louvre, Paris, is about opulence. Painted in Cézanne's last decade, it has the rich, saturated colour, the elaboration of design, and the grand baroque movements which he could now allow himself. It also has a hint, perhaps in the smouldering intensity of colour, of the sombre mood which one often encounters in his late work. Sybaritic and forbidding, it bespeaks the abundance of the earth, and the terrors within it.

In his portraits Cézanne seeks and reveals the grave, silent dignity at the core of each human being. In spite of their basic immobility (to Vollard he shouted, 'You must sit like an apple! Does an apple move?'), his portraits have a formal vitality akin to the still lifes, but less complex. In more than twenty-five oils and numerous watercolours and drawings, the artist portrayed his wife with sober tenderness. In most of them, the immobility of Madame Cézanne's pose, as though she had been seated there for ever, is qualified and enlivened by the slight but concentrated tension between the axis of her body and the slant of the chair on which she sits.

His portraits and the figure compositions of card players and bathers all have a solemn grandeur. This is particularly marked in *The Large Bathers* (60), a composition on which he worked from 1898 to 1905, painting three large versions and many smaller studies. The most ambitious and fully realized of the three is the one in the Philadelphia Museum of Art (82 × 99 inches). The others

are in the National Gallery, London, and the Barnes Foundation, Merion, Pennsylvania. The male bather groups, which he also painted but never in a large format, are looser in their organization, with horizontal bands open at the sides in contrast to the usually closed-in, triangular disposition of the female groups. Cézanne's newness is particularly striking in his very use of the traditional triangle: in his composition, the active areas (figures and trees) form the sides of a triangle *framing nothing*. One might say that in this regard it is less traditional than Picasso's *Demoiselles d'Avignon*, painted in 1907, the year that Cézanne's *The Large Bathers* was exhibited in the Autumn Salon. To paint a heroic-sized composition of bathers in the open air was a challenge which Cézanne's life-long devotion to nature and the grand tradition of art imposed upon him. Although his landscapes are almost invariably devoid of human figures, the theme of bathers in nature had preoccupied him since his student days. It was not, however, until the last decade of his life that he attempted to develop this theme on an imposing scale. He pursued it stubbornly in spite of great handicaps: failing health, the difficulty of moving the huge canvases out of doors and the impossibility of getting suitable models in provincial Aix. The idea came in part from his nostalgia for the days when he and his boyhood friends bathed in the Arc River under the large trees which, as he wrote to his son, 'form a vault over the water'. The sources of his figures were his student drawings and the studies he had made from ancient, Renaissance and baroque art, which he continued to copy even in his old age.

While the small bather paintings are more immediately appealing, each time one stands before *The Large Bathers* one responds anew to the majesty of its conception and the beauty of its execution. Both epic and idyllic, Olympian and Arcadian, it is Cézanne's dream of a pure state in nature. The sex of the figures has no more importance here than it has in Giotto's frescoes at Padua. Although the felicity of the actual painting may not be fully apparent from reproductions, its archaic grace is unmistakable. The severe architecture of its interlocking triangles is modified by sonorous arcs and more quickly changing curves; and the painting is extraordinarily complex and subtle in its trembling nuances of blue and ochre intermingled with many tints of orange, red, rose, lavender and green, brushed on in transparent and semi-transparent overlays of colour. The supple line ripples, curves, sharply squares itself off, disappears, multiplies itself, defines or slices across or runs outside the coloured shapes as it rides on its own free rhythm. The master has so fully conquered 'the knowledge of the means of expressing emotion', which, as he wrote in 1904, 'is only to be acquired through very long experience', that he is able to maintain in this monumental composition the lyricism and refinement of his less heroic painting and to endow it with a noble sentiment.

Like Monet, Cézanne gave full expression in his late landscapes to his deep feeling for the mysterious inner force of nature. The *élan vital* which Bergson celebrated animates each rock and tree, each sweeping line, each plane of colour

as surely as it does in the more overtly expressionist painting of van Gogh. In *Cabanon du Jourdan* (Dott. Riccardo Jucker, Milan) the heaving earth, the chopping strokes of the brush, and the intense orange burning against brilliant blue convey his passion with equal eloquence. This compelling image has the strangely foreboding expression which permeates much of his late work.

A similar deepening of emotional expression occurs in the watercolour medium, which, from the middle of the 1870s, was closely related to the development of Cézanne's oil painting and is as richly varied. In some of the watercolours, by applying only a few transparent patches of colour over quick little pencil strokes he not only creates the illusion of palpable space occupied by solid volumes but he also makes a brilliantly coherent formal structure. Others are more densely built up, layer after layer like transparent sheets of coloured ice. Line and colour weave in and around and under each other, setting in motion angular, curving and sweeping rhythms.

But even the freest watercolours hardly prepare one for the last *Mont Sainte-Victoire* oil paintings (61), which are almost abstract in their daring reduction and transformation of visual sensation to the pulsating life of colour, line and shape. The faceted planes collide and multiply 'like a shell bursting into fragments which are again shells', to use the image by which Bergson described life. If one covers over the mountain, the rest of the picture could be an abstract expressionist painting. However, the mountain remains in its abiding majesty; as one looks at it, the valley falls into place and the small blocks of colour again assume their dual role.

Although Cézanne's innovations anticipated cubism and subsequent abstraction, he only opened the gate to a garden which he had no thought of entering. His spiritual as well as physical vision remained firmly anchored in nature. As he wrote in 1896, 'were it not that I love excessively the configurations of my country, I would not be here.' The pictures which Cézanne painted in his slow and probing contemplation of nature demand our unhurried study. They do not give up their wonders easily or quickly; but they never exhaust them.

Cézanne and a Pine Tree

In his classic study of Cézanne, Fritz Novotny declares that the artist was obliged to sacrifice 'the individual phenomena, the individual value of the human figure, the tree, the still-life subject, etc.'[1] in order to arrive at his monumental style. Although Novotny modified his position somewhat in a more recent essay, even there he states that Cézanne's 'renunciation and omissions . . . demonstrated elementary, basic shapes instead of individual variations; and depicted what was lasting and permanent instead of what was transitory and passing.'[2] One would no more cavil with the statement that Cézanne's art is selective, monumental and permanent than one would wish to underestimate the profound importance of Novotny's work on Cézanne;[3] it is only his view

that Cézanne sacrificed individual phenomena and variations which is in question. There is no doubt that certain phenomena of natural objects, as textural variations, did not concern Cézanne, but their formal and even colouristic individuality did interest him deeply. Novotny's is far from an isolated interpretation in the Cézanne literature. In the numerous analyses of his paintings published side-by-side with the motifs which were their sources, criticism has largely dwelt on the transformation which nature undergoes in the artist's hands. While this comparative analysis is certainly a useful method of approach, most of it has tended to minimize Cézanne's regard for the unique character of the form of objects. When we read in one of his letters, 'were it not that I am passionately fond of the contours of this country, I should not be here,'[4] an image of the majestic Mont Sainte-Victoire immediately comes to mind, but so do many other things: the rocks and the bay at l'Estaque, the quarry of Bibémus, the valley of the Arc. He loved the sandy red earth running through the quiet green fields and he loved the trees, especially the superb pines at Bellevue to which he returned again and again in his drawings, watercolours and oils.

To contend that Cézanne was faithful to the form not only of a particular mountain but even of a particular tree is thus to oppose the frequently held view that in his search for the permanent, generalized form of things he distorted their appearance. The truth is that these two seemingly contradictory positions are no more incompatible than are the two old antipodes of line and colour which are so beautifully synthesized in Cézanne's work. He, like many other great masters of the past, was amazingly faithful to his vision both of nature and of art.[5] One of the special qualities of his art is that the identity of objects and the exigency of pictorial form are not only kept in harmony but are each given the fullest possible force. Cézanne himself is thoroughly explicit on this point: 'There are two things in the painter: the eye and the brain. The two must cooperate; one must work for the development of both, but as a painter: of the eye through the outlook on nature, of the brain through the logic of organized sensations which provide the means of expression.'[6] Banal as that quotation may have become through too frequent classroom repetition, it still holds a key to the understanding of Cézanne's thought and work, as does another familiar passage: 'One is neither too scrupulous nor too sincere nor too submissive to nature; but one is more or less master of one's model and, above all, of the means of expression. Get to the heart of what is before you and continue to express yourself as logically as possible.'[7] It is in his selection and omission of what he sees that Cézanne is 'master of his model', as he conceives and forms the painting. But what he does decide to take from nature he gives back so clearly in his art that the specific objects selected are identifiable beyond question. The means whereby he masters the model have been sufficiently analysed elsewhere. That nature is not art could not be more clear than in Cézanne's work and there is no intention here to minimize his consummate art; its incredible harmony of

subject and form will never cease to astonish and delight. But the point that is being emphasized is that Cézanne arrived at the universal through and in his exact study of the particular. He liked to live as close as possible to the motifs which occupied him at given times; for example, on one occasion he rented a room at the Château Noir and on another a little cabin at the Bibémus quarry. Besides saving the time that would be lost each day in transporting himself and his painting gear from Aix, this procedure kept him in the constant presence of what he was painting. He often visited Bellevue, a property near Aix belonging to his brother-in-law, Maxime Conil; here he painted the house, the pigeon-tower and, above all, the Mont Sainte-Victoire (1) seen from across the valley of the Arc and framed by the great pines at Montbriant. It is here that he painted the watercolour, *Pine Tree at Bellevue* (62), at Oberlin College, Ohio.

Throughout his entire career, great arching or stretching trees, whether in straight landscapes or figure compositions out-of-doors, engaged Cézanne as much as the steadfast, rock-bound contours of Mont Sainte-Victoire, and he often opposed and united their differing qualities. The framing or spreading tree motif appears even in the early imaginative, romantic themes; it is stated very clearly in a pencil drawing[8] of 1868-71 where the violent thrust of the tree, first to the left and then back to the right, anticipates something of the dramatic character of the Oberlin watercolour. From his mature work there is one oil, *Paysage à l'Estaque* in the Sam Spiegel collection (1883-5, V. 410),[9] which particularly resembles the Oberlin sketch in terms of composition. In both pictures, the exaggerated slant of the pine towards the right is abruptly counter-acted by the forceful leftward sweep of its long branches. The tension between these forces, concentrated in the crotch of the tree, subsides into the gentle flapping of the pine foliage and the undulating vertical of the tree on the extreme left. Although, on first impression, the pine tree itself in the l'Estaque painting looks remarkably like that in the Oberlin watercolour, a closer examination discloses its difference. That the Oberlin pine *is* a specific tree, however, can hardly be doubted when one compares it with a series of other pictures. It is unquestionably the same pine as the one on Montbriant at Bellevue which figures as the subject of the oil painting, *Le Grand Pin et les terres rouges* (63),[10] in the Lecomte collection (V. 459). If one covers over the top and right side of the oil painting and visualizes the tree as seen from slightly more to the left, one finds that its structure is similar to the Oberlin tree in the form of the trunk and the shape, number and proportion of the branches and the distances between them and in their direction of growth. The vegetation running across the foreground from left centre to the base of the large pine is also comparable, as are the cluster of buildings below the tree, suggested in the Oberlin picture by a few light strokes of the pencil and brush, and the gentle slopes of Mont Sainte-Victoire on the other side of the Arc valley. This tree also figures in another oil, *Grand Pin et terres rouges* (64),[11] in the Hermitage Museum, Leningrad (V. 458); brilliantly coloured in intense orange burning against the cool foliage, richly

modulated and constructed, that work is a consummate refinement of the same theme. Venturi dated both the Lecomte and the Hermitage paintings 1885–7; but they must be separated by at least five years, the Lecomte no later than 1885 (and quite possibly earlier) and the Leningrad about 1890.[12] Even the thickness of the actual tree hints that the Leningrad picture is later; but there are far more cogent reasons for suggesting that it is a more mature painting. The Lecomte version, with its relatively descriptive character in the representation of objects, of light and of space, is less transformed, less a 'Cézanne painting', than the Leningrad picture where each of the elements – structure, format,[13] colour, line, surface, space, every little squared plane of colour – is adjusted to the miraculous oneness of the whole. The difference between these two pictures exemplifies that process which Matisse defined as 'the condensation of sensations which constitute a picture'[14] and it anticipates Mondrian's tree series going from relative illusionism to relative abstraction.

Besides the oil paintings, there are at least three very exact pencil and water-colour drawings of the specific pine tree in the Oberlin sheet. Of those studies, the one in the Rousseau collection[15] carefully models the structure of the tree in line; its insistent, exquisite pencil hatching is partially covered with a few light washes of colour, whereas in the Zurich *Study for a Tree* (V. 1024; 65)[16] the form of the tree is found entirely through the scintillating planes of colour without any pencil at all. How beautifully these two studies compose the page; how sensitively the drawing conforms to the distinct character sustained in each design. Consistent with the slanting planes of colour in the Zurich sheet are the slightly angular contours of the tree branches as they join the trunk, whereas those edges in the Rousseau drawing are delicately and softly rounded. In the Rousseau composition how important to the total structure are the two horizontals behind the tree trunk. But throughout all the formal and expressive variety of these studies and paintings **Cézanne** remained completely faithful to the tree's own form.

In the Oberlin watercolour, unusual in Cézanne's work is the contrast in handling between the separate parts of the picture; the primarily contained drawing and modelling of the greyed-violet pine tree is quite different from the fluctuating contours of the yellow-green, blue and violet tree and the light orange, green and violet ground on the left. The bush in the right centre (prob-ably a small pine), mostly blue with touches of green and violet, is formed of rapid, swinging zig-zags that set off across the valley. The picture is divided into two unequal parts, one vertically and the other diagonally oriented with maxi-mum tension between them, like many contemporary compositions. But the most startling thing in this atypical Cézanne is the dramatic force of the one great exaggerated rush and opposition of the big tree. There is nothing else in his entire *œuvre* which has quite that breath-taking sweep, that first day of spring air. The branch of the pine plunges out in the direction of its growth and in the force of the wind as explicitly and as ecstatically as any tree of van Gogh's.

The Oberlin picture brings to mind not only van Gogh's painting, but also his notation that he wanted to express in his drawing of the gnarled tortured roots of trees 'the struggle for life'.[17] However, there is no twisted agitation, no pathos, no tragedy in Cézanne's pine as it soars away – off from the hill, out of the frame and free from the earth.

Critics who are primarily impressed by the logic of Cézanne's construction sometimes overlook the passion of the artist who, while selecting, distilling, abstracting, remained 'passionately fond' of nature. Anyone who can not recognize the depth of the artist's controlled feeling in his sober, exuberant, delicate art need only consult his biography and letters for evidence of it. The man of whose youthful imagination and sensibility Zola wrote 'If love had not already been an old invention, he would have invented it';[18] the man who shut himself up in his studio and wept the whole day when he learned of the death of his old friend Zola in 1902, even though he had neither visited nor written to the author of *L'Œuvre* since one sad little letter acknowledging its appearance in 1886; this man revealed himself in his art as surely as he mastered himself and his model.

Time and again in his letters, as in the two examples from them quoted earlier, Cézanne makes clear that expression of feeling is an essential element in his creativity. To acknowledge the existence of the expressionist in Cézanne (not only in the early romantic or late 'baroque' periods, but in his 'constructivist' or 'classical' phase) is difficult for a generation brought up on the cliché of 'Cézanne: back to Poussin and forward to cubism and on to pure abstraction'. That thoroughly defensible but lop-sided view is happily avoided by several critics, particularly Venturi and Schapiro,[19] both of whom stress, in quite different ways, the human significance of Cézanne's work, and more recently by Reff who quite frankly puts his name together with van Gogh's: 'Here, especially in the exalted or profoundly solemn works of his last years, where watercolour was a major vehicle of expression, he was not at the opposite pole from van Gogh, as is sometimes said, but a close colleague.'[20]

Oberlin's *Pine Tree at Bellevue*, like its oil painting, the *Viaduct at l'Estaque*, came from Ambroise Vollard, Cézanne's dealer who had such abundant holdings of that master's work that Venturi did not see all of them when he was preparing his *catalogue raisonné* of Cézanne's pictures. Bought from Vollard in 1936 by Reid and Lefevre and exhibited by them in 1937, Oberlin's watercolour,[21] one of those which escaped Venturi, is to be included in the forthcoming revised edition of his catalogue which, it is to be hoped, will throw light on many puzzling matters, particularly with reference to chronology.

To ascribe secure dates to Cézanne's pictures is notoriously difficult; of his more than a thousand oil paintings, less than a hundred can be dated with reasonable assurance.[22] He rarely affixed dates to them and seldom even signed them. He sometimes worked several years on the same painting and, as Schmidt further observes,[23] there are no abrupt changes of style in his mature work;

rather, the transitions are gradual and any given picture can anticipate the future at the same time that it recalls the earlier work. Rosenberg placed Oberlin's watercolour about 1890–94,[24] Neumeyer 1885–7.[25] It was once assigned,[26] for some curious reason, possibly because of the boldness and openness of the composition, to the last phase of Cézanne's work; but one has only to look at it for a moment in comparison with one of the late pieces, as *Le Pont des Trois Sautets* in the Cincinnati Museum, painted in 1906 (V. 1076), to observe that the 're-laxed drawing' in the Oberlin sheet lacks the bite and brilliant assurance of the late works and it has neither their pulsating, baroque character of swelling and receding space nor their transparent, angular planes floating like thin blocks of coloured ice. Those qualities may be *promised* in some passages of the Oberlin watercolour but they are far from developed and controlled; they are, however, more firmly present by 1890, as can be seen in the *Study for a Tree* (65). Here, there is already much of that fluctuating, transparent quality of Cézanne's late work, where patches of colour run across, dissolve, and simultaneously form the volume, its edge, and the space and shadow around it; whereas objects in the Oberlin picture, particularly the large tree, are drawn with a fairly continuous outline, describing structure rather than evoking it, as is done later, through the interrupted, quivering contours. There is a hint of that quality in the Oberlin watercolour, notably in the tree on the extreme left, but beside the decisiveness of the Zurich drawing it appears tentative and certainly earlier. It could not have been done as late as 1890–94 and it is doubtful that it is as late as 1885–7 as Neumeyer proposes, although the latter dating is far more plausible than the former.

The Oberlin watercolour is clearly related to two studies for the familiar paintings of the Arc river valley with the viaduct and Mont Sainte-Victoire seen through the branches of the pines on top of the hill at Bellevue.[27] Although Cézanne's brother-in-law did not purchase the Bellevue estate until 1885, there is, as Rewald suggests,[28] no reason to assume that Cézanne never worked there before that time since it is not far from the Jas de Bouffan, the family home outside Aix, and since his delight in roaming the countryside, from his boyhood days with Zola throughout his entire life, is well-documented. To one who knows that terrain fairly well, it is quite obvious that Oberlin's watercolour was painted at the same place as the watercolours *La Montagne Sainte-Victoire* (V. 914) and *La Vallée de l'Arc* (V. 913; Albertina, Vienna), although at a different angle – facing the rolling foothills of the mountain. In V. 914, the little house at the left end of the road *could* be the same one whose roof is faintly indicated in the Oberlin picture, but that is an insignificant detail and, moreover, the locale of the tree has already been established by comparison with the Lecomte and Leningrad paintings. It is in terms of stylistic rather than topographical or dendrological similarities that we are concerned now. The study (V. 914) for the Phillips and the Courtauld oils (Venturi calls the latter *La Montagne Sainte-Victoire au grand pin* and writes of it, 'le pin . . . ferme le tableau avec un geste

héroique'[29]) resembles the Oberlin watercolour in the fairly continuous contour of the tree and its irregular shading, the quick roughly parallel strokes of the foliage, and the relative amount of openness and looseness in the total design. Several of these observations apply likewise to the Albertina study[30] (V. 913) which, in addition, is similar to Oberlin's in the comparative vagueness of the sky washes, the loose hatching and spiralling character of the brushwork and the rapid, swinging pencil notations.[31] Venturi assigned the oils which evolved from both of these watercolours to 1885–7 and the watercolours to 1883–7, which generous latitude does not take into account the slight differences between the two. The Albertina one appears to be not only less worked-up, i.e. less realized in terms of spatial complexity and over-all design, but somewhat less accomplished in those elements; this is especially noticeable in the indifferently formed sky and mountain washes already referred to. Moreover, colour is applied in fairly simple, broad areas, whereas in the other work the colour patches create more quickly changing intervals on the surface and in space. These differences suggest that the Albertina sheet came first; Novotny ascribed it to about 1885 in the 1961 Vienna Cézanne exhibition (catalogue no. 54). Its style suggests that it could be pushed as far back as the earliest limit of Venturi's original dating of 1883–7 and it is my understanding that it will indeed be placed at 1883–5 in the revised Venturi. The other study (V. 914) will probably be assigned to about 1885. The Oberlin sketch has elements which are comparable to both the others – some to one and some to the other. In terms of the multiple segmenting of shapes and their lively movement in and out of space, this picture, even in its unfinished state, is closer to V. 914 than the Albertina one is. Curiously, it is also closer to it in the way the great tree trunk and branches are drawn and shaded; but it is nearer the Vienna sheet in the hooked, spiralling and linear treatment of the foliage of the big tree and the shrubbery at its base and to its right. On the other hand, that awkward passage in our drawing is offset by the effective handling of the extreme left tree and ground which are more delicately adjusted in their trembling contours and volumes. To summarize this triple comparison, the Oberlin drawing could have been done between V. 913 and V. 914 – probably closer to V. 914. This means that, if we accept the revised dates for those two pictures, *Pine Tree at Bellevue* was painted between 1883–5, or about 1885.[32]

Of the pine trees at Bellevue, Venturi wrote that Cézanne 'leur a donné de la force, de la fermeté, de l'objectivité, et certaine communion particulière avec l'univers qui les rend humains'.[33] The Oberlin watercolour and the several related studies and finished paintings of that particular tree are a convincing example of the faithful and expressive element in Cézanne's painting, a proof of his ability to remain close to the natural object and to imbue it with lyrical passion.

3 'The Mountain in the Painting and the Painting in the Mountain'

A Nineteenth-century American Nature Painter: John F. Kensett

Among the mid-nineteenth century American artists who placed their cards in the advertising pages of *The Crayon* was John F. Kensett, whose invitation appearing in the 14 February 1855 issue of that New York magazine reads, 'J. F. Kensett, Landscape Painter, Studio, Waverley House, 697 Broadway, At Home on Thursdays'. In 1867 Henry T. Tuckerman wrote, 'Since 1848 . . . his [Kensett's] studio has been one of the attractions in New York to all lovers of art and native scenery.'[1] After Kensett's death, George W. Curtis of *Harper's Magazine* declared, 'There was no wall in New York so beautiful as that of his old studio, at the top of the Waverley House, on the corner of Broadway and Fourth Street, upon which they [Kensett's sketches] were hung in a solid mass.'[2]

The 'At Homes' of Kensett and his painter friends provided only one of several means by which the American artist of a hundred years ago demonstrated his willingness to meet his public more than half-way. Not only were individual studios opened, but groups of artists banding together held large receptions, arranged exhibitions and assisted the art-minded men of business in the organization of museums and art associations.[3] The visitors to Kensett's studio found pleasure in the pictures hanging on the walls, and also in the character and presence of the man who had painted them. None of Kensett's many friends, acquaintances, critics, and the younger artists whom he frequently helped, failed to mention the gentleness and sweetness of his nature. However, Kensett's amiability was tempered with a manly decisiveness, even as the sweet serenity of his paintings was tempered by firmness of control and breadth of vision. This happy combination is in large measure at the source of Kensett's own distinctive style as a painter. Kensett the artist consistently revealed Kensett the man, sensitive, thoughtful and gentle. For the reason that Kensett's painting is to this extent autobiographical and because his life and work are of considerable significance in a study of the condition of art and the position of the artist in mid-nineteenth century America, and because his drawings are often closely related to those of his friends (and sometimes confused with them), the following study is largely biographical, with particular attention directed towards establishing the chronology of his activities.

78

Although regarded by his contemporaries, and in the scant references to him in subsequent literature, as one of the finest painters of the Hudson River School, Kensett, sharing the fate of other members of the group, has not yet received the thorough study which his work merits.[4] The reasons for the decline in popularity of these landscape painters after the 1870s have been sufficiently studied in the recent revival of interest in this group as a whole to merit no repetition here. Regarding Kensett in particular, after the sale[5] of the works remaining in his studio in 1873, and after the Metropolitan exhibition[6] in 1874 of thirty-eight of his 'last summer's work', presented to the museum by his brother Thomas, Kensett's paintings were not shown again in any large number until 1945, when Harry S. Newman exhibited in his gallery thirty-five Kensetts which he had acquired from J. R. Kellogg. In connection with this exhibition, Mary Bartlett Cowdrey published an article on Kensett in the *Old Print Shop Portfolio*, February 1945; sufficient interest was aroused to provoke a few articles in the press[7] and eventual sale of the group of paintings. There are no individual publications on Kensett, with the exception of the *Eulogies*[8], published by the Century Association after his death on 14 December 1872.

In working on Kensett's biography, one of the more troublesome problems has arisen from a discrepancy of two years in his birth-date, some of the references indicating 1816, others 1818. Although I have found some documentary support for the 1818 date,[9] by far the weightier evidence is on the side of 1816,[10] which I am convinced is the actual date of Kensett's birth. The most decisive document in support of this view is a letter written by the artist as a boy on 27 June 1831 to his uncle and grandmother in England, in which the following statement occurs: 'We are just entering into this world . . . the two youngest are at school. Sarah is 8, Fred 11, Elizabeth 13, Myself 15, Thomas 17 years of age.'[11]

John Frederick Kensett was born 22 March 1816 in Cheshire, Connecticut, and died 14 December 1872 in New York City. His father, Thomas Kensett (1786–1829), an engraver who had come from England in 1812, was a partner in the print publishing firm of Shelton and Kensett in Cheshire. (He was also celebrated as the inventor of a process for preserving food-stuffs in hermetically-sealed tin cans.) John Frederick's mother was Elizabeth Daggett (1791–1876), granddaughter of Napthali Daggett, president of Yale University from 1766 to 1777. As a boy John first studied engraving with his father and then went in 1831 'to New Haven to learn the Historical engraving'[12] with his uncle Alfred Daggett (1799–1872), whose firm was primarily engaged in bank note engraving. Leaving New Haven in 1835, the young Kensett spent the next five years in Albany and New York, where he worked as a professional engraver, occasionally trying his hand at painting for relaxation and succeeding well enough to have a landscape exhibited at the National Academy of Design in 1838. Through his friend John W. Casilear, Kensett became acquainted with Asher B. Durand, who was just at this time deciding to devote more attention to painting and less to engraving.

With Durand, Casilear and another friend, Thomas P. Rossiter, Kensett sailed for England on 1 June 1840. On that day he began a detailed journal, of which two volumes running through 31 May 1841 have been preserved.[13] Like many of his contemporaries departing for the first time from the New World with its meagre opportunities for art study, he approached the Old World's treasures of art and architecture, rich in historic association, with an almost grim determination to spare himself no pains in seeing and learning as much as he possibly could. The daily entries in Kensett's diary (usually beginning with hour of rising and closing with time of retiring plus comment on the weather) contain full information on his activities: what he did (engraving, reading, writing); where he went; what he saw; and what his reactions were to everything from St Paul's Cathedral to the Haymarket Theatre. Often his descriptions of architectural monuments are so exact and so complete with historical anecdote that they read like guide books. Although the descriptions of art collections are not quite so thorough, there are none the less some valuable passages on the National Gallery, British Museum, Royal Academy, Dulwich, etc. One's curiosity is aroused by a remark entered on 23 June 1840, when he visited the Society of Water Colour Painters: 'Noted down some in my book of records for future reference'; similar comments from time to time suggest that he may have kept an additional and more specifically art journal. Whenever he went to the country, such as on a visit to his grandmother and uncle at Hampton Court, he dwelled at length on the beauties of the landscape in praise of his great love, nature. He writes of the approach to Windsor, 14 July, 'Not having seen *all* the world I will not say earth contains no spot its equal. Should I see anything finer I shall be most happily disappointed.' This naïve but endearing remark is characteristic of Kensett's conscientious method; he never permitted himself to take anything for granted.

Kensett's seriousness of purpose in studying the works of the great masters is attested to in the following remarks made after a visit to the National Gallery, 22 June 1840. The young Republican was impressed by there being no admission charge, as a result of which 'You find the rich and the poor, the high and the low alike. . . . Thus is there cultivated a national taste which spreads itself through every channel in society and you may see its influences everywhere, elevating and refining the soul. No bounds can be set to its usefulness.' As for the artist, he 'finds here an assistant teacher to his study and meditation and the means whereby he may gain rank and influence in society. If doubt and perplexity overtake him, he turns to the precepts arranged before him and finds there a solution.' After commenting on the lack of such opportunity in America where the artist is 'unaided save by great nature's handiwork', Kensett expressed his faith in the ultimate eminence of American painting. 'There is a star – though dimly seen above the horizon that gradually assumes a brighter hue – that rises slowly but surely toward the zenith where – and the day is not very far distant – it will assume a lustre that will dim by its brightness – even the glory of

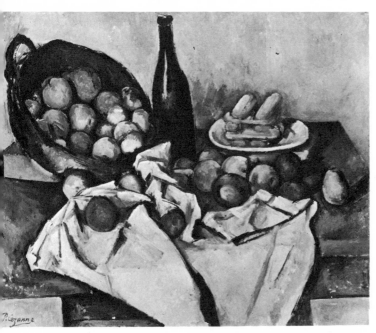

59 PAUL CÉZANNE
The Basket of Apples c. 1895

60 PAUL CÉZANNE *The Large Bathers* 1898–1905

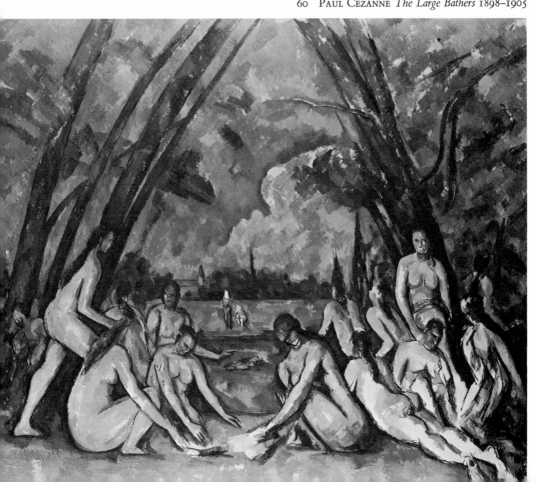

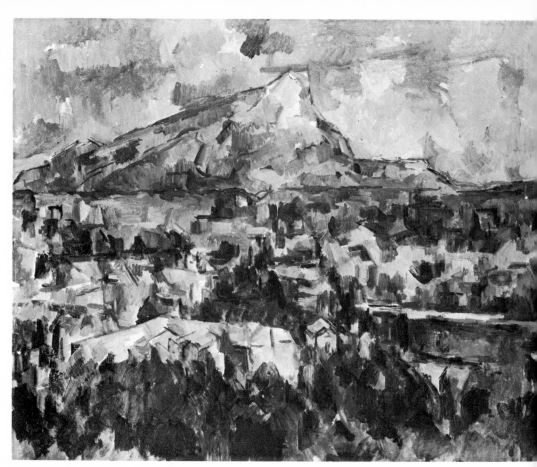

61 PAUL CÉZANNE *Mont Sainte-Victoire* 1904–6

62 PAUL CÉZANNE *Pine Tree at Bellevue* 1883–5

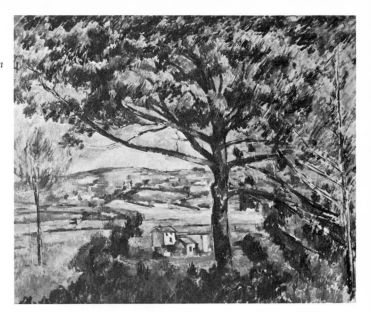

63 PAUL CÉZANNE *Le Grand Pin et les terres rouges c.* 1883–5

64 PAUL CÉZANNE *Grand Pin et terres rouges c.* 1890

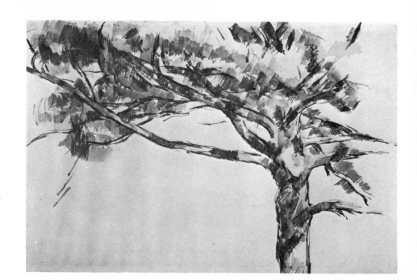

65 PAUL CÉZANNE
Study for a Tree c. 1890

66 JOHN F. KENSETT *Lake George* 1869

67 JOHN MARIN *Study of the Sea* 1917

the past.' After this glorious prophecy, the young artist soberly concludes, 'Not one lesson of wisdom should be suffered to pass by unheeded – Let it be treasured up and transmitted to each succeeding age, as the grain of sand helps to form the wide and extended beach – and the drop of water the mighty ocean, so the soul of intelligence though it be limited in its influence, yet adds a little to the great mass that exercises a power uncircumscribed and without limit.'

During the time covered in the diary, Kensett provided for his studies by engraving banknote vignettes and other items contracted for by engraving firms in America. Frequent entries, beginning 29 June, relate to his work on the plate of *The Studious Boy* after W. S. Mount.[14] On 8 July is noted, 'Commenced a small vignette – an endpiece from a design by J. W. Casilear representing Ceres the goddess of Agriculture. . . . This will make the fifth vignette I have engraved for the firm of Toppan & Co.' In fact, Kensett spent most of the mornings and sometimes the entire day at his work table.

Besides visiting monuments and museums, Kensett also called on several artists, among them Turner, who unfortunately had 'retired to the country for the remainder of the season' (6 August) and the American Healy, whom he found 'a noble fellow . . . kind, affable and generous' (21 July).

On 31 July Durand and Casilear left for the continent, and Kensett and Rossiter followed suit on 14 August. Going to Paris by boat up the Seine afforded Kensett a splendid opportunity to observe and describe the landscape, comparing and contrasting it with the Hudson. Stopping over at Rouen, the young Americans enjoyed the company of two fellow passengers, the charming Mlles Benest. Kensett noted: 'I exercised my very small stock of gallantry and made an offer of my services to the apparently elder sister. . . . It is a little surprising into what an excellent humour one is put after an agreeable interview with the fairer sex. There is an influence quite humanizing – one that softens the harsher points of character' (16 August).

After their arrival in Paris on 17 August, Kensett and Rossiter visited the Benest sisters often and accompanied them and other friends on many excursions. On one occasion when they went with the ladies to Neuilly and walked along the Seine, Kensett was impressed with what a charming place it was for a lover to declare himself. 'Indeed I had half a mind to distinguish myself by making a declaration that I might know how it would seem, I forebore however – nonetheless had I been with one I might mention perhaps I should have hazarded the experiment' (29 August). There are frequent romantic references in the Journal; and throughout his life, judging from the letters and the comments of his friends, Kensett was as agreeable and attractive to 'the fairer sex' as they to him; but apparently he never 'hazarded the experiment', and remained a bachelor.

By 4 September Rossiter and Kensett were settled in their rooms at 7 rue Royale, which they themselves furnished; they had engaged a tutor and begun to spend over two hours a day on the French lesson; and they had seen the major

monuments in and near Paris. On 5 September they went to the Louvre; Kensett noted in his Journal that it might seem surprising that an artist should be in Paris that long before going to the Louvre, but they wanted to get the sights over first before settling down to the business 'of greater importance'.

At the Louvre they found students of both sexes copying the pictures in the Long Gallery. While Rossiter began immediately to copy one of the Rubens *Marie de' Medici* series, Kensett was obliged to keep at his engraving and etching commissions,[15] breaking off only occasionally for refreshment at the Louvre. Here he found himself particularly attracted to the sketches of the great masters. On 10 November he wrote, 'Spent a couple of hours in the rooms where the drawings are collected – I have thus far experienced more pleasure in the examination of these splendid trophies of the genious [*sic*] of bygone spirits – here exhibiting itself in all their native vigour and freshness – than in many of their most finished compositions – Rubens – Raphael – Michael Angelo [*sic*] – Paul Veronese – Claude Lorrain – Titian, and the whole host of bright names that figure on the page of history are arranged here in their true colours. . . . Among this vast collection – all are worthy of examination and study – and present a rich repast which I hope to enjoy many months – and gather new thoughts and fresh impulses from their study.'

Kensett's evenings were spent either sketching in his rooms or from life and the antique at the École Préparatoire des Beaux-Arts; in writing and reading (Shakespeare, Bryant, Irving, Pope, Reynolds and Byron among others); or in relaxation, attending the opera, theatre, concerts; or strolling through the city, dropping into Tortoni's or the Café Anglais for an ice; or at the homes of his friends, dancing, singing, talking and 'drinking in a rational way'.

Because the rooms which Kensett and Rossiter occupied had south light which they found 'disturbing . . . by its vexatious inequality', they moved on 17 October to apartments in the Hotel du Havre, rue de Savoie, number 3. On 2 October Kensett had begun to paint a landscape in oil and from then on he spent an increasing amount of time painting scenes which he had long had in his 'mind's eye' (among them a view near Albany). His progress in the oil medium was sufficient for him to write on 10 November, 'I can perceive a gradual improvement in my pictures – or at least I fancy I do which is equivalent in my own estimation – painted but a short time when I determined upon going to the Louvre for the purpose of making a selection [to copy] . . . resolved however to paint a few days longer in my room before making my debut.'

In April Casilear arrived from Italy and took rooms in the same building; Kensett spent much time with his old friend and was enthralled by his descriptions of Switzerland, where Kensett longed to travel; but circumstances prevented his doing so for some time.

The second volume of the Journal ends on 31 May 1841, just a year after Kensett had sailed from New York; and, as he had done on each monthly anniversary of that date, he took stock of himself and his accomplishments. 'I

have seen much within that period and trust I have also learned much and laid up a stock of knowledge that will serve me at a future day, nevertheless I feel that I have not made the progress I ought to have made surrounded as I am by congenial influences. The mysteries of the art are being gradually unfolded to me and each day I trust adds a little to clear away the mists that knowledge and experience can alone dispel. Another year I hope will not slip away without enabling me to appreciate the higher excellencies of art and lead me in practical knowledge over its threshold.'

Although, as far as we know, Kensett left no other such complete journals, there are a few scattered pages written from time to time[16] and these, together with his letters and sketches and the letters written to him, the accounts written by his many friends, and other sources make possible the continuing narrative of his life and work.

Still in Paris on 31 December 1841, Kensett wrote to Rossiter, who was then in Rome, that he would like to throw the 'gravers and steel to the dogs . . . plodding dissatisfied for that wherewith to keep soul and body together. There is a certainty of my allways [sic] being sure of a respectable living at my present occupation, whereas at the Art to which my thoughts and feelings most tend, there is an uncertainty that weakens the energy of my resolutions, leaving me like a leaf between two currents of wind. . . . I have made decidedly my best efforts in oil since you left, a sunset & a moonlight – These two or one at least I shall send to the N. Academy with the picture I was painting when you took your departure (containing an old chestnut tree).'[17]

By 1845 Kensett's vacillation was thoroughly overcome and his devotion to painting was rewarded by having several of his pictures accepted for exhibition by the British Institution and the Royal Academy of Arts.[18] The painter had the further encouragement of seeing one of his pictures, *A Peep at Windsor Castle*, selected for purchase from the Royal Academy show by a prize-holder in the London Art Union.

From the American Art-Union and the National Academy of Design, Kensett received much-needed financial and moral support during his study years abroad. In 1843 the American Art-Union (known as the Apollo Association until 1844) purchased and distributed two paintings by Kensett, in 1845 eight, and in 1846 and 1847 one each year.[19] This organization, in its thirteen years of operation before it was forced in 1852 to disband on the charge that distribution by lottery was illegal in New York state, made great strides toward the democratization of art through its system whereby each $5.00 subscription entitled the member to an original engraving and a chance on original paintings and sculptures, bought for this purpose from contemporary American artists and distributed annually by lot. Annual membership reached the peak figure of 18,960 in 1849, a year when, as Charles E. Baker points out, there were fourteen American artists studying in Europe through the aid of this organization.[20] Thus the American Art-Union, and many similar groups established throughout the

country, were forerunners of the Fulbright Act and G. I. Bill, with the difference that the earlier organizations purchased the artist's work, exhibited it and distributed it to an eager public. As William Cullen Bryant, President of the American Art-Union for three years, stated in 1846, 'Our gallery . . . by an arrangement more wisely liberal than exists in the Art-Unions of Europe is freely open to the public, crowded day after day and night after night with spectators.'[21] Also, unlike the European groups, the American Art-Union gallery was open throughout the year, not just for the distribution exhibition.

Among the organizations of a different, more traditional character which shared in the dissemination of artists' work was the National Academy of Design, to whose gallery in New York Kensett sent from abroad four paintings in 1845 and two in 1847.[22]

From 1843 to 1845 Kensett was in England, having been called there suddenly at the time of his grandmother's death. According to Benjamin Champney, who had come to Paris as an art student in 1841 and later taken rooms with Kensett on the rue de l'Université, 'Kensett . . . went to England to receive a small inheritance, intending to stay there only a couple of weeks, but the lawyers made so much trouble his stay was prolonged for two years.'[23]

Although, as Kensett sometimes complained in letters to his mother, much time was consumed in business affairs, the time in England was not wasted and marks an important stage in his development as a painter. The *English Landscape* in the Brooklyn Museum from this period reveals a hand which has courageously tried to free itself from the restraint of the burin and to give itself over wholeheartedly to the more flowing, sensuous possibilities of the oil medium. The fairly thick paint is boldly applied in scratches, smears and flecks, in an attempt to catch the movement of light through the foliage and on the ground; thus it is not unrelated to Constable in means and intent, but it is a long way from that master's, and indeed from Kensett's own, mature style. Having forsaken the graver with a vengeance, it was to take Kensett some time before he could apply the control and subtlety which he commanded in engraving to his work in the new medium. But he continued to regard work 'as a moral injunction'[24] and did not allow himself to be seduced into complacency by the circumstance of his early work's being accepted in a few major exhibitions.

Back in Paris in the summer of 1845, Kensett sketched at Fontainebleau and other nearby places; finally, he was able to start out on the journey which he had for years planned to make to Switzerland and Italy. Leaving Paris in July Kensett, together with Benjamin Champney and his friend Dr Ainsworth, then studying medicine in Paris, travelled first by diligence to Coblenz, and then on foot up the Rhine to Mainz, Strasbourg and Basel (where Champney says they were surprised and pleased by the Holbeins).[25] Champney describes in detail the progress of the walking tour; moving from Basel to Neuchâtel, Lausanne and Geneva, they then climbed and sketched their way across the Alps to Como, taking from there the 'shortest way to Genoa, where we took the boat for

Leghorn, Kensett going on, after our arrival there, to Civita Vecchia, the port of Rome, while Dr Ainsworth and myself rode to Florence.'[26]

In the collection of Mr J. R. Kellogg there are a few pages of 'journalizing' by Kensett from the Swiss tour (written 29 August to 13 September in a sketchbook) and many of his drawings, each inscribed with the place and date: *Castle of Marksburg, Aug. 4th, 1845* (at Braubach on the Rhine); *Castle of Shunburg, Aug. 9th, 1845* (this is Schönburg at Oberwesel on the Rhine); *Chateau and Town of Heidelberg, Aug. 16, 1845, Convent of Great St. Bernard, Sept. 3, 1845; Pass of the Grimsel, Sept. 30th,'45* and finally *Lac de Como, Oct. 6, 1845*.[27] In all of these early drawings, the artist's experience as an engraver is at work in the crisp, sensitive line which decisively registers structure, distance and atmosphere. Later he was to succeed in combining the delicate precision of these drawings with the broader, more forceful approach of the early oils and thus establish his mature and unique style as a painter.

Kensett's first year in Italy is recorded by his friend Thomas Hicks in the *Eulogies on Kensett* published by the Century Association. Shortly after his arrival in Rome in 1845, Kensett was stricken with inflammatory rheumatism and was cared for by his countryman Hicks, who writes, 'As soon as he was able to work, he went at it with a will; and by the spring of '46 his portfolios were well filled with valuable studies.'[28] In June of 1846 the two artists set out on a sketching tour of the Alban and Volscian mountains; in early October Hicks returned to Rome, leaving Kensett at Palestrina to walk alone through the Anio valley and return to Rome about 1 November; here he and Hicks shared a studio and apartments on the Via Margutta. A charming picture of the life of the American artists' colony, and Kensett's place in it, is presented in George W. Curtis's nostalgic account of the gatherings at the studios, the restaurant Lepre and the celebrated Café Greco. 'And among all the famous loiterers at the Greco was there ever a kinder, simpler, sweeter companion than Kensett? He was not fluent. He told few stories. But his generous sympathy, his interested attention, was inspiration. He made a sunshine that harmonized and softened all.'[29]

Leaving Rome on 10 April, Kensett with George Curtis and his brother spent the spring and early summer of 1847 on a trip to Naples and vicinity. The course of their itinerary can be followed in the dated entries of a Kensett sketchbook in the Kellogg collection: 15 April Naples; 28 April Pompeii; 8–13 May Amalfi; and 16–18 May Capri. These sketches, some in watercolour as well as pencil, demonstrate Kensett's growing assurance and ease as he learns to see, think and draw in colour. Moving north, the group joined Hicks at Florence, and proceeded on 19 July by way of Bologna and Ferrara to Venice, where they spent several weeks. They parted in September, the Curtis brothers going to Germany, Hicks to Rome and Kensett to Paris and London, where he boarded ship on 3 November.

Arriving home in time to spend Christmas 1847 with his family, Kensett soon settled in New York, where he was already regarded as an American painter of

considerable achievement and great promise on the basis of the paintings which he had sent from England and Italy to the National Academy of Design and the American Art-Union.

Like many of his colleagues, Kensett spent the winters in his New York studio[30] painting thoroughly considered compositions from the oil and pencil studies 'taken' from nature during the summers. That Kensett regarded his oil sketches made in the open air as works of art in themselves is attested to by the fact that he not only exhibited them on the walls of his studio but also sold them, often with the title of 'Landscape Composition', 'Study from Nature', etc. Kensett's sketching tours took him to the mountains, coasts, lakes and rivers at home and abroad. It is possible to establish a fairly close chronology of these excursions from the dated drawings and letters, accounts of his friends, items in newspapers and magazines, passports and similar documents. Most frequently in the East, there were particular spots to which he returned again and again in the White Mountains, the Catskills, the Adirondacks and the Green Mountains; along the shore most favoured places were Newport, Narragansett, Beverly and Contentment Island at Darien, Connecticut. Of particular interest may be his trips away from the East, in 1851 Niagara and Canada; 1852 Niagara again, Lake Erie and Lake Huron; 1854 on the Mississippi River; 1856 in the lake country of England and Scotland; 1857 along 'the headwaters of the Missouri';[31] 1861 to England and the continent (and possibly again in 1867 or later);[32] 1868 on the Mississippi River; and in 1870 to Colorado.[33]

The painted products of Kensett's journeys were eagerly studied by artists young and old, collectors of art and lovers of nature, as they hung on the walls of his studio, the American Art-Union, the National Academy of Design, the Century Club, the Studio Building, Dodsworth's Building, and in many other galleries public and private, not only in New York but in other cities, including Boston, Philadelphia, Troy, Albany and Baltimore. In the critical accounts of the large exhibitions in contemporary journals, time after time the laurels go to Kensett, whose pictures 'no one can gaze upon . . . without . . . finding in them in a marked degree the highest expression of landscape art'.[34]

For Kensett the moral aim of the painter was to transmit, as faithfully as possible, his feeling before nature. However, clearly identifiable as Kensett's rocks, shores, trees and mountains most certainly are, no literal transcription of detail is ever permitted to lessen the total effect of his poetically unified vision and interpretation. This is not to imply that Kensett reduced nature to his own mood, but rather that he cherished the mood which nature evoked in him and which, by his sensitive handling of light, space and colour, he captured and preserved. Usually preferring the repose and quietude of simpler scenes than those which inspired Cole, Church or Bierstadt, Kensett never sought nor portrayed the sensational and grandiose; but there is in much of his painting a solemn purity – in the lonely stretch of sea and shore, in the tranquil expanse of a hill-bordered river, and in the remote serenity of a mountain lake.

These paintings are instinct with religious sentiment, but the sentiment is expressed in lyric poetry, not in sermons. Surely in Kensett's *Lake George* (66) is Wordsworth's 'still, sad music' and 'The holy time is quiet as a Nun/Breathless with adoration'. Kensett, in speaking of 'God's green fields'[35] and in writing that 'The boundless ocean spread out before and around us – the glorious sky above are surely sufficient to call forth our adoration and prayer . . .'[36] underscores his closeness to Bryant,[37] for whom 'The groves were God's first temples', and 'Here is continual worship; Nature, here/In the tranquillity that thou dost love, / Enjoys thy presence.' Like Bryant, Kensett found refreshment and purification in nature, and his painted images, like Bryant's poems, engendered a similar response in others, many of whom were often prevented by business pursuits from contemplating nature directly. 'Here, have I 'scaped the city's stifling heat, / Its horrid sounds, and its polluted air . . . As if from heaven's wide-open gates did flow / Health and refreshment on the world below.' And the contemplation of nature has a moral purpose: '. . . Be it ours to meditate, / In these calm shades, thy milder majesty, / And to the beautiful order of thy works/ Learn to conform the order of our lives.' This attitude towards nature, which is akin to the spirit that engendered the Brook Farm experiment and that led Thoreau to Walden Pond, links Kensett not only to Bryant but to many other men of letters, painters and patrons of the art of his time.

Although Kensett painted what he himself saw and experienced in nature, thus manifesting that very significant characteristic of nineteenth-century romanticism, its firm anchorage in fact, still he managed to preserve not only his poetic vision but also his personal sense of integrated, rhythmic design. Dependence on the fact, the 'truth' of nature, a general attitude of the time epitomized in Durand's aesthetic theories,[38] did not prevent Kensett from making subtle readjustments beyond the usual generalizing and studio 'beautifying' devices. He strove to free himself from the compositional clichés used by many of his contemporaries, which were based on seventeenth-century formulae. These ventures of Kensett's appear more frequently of course in the smaller pictures. He often used a long and rather narrow format, as many more recent painters have done, thus suggesting a lateral extension beyond the edges of the picture rather than the more traditional framing-in. The *View from West Point* in the New York Historical Society illustrates this type of composition and is further daring in the artist's selection of this particular view (from above) which could have resulted in an awkward isolation of parts. However, Kensett has mastered this precarious balance by a geometric interlocking of forms which is almost abstract in its emphasis, and by his sensitive treatment of atmosphere, value[39] and colour.

The *View from West Point* is smaller (20 × 34 inches) than the *Lake George* (44 × 66½ inches). The large pictures are carried to a higher degree of finish, but while details are precisely defined, they are held firmly in large compositional units through a deliberate effort to organize and simplify a wealth of detail. On

the inside cover of one of Kensett's journals is written, 'From the simplicity of indigence and ignorance to the simplicity of strength and knoledge [sic].'[40] This phrase might well be used to describe the change in his painting from the early *English Landscape* to the mature work of the 1860s.

The lessons which he learned in engraving are now applied, and the refinement of his technique in that medium is now matched by his command of oil painting. The restraint of the former is harmonized with the freedom of the latter; precision and delicacy are wedded with breadth and space. The atmosphere hovering over the mountains, water and rocks may be tender and soft; but there is nothing soft about the drawing which forms every object with clear authority. Decisiveness of drawing and firmness of structure are among the style characteristics which most often distinguish Kensett's paintings from Durand's, Casilear's and others of his colleagues.[41]

Kensett was no less accomplished in his handling of colour, which element he also used in creating structure, light, air and space. Sometimes, as in the *View from West Point*, he employed a wide range of hues (red, yellow, green, blue), dispersed freely in the lower right of the composition, in opposition to the subtly varied greys in the rest of the picture, which create light and space in a way that makes one think of a more careful and slightly 'old-fashioned' Whistler or Manet. Sometimes his pictures are concentrated in a narrow range of hues, like the *Lake George* which is predominantly blue-green. All of Kensett's late canvases are remarkably luminous, a characteristic due not only to his distribution of light and selection of colour but also to his technique of painting. He often used the warm underpainting as a colour, sometimes completely exposing it to read as that colour and sometimes covering bits of it with cooler hues, forming structure, texture and illumination by this method. In Kensett's skies, his technical finesse is perhaps most obviously apparent. Here, the underpainting, frequently a light cream-yellow, is partially covered with blue strokes so minute as to be barely perceptible; working up into the sky the blue strokes are put on more densely so that less and less of the yellow is allowed to show, thus giving the effect of a warmer and brighter light at the horizon and a more saturated but still luminous blue higher in the sky. Kensett was obviously a craftsman who loved the job of painting, through which he expressed his lyric view of nature.

That Kensett's paintings were eagerly sought and purchased is attested to by the impressive record of his sales. Fundamentally an orderly person, Kensett began in 1848 to keep an account book in which he carefully recorded his picture sales, listing title, price and with very few exceptions the name of the purchaser, thus providing the student of American art with another document of considerable importance.[42]

There are also among Kensett's papers an income tax form for the year 1864 and lists of income and expenditures from 1866 through 1871, which were evidently compiled for income tax purposes. From the account book we learn that the highest price Kensett himself was paid for a painting was $5,000 in 1866

for the large *Mount Chocorua* (48 × 84½ inches) in the Century Association.[43] In 1869 he was paid $3,000 for the *Lake George*, acquired by the Metropolitan Museum in 1915 by bequest of Maria De Witt Jesup. Although Kensett sold many paintings for between $100 and $300, several brought him from $1,000 to $2,000, among them the *Autumn Afternoon on Lake George*, which he sold in 1864 for $1,500 to his friend Robert M. Olyphant, from whose sale in 1877 it was purchased at $6,350 for the Corcoran Gallery of Art.[44]

In 1869 Kensett's income from the sale of pictures was $9,320, a sizable amount at that time, indicating that the position of the American artist, particularly the landscape painter, was not so unenviable as has sometimes been supposed, especially when one realizes that some of the grandiose canvases of a few other painters, such as Church and Bierstadt, commanded even higher figures. The sale of Kensett's paintings left in his studio after his death brought the phenomenal amount of over $136,000.[45] The six sessions of this sale were held 24–9 March 1873, at Association Hall, Y.M.C.A., 23rd Street and Fourth Avenue, where Kensett had his last studio. Prior to the sale the pictures were on exhibition at the National Academy of Design, located then across the street from the Y.M.C.A. Of the 695 pictures in the sale, only 45 were by other artists and the remaining 650 by Kensett.

Successful as he was in selling his paintings, Kensett spent his life in quiet, persistent dedication not only to his own work but to the total cause of art and the life of the artist in America. In the words of his sister, Sarah Kensett Kellogg, Kensett 'was most gentle, tender and loving as a woman, yet withall decided and firm, a strong advocate for the rights of others'.[46] This attitude is confirmed by countless comments of Kensett's associates, such as the following by Worthington Whittredge, 'No artist of that period exerted a more healthful influence upon the body at large and upon the art of our country than did John Kensett.'[47]

Among Kensett's efforts and accomplishments in this direction should be mentioned the part he played, as one of the Founders and from 1865 to 1870 as President, of the Artists' Fund Society, whose object was the acquisition, through exhibition and sale of works contributed by members, of a fund for the benefit of disabled artists and widows and children of deceased members. The National Academy of Design elected Kensett an Associate in 1848 and Member in 1849.[48] Frequently a member of the Council, active on the Committee of Arrangements and Treasurer of the Fellowship Fund Committee,[49] Kensett was in these and many other ways a loyal servant of the Academy. He also served on several committees in the Century Association, having been elected a member in 1849 and trustee in 1858; he was a member of the Union League Club of New York and of the Sketch Club; in 1854 he was made Honorary Professional Member of the Pennsylvania Academy of the Fine Arts. In 1859 President James Buchanan appointed Kensett, Henry K. Brown and James R. Lambdin to compose the Art Commission for the decoration of the United States Capitol Extension. The report submitted by this committee suggested possible themes

for the decoration of the various rooms, emphasized the desirability of American subjects by American artists ('We want nothing thrown in between us and the facts of our history to estrange us from it'[50]), disapproved excessive and meaningless ornamentation 'destroying the very repose which the eye instinctively seeks',[51] presented an estimate of expenses for the proposed decoration, and recommended further legislation which would more clearly and positively establish the authority and function of the Art Commission. Kensett was chairman of the art committee for the Metropolitan Fair in 1864 in aid of the United States Sanitary Commission; his committee collected $84,000 for the relief of soldiers in the Northern army. He was one of the founders of the Metropolitan Museum of Art, serving on the executive committee as the Recording Secretary in 1871–2. Throughout his successful career he gave financial assistance and friendly professional encouragement to younger artists, among them Eugene Benson, who wrote in 1863 thanking Kensett for a cheque: 'By your kindness to young artists you have made yourself the most loved, and by your genius the most admired member of the profession of which you are one of the most justly celebrated.'[52]

'Never hurried, never idle',[53] Kensett calmly dispatched his many obligations, pleasant or otherwise, with a level head, a gentle tongue and a warm heart which won him the gratitude and affection of all his associates. The regard in which Kensett was held was clearly demonstrated on the occasion of his funeral, 18 December 1872; among the artists and patrons of art present at this service were H. K. Brown; Vincent Colyer; J. F. Cropsey; J. W. Ehninger; R. Swayne Gifford; Sanford R. Gifford; J. W. Casilear; Thomas Hicks; Robert Hoe, Sr; Winslow Homer; Richard W. Hubbard; Daniel Huntington; Eastman Johnson; John LaFarge; Thomas LeClear; Henry G. Marquand; G. T. Olyphant; R. M. Olyphant; William Page; Worthington Whittredge; and J. F. Weir.[54] Virtually the whole American art world assembled to honour the memory of this quiet life devoted to nature, art and his fellow man.

John Marin's Vision of Nature

John Marin was a man of almost thirty when he turned from Sunday sketching and weekday architecture to the profession of painting. After studying at the Pennsylvania Academy from 1898 to 1901 and at the Art Students League in New York from 1901 to 1903, Marin went to Europe in 1905. While he spent considerable time in Paris, where he exhibited in the Salon d'Automne in 1908 and 1910, he found the source of his art less in schools and museums than in his own vision of nature. His independent sketching trips took him to London, the Tyrol and Venice, where he felt particularly close to Whistler whom he greatly admired and emulated in several early etchings. According to his biographers, Marin appears not to have noticed the inventive young painters in Paris at this

time and to have developed entirely independently his own abbreviated, calligraphic style which appears in germinal form as early as *London Omnibus* of 1908 and in a more developed form in the Tyrolean watercolours of 1910. Already apparent in the composition of the latter is a suggestion of Marin's familiar framing-in device, although in these early papers the effect is accomplished by opening up and lessening the concentration of the image towards the outer edges, recalling somewhat the late Cézanne and cubist composition. However, beginning about 1920, Marin achieved a similar effect by positive, though fragmentary and usually angular, enclosure lines. One often has the sensation of seeing the image through a shattered glass or through the ragged opening in a sheet of paper, artfully torn. This generally central focus was a thoroughly conscious part of Marin's composing, as is indicated in the following excerpt from a comparison which he made between his painting and the music of Bach (his favourite composer) and Handel: 'I think that Handel and Bach . . . gave their music real action. I try to make the parts of my picture move the same way, only I always make them move towards the centre of the paper or canvas – like notes closing in on middle C of the keyboard.'

While in Paris, Marin met Alfred Stieglitz, pioneer champion of the *avant-garde* in America, who exhibited Marin's work and became his life-long dealer and close friend. Returning to America for good in 1911, Marin was struck by the exciting vitality of New York and immediately began his paintings which capture so brilliantly the dynamism of the city. Here everything is alive; not only the figures, but the very buildings tilt and sway in agitated opposing directions, as in the city views of Kirchner, but without any of the pathos of the German expressionists. One feels that Marin was elated rather than oppressed by the forces of the city, which he pictured as dancing a lively and syncopated, but thoroughly graceful step. Precariously balanced as the movements are, they *are* balanced, deliberately and insistently. In the notes which Marin prepared for a catalogue of his paintings at Stieglitz's gallery in 1913, he wrote, 'I see great forces at work; great movements . . . the warring of the great and the small . . . I can hear the sound of their strife and there is great music being played;' but he concluded by saying, 'Within the frames there must be a balance, a controlling of these warring, pushing, pulling forces.'

While the lyric composure of Marin's pictures is due in part to the conscious equalizing of tensions, this effect may also be understood in terms of his attitude towards nature. Even in the city views, it is an all-encompassing nature dynamism rather than a specific industrial dynamism to which Marin responds; and his response is that of a lover. Man does not so much pit himself against nature as exult in being a part of the vital forces of nature, of 'the jolly good fight going on. There is always a fight going on where there are living things. But I must be able to control this fight at will with a Blessed Equilibrium.' Helm recounts how Marin attacked the paper with both hands, drawing with the right and brushing the colour on with the left; in this intense absorption he captured and brought

into harmony the energetic opposition of forces through his characteristic jagged, staccato rhythms.

Although in his terseness Marin often exposed the geometry of movement, he disliked most non-objective painting, considering it 'streamlined of all humanity', robbed 'of its – old fashion – sex appeal'. His own aim, explicitly stated, was to make a pictorial equivalent for a specific experience of nature in a given place (67). 'At the root of the matter, however abstractly, however symbolically expressed, I would still have it *Town of Stonington, The Boats of Maine*.' Thus he made it quite clear that he hoped to distil the special character of the land and sea, particularly off the coast of Maine, which he loved so joyously. 'Seems to me that the true artist must perforce go from time to time to the elemental big forms – Sky, Sea, Mountain, Plain – and those things pertaining thereto, to sort of re-true himself up. . . . But to express these [the 'big forms'], you have to love these, to be a part of these in sympathy. One doesn't get very far without this love, this love to enfold too the relatively little things that grow on the mountain's back, which if you don't recognize, you don't recognize the mountain.'

In Marin's pictures, as in Chinese landscapes, one sees both 'the mountain in the painting and the painting in the mountain'. Marin insists on both; and his best works are those in which the balance is equal between nature and art. Less successful are those paintings where the diagrammatic reductions of his style are so insistent that the observer's attention remains focused on the manner of his art. To acknowledge the mannerism in Marin's painting is not to deny the distinction and individuality of the master who ranks in many American and most contemporary European eyes even above Winslow Homer as America's foremost watercolourist.

Marin's accomplishment in watercolour is too often the basis for judgment of his oil painting. It is true that his style was born in watercolour and that basically he speaks the same abbreviated, contrapuntal language in both; but his oils should be regarded and enjoyed for themselves and for their heavier, more sensuous, less elegantly sophisticated idiom. Particularly in his late oils the angular containment of his watercolours is relaxed and gives way to a more open handling and to a more tumultuous and deeply passionate statement. In oil as well as in watercolour Marin succeeded in stating his dynamic, yet somehow tender, vision of nature with authority, brilliance and feeling.

4 The Painting Freed

On the Role of the Object in Analytic Cubism

'I put all the things I like into my pictures. The things – so much the worse for them; they just have to put up with it.' This remark,[1] made by Picasso in 1935 to Christian Zervos, underlines the dual nature of Picasso's relationship to objects, his dependence upon them and his subjugation of them, in terms of forms working in a painting. The remark also serves to point up the Janus-like position of cubism in the history of modern painting. Cubism looks backward in its analysis of visual reality and forward in its subjugation of visual reality towards the complete disregard of the object in 'non-objective' painting. Emphasis on the latter, the revolutionary, aspect of cubism has tended to cloud the former, the traditional, aspect of cubism. The following study of a single cubist painting by Picasso was undertaken as a means of determining as precisely as possible the nature and degree of the dependence, as well as independence, of the cubist composer in his treatment of objects.

Picasso says 'There is no abstract art. You must always start with something.'[2] An attempt is made in this essay to identify some of the objects with which Picasso started in the process of painting a given cubist picture. To do so is not to minimize the role of Picasso the transformer and creator, as he forces the objects 'to put up with' his use of them. On the contrary, the intent of this analysis is to discover how the forms of objects aid Picasso in creating pictorial form as he represents, modifies, and transforms objects around him which interest him, partly for themselves and their associational value for him, and partly because their forms suggest pictorial form to him.

In 1933, Roger Fry declared, 'Le Verre d'absinthe by Picasso at least is a more or less pure painting in the sense that, as there is no recognizable object, we cannot look for associated ideas.'[3] That picture, The Glass of Absinthe (68), painted in 1911 and now in the Allen Memorial Art Museum at Oberlin College, is an excellent and characteristic example of analytic cubism, wherein objects are viewed, remembered, and conceived in several aspects and from several observation points at the same time. The object images are invaded, concealed and enriched by overlappings, reflections, transparencies, shadows, repetitions, variations from shifting angles, rotating positions, and differences in scale, and

by pure inventions. Objects emerging towards identity as objects are fragmented, overlapped and lost. Individual planes and volumes pass freely from opacity to transparency. Forms clearly defined at certain edges are merged at other edges into a nebulous spatial location. Through this merging device, *passage*, depth becomes shallow, space shifting and ambiguous, and objects and pictorial forms are constantly brought to the surface of the picture, emphasizing its two-dimensional painted nature. The observer not entirely weaned from the Renaissance tradition of the fixed, single view of objects in a mathematically measured space, and unfamiliar with Picasso's painting from 1907 to 1911, may at first find it somewhat difficult to see that the point of departure for *The Glass of Absinthe* was a group of objects on a small table covered with a fringed cloth.

In seeking to identify these objects it is helpful to disengage them somewhat from their complex relationships in the total pictorial structure. To this end several studies of *The Glass of Absinthe* have been made: diagrams, tracings, and overpaintings on photographs of the picture. In the study (69), those forms the identity of which as objects can be clearly established, or reasonably proposed, have been isolated from the rest of the picture by painting over the unidentified areas with flat white paint. The danger in such a procedure is that, by cutting certain forms arbitrarily at those places where their relationship to objects is uncertain, the subtle harmonies and modulations of the entire picture may be lost sight of. For this reason, the reader is urged to keep constantly in mind the unified whole (68) while proceeding to analyse the parts.[4]

The first object to be noted is the glass which occupies a large section of the right centre of the picture. A glass, with its transparency and myriad reflections, providing the possibility of complex analysis of visual appearances and suggesting innumerable modifications and inventions, was understandably a popular subject in the analytic cubist period. Readily discernible is the absinthe glass, bell-shaped and footed, with a spoon resting over the top of it. On the rim of the glass in which absinthe is served is placed a perforated, shallow spoon (resembling somewhat a bricklayer's trowel), containing a cube of sugar through which water is dripped into the absinthe. An actual spoon of this type appears in Picasso's painted bronze *Glass of Absinthe*, in the Philadelphia Museum of Art.

Picasso has not conceived and drawn the glass as a clear unbroken image; he has fragmented it, not only by the familiar means of analysing the reflective, refractive and transparent phenomena of glass, but more significantly and inventively by the addition of unconventional complications deriving from multiple views and form improvisations. The stem of Picasso's glass is presented in profile, slightly shifted in axis from the upper section, the bowl as a rectangle, and the opening almost directly from above with the curved rim somewhat off axis on the left. Below and to the left of the rectangular base of the bowl is a curved cross-section of it, again off axis. The sugar-cube and spoon are shown in several aspects, the projecting handle of the spoon in both profile and frontal views.[5]

The tracing (Fig. 3) was made as a means of analysing the process involved in Picasso's enrichment of the image and his integration of it with the total composition. Picasso viewed and formed the glass in a combination of curves, which are traced with wide lines, and angles, traced with narrower lines. The stem of the glass resembles a compass describing a circle, with the knob serving as the pivot. Picasso has not only transformed visual effects in this manner, but he has also invented forms by selecting a fragment of an object and extending it into a plane or volume analogous in shape to part of the original object, the new motif then evoking further repetitions and variations. In the tracing the broken lines indicate such inventive modulations and repetitions, suggested by the knob and stem and bowl of the glass. Thus the knob of the stem has become the cross-section of a cylinder on the left which is extended back, down and towards the centre of the picture. Above and slightly to the left of this new shape, recalling the stem of the original glass, appears a related form, also associated with the glass, although shifted in axis and fragmented in three sections: lower stem, knob and upper stem. A consonant but more flatly handled shape is seen on the other side of the original stem; and above this last form are first a semi-circular area and above it a rectilinear one, repeating the basic theme of the glass. The trapezoidal shape, traced in narrow lines, at the foot of the glass constitutes a variation of the rectilinear aspect of the glass motif; it may have been suggested by a cast shadow. The third cylindric image, to the right of the foot, may also be associated with a cigarette or the stem of a pipe, evidencing the multiple references characteristic of the cubist idiom. Looking at the complete painting (68) one sees how these inventions contribute to the entire spatial activity as they are made to move forward and back, up and down, and across by their modelling, overlapping and diagonal directions.

Fig.3 Tracing of glass

In an earlier painting by Picasso, *Glass and Jar*,[6] 1908, a still fairly conventional glass stands in front of a jar, the distorted view of whose side appears in the glass. Comparing this image with the Oberlin *Glass of Absinthe* demonstrates forcefully how Picasso, in three years, moved from a relatively simple to a highly complex visual and formal analysis.

The 1911 glass, no ordinary one for serving absinthe, but now thoroughly identifiable as one of a special order, *genus Picasso*, stands on a small, round or oval table. Figure 4 represents a tracing of those elements directly associated with the table. Again, edges of areas have been traced in such a manner as to indicate the general form of the table. The wide tracings, when completed by dotted lines where the contour of Picasso's table is invaded by other forms, reveal a table top with fringed cloth hanging from it on the left. Of the narrow traced lines, the horizontals and verticals on the right are consistent with Picasso's combination of rectilinear and curvilinear aspects of a single object, as met before in the glass analysis. The four horizontals on the right, which could be repetitions of the back edge of the table, and the long vertical are essential to the lively balance of tensions from left to right across the picture. The other narrow tracings in Figure 4 reveal in the lower section two more views of table edge and fringe, higher on the left and lower on the right, and differing in scale from the first view. A beautifully spaced repetition of the corded motif appears in the top

Fig.4 Tracing of table

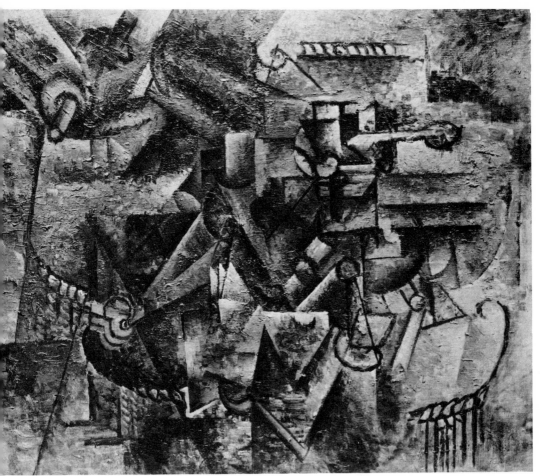

68 PABLO PICASSO *The Glass of Absinthe* 1911

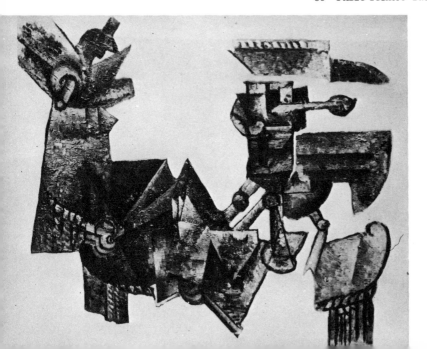

69 PABLO PICASSO
*The Glass of
Absinthe* 1911.
The photograph is
partially painted over
to isolate the
identifiable objects

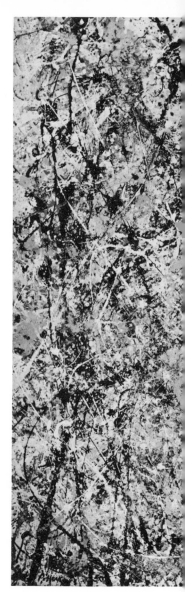

70 JACKSON POLLOCK *Number 1* (detail) 1948

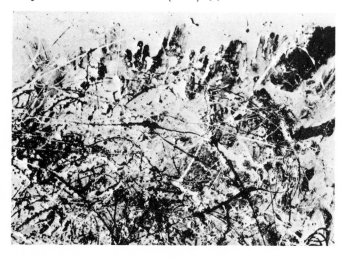

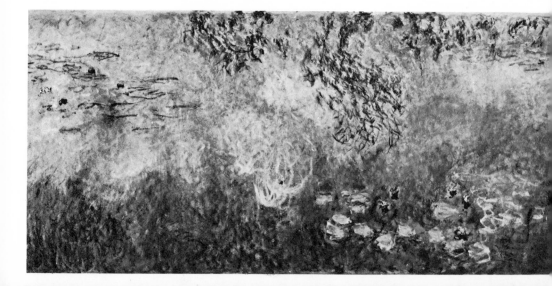

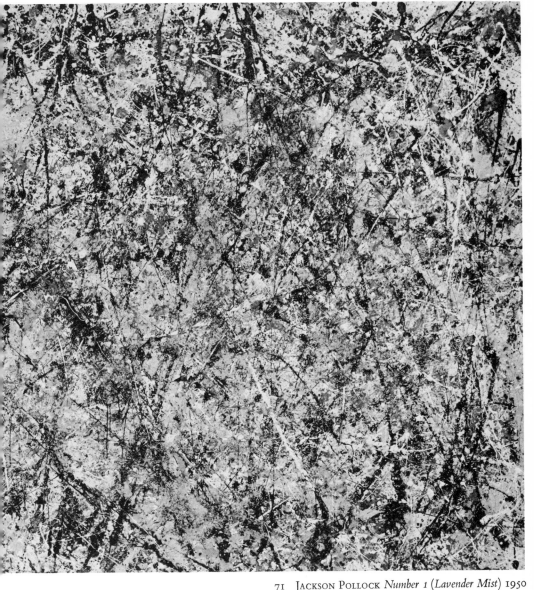

71 JACKSON POLLOCK *Number 1 (Lavender Mist)* 1950

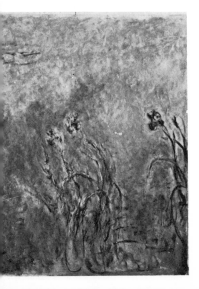

72 CLAUDE MONET *Waterlilies c.* 1910

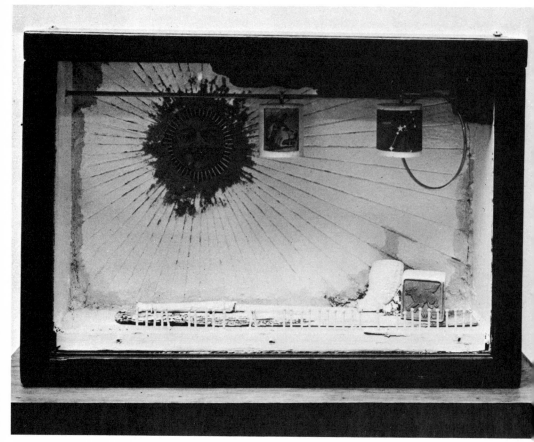

73 JOSEPH CORNELL *Sun Box (Fox Block)*

right where its arbitrary inclusion creates an indispensable element in the slow movement around the table, unites the near and far, and connects the top and bottom and sides of the picture.

The fringe with looped heading appears in much the same relationship in several other pictures painted by Picasso during the spring and summer of 1911.[7] While tracing the part played by this and other objects, one should bear in mind that the works have also evolved one from another. The fringed table-cloth is again present in 1912–13 pictures;[8] but here, in Picasso's 'synthetic' cubist phase, the object undergoes a different kind of translation, being transformed into the larger, flatter planes characteristic of this later period.[9] A similar, if not the same, table-cloth occurs as late as 1919.[10] There also appear in his paintings of this decade two chairs which are corded and fringed at the base in a motif very close to that associated with the table-cloth.[11] A 1914 still life constructed of painted bits of wood, in the collection of Lady Penrose, has a table top decorated with an actual piece of upholstery fringe. Apparently the fringed pattern appealed to Picasso and he evidently enjoyed the furniture so decorated in his own home. When the Oberlin picture was painted, in 1911, he had moved from the battered *bateau-lavoir* on rue Ravignan to 11 boulevard de Clichy, which must have been by contrast a startlingly sumptuous studio apartment. Fernande Olivier, who was living with Picasso at the time, has written in her memoirs a chapter called *Picasso s'embourgeoise*, in which she describes the apartment and his pleasure in furnishing it. Illustrating the contrast between the old and new studios, she recalls how one of the movers said to Maurice Raynal who was helping Picasso, 'These people certainly must have won the grand prize in the lottery!'[12]

Returning to our identification of the objects as isolated in the first study (69) we can discern, on the lower left, woven in with the two views of the table, a fan. In the tracing (Fig. 5), the unbroken lines disclose the base, the ring, and several sticks of an open fan.[13] If we look downwards from the top left, the fan becomes transparent, merging with the table (and becoming in the final analysis, as do all the other forms, the richly varied painted surface of the canvas). Below that area this particular view of the fan is interrupted by another open fan form, superimposed on the first. The left and top edges of this second form are traced with broken lines; the right edge is left continuous, since it delineates both views. This dual reference is characteristic of the cubist idiom, wherein a single line or edge often belongs to two different aspects of the same form, as well as charac-terizing edges of two different forms.

The line describing the lowest right stick of the fan also defines the boundary of the next group of planes and volumes, extending across from the fan to the foot of the glass (Fig. 6). The point of departure here appears to have been a book, again several aspects being welded into a unified image. The wide tracings convey selected views of a partially opened book, the curved form on the bottom suggests the base of the spine, and the lines going out from it left and

Fig.5 Tracing of fan

Fig.6 Tracing of book

right, the binding. The outer edges of the book are fairly continuous; the central and top sections are broken by sharply edged forms associated with pages. The narrow and broken lines are related to other views of the book and pages, as well as being repetitions, extensions and inventions as analysed in the study of the glass.

The identification proposed here of the object as a book may seem more valid and understandable if one looks at Picasso's drawing, *Book* (reproduced in Zervos, II, 872), and if one imagines the artist's deliberate selection of certain planes and lines (all straight except for the curve of the spine). Multiple views and slight shifting in position of book sections helped Picasso create in the painting a complex organization of forms, any one of which moves easily from angular to semi-circular, from stereometric to flat, from opaque to transparent, and from cylindric to cubic. This form activity and ambiguity are interwoven with a space activity and ambiguity so that any single solid or plane is located in some places in front of and in others behind neighbouring ones.[14]

Fig.7 Tracing of scroll

The spiral form on the top left is the last for which a possible identification is proposed. It may be associated with the scroll of a violin; in the tracing (Fig. 7) the wide lines can be read as the neck and scroll, with a cylindric projection at the centre of the volute. This spiral also serves as the scroll of another violin view, indicated by broken lines. The narrow lines in the tracing correspond to the scroll seen from the other side; this opening out of a form into a double image occurs often in Picasso's construction. In the collage *The Violin*, in the Philadelphia Museum of Art, the violin scroll, again with cylindric projection from the core of the spiral, is spread out so that both sides are simultaneously visible, although the views are not reversed as they are in the Oberlin picture; the semi-circular shape at the top of the finger-board is apparently its cross-section. In *The Glass of Absinthe* (68) a similar circle segment appears to the right of the double scroll. If the interpretation of it as the cross-section of the finger-board is acceptable, then, in the Oberlin painting, the two diagonals extending from the segment towards the glass might be identified as two views of a finger-board, with its cross-section dislocated in position, a characteristic cubist compositional device. The segment, finger-board, and scroll appear again in another painting, *The Violin*, [15] 1912, where there can be no question of their identification. This evidence, while significant, is hardly conclusive and the reading of the image in the Oberlin picture as violin parts remains a reasonable, but only tentative, identification. It is also possible that this spiral form could have derived from the volute decoration on a chair or sofa arm;[16] and it has further been suggested that the object in question may have been a household fixture, such as a curtain tie-back or skylight regulator. It is interesting to note that photographs and drawings of Picasso's studios[17] often reveal musical instruments hung on the wall or placed on sofas; thus it is conceivable that the detail of a violin could have fallen within his vision, particularly in the light of the cubist freedom to select and modify from multiple, not single, observations; and from past and future times, not any present moment; and, above all, from a visual idea – an image held in the mind. Moreover, he *liked* musical instruments; like the glass and bottles, they were a part of his world in the home, the studio and the café. Formally, the scroll motif is essentially related in character to several other shapes in the picture: the flaring rim of the glass and its curved foot, the extended curve of the table lower right, the spine of the book, the base and ring of the fan,

and an unidentified configuration in the top centre which, somewhat resembling Picasso's image of a pipe in other pictures,[18] is of considerable importance in the pictorial play of theme and variation.

Through this study of *The Glass of Absinthe*, we have seen that the point of departure for the painting was an arrangement of objects on a table; to this extent the picture is an ordinary still life. The most extraordinary feature of this ordinary still life is not the fact that Picasso combined multiple and fragmented views of objects in an ambiguous space, but the fact that Picasso synthesized his multiple observations, modifications and inventions into a masterful, firmly integrated work of art.

Although we have been primarily concerned with forms and their intricate relationships, one should not underestimate the handling of colour in *The Glass of Absinthe* as a unifying element of major importance. Characteristic of this period, the palette is muted: black, grey, earth-yellow (yellow ochre or raw sienna), red-brown earth (probably burnt sienna) and beige (raw or burnt sienna). The warm earth colours in their application and delicate modifications lend a dusted gold effect to the painting. Colour, as well as form, is intricately interwoven and it begins 'to live its own life'[19] (albeit a subdued one) as a partially independent pictorial instrument. While value is used to model forms to a certain extent, it cannot be said that colour is used to describe objects; the integrity of local hues is disregarded in the non-representational selection and adjustment of tones for pictorial reasons.

To analyse the subtle and arbitrary colour changes with black and white reproductions is obviously impossible, as the following example will testify. The table top on the left is primarily warm grey, but it is abruptly split by a band of the most positive yellow in the picture cutting across the vertical sticks of the fan. This change of hue is not perceptible in the black and white reproductions because the value is kept constant in the lower section of the table top. The reader able to refer to the original painting or to others of the same period, as the well-known *Ma Jolie* in The Museum of Modern Art, is asked not to accept too readily the frequently held view that colour is of minor consequence in analytic cubist painting. Admittedly the hues are subdued and the range limited but, within this restrained and disciplined handling, their placement and modifications are subtly harmonious and attest to Picasso's growing control of colour as well as form in 1911, the high point of analytic cubism.

Likewise significant as unifying elements in the painting's design are the brushwork and the texture of the paint surface. Irregular and roughly textured areas contrast with and complement carefully patterned areas wherein the parallel strokes follow and implement the horizontal, vertical or diagonal directions of forms. The stroke patterning is not so consistent as Cézanne's and not so varied as Monet's, but falls somewhere between the two and is definitely related to both, as a deliberate instrument of design, and as a reminder that 'the painting is the thing'.

Throughout this analysis of *The Glass of Absinthe*, we have seen that the artist has made no effort to conceal, but has rather tried to reveal, the process from representation to transformation, from imitation to creation. We have discovered that some of the picture's forms can be identified quite clearly as deriving from actual objects, some of them are less closely related to objects, and some are more nearly pure inventions. We have found that to identify all of the forms in this painting, or even to place every form absolutely into one of the three above categories, is impossible because of the very nature of cubism, wherein a deliberate ambiguity between 'real' and 'invented' is one of the basic and most captivating qualities. The real is interwoven with and concealed in the invented because the cubist creator insists that a painting be regarded as an object in itself, which has its own 'reality'. However, the picture's reality is composed of multiple associations with other realities, objects and ideas which have been amalgamated into it. This is the firm lesson of cubism, and the basis of its interpretation as both traditional and revolutionary.

5 *'I* am *Nature'*

Jackson Pollock and Nature

Jackson Pollock's retort 'I *am* nature!' to Hans Hofmann's critical comment 'You do not work from nature' is so appropriate to both the myth and the actuality of the man and his art that a critic might have invented it for him, had he not said it himself.[1] The defensive brusqueness of that remark, and of the others Pollock made that day when Lee Krasner brought Hofmann to see his work ('I'm not interested in your theories. Put up or shut up!'[2]), is characteristic of the attitude which helped create the popular image of Pollock as the two-fisted, rough and ready frontiersman. While that legend was undeniably fostered by his truculence, his hard drinking, his then uncommon Western clothes and his battered old Ford, and while it *is* accurate as a metaphor – Pollock clearly did penetrate into unknown territory and cut a path for others to follow – it obscures and denies many essential facts about the man. Fortunately, by now, the delicacy and privacy of Pollock's feelings (Lee Krasner says he kept his books in drawers because one's choice of reading is such a personal thing[3]) and his love of poetry and music need no further defence and clarification than they have finally received from the published statements of his widow, friends and other associates.

A similar blending of fact and fiction pertains to the presentation of Pollock as an existential hero, a view which again finds support in the declaration 'I *am* nature!' Although Harold Rosenberg now objects to the existentialist interpretation, he himself was primarily responsible for it, through his enormously influential essay, 'The American Action Painters', published in *Art News*, December 1952. The following are only a few of the numerous passages that could serve as a textbook explication of the artist as existentialist:

> At a certain moment the canvas began to appear to one American painter after another as an arena in which to act. . . . What was to go on the canvas was not a picture but an event. The painter no longer approached his easel with an image in his mind; he went up to it with material in his hand to do something to that other piece of material in front of him. The image would be the result of that encounter . . . there is no point to an act if you already know what it contains.[4] . . . The act-painting is of the same metaphysical

substance as the artist's existence. The new painting has broken down every distinction between art and life.[5] . . . Art as action rests on the enormous assumption that the artist accepts as real only that which he is in the process of creating . . . the act on the canvas is an extension of the artist's total effort to make over his experience[6] . . . the dialectical tension of a genuine act, associated with risk and will.[7]

In a vivid image, Rosenberg asserts: 'The American vanguard painter took to the white expanse of the canvas as Melville's Ishmael took to the sea. On the one hand, a desperate recognition of moral and intellectual exhaustion; on the other, the exhilaration of an adventure over depths in which he might find reflected the true image of his identity.'[8]

The freedom which Pollock embraces was as great a burden to him as it was to Camus's lawyer, who discovered that

It's a chore . . . and a long-distance race, quite solitary and very exhausting. No champagne, no friends raising their glasses as they look at you affectionately. Alone in a forbidding room, alone in the prisoner's box before the judges, and alone to decide in face of oneself or in the face of others' judgment. At the end of all freedom is a court sentence; that's why freedom is too heavy to bear . . .[9]

Pollock's freedom to choose, to invent, to continue pulling something new out of himself, became ever more painful as he was increasingly identified with the revolution in American painting which occurred after the Second World War. His friend and fellow action painter, Willem de Kooning, characterized Pollock's importance bluntly: 'Every so often a painter has to destroy painting. Cézanne did it and then Picasso did it again with cubism. Then Pollock did it – he busted our idea of a picture all to hell. Then there could be new pictures again.'[10] At a time when the new art was not so publicized and clamoured after as it seems to be now, to be a leader of the *avant-garde* was a bitter and lonely responsibility. Pollock took the responsibility of leadership with deadly seriousness. In his last two or three years, when he painted what was for him very little, it must have been a particular torment to realize that for artists all over the country he was the symbol of revolt – freedom personified. One could almost say that he committed himself to the symbol which he had become. That symbol was forever fixed by his early death in 1956 at the age of 44, in a motor accident while he was driving at night on a dangerous section of Fireplace Road, on which he lived.

That Pollock sought the nature of the self in the nature of painting is evidenced in his words as well as his work. He called No. 31 of 1950 *One* because he said he felt at one with it. Selden Rodman quotes him as saying, 'Painting is self-discovery. Every good artist paints what he is.'[11] That statement was made in Pollock's last summer; but already in 1947 he had given his memorable explanation

of why he preferred to work on the floor, 'I feel nearer, more a part of the painting, since this way I can walk around it, work from the four sides and literally be *in* the painting.'[12] If any observer could otherwise fail to recognize Pollock's physical presence in the great sweeping whole-body rhythms of his painting, the artist makes the point inescapably clear in his *Number 1*, 1948 (70), in front of which one almost hears him insist, 'This is *me* painting', as he imprints his hand several times on to the wet picture. Unquestionably, he found his identity in the act of painting and his paintings could no more be planned in advance than he could; the created and the creator could come into being only in the act of creating, in the act of living. (Rosenberg spoke of the action painter as 'living on the canvas'.[13])

But what the popularizers of the existentialist interpretation missed (and what Rosenberg signalized a little more clearly in later essays[14]) is that Pollock's act was neither mindless nor undisciplined. The first spontaneous swinging gestures, which he made in the process of painting his great web pictures, correspond to the kind of constantly moving linear rhythms which he wanted and which he trained himself to execute. In a 1969 interview with B. H. Friedman, Lee Pollock described Jackson's 'amazing control' in the use of 'sticks, and hardened or worn-out brushes (which were in effect like sticks), and basting syringes'.[15] Although she was referring in that specific instance to the black and white pictures, her remark applies equally to the process which Robert Goodnough described in detail in his 'Pollock paints a picture', published in *Art News*, May 1951.[16] He recounts how Pollock first stood looking for some time at the bare canvas rolled out on the floor, before taking up the large can of house painter's enamel, which, unlike traditional artists' tube oil paints, could be poured easily, thus making possible the kind of continuous, flowing rhythms which Pollock wanted to achieve. The next day he tacked the canvas to the wall 'for a period of of study and concentration'; after about two weeks of this 'get acquainted' period, as Pollock called it,[17] he again spread the canvas out on the floor and began slowly and deliberately to interweave the innumerable skeins of paint into a rich and complex whole. Goodnough concludes his article, 'Of course anyone can pour paint on a canvas, as anyone can bang a piano, but to create one must purify the emotions; few have the strength, will or even the need to do this.'

Pollock's random-looking paintings are the result of exhaustive decisions, some utterly rational, others more subconsciously arrived at (if it is not too much of a contradiction in terms to speak of a subconscious decision). The surrealist idea of freeing the subconscious was what, Pollock said, interested him most in his association (together with that of the other American 'myth makers' during the Second World War) with Peggy Guggenheim and her circle of visiting European surrealists. It is also worth remembering that in his long, cruel battle against alcoholism he was often in analysis, beginning when he was about eighteen, and that he seriously read and admired Jung, who wrote: 'The un-

conscious functions satisfactorily only when consciousness fulfils its task to the limit of its capacities.' That any stage of his maze-like paintings was deliberately ordered by Pollock's intellect was impossible for most observers to grasp in the beginning. Even many of those who admired his work for all its other great qualities of dynamism, openness, audacious untrammelled style, for its vast spaciousness and grandeur of scale and concept, still were unable to perceive the delicacy and lyricism of his mature work until after his death. As Gertrude Stein declared, all masterpieces are ugly at first; it is only after they have become familiar, largely through imitation, that one sees how beautiful they are.[18] Now it is easier than it was twenty or twenty-five years ago to see that what Pollock created was a new kind of order. As he admitted not long before he died, he and two or three of his associates 'changed the nature of painting'.[19] In 1950, when answering a question (in a taped interview) as to whether it wasn't more difficult to control his liquid, flowing paint than the usual brushed-on tube oils, he answered, 'No, I don't think so . . . with experience – it seems to be possible to control the flow of paint, to a great extent, and I don't use . . . the accident . . . I deny the accident.'[20] He gently tried to set the record straight, 'I do have a general notion of what I'm about and what the results will be.'[21] He was obviously disturbed by the popular notion of Jack the Dripper, pouring out pictures in a mindless frenzy. Lee Pollock tells us that 'Jackson was furious' when James Johnson Sweeney called him 'undisciplined' in the otherwise 'fine introduction'[22] he wrote for the catalogue of Pollock's first one-man show, November 1943, at Peggy Guggenheim's Art of This Century Gallery.

Ironically, the new order in Pollock's overall linear structures can even be considered traditional in one respect: he seems to have had a predilection for discrete designs. It is not only that the grand curves of paint swinging out beyond the edges of the picture are always brought back into it (obviously it was his intention to paint the canvas, not the floor); but the total configuration of the image turns in towards the centre, for all the world like the figures on a Greek stele. That inward-turning factor of the design (often lost in reproductions because of incomplete or cropped photographs) is one of the essentially cubist elements of Pollock's work, which is sometimes accentuated by a greater openness and lessening of pictorial activity out towards the edges of the canvas.[23] The design within the edges is complete; but in spite of that, the picture goes out into the world around it. It is a complete part of a continuing, living whole, like a tree in a forest. It is this latter, rather specific interpretation of 'nature' that I particularly want to explore because I believe that Pollock's move to Long Island was of decisive significance for his art.

All of the work that we think of as uniquely his dates from the last decade of his life, when he and his wife lived in the house which they bought (borrowing money from Peggy Guggenheim) on Fireplace Road at Springs, East Hampton. Consider even the change in titles of the pictures painted before he left New York with those he exhibited after he had lived at Springs a whole year – four

full seasons. The pictures in the earlier show, held at Peggy Guggenheim's Art of This Century Gallery in April 1946, have such names as *Circumcision, Troubled Queen, An Ace in the Hole, Once Upon a Time, High Priestess*. His next show, at the same gallery in January 1947, was composed of two series, *Sounds in the Grass* and *Accabonac Creek*. Among the revealing names in the *Sounds in the Grass* group are *Croaking Movement, Shimmering Substance, Eyes in the Heat, Earth Worms*; in the second group, *Bird Effort, Constellation, The Water Bull* and *Magic Light*. Although Pollock sometimes got help from others in the difficult task of naming paintings, Lee Pollock says that even so he never accepted a suggestion unless it fitted in with his own ideas; and in any case the *Sounds in the Grass* and *Accabonac Creek* titles were entirely his own.[24] The latter is the name of the body of water lying at the back of his property. In 1948, he went along with his confrères and began to assign numbers rather than names to his pictures, but the fact that he later reverted to titles and even went back and named some of the numbered paintings (*Number 9*, 1948 was changed to *Summertime*; *Number 1*, 1950, to *Lavender Mist* (71); *Number 30 (or 4)*, 1950 to *Autumn Rhythm*; *Number 31*, 1950 to *One*) is of more than passing interest to the whole issue I am raising.

Another little fact directly underscores how important his natural surroundings were for him; he had the barn (which he used as a studio) moved to one side so that he could see from his house all the way back across the fields and marsh to Accabonac Creek. With his dog Gyp or Ahab by his side, he walked down there often or tramped through the woods and along the shores of the bay and the open ocean. Even the short distance from his back door to his barn-studio took him through the buzzing, swaying, living grass.

Nature was not something apart from himself ('I *am* nature' has to mean that, no matter what additional interpretation one gives to it). As he had identified himself with his painting and with the act of painting, he now felt himself and his art become one with nature's constant movement, beat and change, as he discovered and absorbed it in the grass, dunes and sea around East Hampton. As he lived 'in' the painting, he lived in nature. One could almost say of Pollock as van Gogh said of the Japanese artists that they live in nature as though they themselves were flowers.[25] (Comparing Pollock to a flower is not so ludicrously out of key as it might sound to those who have heard only of his roughness when he was drinking, and have seen only those photographs which emphasize his tragic intensity, and who know nothing of the sweetness and gentleness his friends recall.)

Obviously such paintings as *Autumn Rhythm, Lavender Mist* and *Blue Poles* are not landscapes in the traditional Western or Eastern sense; but in a more significant way they are like the landscapes of such masters as the Sung painters, Cézanne or Monet: above all, they are *paintings* which are metaphors for the inner life of the external nature in which the artists immersed themselves. Fan K'uan walked through the snow-clad mountains for months before he put a single stroke on silk for his winter landscapes; Monet lost all sense of solid

substance in his 25 year long devoted study of the reflections and the swishing life in the water garden which he had constructed. When Cézanne rented a room at the Château Noir and a *cabanon* at Bibémus Quarry to paint the Mont Sainte-Victoire from those views, surely he did so for more than the practical convenience of having his painting gear ready at hand. That he and Monet and the Chinese landscapist deliberately planned their total experience of the 'motifs' whereas Pollock unconsciously absorbed nature, and that they represented visual appearances whereas Pollock chose, as he phrased it, to 'veil the imagery',[26] is of less consequence, I think, than is the similarity in the meaning of their work as it relates to nature. They all succeeded in expressing what Cézanne referred to as 'the heart of what is before you', [27] the Chinese as the 'Ch'i' ('spirit resonance', 'energy', 'inner reality') and Pollock as 'the energy, the motion, and other inner forces'.[28] Pollock said, 'My concern is with the rhythms of nature . . . the way the ocean moves . . . I work from the inside out, like nature.'[29] Those inner forces which are at the heart of Pollock's work were not fully expressed until he had lived on Long Island through one winter and into the summer. It was only then that, abandoning the rough jagged expressionism of such paintings as *The Troubled Queen* of 1945 and the still faintly surrealist imagery of many works like *The Totem, Lesson II* (1945), or *The Key* (1946) with its intense, violently contrasting hues (red-green, yellow-purple) applied in distinct, harshly outlined shapes – usually of a single colour – he began to develop his celebrated, all-over linear style, whose dazzling shimmer of continuously changing colour and line conveys his observation and experience of natural phenomena. The relationship to nature of Pollock's revolutionary art began to emerge in such transitional paintings as the 1946 *Shimmering Substance* and *Eyes in the Heat* and is clearly apparent in *Full Fathom Five* of 1947. These densely active paintings 'sound to the eye' (a Gauguin phrase)[30] like the sounds in the grass. Extraordinarily rich in texture, and not yet so open and weightless in its linear arabesques as his slightly later work, *Full Fathom Five*, in The Museum of Modern Art, New York, is an exquisite web of silver, green, black and white calligraphy, weaving over and behind and in and around in layer after layer, enmeshed with bits of red, purple, yellow, blue. Its continuously changing movement evokes multiple sensations of nature: the silky filament of cobwebs gleaming and disappearing in the sun; the shifting, shimmering grasses which move so mysteriously even on a still day; sea spray swishing along the shore and blowing over the surface of the water, with the plant and animal life of the sea stirring in its depths.

Pollock told Selden Rodman, 'I'm very representational some of the time, and a little all of the time.'[31] His *Blue (Moby Dick)*, a gouache and ink of 1946, is clearly a seascape, although it comes at least as much from Miró as from the Atlantic. In *Summertime* of 1948 it is easy to find suggestions of creatures in the swelling and splashing of the lines – hybrids of human, animal and insect life. But the analogy between Pollock's painting and nature does not rest only on such explicit references in those occasions when he did not choose, as he said, to

'veil the imagery', but rather on the never-ending motion of matter in an unstable, fluctuating space, which his lines of colour convey. From 1947 to 1955 Pollock caught the mobility of life itself in one masterpiece after another: *Lucifer* (1947), *Arabesque* (1948), *One* (1940), *Lavender Mist* (1950), *Autumn Rhythm* (1950), *Blue Poles* (1952), *The Deep* (1953).

Pollock could have said of such paintings (several of them over 16 feet long), as Monet did of his *Waterlilies* (72), that his aim was to 'produce the illusion of an endless whole, a wave without horizon and without shore'.[32] There is no sky, no prescribed eye-level, no point of reference. The lines in Pollock's all-over paintings never stop swinging long enough to delineate or imply shapes on a ground (as most previous paintings had done); instead, they form fields of coloured motion in space, without foreground or background, without beginning or end[33] – thus it is not only the mural scale which induces in the viewer the sensation of being totally surrounded by the painting, immersed in it as the artist himself was in the act of painting it. In Monet's swaying, undulating coloured reflections and in Pollock's ceaselessly active lines – like the veering paths of energy in the great chain of life – volumes are dissolved, dematerialized. At the same time, paradoxically, the material nature of the paint insistently demands our sensory response to its enormous variety. This is true even when the paint is thin and stains the canvas – becoming one with it; in this sense also the ground is eliminated and the homogeneity of the surface is further emphasized. In some pictures, Pollock enriched the already sensuous surface by adding bits of other matter; *Full Fathom Five* is especially rich in this regard. Several foreign objects are embedded in its oil and aluminium paint; but the thumbtacks, pennies, cigarettes, paint-tube tops, matches, etc., are only discovered by very close scrutiny. Lost in the life of the painting, they 'suffer a sea-change into something rich and strange'. Pollock's grand scale paintings are curiously both intimate and public in what they give – and what they ask of us. Being in their actual presence is somewhat like sitting in the front row at a symphony concert – one feels mixed up with the music, physically involved in the very process of making it.

Number 29, 1950, a painting on glass which he worked on in Hans Namuth's film, is another of the rather rare instances when he added bits of foreign matter, shells, pebbles, string, pieces of coloured plastic, sand, wire mesh. Watching Pollock at work in the film, one sees vividly the correspondence between his linear movements and the swishing of the grasses around him; on the surface of the glass the insubstantial, spatially ambiguous reflections of sky and clouds come and go. The film also demonstrates how his sensibility and intellect controlled the apparent automatism of his method. While he worked with great speed, he did not throw the things helter-skelter on to the glass; he would pick up an object, a spiralling piece of wire, place it on the glass, study it, take it off, replace it, rapidly but critically building and rebuilding the intricate design. He constructed the oils in the same way; as he said about the glass picture, 'Generally it's pretty much the same as all of my paintings.'[34]

It is most unlikely that the things (pebbles, tacks, etc.) in such pictures as *Full Fathom Five* or the glass painting were intended to carry any specific content or evoke any particular emotional response; they were simply things lying around, at hand. None the less, they keep their visual independence; they remain concrete entities, just as the richly varied blobs, hunks, drips, ripples, stains, alligator skins and splashes, as well as the constantly changing thick and thin streams of enamel and aluminium paint, do in *Blue Poles*, for example.

Like the things and the lines, the colours also retain their individual existence in the overall structure. Pollock was either not much of a colourist or an extraordinarily audacious one. Many critics would go along with Clement Greenberg who wrote in 1947 (a time when he was still one of the few critics who recognized Pollock as the top American painter of his generation) that Pollock was 'of no profound originality as a colourist'.[35] One might say that Pollock was simply not interested in colour (which would seem rather curious for someone who used as much of it as he did); but is it not more likely that he was indifferent to the customary 'harmoniousness' of hues, and that he replaced 'colours that go well together' with abrupt or unexpected juxtapositions of raw-looking colour? The kind of paint that Pollock used for his sweeping arabesques, usually industrial enamel interwoven occasionally with aluminium, has something to do with that uncooked appearance and a great deal to do with the directness and immediacy that Pollock achieves. Moreover, if one considers the expressive range of Pollock's colour and its appropriateness to the specific character of each painting, it is difficult not to conclude that here again an astonishing delicacy and refinement are at work: *Autumn Rhythm*'s sere brown, tan and black, shot with glimpses of crisp teal blue; the pearly hues of the spectrum gleaming in *Phosphorescence*, or almost submerged by tempest in *Grey Rainbow*; the sombre gnarled and thick black, grey and ochre of *Ocean Greyness*; and the golden warmth of summer in *No. 5, 1948*. In *Blue Poles* the bam-bam-bam of the bright red, blue and yellow, flung and dripped along with the white, black and aluminium, corresponds to the powerful beat of the blue poles as they swing across the canvas. John Russell speaks of 'great pounding rhythms'[36] – a vivid allusion, even if unintended, to the majestic beat of the Atlantic surf. In one of Pollock's extremely rare references to the ocean, replying to a question as to why he preferred living in New York to his native West, he said, 'Living is keener, more demanding, more intense and expansive in New York than in the West: the stimulating influences are more numerous and rewarding. At the same time, I have a definite feeling for the West: the vast horizontality of the land, for instance; here only the Atlantic Ocean gives you that.'[37] Although that remark slightly antedates his move out to Long Island, it indicates some of the natural qualities which attracted him to the locale and which are reflected in the sweeping space and scale of his paintings. When Lee Krasner Pollock was asked in a 1969 interview about the possible connection of the black and white and some of the coloured paintings 'with the feel of the East Hampton landscape, particularly

in winter: the look of bare trees against the sky and flat land moving out
toward the sea', she referred to the published statement of Pollock's quoted
above, saying, 'Then [1944] he emphasized the West, but by the time of the
black-and-white show, after living in Springs for six years, I think he would
have given just as much emphasis to this eastern Long Island landscape – and
seascape. They were part of his consciousness: the horizontality he speaks of, and
the sense of endless space, and the freedom.'[38] She and his close friends tell of
how he would walk or sit with them for hours without speaking, staring at the
grass, the sea and the sky. Tony Smith says Pollock would take him to see the
places he especially liked and 'on clear nights we would get out of the car and
look at the stars.'[39] Alfonso Ossorio wrote that Pollock 'knew every inch of the
Island, the dunes, the northwest woods, the beaches between here (East Hamp-
ton) and Montauk, all of them. Fifteen years ago no one went to these beaches.'[40]
When I asked Lee Pollock if Jackson had ever talked about what the place meant
to him, she answered, 'No, but the very fact that he moved out there says some-
thing.'[41] What it says is not just that he 'wanted to get away from the wear and
tear';[42] it also says that he deliberately chose to live that kind of life in that
particular environment. From the incessant buzzing of the insects in the grass by
his studio to the nebulae floating in outer space and, above all, the everlasting
rhythm of the ocean – whether roaring in anger, sullen in its cold grey depths,
or twinkling through the gossamer veils of *Lavender Mist* – the nature he loved
is in Pollock's paintings.

Arcadia Enclosed:
The Boxes of Joseph Cornell

Joseph Cornell was born on Christmas Eve in 1903, was his own teacher in art,
and lived in a house on Utopia Parkway. For more than forty years he exhibited
boxes (73) which hold the light of the sun, the moon and the stars, the movement
of the planets, sands and currents of the sea, the fragrance of the lily of the valley,
and the solemn innocence of a child. Among the most beautiful of his boxes is a
series called 'Winter Night Skies', which are like the wondrous, blue-black and
white world of silent snow through which processions of sleighs used to glide to
early Christmas morning service. Snow is evoked in much of Cornell's work; it
falls incessantly in the scenario he wrote in 1936, *M. Phot*, which reads like a
source-book for his subsequent imagery: snow, night, glass (chandeliers,
windows, a glass store, mirrors), 'distant harp music . . . caused by the falling
drops of water. . . . The scene is one of inexpressibly serene and satisfying beauty.
. . . A street corner at night, at which time it takes on an appearance of super-
natural beauty. Enclosed by a low lattice-work fence are two lampposts placed
among life-sized marble statues of women in classical poses. The bluish light
from the gas flames gives the statues the appearance of figureheads on old ships,
illumined by phosphorescent seas. Snow is falling.'

Surrealist as it may be in unexpected juxtapositions and irrational shifts of time and place, Cornell's scenario, like his boxes, is closer to Hans Christian Andersen's *Snow Queen* or Resnais's *Last Year in Marienbad* than it is to the shocking, fearful or morbidly sexual world of Breton and Dali. Although changes of speed in action do occur, the overall tempo of his scenario is that of his boxes: the slow, measured rhythm of a saraband, resting 'At the still point of the turning world'.

If in some fantasy of an art historian Duchamp, Watteau and Mondrian joined forces to create a single work, it might have something of the quality of a box by Joseph Cornell. *Taglioni's Jewel Casket* of 1940 (34) is visually related to Duchamp's *Why Not Sneeze?* (1921); but in content it has nothing to do with the Dada master's particular kind of ironical wit. Cornell's construction is a fragile romance, remote and nostalgic as a pair of lovers in the 'rarefied realms' of Watteau. Inside the lid of the jewel box, which is lined with old dark blue velvet, Cornell inscribed:

> On a moonlight night in the winter of 1835 the carriage of Marie Taglioni was halted by a Russian highwayman, and that enchanting creature commanded to dance for this audience of one upon a panther's skin spread over the snow beneath the stars. From this actuality arose the legend that to keep alive the memory of this adventure so precious to her, Taglioni formed the habit of placing a piece of artificial ice in her jewel casket or dressing table where, melting among the sparkling stones, there was evoked a hint of the atmosphere of the starlit heavens over the ice-covered landscape.

The text, in light blue on the dark ground, begins and ends with a band of squares like the cubes of ice – a characteristic example of Cornell's accord of form and idea. Among the bluish crystals 'melting' in the bottom of the box one glimpses bits of red, yellow and purple jewels.

The crystal ice cubes and marbles, the mirrors, the liqueur, wine and whisky glasses so often present in his compositions reflect, refract and intensify the light which fascinated Cornell. Light for him was not so much an optical phenomenon as a state of being. He did not reproduce light; he presented it in itself. This is one of the many ideas of Cornell's which younger generations of Americans (Flavin, Landsman, etc.) have pursued.

Cornell's affinity with Mondrian rests primarily in the purity and subtlety of his formal adjustments – basic horizontals and verticals brought to life through delicate balancing of asymmetric elements. In the spatial dynamism of Mondrian's paintings which, as de Kooning says, 'keep changing in front of us', the spectator plays no role (except with his eyes) in shifting the forms in space. In Cornell's work, on the other hand, the observer is intended to set certain of the objects into motion, to modify the design. The *Sand Fountain* can be moved so that the sand flows and spills like wine-dark water; the *Dove Cot* can be rolled

so that the white balls (the doves) perch or peep out from different openings, and in several works the rings and cork ball glide on suspended bars (73).

The 1936 *Soap-Bubble Set*, which was included in the historic 'Fantastic Art, Dada, Surrealism' exhibition of that year at The Museum of Modern Art in New York, does not have the mobile asymmetry of the later work, but it has the same kind of formal and evocative consistency. The objects which Cornell assembled into his boxes belong together: the globe of the moon, the cylindrical blocks – two of them with stellar images – the egg in the glass, the white clay pipe for blowing the bubbles evoked in the circular forms throughout the composition, and the sweet doll's head (like the later smiling suns). In the later pieces, light is more dazzling as it penetrates and bounces off the glasses and through the crystal bubbles (marbles); but the character of Cornell's world was already established in the early work: the inviolable magic of fairyland and the simple mystery of light, space and sea. Although the actual space in his constructions is shallow, the series of planes moving back into depth and repeated in mirrors expands into the endless space of dreams.

Within the consistency of Cornell's objects and forms is an astonishing variety wherein the elements of texture and colour play a special role: sparkling glass, light-absorbing cork and clay, blistered paint, crisp metal bars, sand-and-sea-worn shells and weather-silvered wood which keep the rhythm and the presence of the ocean. The background of his sea and sun pieces is usually white, some-times touched with pale yellow; the corks are often softly coloured blue or yellow; most of the crystal marbles are clear, but occasionally they have subtle touches of translucent colour. The frames and backs of the boxes are frequently covered with pages of old books through which one reads tantalizing bits of text in a foreign language. Cut out of context and robbed of identity, these veiled phrases further encase Cornell's boxes in mystery. The sand moving over layers of glass in some of his tray boxes is tinted blue or pink like the exotic shores of Tahiti in Gauguin's paintings. But Cornell has a more basic affinity with Gauguin in that both artists deal in the realm of feeling which poetry evokes. In its reliance on metaphor and enigma Cornell's work is equally a fulfilment of the Symbolist poets' aims.

One of Cornell's most enigmatic works, the *Medici Slot Machine* (1942) – composed of parts of reproductions and photoengravings of paintings, frag-ments of maps (the Palatine Hill and other areas of Rome, and a section of Sicily), a compass, a child's block, jacks and marbles multiplied by mirrors – stands behind Rauschenberg's combines. Certainly there are many other ancestors of Rauschenberg's work, and his rich and raucous painting is entirely different in spirit from Cornell's slightly melancholy, aristocratic and quietly symmetrical image withdrawn behind glass. Like the cabalistic texts on many of Cornell's boxes, the fragments of reproduced paintings in *Medici Slot Machine* are not in-tended to be precisely 'read'; but recognizing such details as the head of Botticelli's *Giuliano de' Medici* and Pegasus or the dancing figures from Mantegna's *Parnassus*

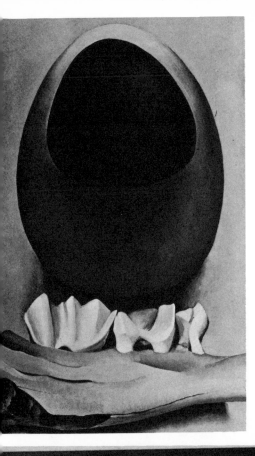

74 GEORGIA O'KEEFFE
Red and Pink Rocks and Teeth 1938

75 STUART DAVIS
Little Giant Still Life 1950

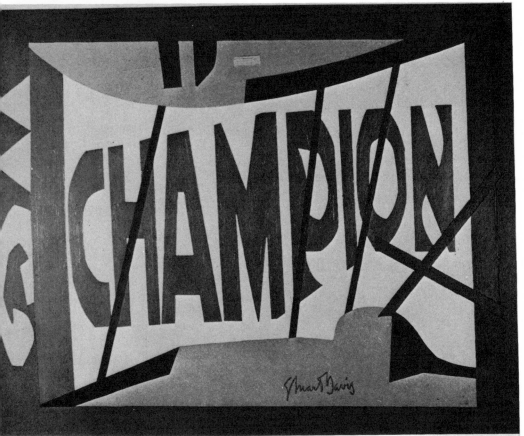

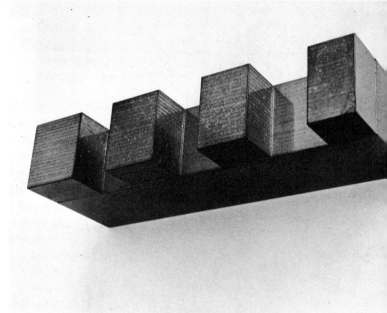

76 DONALD JUDD
Untitled 1967

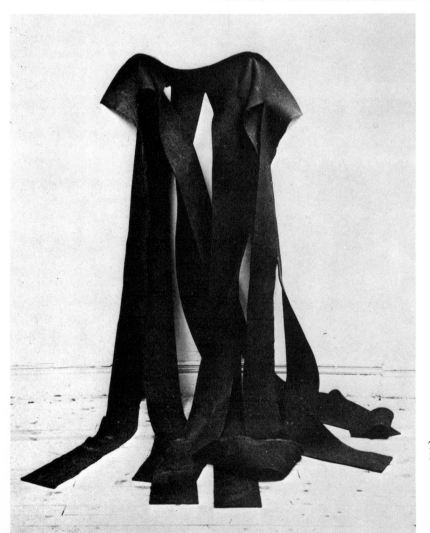

77 ROBERT MORRIS
Untitled 1967

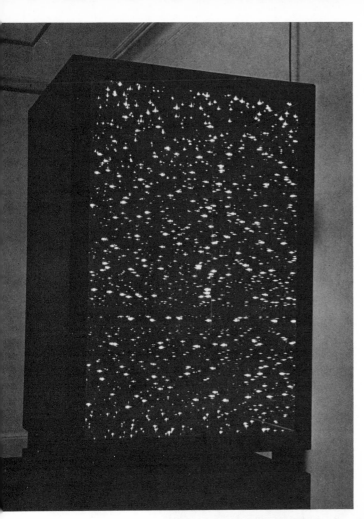

78 STANLEY LANDSMAN
Pinocchio 1967

79 WILL INSLEY
Wall Fragment 1967

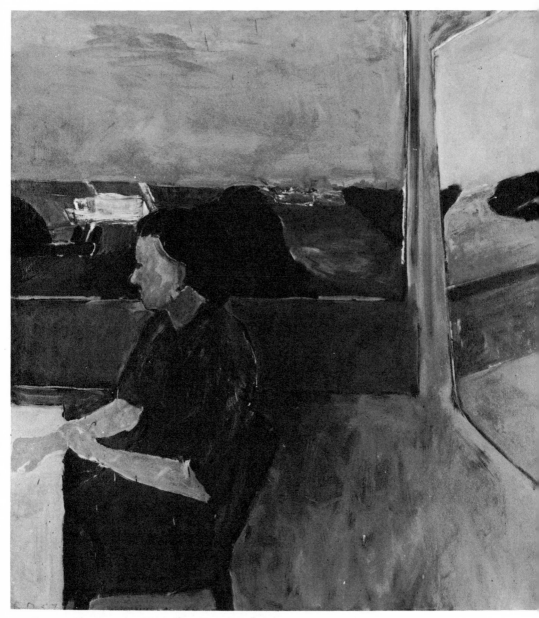

80 RICHARD DIEBENKORN *Woman by a Large Window* 1957

makes the whole work, including the title, that much more piquant. A meta-phorical coin in a magical machine sets in motion before us all the wonders of the court of Apollo and the muses preserved in the Renaissance. In the compart-mented space of *Medici Slot Machine*, the details from paintings are repeated with slight shifts in their placement behind the vertical bands, like the moving frames of a film. Twenty years before Andy Warhol and other younger artists, Cornell used this cinematic technique in his constructions; he too made films and was indeed a pioneer in the field.

But in spite of this interest and in spite of the actual motion of rolling balls and gliding rings, an effect of stillness prevails in all of Cornell's boxes – as it does in the appreciation he wrote of Hedy Lamarr, which begins with this significant statement: 'Among the barren wastes of the talking films there occasionally occur passages to remind one again of the profound and suggestive power of the silent film to evoke an ideal world of beauty, to release unsuspected floods of music from the gaze of a human countenance in its prison of silver light.' Cornell pays tribute to 'the enchanted wanderer, who again speaks the poetic and evocative language of the silent film' and whose 'depth and dignity enable her to enter this world of expressive silence'.

Each box by Cornell is 'a garden inclosed', suspended in a timeless silence. The boxes themselves, as the individual objects within them, exist so intensely that they create their own inaccessible and motionless space around them. Theirs is an Arcadian calm stirred only by such sound and motion as

> The rising of the sun
> And the running of the deer . . .
> Sweet singing in the choir.

American Attitudes towards Art and Experience

A quality of concentration, clarity and oneness, giving no harbour to the irrelevant, distinguishes the American tradition in art. It is a tradition not in the sense of an inherited method but of a shared attitude towards art and reality: an emotive factualism which uncovers the unknown in the familiar and a stubborn need on the part of the artist to wrest the image from his own personal experience. We tend to value more the early portraits which Copley painted alone in colonial Boston than his more learned and fluent London paintings. Much of the best of American art, from the work of the unknown portraitists in the seventeenth century to that of the painters and object-makers of today, has evolved from an intense examination of the object seen to the creation of new objects which sometimes allude to visual reality, without necessarily evoking the illusion of it.

By isolating and concentrating on single objects from his daily environment (a flower in the garden, a toaster in his kitchen) the artist creates an image which

may be an intensification of his experience – of the mysterious power of simple things, of the wonder with which he regards his world – but which he has brought into an entirely different state of being from the source object. Whether the new objects are built directly *of* other objects, as Cornell's boxes are, or whether they make reference to other objects, as most of O'Keeffe's paintings do, or whether they refer to nothing but themselves, as Judd insists is the case in his work, is as irrelevant a question as whether they are constructed in two or in three dimensions. These created objects 'lead their own lives' and find their meaning in the realm of shape, line, colour, texture, volume, plane. Although the life they lead may be silent or boisterous, abundant or austere, mobile or still, harsh or elegant, the objects examined in this essay have in common a distinct presence. They are concentrated, exclusive, sometimes obsessive or hypnotic.

To suggest that the qualities which are often met in American art are not found elsewhere is far from my intention. While our art may speak the language of modern art with something of an American accent, reflecting our environment, our values, our sensibilities and our artistic tradition, that language itself is universal. Contemporary American art is based on the great traditions of Western and Eastern art and its immediate vitality rests on that foundation as well as on the historic willingness of modern art to change, to shatter hierarchies of subject and medium, to break the boundaries between genres, to extend the limits of what constitutes art, pushing its frontiers ever farther into the unknown. In 1944, Jackson Pollock, with whom the breakthrough occurring in American art during the 1940s is most often identified, answered the question, 'Do you think there can be a purely American art?' in these words:

> The idea of an isolated American painting . . . seems absurd to me, just as the idea of creating a purely American mathematics or physics would seem absurd. . . . And in another sense, the problem doesn't exist at all; or, if it did, would solve itself. An American is an American and his painting would naturally be qualified by that fact, whether he wills it or not. But the basic problems of contemporary painting are independent of any one country.[43]

Like Pollock, the old masters of an earlier generation, Georgia O'Keeffe and Stuart Davis, worked out their own deeply personal and inventive art from grappling with the problems and understanding the solutions in other art. Stuart Davis's work, which looks so American in its staccato rhythms, found itself through his response to modern French painting, while Miss O'Keeffe was able to create her startlingly *avant-garde* abstractions of the second decade from a profound comprehension of the structural principles of both Eastern and Western art, which she gained in part from the teachings of Arthur Dow. O'Keeffe's affinities with Eastern art so struck F. S. C. Northrop that he reproduced one of her 1916 watercolours, *Blue Lines, Number 10*, as the frontispiece of his influential book, *The Meeting of the East and West*. The extreme simplifica-

tion and intrinsic scale of Miss O'Keeffe's images (74) and their singular presence in a non-illusionistic space anticipate qualities in the work of such diverse younger artists as Frankenthaler, Bannard, Judd, Morris and many others. Moreover, the openness and quiet grace of colour in her paintings are analogous to those of Morris Louis, while their sensuous modulation of colour values calls to mind an entirely different painter, James Rosenquist, whose work is otherwise closer in subject to Stuart Davis. Like O'Keeffe's is the intensity which Oldenburg gains through isolating the single object or a fragment of it and presenting it close-up in expanded size, thus destroying, while exaggerating, its normal existence as an object. Both educe from the ordinary the extra-ordinary, from the real the dream, as they move from actuality to abstraction.

Miss O'Keeffe's relation to recent American art is more in the nature of prophecy than specific influence. Stuart Davis (75), on the other hand, stands directly behind several younger artists. Like O'Keeffe's, Davis's space is non-illusionistic and his images are simplified, but his paintings are usually built of a greater number and variety of parts whose interaction and colour contrast are more dynamic and harsher, less tender and contemplative. Davis wrote in 1943, 'I have enjoyed the dynamic American scene for many years past, and all of my pictures ... are referential to it. They all have their originating impulse in the impact of the contemporary American environment. And it is certainly a fact that the relevant art, literature and music of other times and places are among the most cherished realities of that environment.'[44] His iconographical sources in the everyday American visual patterns are just as significant an aspect of his influence as the astringent clarity of his shapes and colour. His urbanity as well as his succinctness find echoes not only in Lichtenstein but also in Oldenburg, Judd and many other contemporaries.

Where Davis's paintings vibrate with the rhythms and even the sounds of our modern world, Cornell's boxes are as silent as the fall of snow and as remote as Watteau's Isle of Cythera. No wind stirs the inviolate calm which Cornell preserves in a small rectangle of space behind glass. Light moves quietly in mirrors, glasses, and marbles; and a single shell glows more intensely white than paint could capture against the night-blue sky of Auriga. Although time is suspended in the constructions of this artist, who lived and worked apart from the frenzied market, Cornell contributed directly to the art of his own time, and many of the younger painters and sculptors looked with profit at his work. But only a few of the countless boxes made by others after 1945 can approach Cornell's in purity of form and enigmatic content.

In 1942, Cornell exhibited, together with Duchamp and Lawrence Vail, at Peggy Guggenheim's Art of This Century Gallery, where Jackson Pollock was given his first one-man show the next year. At Miss Guggenheim's gallery and home, Pollock came in contact with several European surrealists about whom he remarked, 'I am particularly impressed with their concept of the source of art being the subconscious.'[45] In freeing the subconscious, Pollock

and the whole generation of American artists whom he represents freed painting, opening it into entirely new possibilities. Pollock has been the least imitated of the masters in his generation but none of the others, except Barnett Newman, has generated such far-reaching innovations on the part of younger artists who drew their courage from his. Pollock's importance lies less in his unorthodox attitude towards materials and their application than in his daring to make painting something different from what it was before, to transform coloured line from its earlier role of describing or defining shapes into streams of energy charging through space, winding in and out and back and forth, building homogeneous webs of movement without beginning or end.

In 1947 Pollock declared:

> I intend to paint large movable pictures which will function between the easel and mural. . . . I believe the easel picture to be a dying form, and the tendency of modern feeling is towards the wall picture or mural. I believe the time is not yet ripe for a *full* transition from easel to mural. The pictures I contemplate painting would constitute a halfway state, and an attempt to point out the direction of the future, without arriving there completely.[46]

A major part of contemporary American art continues to be conceived and executed on a large scale which, whatever its drawbacks, is commensurate with the scale of our architecture and our rural and urban landscape. While many of our artists begin by working in comparatively small sizes, as they grow in command of their powers, the scale of their work tends to become increasingly monumental. The boundless and mysterious fields of coloured space and the austerely simplified three-dimensional structures created by many American artists are, curiously, both personal and public, immediate and remote. In Robert Morris's view, size determines whether a work be in the public or intimate mode.

> It is obvious yet important to take note of the fact that things smaller than ourselves are seen differently than things larger. The quality of intimacy is attached to an object in a fairly direct proportion as its size diminishes in relation to oneself. The quality of publicness is attached in proportion as the size increases in relation to oneself. . . . In this sense space does not exist for intimate objects. A larger object includes more of the space around itself than does a smaller one. It is necessary literally to keep one's distance from large objects in order to take the whole of any one view into one's field of vision.[47]

Moreover, the large work involves the spectator more directly in a physical sense. He shares its space; he cannot escape it; it shuts out everything else and has the power to absorb him completely in his contemplation of it.

This power results from scale, which is related to largeness of physical size, but is not, however, contingent upon it. While a powerful scale calls for gigantic

size, it does not absolutely require it. Over half a century ago, Georgia O'Keeffe implied that she wished to paint large pictures when she said, 'I have kept my pictures small because space in New York necessitated that.'[48] Recently she has made a painting eight feet high by twenty-four feet wide; but even her smallest pictures have a breadth and magnitude which prove that scale is not just a matter of feet or yards but of the artist's concept and forming.

Among the numerous artists who have gone forth from Pollock (or from a combination of Pollock and others) are such strikingly different individuals as Oldenburg, Frankenthaler and Poons. Claes Oldenburg's layers of dripping colours on an undulating plaster ground vibrate with an independent energy akin to Pollock's (and his work can also be as surprisingly delicate). He could just as well have been speaking for Pollock as for himself when he said: 'I know that down to the last simple detail experience is totally mysterious . . . what I want to do more than anything is to create things just as mysterious as nature.'[49]

Although the immediate sources of Oldenburg's subjects are almost exclusively manufactured products (advertisements, foodstuffs, objects used in the home and displayed in the city), still the content of his art is related to natural processes – mobility and change. His soft objects fundamentally revised our conception of sculpture and its nature, and opened the way for further departures. Our pleasure in Oldenburg's humour and his wit, as evident for example in the ironic play between his soft, yielding, mobile constructions and the hard, rigid, fixed original objects, should not obscure the historic significance of his sewn sculpture. The audacity of this soft sculpture, first exhibited in 1962, as well as of his earlier plaster objects, was recognized by many other imaginative artists and served as a stimulus, directly or indirectly, to their creativity. In this general rather than specific sense, it might be said that Oldenburg's premises and accomplishments stand behind or at least beside the work of many contemporary artists who share his ideas. Oldenburg's objects have an immediacy of impact, a wholeness and a monumentality of scale (even when their size is distorted downwards from the original object rather than greatly enlarged as is more often the case) which link them to the structures of Judd and Morris, for example.

Donald Judd's work (76) is strictly non-referential. His 'specific objects', as he has defined them, are 'just there'. They refer to what they are and nothing else; they are there to be looked at – beautiful objects which command the space they occupy with a clear, uncompromising order. Like Morris's, they are not composed traditionally by relating and balancing dissimilar parts; they are 'wholistic', one-minded. When constructed of several similar units, the sequence can be extended indefinitely and still the work will maintain its all-of-one-piece quality.

Robert Morris's work made of automotive felt (77) was to some observers on first sight shockingly different from anything he had done before; but its

'unitary' impressiveness relates it to his earlier *œuvre* and to Judd's. Moreover, it has the majestic sobriety and the mysteriousness which one often encounters in Morris's structures (even though such a response may be alien to the artist's intention). In this respect it is quite different from the lusty sensuousness of such works by Oldenburg as the soft light switches hanging from two hooks which it more obviously resembles. Equally boneless, it is equally positive; in both works change, mobility and chance are more than metaphoric. Shape in Morris's earlier work remained constant except to the extent that it could appear to be altered by the viewer's changing of his position. In the felt pieces there is no constancy of shape; as the viewer decides at what points to hang the work, he even participates to some degree in modifying its form. But only so far; its character is fundamentally determined by the artist: in his plan, in his awareness of how the work would exist in the observer's space and, obviously, in his choice as well as cutting of the material. In one way, this phase of Morris's work extends an idea which he expressed in 1967, in writing of the type of structures made by himself, Judd, Andre, etc.

> Successful work in this direction differs from both previous sculpture [and from objects] in that its focus is not singularly inward and exclusive of the context of its spatial setting. It is less introverted in respect to its surroundings. Sometimes this is achieved by literally opening up the form in order that the surroundings must of necessity be seen with the piece.[50]

One might interpret a felt piece by Morris as though the artist had taken the structure of a painting physically in his hands and nailed that illusory element to the wall as an actual substantial thing. Pictorial line and shape become physical facts existing in space which surrounds them on all sides. Less fancifully, it can be understood as sculpture made from a material which has no structural properties of its own. (Many of his previous structures had been industrially produced in fibreglass or steel according to his specifications.)

Morris, Judd, Landsman and Oldenburg take advantage of modern technology, but they use it to their own ends rather than displaying technological means as an end in themselves, as some of the kinetic and light artists have done. Among the artists working in light who have succeeded in creating something personal and significant in the medium (besides Flavin) is Stanley Landsman (78), as the superbly crafted and poetic construction which he made for the first New Delhi Triennale clearly demonstrates. Through his use of ordinary manufactured products, Landsman builds a wonderland of light sparkling to infinity.

Another current mode, the three-dimensional canvas construction, is represented here by Charles Hinman (103), who translates the ambiguous interaction between two-dimensionality and implied three-dimensionality of synthetic cubist painting into structures whose air-filled solids and flat surfaces play against each other in actual space; and he does so with a refinement reminiscent of Braque. Hinman seeks further paradoxical spatial relationships by painting

the illusion of a volume in 'reverse perspective', as he calls it; his art is a continual shifting between statement and denial of plane and volume, weight and lightness, gravity and suspension.

While Will Insley also shapes his paintings, he maintains a single surface and his images remain consistently flat (79). They are tersely reduced in colour, almost never more than two tones. Often pierced in the centre, his shaped paintings have a power of expansion which forms and enlivens the space around them. Sometimes the implied motion of the outer shape is in opposition to that of the internal aperture; but, consistent with his idea of his paintings as 'wall fragments', he keeps these tensions equalized and strictly planar. Moreover, Insley's work which, like Stella's, Judd's and Morris's, deals ostensibly with internal concerns (shape, dimension, axis, etc.) has something of the poetry in its space and scale that one often encounters running hand-in-hand with the matter-of-fact in American art.

Unlike Insley, Larry Zox and Darby Bannard retain the rectangular format of traditional painting; but, like Hinman, they create an ambiguous relationship between depth and surface, combining an inconsistent illusion of space with consistent flatness. Against the severity of Zox's diagonally formed paintings, Darby Bannard's appear sensuous, although they are no less simplified. Although the paintings of both these artists are composed of interrelated parts, at variance with the 'non-relational' structures of Judd and Morris, still those individual parts are brought together with the powerful scale, simplification and directness which have been noted throughout this survey of modern American painting and sculpture. Like any other serious art, it is, as Stuart Davis declared, 'the responsible social act of the artist, and is one of the surest, most direct forms of communication known to man.'[51]

Diebenkorn's Woman by a Large Window

The figure compositions which Richard Diebenkorn began painting in 1957 (80) were as welcome to many critics and collectors as a spring rain to the parched traveller who had wandered for forty years in the desert of abstraction. From time to time, there had appeared some faint mirages of a 'return to nature'; but here was a real oasis for the abstraction-weary, provided by a painter who had reversed the familiar process from representation to abstraction. This thirty-five-year-old painter, with plenty of honour in his own field, had left it and taken the hard road back to representation.[52] At least, that was how his new work was often gratefully interpreted at the time.

But although Diebenkorn was welcomed like the Prodigal Son because of his beautiful new figure compositions, he was nevertheless much the same kind of painter that he had been before; moreover, his earlier pictures, like many if not most abstract paintings, had an implicit relationship to nature: the distinct landscape character is unmistakable in the big *Berkeley* series. Just because the

relationship to nature is neither overt nor singleminded, it does not follow that no relationship exists. In the *Berkeley No. 42* (81), painted in 1955 and now in the Cleveland Museum of Art (in 1958 he wrote: 'It was an extremely unsatisfactory system of naming paintings – number this and that; I haven't any idea which was which'[53]), the landscape character is related to general sensation rather than to specific view. Equivocal and multiple in possible associations, it suggests the land as seen from the air, or a rocky sea-coast. Unconcerned with specific reference, the painting does evoke a sensation of the vast open space, the sandy colour and glowing light that one associates with the West. Springing thus from experience of nature in a general way, the painting also comes out of preceding pictures in the same series. Once more, art finds its dual source in nature and in art. Characteristically twentieth-century is the construction of a series of paintings, suggesting the artist's hesitation to make a single, final statement and emphasizing rather the relativism of one painting connected with another and the dynamism of work in progress, unfinished, changing. In both the *Berkeley No. 42*, 1955, and the *Woman by a Large Window* (80), 1957, acquired by the Allen Art Museum, Oberlin, early in 1958, these qualities are present in technique, composition, and even framing – or rather lack of framing. Like so many contemporary pictures, Diebenkorn's are 'framed' with an unfinished wood strip which lets the painting expand beyond its edges instead of being confined and ended-off by a traditional elaborate moulding. When Picasso once was asked if a painting were finished, he suggested putting a label on it: 'Don't touch. Painting still alive.'

The lively and deliberate unfinish found in some of Picasso's work is carried to such an extreme degree in American abstract expressionist painting that it has become the hallmark of a style which has found many emulators among some of the more traditionally tasteful European painters. In both the Dieben- korns reproduced, this dynamic distaste for finish is apparent in the segmenting of forms at the edges of the picture, in the haste and roughness of execution, the slapping, scratching and splashing of the paint with a broad brush which often leaves rough bristles embedded in the surface, and in letting many of the paint drips lie where they fall. As a student remarked, "It is obvious that the drips he left were left intentionally; any idiot could have wiped them off" (unless, of course, they fall on a wet area where the difficulty of removing is great and, as Diebenkorn says, the artist 'must decide – has this area been destroyed or its meaning altered?'). This way of painting is more than an indifference to traditional technique; it is a positive style created deliberately to affirm freshness, immediacy and the excitement of forces in tension. The speedy freedom of execution emphasizes large rather than minute elements and enhances the sense of vast space.

The style fits the size of the painting as it fits the content; *Woman by a Large Window* is $70\frac{7}{8}'' \times 65''$, and *Berkeley No. 42* is $57\frac{1}{2}'' \times 51\frac{1}{2}''$. Like many other contemporary American pictures, these works approach a mural scale, thus

indicating the artist's energetic wish to tackle something big; size is a challenge and a stimulus to his creativity. Does a mural scale also reveal an unconscious desire to communicate to a larger audience than the intimate easel painting affords? Unquestionably, the size has the desired effect of forcing the observer into a more direct participation in the painting, as the larger the picture gets, the more it tends to surround him. In commenting on why he had abandoned easel painting, Pollock said, 'On the floor I am more at ease. I feel nearer, more a part of the painting, since this way I can walk around it, work from the four sides and literally be *in* the painting.' This sensation of being 'in the painting' is transmitted directly to the observer through the size and style of the painting in Diebenkorn's as well as Pollock's and many other contemporary artists' work.

Before turning to a more specific analysis of the *Woman by a Large Window*, 1957, one should note the compositional similarity between it and the earlier *Berkeley No. 42*, 1955. This particular way of forming the picture is a major element in Diebenkorn's style; since his first New York one-man show in 1956, one often encounters reflections of his form in other artists' work. It is captivating, this way of organizing the picture plane into large, relatively open areas interrupted by a greater concentration of activity, a spilling of shapes and colours asymmetrically placed on one side of the picture. In *Woman by a Large Window* the asymmetry of the painting is further enhanced by having the figure not only placed at the left of the picture but, more daringly, facing directly out of the picture. This leftward direction and placement is brought into a precarious and exciting but beautifully controlled balance by the mirror on the right which, with its startling effect of taking off from the solid ground, creates a fascinating ambiguity and enrichment of the picture space. Diebenkorn himself says, 'I find particular pleasure in painting mirrors, although a couple of years ago I might have thought that this pleasure should be the province of baroque painters.' The mirror image pulls upwards at the same time that it moves both forward and backward; the action produced expands and enlivens the space of the picture and creates a visual attraction sufficiently acute to wrest the observer's attention from the compelling, still image of the woman. Thus one of the major unifying principles in Diebenkorn's organization is balance of opposites, seen also in the combination of activated and non-activated areas indicated above in the analysis of his style of composing in general.

Opposition is also present to some extent in the treatment of colour and paint texture. The interior of the room and the woman in it are painted in subdued, desert-sand colours, roughly and vigorously applied with much of the drawing achieved by leaving exposed an earlier layer of paint. The edges of the window, table and chair, and the contours of the figure, not to mention the purple eye, were drawn in this way. In other areas, the top layer, roughly applied as though with a scrub brush, is sufficiently thin to permit the under-colour to show through and vary the surface hue. This is the case in the dress; the sandy tan over-layer is modified by and sometimes directly mixed with the earlier light

blue in the bodice, which gives it a warm blue-greenish cast. In the lower part of the dress, the tan surface-coat is applied in a semi-transparent layer over red and dark blue, the three combining into a new and indefinable tone which still retains the individual effect of each of the component colours. While the interior is sombre in colour and the paint rather thinly applied, the landscape is more positive in hue and value contrasts and the paint more thick and rich. The bright apple-green of the fields and the very dark green of the trees are enlivened by smaller areas of orange, yellow and purple; the sky is intensely blue. The glowing landscape takes on added sparkle by contrast with the muted interior, where the quiet woman sits serene and slightly melancholy, disregarding the shining day outside. She even turns her back to the mirror reflection which brings the out-of-doors into the room. Pictorially, however, she is anchored to the landscape by the dark of her hair forming one value and shape with the trees behind her. This union of in and out, of near and far, repeated in the mirror image, emphasizes the plane of the picture, the two-dimensional character of which is further asserted by the planar organization into four horizontal divisions: floor, ledge, landscape and sky. Thus, while the distance of the landscape is firmly stated, it is just as firmly denied, not only by all these means discussed but also by the way in which the bottom of the picture is directly united with the top in the passage on the right where the floor, the corner of the room, and the upper wall constitute a single unbroken plane.

While the mood of the picture is conveyed most obviously through the position and attitude of the figure, still the entire painting functions in evoking this response; Diebenkorn's abstractions create much the same general effect of gentleness in tension, without the explicit psychological element present in the *Woman by a Large Window*. Lonely but composed, withdrawn from but related to her environment, the woman reminds one of the self-contained, quiet and gently melancholy figures on Greek funerary reliefs. Like them, relaxed and still, she seems to have sat for centuries. But how different this work is from the discreetly framed-in composition of Greek stelae. In Diebenkorn's painting the quiet figure faces *out* of the picture and the static horizontal banding is abruptly shattered by the jarring angles set up in the mirror reflection. It is in these two factors that serenity takes on overtones of disquietude. While recalling Edvard Munch in this element and to some degree in composition and technique, nevertheless Diebenkorn's figure paintings possess a classic calm, gentleness and restraint far removed from the emotional anguish of the Norwegian painter who always 'felt the great cry throughout Nature'.

Reminiscent sometimes of Munch and also of the more serene inventions of Matisse, still Diebenkorn's work is very much his own. It is the work of a young painter not only worth watching but well worth congratulating on his already distinguished achievement.[54] Just as in his representational paintings, which received particular acclaim in the late '50s, he did not abjure his abstract style, so he has never completely turned his back on nature in his abstractions.

6 *Object as Art*

Is Beauty Dead?

> A work of art should not be beauty in itself for beauty
> is dead. . . .
>
> <div align="right">TRISTAN TZARA</div>

In his 1918 Dada manifesto, scrapping old dogmas and formulae of beauty and
extolling a new living art for a bitter new world, Tzara was really saying Beauty
is dead, long live Beauty! – a new beauty of the commonplace, of freedom,
spontaneity, contradiction, absurdity, in short, as he put it: 'LIFE'. As changing
generations and individual artists of stature constantly redefine art, they con-
tinue to forge new kinds of beauty. Even when an artist's work poses the
question, 'Is this art? Does art exist?', he is answering it in the affirmative by his
act, as the writer of the absurd dispels the absurd by recognizing it and writing
about it. One cannot be anti-art and at the same time make art – absurd, anti
or otherwise. Or, as Duchamp phrased it, "The only way to be really anti-art
is to be indifferent.'

Each of the three young Americans grouped together here[1] – Mitchell,
Rauschenberg and Oldenburg – may stand for one of the several new kinds of
beauty which continue to enliven our art. The confrontation of these three
very different artists points up the generative power of the break-through in
American art which occurred during and after the war. One of them works on a
two-dimensional, rectangular surface; another combines three-dimensional
found objects with painting on a traditionally shaped canvas; the third paints
three-dimensional objects which he has constructed of plaster or cloth and
foam-rubber; yet all three are painters and sensuous painters in the 'tradition
of the new'. Except for the variety of materials employed, they differ no more
nor less from each other than do any three of the first generation New York
painters, say Kline, de Kooning, Rothko. Equally dedicated to freedom and
individuality, these three young Americans also continue their predecessors'
aim to abolish the distance between art and life, to bring life into the work,
and to involve the spectator more directly with the work of art. This they
accomplish through the vitality of the painting, its unfinish, its movement,
energy, change, and its engulfing size; through the incorporation of objects
of actuality and the physical projection of the picture's world out into our
world; or through the creation of objects related to the commonplace things

of everyday life and the combining of these things into environments. In modern art, the struggle involved in the act of creation has taken on a new intensity through the artist's increased freedom of choice; the intellectual and moral character of this struggle was defined and celebrated by Harold Rosenberg in his decisive article of 1952 when he introduced the name 'action painting'.

Joan Mitchell (82), in her grand freewheeling strokes of colour, remains the closest of the three to the earlier action painters; but she is unique in her special combination of power and grace, of motion and calm, of freedom and control. She selects and even wills 'accident' in her tumultuous but steady and curiously refined painting. This is particularly apparent in the way that the dripping of the paint, seemingly such a fortuitous element, often forms a kind of screen which serves to anchor, to bring to rest, the outward swaying and eruptive movements. The drips are sometimes as delicate and sensitively adjusted as the rain in a Hiroshige print. Tension between letting loose and restraining is part of the conflict which engenders her art and which sustains one's interest in it. Such opposition is consciously sought; in Miss Mitchell's own words, 'A movement should also sit still.' Resolution of opposites characterizes the total construction of her painting, not just the directional force of strokes and drips. The riotous colours run the gamut of intensity, hue and value contrast, but they address themselves to each other with sensitive modulations and they are kept within certain specific and characteristic ranges of choice. The palette enforces the sensations of nature which her paintings evoke: as crisp and clean as the first smell of snow or as hot and hovering as a summer day. One feels the air, the trees, skies, and water – sometimes spilling over rocks, sometimes lying becalmed, more often thrashed by rough winds and washing out to sea.

In Mitchell's later work the full, sweeping arcs, so familiar in her paintings of the 'fifties, are more interrupted, dissolved by light and atmosphere. More open and expansive, it has a quality which would tempt one to call it more acquiescent were it not still so powerful. The passion deepens and matures.

'The moment that I am self-conscious, I cease painting,' Miss Mitchell has remarked. But the self, absorbed in the *act* of painting, is released as a living presence in the painting as an object. This is a different kind of detachment from that of Rauschenberg, for example; with him one senses the presence of an ironic second self looking on as he works.

Like that of the other two artists, Mitchell's painting catches and holds change, the process of becoming, of life itself; it shuns finality. Its space swings out and encompasses the space around it; the act goes on acting in our space. The sensation of palpable space occupied by moving forms which Mitchell achieves on a flat surface is more related to the shifting, changing, undulating character of Oldenburg's painted actual volumes that it is to Rauschenberg's somewhat planar layers of space. This contrast recalls something of the difference between the rather arid world of synthetic cubism and the more organic, natural atmosphere of analytic cubism.

Like Duchamp, Robert Rauschenberg would probably hold that art resides more in the invention of ideas than in the painting itself. There certainly is no scarcity of ideas in the productions of this witty and ironic young iconoclast. He challenges old fixed concepts of format, substance, subject, meaning. Like Oldenburg and many others, Rauschenberg abides by no hierarchy among things. He likes living in this world and he brings anything in the world he wants into his pictures. He undermines the tyranny of the four-edged, two-dimensional surface by making what he calls 'combines'. In *Cartoon* he transforms the surface into a door (and other things) by attaching an actual window sash and a suggestive knob to the canvas; or he gives the picture a physical mobility by putting it (a real door this time) on wheels and wittily underscores and reverses the idea of chariot by harnessing it to an old bucket half full of cement and naming the work *Gift for Apollo*. He thrusts his created world into our world and brings life to both. Nothing remains as it was; he wants to keep a state of flux, of impermanence: a clock ticks the seconds as they pass, decaying matter still clings to the crushed garbage-can (the Ash Can School had some of Rauschenberg's kind of motivation but they lacked his particular antecedents and his wit).

Rauschenberg's irony and satire operate on many levels and they do not spare himself; a distinguished example of this tendency is his *Black Market* of 1961. On the painted canvas are attached several objects, including a licence plate, three clip-boards with movable metal covers reflecting the spectators' shifting world, and a One Way sign shooting out beyond the picture's edge. Fastened to the picture is a rope connecting it to a suitcase in which are several objects that keep changing as spectators select and replace them and make pictures of them on the clip-boards (83). Thus the spectator actually changes the picture. The picture certainly changes him. As the artist ridicules our 'do it yourself' madness, he also mocks some of his own principles: change, 'unfixity', bringing the work out into the spectator's environment and getting him to participate directly in it (the person looking at it makes the work of art). *Black Market*, like so many other Rauschenbergs, is an elegant picture, composed of startling but subtly harmonious juxtapositions of texture, shape, line and colour.

In spite of his pledge to immediacy and his witty play on the contradictory and absurd, Rauschenberg appears unable to escape his personal sensibility as a painter and the almost classic calm of his form. It is of course possible that he does not mind being an appealing painter and a tasteful composer, but it is more likely that he welcomes the struggle between painter and non-painter as another instance of the essential condition, paradox. In any case, in such works as *Second Time Painting* of 1962, the block-like areas into which he divides the format tend to be less rectangular and regular than formerly and they depart more freely from the earlier horizontal–vertical alignment. Moreover, the paint moves behind, over and around the blocks more openly, breaking down the old collage look. Colour still plays a major role and the rectangular divisions

are still there, but they are more organically varied in shape and interaction in space. Across and into a vaguely geometric field of pink, grey, white and red block divisions, a large grey shape arcs gracefully downward from upper left to right, starting off a series of consonant shapes cascading from it: bright orange into which ochre is dragged over cadmium red, below that an analogous figure in sparkling black swinging the movement towards the left through grey, then white ground and over to blue. From there it moves up again through the blood-red cloth stamped with white letters and so on, in and out of the entire painting. Several of the coloured shapes are 'foreign' elements: the cadmium red silk, an alarm clock (upside down), two fragments of a Consolidated Edison banner (also upside down), a piece of an old sweatshirt (inside out), and a section of work trousers (backside to). One particularly important passage of the painting is the little thinly washed white over black area between the shirt and trousers; it states the basic theme and its interlocking in the whole tastefully adjusted and energetically varied design.

Although Rauschenberg uses the refuse of attics, closets, streets and backyards, he seems to walk through this debris with the cool superiority of a nineteenth-century *flaneur* whose sophistication sometimes belies the warm and engaging young man, notoriously devoted to concealing passion. When Rauschenberg puts dead things into his pictures he brings them back to life; he gives them a new life in his magical, mysterious, enigmatic art. The best of his work does have that quality of which he speaks: 'Painting is always strongest when in spite of composition, color, etc., it appears as a fact, an inevitability, as opposed to a souvenir or arrangement.' The specific 'souvenirs' which are incorporated in Rauschenberg's haunting images *lose* their personal, private identity as they are transformed into the inevitable oneness of the work. In fact, in some ways, the old worn shirt in Rauschenberg's picture is more remote from the personal life of the artist than is the completely created shirt by Oldenburg. This is to say that Rauschenberg's aesthetic detachment is cooler, more classic than Oldenburg's; it is not to say that Oldenburg's work, for all its greater immediacy, its 'direct impress of life', lacks detachment. Irony helps to hold Rauschenberg's work in what he calls the 'gap' between art and life.

Claes Oldenburg tries to fill that gap by making objects which, he says, 'give an account of my thoughts and feelings in terms of the material of my surroundings'. It is an axiom that the artist creates reality; Cézanne did it with a mountain (1), Monet with a haystack (2), and Oldenburg does it with an icecream cone (86). Because of the new world of art formed by the artist, the actual things that served as impulses for his creativity will never again be for us the same old things they were before they struck his imaginative sensibilities.

Commercial displays and products with their wonderful and vulgar shapes, colours and sizes, with their immediacy and inescapability, their use and obsolescence, their absurdity and anonymity, are the signs and symbols of the

visual environment in which today's artists live and work – and react to, according to their individual temperaments as artists. While irony and satire do not function deliberately in Oldenburg's image-making, humour most certainly does – a less cerebral, more earthy humour than Rauschenberg's. Oldenburg's objects (not 'found' but constructed by him) are as anonymous in subject matter as they are personal in formal character. The things are the most simple, common necessities for daily living: food, clothes, a stove, sewing-machine, umbrella, toys, calendar, breakfast table, newspaper. His objects have a used, loved and intimate character, a warm human presence. And they have an abrupt and startling aesthetic presence; once seen, they stick in one's mind. The intensity of his images is partly due to his use of scale; usually over life-size, they are sometimes enormously wrenched out of their habitual dimensions (a seven-foot hamburger, an eleven-foot icecream cone). The ordinary is extraordinary; reality is hallucination.

Suspended from the ceiling (84), hanging against the wall, standing on the floor or resting on the table, Oldenburg's plaster pieces are not so much coloured sculpture as they are paintings on a sculptured ground. To clarify a misconception which has frequently appeared in the press, his objects are not papier-mâché. While the sewn pieces from 1962 are soft sculptures made of sail-cloth or awning material filled with shreds or hunks of foam-rubber and covered with latex paint (the final coat might be enamel, depending on the kind of surface desired), the earlier plaster objects begin with a chicken-wire base over which the form is built up with muslin or burlap soaked in plaster, which is then covered with several coats of enamel paint.

Chicken-wire is alive, as anyone knows who has tried to use it to support climbing roses or other vines. When you pull it in one place, it moves somewhere else; it moves by itself. And it is exactly that quality which Oldenburg keeps as he makes an inert substance, dead-weight plaster, conform to the quivering life of wire. He retains and enforces that vitality not only through the obvious presence of the wide, loose screen sometimes directly apparent in the shape of the surface coat or in the actual bits of wire which shoot up free from the plaster, but also in the swelling and receding of changing volumes, the vibrating edge, and the coloured line, crisp, rollicking or relaxed.

Someone made the comment that 'you cannot speak of Oldenburg's colour', meaning that, in so doing, one would not evoke a specific sensation as one would, for example, in saying 'Renoir's colour' or 'Mitchell's colour'. However, Oldenburg *likes* commercial colours and chooses to use their 'anonymous' character, and in that choice already rests something of his identity. Moreover, his colour has a personality which reflects the will as well as the sensibilities of the artist. Not a slave to defining and describing substance and object, his sensuous coloured paint rides free and bold as it drips and splashes and conceals or reveals the rippling volumes. Sun-filled yellow and orange burning against green (*Oranges Advertisement*), shining yellow-green, black and smoky blue

over red (*Sewing Machine*), tender, warm white over yellow-green and pastel raspberry over orange against blue (*Girls' Dresses*), and sombre but rich chocolate brown with a little bright blue and black and white (*Men's Jacket with Shirt and Tie*), Oldenburg's colour jostles, conforms, attracts or repels as he cunningly builds it up, partially exposed layer over layer, to a complex, richly changing whole – which expresses what he has to say. He does all that with a kind of commercial enamel which is available in only seven colours and he does it with conviction, authority and astonishing delicacy.

Bumptious as his work may look, it has an unexpected refinement, a quality which is somewhat akin to what Zola (possibly aided by Cézanne) perceived in Manet's painting when he wrote of its 'tender brutality'. To learn that Oldenburg greatly admires Manet is revealing, but not surprising.

In the sewn pieces, on which he began working in the summer of 1962, Oldenburg took a new direction; moving more towards sculpture than painting, he swung away from colour and surface and concentrated more on composing volumes. Once the response of shock to the incongruity of size, and of amusement to its humour, subsided, one recognized in the large hamburger or layercake, for example, a formal seriousness and austerity. As Oldenburg noted, 'The absence of subject matter did not help people to see the real content of a work, and I don't suppose the obvious presence of, say, a hamburger will either.'

The work of Oldenburg and several of his contemporaries who have been put together in the category of Pop art is not, as Thomas Hess said it was, 'founded on the premise that mass culture is bad', any more than a still life by de Heem with Oriental rugs, Venetian glass and Mediterranean lemons was founded on the premise that the seventeenth-century Dutch mercantile civilization was 'bad'. Oldenburg's art is founded on the premise that what is, is worth noticing and that art can be made of it by a forming mind and sensibility. More enchanted than disenchanted by the vulgar, absurd and anonymous character of his environment, he accepts and affirms; he does not condemn or bemoan. While this may indicate that Everyman is replacing the Existentialist hero, still art remains what it has long been – a matter of individual human beings creating things which have the power to move other human beings.

The Living Object

Sophisticated, vulgar, ephemeral, lasting, harsh and tender, Claes Oldenburg's work is poignantly alive. The *Two Girl's Dresses* hanging on the wall of his studio in New York's Lower East Side are as full of movement as the dresses dancing in the wind in front of the dingy shops in his neighbourhood; but Oldenburg's creations have a compelling aesthetic and human presence. Unforgettable images, they are as personal, evocative and touching as van

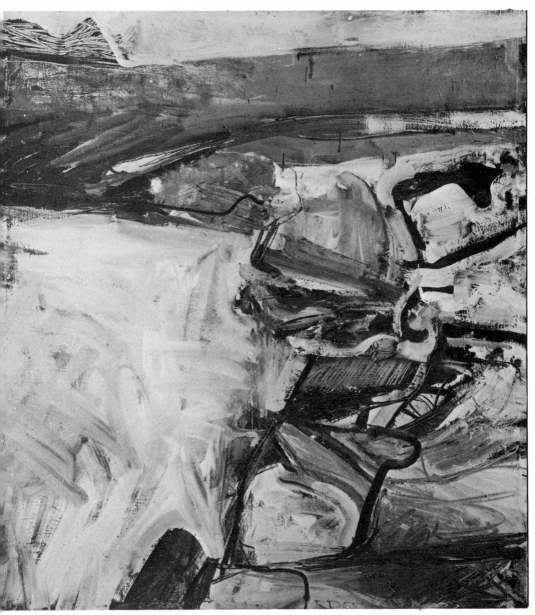

81 RICHARD DIEBENKORN *Berkeley No. 42* 1955

82 JOAN MITCHELL *County Clare* 1960

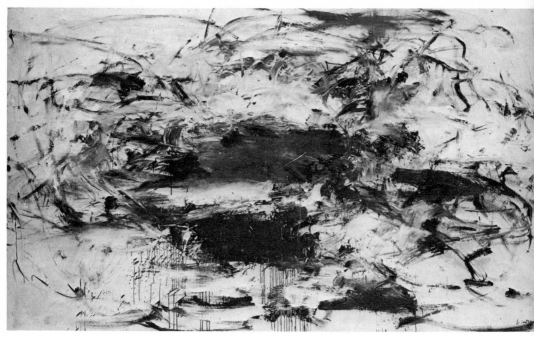

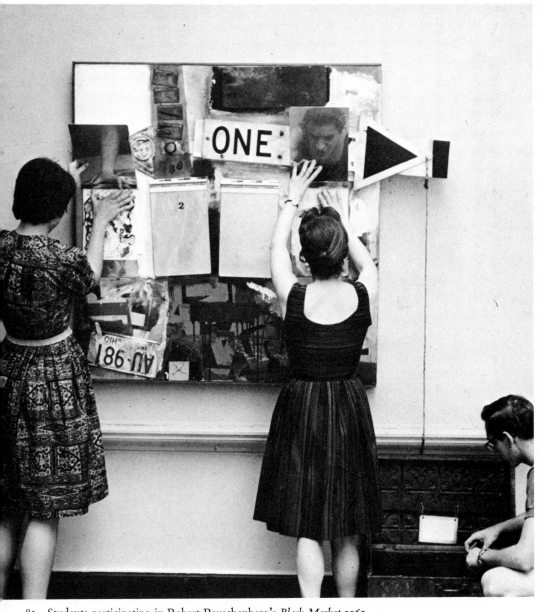

83 Students participating in Robert Rauschenberg's *Black Market* 1961

84 CLAES OLDENBURG *Men's Jacket with Shirt and Tie* 1961

Gogh's *Chair*. Oldenburg's painted sculpture dresses, shirts and shoes, in their subtle undulations and projections, bear traces of the human body; they are still warm with life, a life that is there through his art. While the range of his expressive force extends from gay to ominous, even the most appealing little strawberry tart has something of the blunt power which is so arresting in works like the *Men's Jacket with Shirt and Tie* (84).

To an artist who declares himself 'fond of materials which take the quick direct impress of life', restriction to the conventional domain of sculpture or of painting would be oppressively limiting and the barriers between the two mediums, increasingly threatened in modern art, are completely dissolved in Oldenburg's work. Of painted sail cloth stuffed with foam rubber, or of enamelled plaster built up with burlap or muslin on a chicken-wire base, Oldenburg's objects are both painting and sculpture. Some are in the round and others, like the dresses, pyjamas and sewing-machine, are wall-pieces, reliefs made to be seen primarily from one side; but with their richly painted humps and hollows they are also like canvases with a curiously mobile irregular substance pushing from the back. When traditional sculpture is coloured, the paint is usually 'added', rather than given an independent existence as it is in Oldenburg's, where the paint flows free and drips and splashes in a moving surface. Colour is used as a painter uses it – arbitrarily, to construct and accentuate, or when desirable to reduce volume and space.

Like most artists of his generation (or even since the first scrap of paper was pasted to a cubist canvas) Oldenburg wants to demolish the distinctions between art and reality, at the same time insisting on the aesthetic autonomy of the created object. As he isolates fragments of his experience and fixes on them obsessively, he creates images of shocking intensity, more powerful than reality. Thus, the deeper the realism, the less the illusion and the more startling the creation. By his insistence on both – original object and created object – he recharges the age-old dialogue between art and reality. In his words, 'Recreating experience is the creation of another reality, a reality according to the human experience, occupying the same space as the other, more hostile, reality of nature. A reality with tears, or as if a piece of pie had attained a state of moral responsibility.'

Oldenburg is a deeply sensuous artist, appealing as much to touch, taste and smell as to the loftier sense of sight. The (*Giant*) *Icecream Cone* (86) is so luscious that one's mouth may well water in contemplating it. He pushes the realism (and the humour) further by pricing the merchandise in his *Store* (85) at $69·95, etc. and by his manner of presenting it: men's shirts and shorts in cardboard boxes, pastries in glass cases and on little serving dishes, a ham and a tray of frankfurters and a kettle of stew on a stove. In one sense, you can't get more realistic than that, and such extreme realism makes more pungent the ironic realization that these are *created* objects: far from being sweet, sticky and melting, the cake is heavy, solid plaster. (Not a new joke, but still a funny one

to people who enjoy marble sugar-loaves.) No one would be any more tempted to bite into an Oldenburg icecream cone, even those in natural scale, than into a Cézanne apple.

Always conscious of the evocative power of scale, Oldenburg plays with it, sometimes playing it straight and natural and sometimes putting the objects or fragments of objects in startling, haunting over-lifesize. Something of the effect he wanted to get in installing his 11 foot long icecream cone and 4 × 7 foot hamburger in the Green Gallery in 1962 was that of big cars displayed in shop windows uptown. The monumental scale not only affords Oldenburg the challenge, so essential to contemporary artists, to work big, but it also under-lines the basic irony in the battle between natural object and created object. As there is a give and take between reality and art, between Oldenburg's experience and his recreation of it, so is there a constant interchange between materials and form, each giving play to the other. (Likewise, his happenings spring from his plastic art, growing out of it poetically, spatially and technically.)

Scaled to size or expanded majestically, Oldenburg's pies, sandwiches and cakes are not intended to attack the materialist-centred American in the way in which Hess interprets Thiebaud's dessert-filled canvases as 'major social criti-cism preaching revulsion by isolating the American food habit'. Oldenburg is not throwing the pies back in the public's face; he is not so much condemning us or 'urging us . . . to leave the new Gomorrah . . . to flee to the desert and eat locusts and pray for faith' as he is sharing with us his personal experience through the vitality of his art. Granted that part of his experience, on which he com-ments consciously or unconsciously, is the immense, vulgar and wonderful American love of things, that is not the totality of his reference (let alone the reality of his art). 'I am for an art that takes its form from the lines of life, that twists and extends impossibly and accumulates and spits and drips, and is sweet and stupid as life itself' (see his complete, poetic statement for the catalogue *Environments, Situations, Spaces*, New York, Martha Jackson Gallery, May–June 1961). Although one cannot deny that the rough, even violent power of his imagery may harbour a caustic appraisal, as well as open acceptance, of whatever is, still Oldenburg does not preach. He is both too detached and too committed in his art to do that. His subjects and materials are chosen because they are at hand, they are his, and in their cheapness and immediacy they are the most fitting tools for his art in which he celebrates so eloquently the life of the city, dirty, cheap, absurd, ephemeral, always on the move going nowhere. He loves his environment as tenderly and bitterly as Beckett loves Estragon and Vladimir and he takes us with him through the 'harsh, sweet poetry' of his work. After seeing Oldenburg's *Store*, or a performance of his theatre, one feels compelled to walk and linger through the Lower East Side, suddenly aware of the curious, tawdry beauty of store-windows full of stale *hors d'œuvres*, hamburgers on Rheingold ads, stockinged legs, of five big old caps standing in a stately row on wooden mounts, of human cast-offs wandering aimlessly or hopefully loitering

around the noisy bars. As a poet, Oldenburg does not speak directly of human beings, but their presence inescapably haunts his art. To walk along East Third Street is to walk with Oldenburg – it is somewhat like the sensation when driving around Aix and l'Estaque of driving through a Cézanne canvas. But with Oldenburg the sensation is at once more scattered and more immediate and the young American's transformation of his environment is more shocking and strange.

Immediate and ephemeral as Oldenburg's objects may be in character and material, they fix and hold the warmth of the moment, capturing 'the timeless with time'. Moreover, his objects are permanent symbols of human life, of simple, essential activities: bread, shirts, shoes; sewing-machine, iron, cash register. On first impression the cash register and other 'machines' in *The Store* looked surprisingly nostalgic and old-fashioned for a man so committed to the present and the ephemeral, but it soon became apparent that it is not so much a matter of industrial design which separates them from the latest IBM sterility as it is their used, lived-with character, not to mention their formal exuberance and sobriety. And it is not Park Avenue but the ragged, tattered human and paper-filled streets of lower New York whose sights, smell and feel Oldenburg so powerfully evokes.

The emotive content of Oldenburg's work is heightened by the importance which he gives to the feeling of time. In the shirts and shoes there is a quality of the immediate past, of the present in the dresses blowing in the wind or the icing running down the side of a cake, of the immediate future in the expectation contained in a letter, or the tempting promise of the pastries and in the whole idea of a store, with infinite possibilities of finding exciting, desirable things. Oldenburg's time range is close and concentrated; immediate past, present, and immediate future are all elements of an extended present, sustained in his objects (as well as his happenings). The immediacy, the look of life on the wing, recalls the work of the earlier New York painters as do many other elements of Oldenburg's art (giving the lie to those critics who see him as revolting against Pollock, de Kooning, etc.): the expansive size of the work, its subjective, autobiographical nature, the search for identity in the act of painting, its dripping, lively physical character and its harsh, impure expressiveness.

It has frequently been pointed out that the older generation's projection of the picture's space out into our world, engulfing the spectator and demolishing the barrier between him and the work of art, finds its natural outcome in the spatial environments and happenings of the younger artists. Among Oldenburg's work in these media are *Snapshots from the City*, *The Street*, *The Store*, and the Ray Gun Theater which presented five pieces, each in two versions and two performances, during the winter and spring of 1962. Ray Gun is a name Oldenburg began using in 1960 in a show with Dine at the Judson Gallery. 'It's a name I imagined. Spelled backwards it sounds like New York and it's all sorts of things. It's me and it has mystic overtones.' He calls his studio the Ray

147

Gun Manufacturing Company. For each of his 1962 happenings (87; he tends to prefer the word 'performances'), Oldenburg, his wife and other members of the cast usually spent three evenings talking it over, exchanging ideas, working out the time, the objects and the spatial compositions. One of his problems is how to give his performers free rein while still controlling the action and character of the whole production. In his performances, people are the material which Oldenburg's sensibilities work on, people and objects, in absurd, touching, strange and commonplace events. Although, in his aesthetic detachment, he treats people as objects and emotions as objects, his work is deeply felt and moving.

In the Ray Gun Theater there are no professional actors, no dialogue and no script, but no happening is completely unplanned or lacking in sound and action. There is no audience in the traditional sense, only a small, almost exclusively 'in' group (limited to about 35) jammed together in a narrow passage, so physically involved with the performers that one suddenly feels long hair being brushed in one's face or a leg dangling in front of one's nose or swill splashing on one's ankles. It is messy, vulgar and enchanting. The spectator is transfixed as at a circus, expecting and welcoming the unexpected. It is even more like the ancient mysteries; the spectator's participation is emotional, sensory, mystic. Oldenburg's pieces are performed for a public of initiates, often in tense darkness suddenly broken by startling light as something happens in each of the three sections, but no one can see exactly what is happening because distance and angle obscure two of the areas and the third is too shockingly close, surrounding, suffocating. What happens cannot be known; it can only be felt by those who are over-sensitive to things, colours, shapes, to darkness and light, to sound and silence, to movement and suspension of time. Far from primitive, happenings are the mysteries of the sophisticated.

Sensitivity to the absurd is a mark of extreme sophistication and happenings have obviously some of the same roots as the Theatre of the Absurd, but they are 'farther out' and more abstract. In the Theatre of the Absurd persons lose importance but they are not reduced completely to objects and both intellect and sentiment somehow still work together in a coherent way; the *Bald Soprano* is a highly polished, inescapable satire. In the Ray Gun repertory some of the pieces have a little plot but most have none at all and things rarely 'mean anything'; certainly they never mean the same thing to everyone. Improvised in appearance, impermanent and irrelevant, they are over much too soon, about 30 minutes. One of the performances ended with a girl dressed in a little blue burlesque costume, passing pink ice-cream directly from her fingers to the spectators' mouths. This outrageous act was a pretty little piece of irony, spoofing one of the basic ideas of happenings – audience participation. Producing a happening may sound a little like having someone direct The Game, a kind of charade which we used to play, but the Ray Gun Theater is conceived, directed and presented by an artist who creates living, moving sculpture with

people, objects and events as he does with foam rubber, cloth, latex, chicken-wire, plaster and enamel in his no less moving 'still life' sculpture. Man is no longer the measure of things, but with Oldenburg things still measure the man because, as Picasso observed, 'The artist is a receptacle for emotions, regardless of whether they spring from heaven, from earth, from a scrap of paper, from a passing face, or from a spider's web. That is why he must not distinguish between things. *Quartiers de noblesse* do not exist among objects.'

The Poetry of Everywhere

Claes Oldenburg is sometimes called a poet, and rightly so, not simply because he has written poetry, but because as a visual artist he thinks and works like a poet. Most of his poems date from 1956 to 1958; some of them are extremely metamorphic, corresponding in character to such collages as *Obsessive shapes: falling forms, elephant and chocolate, knees*, 1957. His first one-man show in New York, at the Judson Gallery in May 1959, was a composite of drawings, sculpture and poems. Although he no longer writes poetry as such, still his plastic art continues to betray tendencies germane to that medium. Besides using cadence and other devices common to all the arts, he builds with inference, metaphor and analogy to convey meanings far removed from ostensible subjects. His images rhyme with each other formally as they metamorphose from one object or state of being to another. Words, which he loves for themselves as independent entities, function that way in his art; and sound, to which he is hypersensitive, is deliberately evoked through pictorial and sculptural means. His work is in accord with his statement, 'I consider visual art as poetry, a form of writing, or writing a form of visual art.'[2]

His 1959 *Empire (Papa) Ray Gun* (88) is what Kubler would call a 'prime object', a paterfamilias as it were. Its life-filled and life-transmitting physicality and its basic form recur in an astonishing variety of guises throughout Oldenburg's work. Magnificent anywhere, it was especially effective suspended from a beam in his immense 14th Street studio where, when struck by a shaft of evening sunlight, it glowed mysteriously in the cavernous darkness like a golden cult image in an ancient grotto. Some of the later ray guns are more reduced and regular in form and less overtly phallic, and their closeness to prehistoric mysteries is less readily apparent. Among the abundant collateral descendants of the *Empire (Papa) Ray Gun* (i.e. collateral in subject but lineal in form) are an arm, a door handle, a 7-up sign, a car, a vacuum cleaner, a Dormeyer mixer (89), a toilet, a shrimp, a shoe, and a map of Chicago. The fireplug, drainpipe and lipstick monument are double-handled, single-barrelled ray guns. In 1969 the artist made a series of drawings which he called 'System of Iconography' to illustrate these specific analogies that I had selected from numerous reappearances of the ray gun image (Fig. 8). One of the disguises in which he

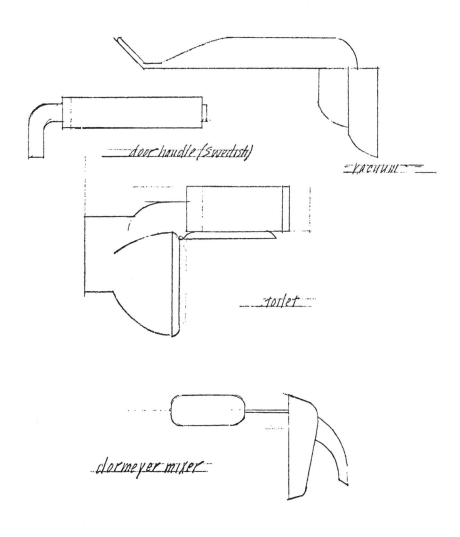

System of Iconography: Four "Home" Ray Guns

door handle (Swedish)

VACUUM

toilet

dormeyer mixer

CO ⁱⁱ/6/69

Fig.8 CLAES OLDENBURG *System of Iconography: Four Home 'Ray Guns'* 1969

cloaks himself, the ray gun is a symbol of his manhood and his creativity and of his faith in what he calls the 'ultimately unknowable'.

Partly the product of his prodigious fantasy, these metamorphoses also have their origin in Oldenburg's consciously or intuitively selecting those subjects in which he recognizes his favourite formal motifs. All of his mature work is

deliberately reducible to a few simple forms, primarily rectangles and circles with occasional triangles, and their spatial extension into solids. By repeating, combining, modifying and changing the position of his formal constants, and by stressing their affinity, widely divergent things are made to 'rhyme' with each other. 'The countryside is afloat with doubles', Oldenburg wrote in a 1956 poem, which reads in full:

> *mirrors*
> *polish up your annihilations*
> *instruct metal in ambiguity*
>
> *there is an order standing*
> *for revolvers panelled with invisibility*
>
> *a mouth is loose*
> *victims have seen themselves*
>
> *the countryside is afloat with doubles*

Oldenburg's formal correspondences are largely responsible for the unity which distinguishes his exhibitions, particularly those which he himself plans; but any selection of his work is remarkable in its consistency as the consonant forms move freely back and forth cutting across major subject categories and marrying opposites. The *Floor-Burger (Giant Hamburger)* can be reduced to three major circles and one minor one, the *Giant Blue Shirt with Brown Tie* a large rectangle with a 'tail', *Giant Soft Swedish Light Switches* four circles, and *(Giant) Icecream Cone* a circle on a triangle (the solid form of which Oldenburg describes as 'disks continued in space but seen in vanishing point perspective',[3] i.e. a cone). The *3-Way Plug* can be read as the crossing of two cylinders (discs multiplied), with two rectangles suspended from it; *Giant Fagends* is entirely composed of cylinders on a hexagonal prism, and the whole *Bathroom, Airflow* and *Bedroom* ensembles are complex orchestrations of the basic motifs. Clearly, almost any art can be reduced to basic geometric forms; as Oldenburg says, 'That's what gives it strength. It is the bones, the skeleton – the truth. I've just made a game of what every artist concerned with universal structure does.'[4] However, Oldenburg is unique in his obsessive concern with the formal correspondences which he can find or establish between otherwise totally unlike objects; and his studio notes abound in references to such equivalents:

Drum set = bed = big 'erotic' drawing = car (Airflow) = Fagends
Thames ball = hat on sidewalk
Typewriter eraser = tea bag = punching bag = keyhole = sperm cell

Hundreds of similar analogues occur throughout Oldenburg's notebooks, which fill several shelves and attest to his compulsion to give form to his thoughts, however fleeting or complex and sustained, and to the fact that he does so as both a poet and a visual artist. They also make clear that his intellectual activity

is inescapably rooted in his physical being; he responds to words sensuously and uses them as objects, emphasizing their autonomous qualities. 'Words are, do not only do,' he noted in 1967. 'Dick and Alison said they sat on a sofa but I could see it was a couch, i.e. the letters correspond to the form of the object described. I now attack the abstraction of language.' And in January 1969, 'The name of a thing is a verbal form of the shape of it, used that way, to call up a shape easily. Name that is an abstract as well: cone, for example." Much as a good actor or orator does, Oldenburg makes us feel a word's weight, density, lightness, or other aspects of its form and substance. Sometimes he incorporates words as an intrinsic element in the work: many of the *Street* and *Store* drawings and three-dimensional pieces have words and numbers painted or drawn on them. He frequently inscribes the name of the object on it, as in *Giant Soft Ketchup Bottle* and on each item of *Soft Ladder, Hammer, Saw, and Bucket* (39). Often he writes equivalents suggested by a work directly onto the studies for it, as on a vacuum cleaner drawing: ' = typewriter = shoe = sailboat.' Occasionally a word is the sole subject of the work as in *Céline Backwards*; sometimes a single letter forms the work. A monument is constructed of a T, a tree of a compact cluster of full-bodied B's, and a museum of its own letters. As has been the case for many of his contemporaries, a major source of Oldenburg's use of words and numbers is their preponderance in the city landscape. 'A city is all words – a newspaper, an alphabet,' he writes in the Gemini portfolio notes. Another source has been maps, which he constantly consults. In 1966 he wrote, 'I feel shut in if there is no map on the wall to look at.' The initials of his own name haunt his work: a giant C is dropped on a building; the drainpipe is a T; the hamburger a series of O's. He notes, 'CTO C (see) CO toilet cover C toilet O bathtub T sink'; and he observes that several works are based on A's, as the ladder piece, A for Aquarius, his zodiac sign. Like the runes of his Viking forebears, words and letters have magical power and their combinations are incantations in Oldenburg's notebooks.

In incorporating words in his visual art, Oldenburg is deliberately adding the element of sound; when we see the word, we experience it aurally as well as visually. He further introduces sound not by the literal means of attaching mechanical devices but by the choice of sound-making subjects (telephone, typewriter, cash-register, drum set) and, on a more subtle level, by formal allusions to the kind of sound they make. The liquid folds of *Soft Tub* fall like water slowly plopping; the *Perspective Drawing for Home Saw* whirs and buzzes around the page; the hard white circles of the *Soft Typewriter*'s keys click against the black vinyl. The *Giant Soft Drum Set* is as noisy in its extravagant variety of materials, shapes and colours as the *3-Way Plug* is silent in its austere oneness.

While in some respects Oldenburg was the innovator, and in others the catalyser of several major changes in form and attitude which sculpture underwent during the '60s, he retains closer ties with tradition than most advanced

sculptors do; but he does so in a unique and contradictory way. His sculpture is still based on the human body, but never the whole body, only parts of it, and these fragments are presented in the guise of manufactured products. The apparent subject is very different from the actual subject and the content is far greater than either. Again, unlike most of his contemporaries, Oldenburg builds multiple associations and meanings into his work and he welcomes the varying and paradoxical responses which it educes. One of the most subject-conscious of today's artists, he is also one of the most abstract in his formal constancy and concern. Because he stresses each of them to an extreme degree, Oldenburg, as much if not more than any other artist of his generation, exemplifies the truth of Picasso's contradictory statements, 'There is no abstract art' and 'All art is abstract'.

That Oldenburg delights in such paradoxes is clear from his equivalents cited above. Contradiction is a constant preoccupation of his mind and a life-giving principle in his art. Obviously, opposition is present in all art, but he pushes the polarities so strenuously that paradox (and its resolution) must be recognized as a basic condition of his mind and sensibility. It operates throughout his work, from the fundamental tensions between subject and abstraction, nature and technology, man and the machine, to such specific ironies as the presenting of a rigid mechanical object in soft, yielding material.

The major thematic contradictions which engage Oldenburg are sometimes played against each other between objects in the same group, but most often within the same work. The Yale lipstick monument is both phallic, life-engendering, and a bomb, the harbinger of death. Male in form, it is female in subject; a two-inch object carried in every woman's purse stretches twenty-four feet into the sky. This amusing conceit cloaks a sober truth which Oldenburg dwells upon, the interchangeability of life (Eros) and death. As he once wrote, 'The presence of death defines life.'

A primary visual source for Oldenburg, as for so many artists today, is the endless barrage of advertising images in newspapers, magazines, films, television (especially the animated cartoon for Oldenburg's metamorphic ideas), billboards, marquees and shop displays. His images are often second-hand, i.e. the sources themselves are already abstracted, isolated and enlarged. His scale changes, from Lilliputian to Brobdingnagian,[5] owe as much to advertising and air travel as they do to the hallucinations of his fantasy. The fretted edges of his *Store* pieces reflect the very act of tearing out an ad which touched him, and they contribute greatly to the immediacy which distinguishes his art. In 1961 he referred to his fragmented images as 'rips out of reality'; equating, as he did, newspaper with experience, a torn piece of it implies a 'continuum of experience'.[6] The original ads, many of which are preserved in Oldenburg's studio archives, and the source objects in his home (fan, juicer, typewriter eraser, three-way plug, etc.) look utterly insignificant and 'puny' when compared with the powerfully existent and monumental work stimulated by them. Only a creative

intensity like Oldenburg's could use these trivia as vehicles of passion and majesty.

Oldenburg never copies the clipped image; it simply starts something going in his mind, or fits in with something already in process, or reminds him of a piece which he has already completed and sent out. In many cases the actual subject of the clipping has no relevance to the finished work. An advertisement of a cup and saucer on a tray is metamorphosed into a hat lying on an empty expanse of sidewalk, his moving memorial to Adlai Stevenson. The red-tipped Con Edison towers, which rise over several sections of New York like Mont Sainte-Victoire over Aix, have taken part in the genesis of several works, particularly the Yale lipstick monument.

There are several occasions in which Oldenburg has adapted and metamorphosed other works in the evolution of one of his pieces. Brancusi's *Sleeping Muse*, a little illustration of which Oldenburg pasted on a notebook page and inscribed '= headlite', lies behind such works as the *Proposed Colossal Monument to Mayor Daley*, his own life mask and the *Geometric Mouse I*, which, as he has indicated, also has sources in fallen antique heads and a specific Easter Island head at the Lippincott factory in New Haven. Other Brancusi sculptures which have had special significance for Oldenburg are those which include Brancusi's own bases. Oldenburg is attracted by the contradiction between the elegantly sophisticated and highly polished marble or bronze form surmounting a rough, primitive supporting structure. Also, the piling up of one upon another contrasting shape in Brancusi's composite works is reflected in several of Oldenburg's sculptures, such as the *Soft Toilet*. Brancusi's *Torso of a Young Man* has played a decisive role in the genesis of several works, most especially of the *Fireplug* group, which is as indebted to it (and, in some measure, to Duchamp's *Chocolate Grinder*) as it is to the actual fireplug which Oldenburg filmed from his window when he was a boy in Chicago. In some of the drawings and in the multiple *Fireplug*, he softened the adamantine purity of the Brancusi into a relaxed and lumpy human configuration. Making a melted Brancusi is an inverted and playfully irreverent means of acknowledging how much that master has meant to him. In the *Fireplug* and many other Oldenburgs, forms are symmetrical, paired like the body-parts for which they are metaphors: one sees a pair of shoulders, torso and penis in the drainpipe, a pair of legs in the light plug, hips in the axle of the car and thighs and ears in its fenders, a face in an electric orange-juicer and male genitals in a Dormeyer mixer. Usually the body imagery is multiple in its references, as both breast and testicles in the soft light switches. However, as I have tried to indicate, simple identification of the subject matter and its metamorphoses does not ensure recognition of Oldenburg's content, which is always more significant than it may first appear to be. In 1966 he wrote, '"Plugging in" or establishing contact is a theme, which goes beyond the merely sexual – the contact of the individual with his surroundings.'[7]

The soft drainpipes are more than sexual images. As they are attached to pulleys, their differing emotive qualities can be exaggerated or decreased by varying the tautness of the cord. When cruelly bound to the cross-bars from which they are hung, they not only evoke images of crucified bodies, but they do so with the violence of a Grünewald. The combination of mutilation and eroticism in the 'bloody' version is more brutal than in the *Soft (Cool) Drainpipe* in the Tate Gallery, London, whose dry texture and blue colour are less carnal; but the anguish expressed in it is no less painful for that. In one of his equivalents Oldenburg wrote, 'Blue drainpipe = Holy Ghost'. While, according to Oldenburg, that may be a somewhat playful, and certainly not a programmatic, association, still there is no escaping the implications of his subconscious in arriving at that analogue.

As is true of any serious work of art, each piece by Oldenburg springs from many levels of his being and experience, and its genesis and evolution cannot be charted with strict exactitude. Its content is never exclusive or single; were it so, it would violate life's mobility, change and contradiction which are expressed so poignantly in every aspect of Oldenburg's art, whether it be drawing, painting, sculpture, poem or performance.

Anyone who has experienced an Oldenburg theatre piece (87) will clearly realize that music must be as important to him as poetry is; not because he sometimes uses music in his performances, but because, like a musician, he shapes time. Through his spacing of silence and sound, and of stillness and motion, and by changes in lighting, often plunging audience and players into darkness, he makes us feel time as a physical force, almost a tangible substance. Time is not measured – so many seconds in a minute, so many minutes in an hour. It is not a concept, but a felt reality, expanded, contracted or suspended. To stand, as one often did at the Ray Gun Theater, in total darkness in a very narrow space, is to feel time so mysteriously drawn out or even stopped that one can hardly breathe and the sweat breaks out on one's body. Even reading the script for Oldenburg's 'very last happening', *The Typewriter*[8], can evoke a physical sensation of time in duration. Like contemporary composers, he discards the linear treatment of time, preferring, in his words, to focus on the 'expansion or unfolding of a moment'.

Oldenburg's happenings have been a rich source for his other art. The materials and the objects, which he discovered or himself constructed for use in the performances, often engendered specific works and stimulated or furthered his plastic innovations. The idea for his large *Ironing Board with Shirt and Iron* of 1964 came from the actual appliance on which soft obelisks were ironed in his *Stars*, presented in Washington in 1963. The gigantic ties used in that performance are related to many of his flexible hanging pieces. In fact, Oldenburg's invention of soft sculpture, which has been of such decisive importance in contemporary art, is sometimes said to have actually originated in the props which he made of stuffed and painted cloth, such as *Freighter and*

Sailboat for *Store Days II*. The truth is, of course, that he had made a considerable amount of soft sculpture before that time, as for example the well-known *Street Heads* from 1960, made of burlap stuffed with newspaper. However, this fact does not invalidate the assumption that the materials which he worked with in his performances were provocative to him in his other art. Nothing that he makes is wasted; he builds constantly on what has gone before in his production. In fact, one might almost say that his mature work was prefigured in his childhood invention of a whole imaginary country, 'Neubern'. Among his studio documents is a file of that material, most of it done when he was eight and nine years old; by the time he was twelve, he had completely put aside Neubern. There are exact scale maps of the country and each of its thirty-six states and their principal cities, its industries, topography, national parks, temperature ranges, networks of communications with plans and elevations for several types of trains, planes and ships (both naval and commercial), all named and assigned handsome insignia. The red on white symbol of Neubern's airforce is an early example of the right-angled ray gun form, which was to become identified with the mature artist and his work. There are striking pages of coats-of-arms of the states and cities, plans and drawings of their airports, terminals, stadiums and skylines; historical charts of Neubern's territorial changes and its rulers from John Boule in 1436 to Claes Oldenburg in 1935; numerous magazines, newspapers (some in Swedish, some in English, some typed, some lettered by hand), comics, posters for film and stage productions, some of which were actually presented under the direction of the young Oldenburg. Among other prophetic childhood activities, he built models, carved planes, constructed a miniature drum set, and made plans for non-functional giant objects. It is all an extraordinary foretaste of the colossal scale of Oldenburg's conception and the precision of his execution. Then, as now, he did not just live in his imaginary world; he brought that world to life through form.

Oldenburg's Giant 3-Way Plug

In American art of the 1960s, Claes Oldenburg's work served as a kind of barometer registering the changing sensibilities of the decade. While one could easily name several other artists who worked in a variety of styles during that time, it would be difficult to find one who could match the audacious range, inventiveness and abundance of Oldenburg's productivity. From his known drawings, paintings, collages, reliefs, free-standing (and lying or hanging) sculptures, prints, multiples, poems, happenings, lectures, films and numerous publications, and even more so from his unpublished notes, sketches and other studio documents, it is clear that he has thrown away or put aside more ideas than many artists have had during the past eleven years. His profligate creativity,

the generosity of his thinking, and his peculiar amalgam of innovation and tradition are among the possible explanations for the exceptional regard in which his work is held by artists and critics of the most diverse persuasions.

Probably the most radical feature of the *Giant 3-Way Plug (Cube Tap)* is that it not only rejects but actually demolishes the base on which monuments traditionally stand, becoming instead a part of the earth, as its three-and-a-half ton weight thrusts into the ground like a boulder hurled from the sky (90). Even so and despite its ignoble subject, the formal qualities of the *Plug* are immediately recognized by most observers, and its reception in Oberlin has been far warmer than that accorded his *Lipstick* at Yale, which was offered by a group of students and faculty to the university, but was not accepted; it remained unfinished (the wooden caterpillar tracks were to have been replaced with metal); and it was so badly treated that Oldenburg removed it.[9]

The Oberlin sculpture, on the other hand, was officially commissioned by the Allen Art Museum in January 1969 (although discussions regarding the possibility of such a project go back to the early '60s). After two or three visits to the campus to select a site, Oldenburg submitted models (including the *Ice Bag* which was not feasible for practical reasons). The *3-Way Plug* having been agreed upon in April 1970, the final work was fabricated at the Lippincott Co. in close collaboration with the artist, and was installed in the late summer.

The site, chosen by the artist, is perfectly appropriate to the qualities of the work. On a softly sloping lawn, surrounded by trees and bushes, it lies between the museum, built in the Renaissance style by Cass Gilbert with a mid-1970s addition by Robert Venturi, and the Hall Auditorium by Harrison and Abramovitz. The sculpture plays with and against the architecture as it does with and against the natural setting. Like a drum of an octagonal column transversed by a cylinder, the *Plug* matches the Renaissance design in its combination of rectilinear and curvilinear elements and in its strict bilateral symmetry, which is, however, hidden, almost denied, by its partly submerged, dropped position. Its rusted Cor-Ten steel (the rusting is actually a protective device), earth-red in colour and like raised velvet in surface, contrasts with the smooth, brightly polished brass of the prongs. In the summer, the *Plug*'s only companion colouristically is the red of the decoration on the walls of the museum and its tiled roof; but in the autumn it joins with the crimson, scarlet, copper, garnet, gold, orange, bronze and purple leaves and the bright red berries hanging on the bushes. It continues to change in winter under the deep snow and frost, and in spring against the delicate pinks and white of the flowering crabs and other trees.

Oldenburg commissioned a cinematic record of the monument in different seasons of the year, because its constantly changing relation to nature is an important part of the work and its significance. Like the weathering of a toppled ancient sculpture, the induced rusting implies that nature is taking over; the geometric and electro-mechanical oppose and give way to the organic and

natural. Man-made approaches nature-wrought, but only approaches; the *Giant 3-Way Plug* remains alien to nature, while perfectly at home in it. It is first and always a majestic sculptural form in the guise of a trivial mechanical object. Irony, contradiction and the wedding of opposites are fundamental qualities of Oldenburg's work, as are its richly varied iconographical and formal sources, analogies, associations and ultimate meaning.

As the artist himself said, 'It is important to me that a work of art be constantly elusive, mean many different things to many different people. My work is always on its way between one point and another. What I care most about are its living possibilities.' The *Plug* belongs to the same Oldenburg form family as several other objects in his game of equivalents: Mickey Mouse, Good Humor bar, light switches, lipsticks, ping-pong paddle, Ray Gun, Airflow engine. The *Giant 3-Way Plug*, sunk into the earth, has among its ancestors such fantasies as Lequeu's design for a stable in the shape of a cow. It is also related to Hubert Robert's *The Louvre Imagined in Ruins*, although the fear of nature's revenge against man's presumptuous inventions and assaults is far more urgent now than it was in the seventeenth century when the romantic cultivation of ruins was at its height.

The idea of fallen sculptures has interested Oldenburg at least since 1965, when he began making his 'proposed colossal monument' drawings in two versions, one with the object erect and the other with it prone, as the Teddy Bear for Central Park. While thematically entirely different, the *Plug* is formally related to the *Small Monument for a London Street: Fallen Hat for Adlai Stevenson*, *Proposed Colossal Monument for Mayor Daley* (which sinks into a platter as the plug does into the ground), Oldenburg's life mask in jello, *The Letters L and O in Landscape*, and the large *Geometric Mouse*, or 'M(o)use' as Oldenburg puts it, in open acknowledgment of his indebtedness in all of these works to Brancusi's *Sleeping Muse*, as well as to fallen antique heads and a particular Easter Island head at the Lippincott factory. Another sculpture by Brancusi which figures in the visual background of several of Oldenburg's pieces including the *Plug* is the *Torso of a Young Man*, as indicated in his equivalent 'plug = brancusi' drawing from a notebook page of 1965. Probably the first appearance of the 3-way plug image in Oldenburg's *œuvre* was the bold, expressionist wash-drawing of 1965. A three-dimensional cardboard model, which he says he began in order to better understand this deceptively simple (actually very complex) form, was followed by some extremely precise drawings, including one in pencil and another of cut-out paper, pencil and spray enamel, both looking as though they came from an architect's drawing table.

The *3-Way Plug*, like so much of Oldenburg's work, is distinctly architectural in concept. (The other two extension plugs which figure in his *œuvre*, one Swedish and one English, appear as proposals for buildings.) This architectural quality was particularly apparent in the 1966 cardboard model as it was exhibited, for the first time in this country, at The Museum of Modern Art's Oldenburg

retrospective in the fall of 1969. Suspended high up in the dimly lit area near the ceiling, its basic architectural form of a groined vault, i.e. the crossing of two tunnels, evoked the spatial sensation of a Romanesque cathedral. The cardboard model, like the actual outdoor monument, has a nobility of form which makes such an analogy possible. Among Oldenburg's 'fantasies' (as he often refers to his analogies, equivalents and associations) which he mentioned at the inauguration of the *Plug* was a reference to Hagia Sophia in Constantinople. It is an analogy which had readily come to my mind also upon first viewing the monumental *Plug*, before its 'burial' belied its basic design, which, speaking strictly, is closer to those churches of less modified 'Greek cross' plan than Hagia Sophia. One's response to the sculpture in architectural terms may stem in part from its curious power to make one imagine what it would feel like to be inside it, a reaction that is induced at least as much by the monumentality of the work as by the fact that one can see a little way inside it through the 'eyes' of the outlets. (Why are they not called inlets?) The form is so full-bodied that its interior space seems to be alive, to be thrusting outward, at the same time that the dark apertures draw inward.

Another, more dynamic tension occurs between the dramatically projecting prongs and the three receding round inlet sides. One does not need to be familiar with Oldenburg's metaphoric style or even with electricians' language to identify the male and female elements of the *Plug*. The single male factor easily overrides its triple opposition because of its powerful outward movement, in contrast to the earth-bound bulk of the work, as inert as a turnip or an elephant turd. At the same time, in characteristic Oldenburg contradiction, the body of the plug has a tautness of form which suggests a storehouse of energy. The male dominance is further ensured by the fact that the female section is partially hidden (a womb within the womb of the earth). Had the *Plug* been placed otherwise, for example standing on its prongs like a building on stilts, as the English 3-way plug does, it would have had a totally different meaning. Burying the plug immediately gives it mystery, a *sine qua non* to Oldenburg, who would quite certainly still subscribe to what he wrote a decade ago, 'What I want to do more than anything is to create things just as mysterious as nature.'

Concealing the identity of the plug extends its possibilities for other identities and associations: the rusty old carcass of a ship stranded on the shore, a mammoth hickory nut still in its outer husk, the lost shell of an astronaut's craft, a bell (which music students have discovered can yield a strange composition of sounds when slapped with the hand), a prehistoric burial mound. The implication of death is inescapable; it is interesting to note that in his drawings of the Swedish and English plugs Oldenburg identified the buildings into which he transformed them as a 'mortuary chapel' and a 'crematorium (or museum)'. Among his notes for the *3-Way Plug* appear the words 'skull' and 'grave', a reproduction of Elihu Vedder's romantic painting of the Sphinx half-buried in the sands of the desert (*The Questioner of the Sphinx*), and an allusion to

Debussy's *La Cathédrale engloutie*. With reference to this last analogue, Oldenburg proposed water as a possible environment for one of the two other future versions of the *Giant 3-Way Plug*.[10]

The fallen *Plug* is an object of pathos; Oldenburg has imbued it, as he does most of his objects, with such an intense existence that, in this case, one feels almost physically the helplessness of a noble thing brought to the ground. One might suppose that the soft versions of the *Plug* would be even more pathetic since they contradict so utterly the original object's firm practicality, but actually they evoke a different set of responses, and engage other phenomena of nature. At the inauguration of the monument, Oldenburg spoke of the soft versions then being constructed, saying they 'will have an entirely different aspect. I like very much to take an object, a very generalized object, and put it through changes by changing materials and conditions and all kinds of situations. It's almost as if the object was going through a series of impersonations. In one case it's pretending to be a balloon. In another case it's pretending to be an anchor. And it's pretending to be a potato or a cannon or whatever. But it maintains this essential generalized geometric shape the electric plug came in.'

Had the Oberlin *Plug* been installed with the prongs concealed in the earth, the whole idea of contact, which it so forcefully presents, would have been lost. Among the multiple uses of the sculpture, Oldenburg suggested that it could serve as a monument to Thomas Edison, who was born in Milan, Ohio, near Oberlin. Obviously the prongs act as a lightning rod between the earth and the sky; and there are other levels of meaning (besides those already discussed). Several years ago, in a different context, Oldenburg wrote, '"Plugging in" or establishing contact is a theme which goes beyond the merely sexual – the contact of the individual with his surroundings'; and when he was in Oberlin with the wooden model and thinking about how he might install the finished monument, he remarked that 'there are plugs lying around in drawers all over the world; they are nothing until contact is made' – an appropriate symbolic theme for a college, the kind of institution for which Oldenburg feels monuments are especially suitable. In February of 1969 he wrote in his notebook, 'The streets where revolutions have usually taken place and where monuments have usually stood . . . are not the new battleground which is the University. . . . My monuments are for intellectual consumption anyway. . . . Protest or not or what, I think monuments are better for universities (and newspapers) than for streets and corporations.' The *Lipstick* at Yale is more drastically opposed to its environment and more overtly militant in its imagery. However, although the *3-Way Plug* 'impersonates' a far greater range of objects, it does also distinctly resemble a cannon or other ballistic weapon. This is another aspect of the work's inverted traditionalism, relating it thematically to a large proportion of the world's sculptural monuments. But Oldenburg's piece in no sense celebrates victory or war; in fact, in its partially buried state, it is closer to a condemnation of the waste and futility of war, as the artist himself implied in his remarks at

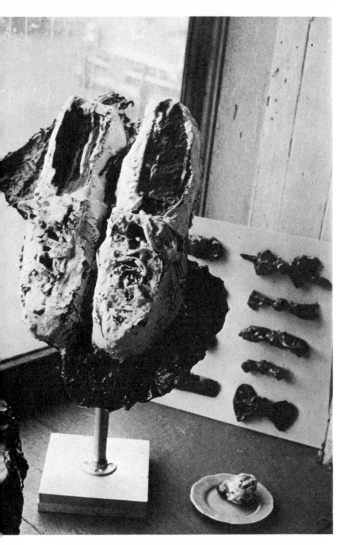

85 A corner of Claes
Oldenburg's *Store* 1961–2

86 CLAES OLDENBURG
(*Giant*) *Icecream Cone* 1962

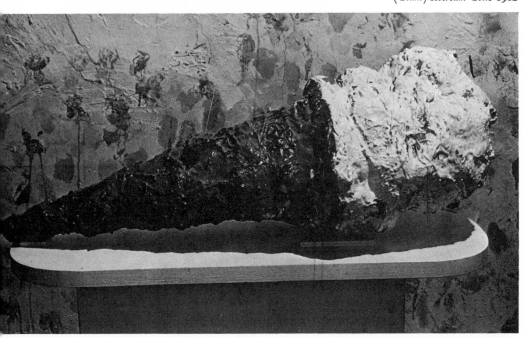

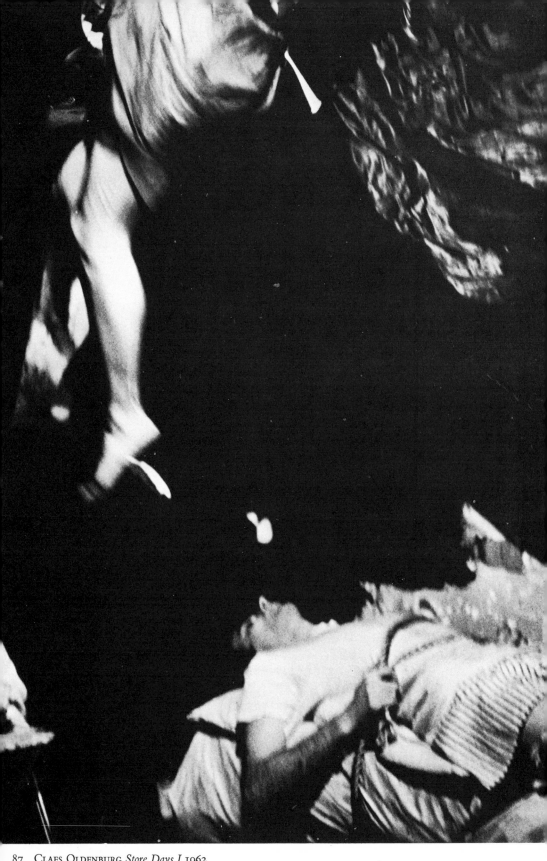

87 Claes Oldenburg *Store Days I* 1962

88 CLAES OLDENBURG
Empire (Papa) Ray Gun 1959

89 CLAES OLDENBURG *Dormeyer Mixer* 1965

90 CLAES OLDENBURG *Giant 3-Way Plug* 1970

91 GEORGE SEGAL *The Dinner Table* 1962.
Left to right, seated: Jill Johnston, Lucas Samaras, Segal, Allan Kaprow; standing: Mrs Kaprow, Mrs Segal

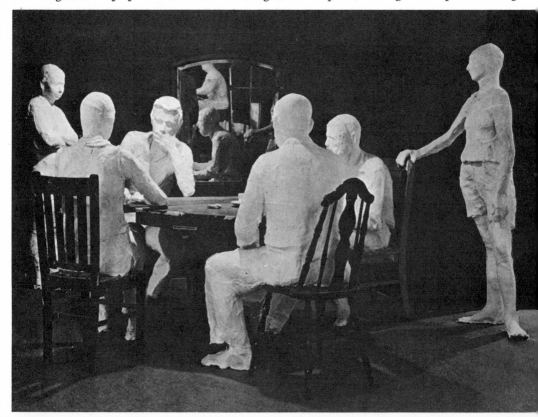

the inauguration: 'It makes me think of something I've never seen but I suppose is a common sight in other parts of the world – a battlefield after the battle when the grass and trees and things take over and grow over the tanks and war machinery.'

The Oberlin sculpture also differs from the *Lipstick* in that it was made for a particular place, where nature and man's works are sympathetic; where people watch with delight as it responds to the changing seasons and where everyone accepts that it is a serious work of art, which began when a major sculptor looked at a little twenty-five cent plug that the rest of us take for granted.

Cast from Life

Halfway between the real and the invented, halfway between life and art, Segal's images (91) fulfil the condition of paradox so appealing to the contemporary sensibility. In Segal's hands, this paradox takes on an especially startling ambivalence between poetry and objectivity, the dream and the fact. How can he take direct plaster impressions of ordinary human bodies and endow them with mystery, loneliness and 'silent grandeur'?

Setting the living person in dead plaster in a real environment dramatically increases at the same time that it diminishes the distance between art and reality. The *Woman in a Restaurant Booth* is placed way over to one side and on the edge of the seat, oblivious of her surroundings, quietly and deeply withdrawn. The stark white of her figure against the dark background heightens her isolation from the environment which she inhabits with such familiarity and ease. The plaster sculpture is taken from an actual person and the table, seat and coffee cup are actual objects from an everyday situation. That is dead-centre realism; but the emotive quality of the figure is in striking tension with the commonplace surroundings, and its whiteness, associated as it is with all the white marble and plaster figures of the past, places it immediately in the realm of art and forces us to see the art in the juxtaposition of concrete and ideal in the total composition. The *Woman Painting Her Fingernails* is as composed and as remote as Artemis would be from the makeshift, oilcloth-covered dressing-table, the cheap nailpolish and the old spattered chair. Her body is held gently and discreetly to itself; the elbows are in, one leg is curled around the other, and even the veiled image of her face in the mirror is concealed by her hand. The *Man at a Table*, sitting with his elbows wide apart and his feet squarely on the ground, commands his environment with the awesome dignity of an Old Kingdom Egyptian; but he too is alone. 'Nothing beside remains.' He seems to have sat there for centuries, as Picasso's *Man with a Lamb* appears to have stood for ever in the village square at Vallauris. Segal's sculpture is sometimes compared with the shocking casts from Pompeii of humans and animals contorted in violent death. His images do have something of the haunting intensity of

these casts, but where they are grotesquely tragic, Segal's are serene and noble.

Could just anyone take cheesecloth soaked in plaster, slap it onto a person, let it dry, open it at the seams and reassemble the pieces with the same touching results that Segal gets? Many observers might think so, believing that Segal's figures are the ultimate in realism, that they are exact casts, that 'the plaster cannot lie'. What is closer to the truth is that they are only approximate casts; in fact they are not really cast at all, but modelled. In terms of the traditional method of casting, Segal's figures correspond to the freely formed outside of the negative mould; whereas, if he wanted to make an exact replica of the model, he would make a positive cast from the inside of the mould. And even without taking an impression of the figure, he could get greater exactitude than he does, by modelling clay with numerous, precise and minute measurements and casting it or having it cast. But that system would be much slower, more laborious and costly and it would not give him the desired immediacy and direct physical touch with the model. He wants his sculpture to be close to reality in feeling, not in detail or finish, and that rough, blurred, halfway state is appropriate to his intent. What Segal does to the plaster impressions which he takes from his models is deeply personal. Granted that he is 'stuck with them' in terms of the main volumes and basic postures, and granted that he cannot reduce their dimensions but only add to them (in fact they are inevitably thicker by the width of the plaster and cloth), still it is he who chooses and directs the gestures in the first place. Obviously he has to be thoroughly familiar with the human body, to know how posture and gesture express character and meaning. To this end, and because he delights in doing so, he makes quantities of drawings, occasionally as plans for compositions but mostly as studies of movement, colour and gesture (he has also made several more independent or 'finished' pastel drawings which are highly appealing in their saturated Fauve colours and wide dark contours and in their striking mixture of boldness and grace). As he applies the wet plaster, he gives character to its structure and surface; the close-up photograph of *Woman Painting Her Fingernails* shows clearly the textural and formal variety which he achieves by his speedy, direct technique, using no tools other than his hands. He can also make adjustments after the plaster is dry: as he builds the figure from the separately cast sections, and reinforces it with additional plaster and burlap on the inside, he can modify the distance between body parts and change the position of an arm, leg, head or even of the entire torso. Moreover, he can change the expression of the face by a few well-chosen strokes. The lack of finish and the relatively impermanent medium conflict with the sense of eternity in the psychological content of Segal's work; and that tension is a decisive factor in its expressiveness. A plaster sculpture is not really any more fragile than terracotta for example, and more permanent than oil painting on canvas, but it is impermanent compared with stone, wood or bronze. Lowly plaster appeals to the contemporary artist who rejects the traditional hierarchy of materials and embraces the cheap and fleeting.

Furthermore, in keeping with the commonness of Segal's themes are the connotations of plaster. One thinks of mass-produced figurines from Times Square, Woolworth's and religious supply houses; one remembers plaster dolls won at carnivals, vulgar mementoes of amusing moments (who ever saved one?). Moreover, the medium connotes the dusty old plaster casts that used to fill museums and studios – reproductions of great works, second-hand art, in itself an important element in the contemporary aesthetic. Segal's work implies all of these associative factors: cheap, transitory, mass-produced, second-hand; but his pieces all end up as Segals. They have a family resemblance, a quality of serious, sober grace. He has 'put his claws' in them.

Of course there are many hazards in his method. 'There are so many choices possible – I have to give it a nudge in this direction or that.' He could easily go too far in the direction of realism or anecdote and he has to choose his models with the greatest care. He is almost as dependent on his models as the producer of happenings is on his actors; but he is, at the same time, more 'master of the model' than they. While he shares many of the same impulses as his friends Kaprow, Oldenburg, Whitman and other producers of happenings, and while he has been directly involved with them since their beginnings (Kaprow did his first happening on Segal's farm in 1958), still he himself has refused to make any because, as he says, he requires more contemplation in his art. However, like his colleagues, he makes total environments, mixing art and life, as he strives to capture the living present and to create a poetry of reality.

Segal's compositions are slices of his environment; the figures are his family, friends and an occasional professional model; their acts are simple, everyday occurrences of home, studio, town and country life: the woman preparing her toilet, the man setting off on his bicycle, the woman leaning against the chimney which stands in Segal's attic-studio – a steady, upright support, uniting his life and work; the bus driver confident and reliable, responsible in his job but pursuing his own thoughts; the girl in the red jacket looking through the window of a chicken-coop. For several years, Segal taught at a public school in New Jersey, not far from New York where he grew up and is still thoroughly at home; he lives on a chicken-farm which he actually worked for about ten years. Both peasant and philosopher, he moves in his differing worlds with equal ease and the same lively awareness and grave, intellectual detachment. The sections of his environment which Segal constructs are not really 'occurrences'; nothing happens in them, they are simply there, pieces of actuality. In the settings, Segal insists on complete exactitude, either by incorporating the things themselves – a section of a bus or his crusty old palette and painting stand – or, if that is impossible, by constructing absolutely accurate replicas of the things. *The Farm Worker* sits in unbaked thoughtlessness outside his house, which is faced with a cheap, artificial brick veneer of dark red with window frames painted in pale blue. This actual place is just down the road from Segal's farm. To reproduce its appearance faithfully, Segal got 'seconds' of brick siding

so the joins do not fit exactly and, with considerable difficulty, constructed the window so it would not quite close.

It is of course not just for the sake of accuracy itself that Segal expends so much care on environmental objects; it is also to make them work for his aesthetic and psychological ends. In *The Sleeping Couple* the tawdriness of the poor, ugly bed, the worn old mattress and crumpled sheet is essential to his meaning, real, vulgar and pure. Formally, the shape of the bedstead, two large unbroken semi-circles, is in stable harmony with the forms of the entwined bodies; and the rough texture of the plaster and the interrupted, irregular folds of the sheet are played against the smooth, unvaried surface of the metal.

Segal's figures are usually solitary or isolated couples, with the important exception of *The Dinner Table* (91), an ambitious group of six figures. Just a group of friends sitting at table, but with an almost biblical solemnity. The models for this piece were, from left to right, Jill Johnston, Lucas Samaras, Segal and Allan Kaprow seated round the table; standing are Mrs Kaprow and Mrs Segal. On one of the black walls enclosing the composition is hung a large mirror, which complicates and enriches the design by repeating different views of its own elements and bringing in reflections from the spectators' changing reality. When it was exhibited at Sidney Janis's *New Realist* show in 1962, a woman who had walked around looking at it for several puzzled and mistrustful moments finally asked, 'What's it supposed to be?' Either she was acting out the bewilderment she was 'supposed' to feel from modern art, or the un-expected realism of this piece was even more unnerving than the screaming red-lined refrigerator near by. When the public has gotten accustomed to not understanding art, it is completely mystified to encounter things which no longer look like art. The woman's question got the surprising answer, 'It's supposed to be Cézanne!' *The Dinner Table* is, in a way, Cézanne's *Card Players* come to life. There is a similarity in the monumental volumes and in the quality of feeling, sober, dignified and timeless.

To compare Segal's sculpture with a painting is not inappropriate because his approach is at least as much that of a painter as a sculptor. When one thinks of earlier artists who may have meant a great deal to him, or those whose work has something in common with his, more painters than sculptors come to mind – Rodin, but also Giotto, Courbet and Degas, among others. Although Segal constructs with actual volumes and spaces and although his things can be seen from several different views, still it is almost as though he were putting pictures into three dimensions, playing volumes against planes as a painter does. There is a planar quality to the spatial organization in Segal's compositions which is accentuated by the way they are often set in walls, suggesting the 'picture box'. There is also an implied picture plane which is maintained; neither figures nor objects nor directional forces project forward from it. Sidney Tillim recognized this quality in his observation that Segal puts 'effigies of humans *behind* the frame where illusions of them once were' (*Arts*, March

1963, p. 62). Moreover, Segal has a painter's interest in colour and light. This is not to say that sculptors are not interested in light, but Segal works colouristically. The yellow wall in *Woman in a Bathtub* has a quality of light which is both crisp and shimmering; a curved, organic form on a geometric ground, the plaster girl herself becomes insubstantial in this floating field of yellow light. The coloured ground is a major element in the whole design, replacing the black walls against which his pieces have usually been displayed in galleries, where the brilliant contrast of white plaster and black surroundings tended to make one think of them as basically black and white compositions. Actually, however, Segal has always worked with colour in the environmental objects and has increasingly given it a more open and prominent role. *The Gulf Station*, constructed in the summer of 1963, is a complex organization of colour relationships around, on and through a large sheet of glass. The brightly coloured showcards and other displays, so familiar that they are hardly seen when one drives up to a gasoline station, are placed in parallel alignment to an implied picture plane. Segal makes concrete the cubist pictorial exploration of plane, volume, space and transparency. *The Gulf Station* is really a huge collage whose colour components are separated and united by actual air and space instead of illusion and paste. Although he has increased the colour of their surroundings, thus far, except for the red jacket on *Girl Looking in a Window*, an early armature piece, he has not painted the plaster figures.[11] If he did they might become too realistic, or even cute, and he would lose much by giving up the provocative juxtaposition of the chaste, dream-like figures with settings of actuality. *The Cinema*, set in a black room in the Sidney Janis *4 Environments* show, January 1964, is constructed of metal and plexiglass lighted from behind. The word 'Cinema' is in brilliant red light over a field of white light, against which the plaster figure is wonderfully organic and human in its mechanical situation.

In his environments, Segal is extending the ideas of collage and the ready-made, both of which were the invention of painters: Picasso, Braque, Schwitters, Duchamp, followed by Rauschenberg, Johns and all the others. He made his first sculpture 'cast' from a living body (*Man at a Table*, 1961) as a kind of Dada joke, 'a ready-made person at a ready-made table', but like many of his predecessors he turned the witty and the accidental into a serious form of art. Segal's sculpture before 1961 had been in plaster on armatures; some of these pieces were exhibited together with his paintings at the Hansa Gallery in February 1959. He had other one-man shows there and in 1960 and 1962 at the Green Gallery; and in October 1963 at Ileana Sonnabend's gallery in Paris; he then became associated with the Janis Gallery, and remains with them. Segal's sculpture has been much sought after, but his painting, which has a savage though learned quality, has not been so well received, although the sculpture compositions have grown quite naturally from the painting with its free, rough drawing and its massive, brooding figures pushing themselves out of the flat colour planes – D. H. Lawrence at war with Matisse and Bonnard. Segal was

painting Old Testament, allegorical and other figure subjects at a time when such compositions were in no special favour, whereas his life-sized, three-dimensional figures with actual objects of their environment have come at a moment in the art world which is ideally ripe for them. However, the artist helps to create such a moment as surely as it creates him – a fact which de Kooning modestly forgets when he says, 'There are certain things you cannot do at a particular time' (*Location*, I, 1, p. 46). To explain Segal's success on the basis of fortuitous timing would be unjust and inaccurate. He is an artist who, maturing steadily and for our times slowly, has evolved a singularly personal and touching form to express his poetic response to reality. Where he had not quite found his own way in either painting or sculpture alone, in his particular combination of the two he most certainly has; and in so doing he has opened a path into a land rich in possibilities, but not without perils, for himself and others.

7 Art as Object

Art about Art:
Jim Dine and Jasper Johns

As Jim Dine says, his paintings make 'a statement about art the way someone else talks about Detroit cars, objectively, as another kind of thing, a subject.' Although Jasper Johns's thought and language are usually more involved, he put a similar idea simply when he said, 'We paint the things we work with.' But Johns presents those things very differently from Dine, whose palettes, colour charts, watercolour boxes and T-squares are stark, unadorned images, objects which 'are just there', whereas Johns tends more to *use* his colour devices, value scales, rulers less for themselves than as but another item in his slowly worked, carefully adjusted painting. Where Dine's focus is direct in its absolute clarity, Johns's, except perhaps for the early flags, is a multifaceted, equivocal, rotating focus. Dine's images are fixed, immutable; even when he paints the transmutation of a flower into a fan, he does it in a series of five distinctly intact images. In Johns's work, however, as *Diver* (92), the complex interweavings between the panels and the contradictory images imply constantly changing time, location, morphology and meaning. The diver's arms thrust tautly up and down at the same time; the word 'red' appears in blue paint, the 'yellow' in red and the word 'yellow' is cut off in the middle, suggesting that time extends beyond the edge of the picture. In some of his paintings, *Fool's House* for example, a word broken off on the right is completed on the left which induces a feeling of rotation as though the space implied on the two-dimensional surface continues physically around and encircles the picture. The value scale in *Diver* moves down from black to white but at the bottom it unexpectedly takes two large steps back toward black. Moeover, the scale is surprisingly shaded on some of the greys, and this, together with the scale's proximity to the diver's arms over the actively brushed 'water', suggests that the value scale could also refer to a flight of stairs – in any case to something with a more mechanical regular beat, repeated in the tape measure running across the centre bottom of the picture. The colour device on the upper left, made by swinging the section of a stretcher like a compass over wet paint, does not follow an exact spectral sequence. Predominantly hot – red, yellow and orange with a few

interrupted swipes of green and whitened blue and violet – it is more a ball of fire in the sky than the spectrum it might appear to be on first impression. What do the attached chain, the knife and fork and spoon have to do with the rest of the picture? Suddenly, the series of panels, slightly tilted at the bottom right, suggest a group of canvases stacked against the wall. It is both the studio and the Cape Hatteras shore; it is Jasper Johns being personal, but still retreating in ambiguity and enigma. Johns's subject matter is usually primarily and deliberately impersonal, inscrutable; but in such pieces as *Diver*, his determined detachment has relaxed somewhat. In spite of its exuberant summer-bright colours, *Diver* is a haunting picture, the stretching arms a paean of praise plunging into darkness. Although the early target compositions included images even more personal than the imprint of a hand, still, in context with the inexorable targets, their effect was to shut the observer out, to close the door quietly but firmly in his face. Now the door is slightly ajar – but only slightly; Jasper Johns is nothing if not discreet.

The mystery in Jim Dine's work is of another kind, but it is no less present; and fiercely objective as his images are (22), they are no less but indeed more personal than Johns's. (Is one artist personal in an impersonal way and the other impersonal in a personal way?) The mysterious, hieratic character of Dine's work rests not only in the strange power which objects assume when seen in isolation, but also in the ruthless simplicity of his image-making. Presented bald-faced as they are, Dine's palettes, colour charts, rainbows, tools, as well as all the other objects which he represents or incorporates, are intensely personal; they spring directly from home-base: his love of his family, his home and his trade. The symbolical character of Dine's treatment of objects is nowhere more apparent than in his many versions of the palette theme (93), an outspoken symbol of the artist himself, his work and his environment (what he calls his 'landscape'). That he directly identifies the palette motif with himself was already clear the first time he painted it, *A 1935 Palette*, executed in 1960–61. The '1935' of the title refers to the year of Dine's birth. This identification is made even more explicit in the early 1960s series of palettes and robes, whose unequivocal frontality and flatness often suggest Egyptian painting, a comparison that is reinforced by the mysterious group of converging diagonals appearing in lieu of drapery folds on several of the robe self-portraits. Dine presents himself as his palette or his robe, that is, as an object; but even so the image is extremely personal. The palette is an ideational identification whereas the robe is a corporeal one, almost a direct representation of his bodily character: straightforward and sturdy, with shoulders thrown back. Although the actual source of this image was an advertisement, no photograph of Dine himself could evoke so startlingly his physical presence as his painted robes do.

With the recent robe motif Dine combines not only the palette but also the colour chart theme, on which he has played several lively variations from 1960 to the present, as blocks and swatches of colour, paintings of watercolour

boxes, rainbows, coloured windows, and actual spools of coloured threads. The colour charts have come to be as identified with Dine in the minds of the rest of us as the palette seems to be in his own mind. So much is this the case that Roy Lichtenstein said when speaking of one of his own 1964 landscapes, a large composition moving from red through orange to yellow, that he was thinking of calling it 'Jimmy Dine Sunset'.

Of course, colour charts appear in other artists' work before 1960; but that is exactly the point: they *appear* in Duchamp's *Tu m'* of 1918 or Rauschenberg's *Rebus*, 1955, but they do not constitute the picture as in Dine's *Four Pictures of Picabia*, 1960. This composition consists of four separate canvases, each a value scale of a single colour: red-violet, greyed blue, yellow-orange, blue-violet. Painting the colour chart alone, naked as it were, helps Dine to get the effect he seeks of the picture as another object in a world of objects. This is an abstract approach in conflict with the highly personal nature of his choice of objects; such paradox is anything but unusual in contemporary American work. What strikes me as distinctly Dine is the way he *pushes* each of the conflicting roles of the object: its everyday anonymity, its personal associative power, and its service as a form in the picture. The white wash-basin attached to the canvas in his *Black Bathroom No. 2* (22) works like one of the white areas in a big Kline drawing (23) but it remains relentlessly itself: 'There's nothing that could be more real than the real thing' and 'The canvas is the last vestige of unrealism. . . . It's so unrealistic to put that wash-stand on that canvas I have to do it. Otherwise there is no more art; you could destroy it.'

Dine's *Four Pictures of Picabia* is also autobiographical in a sense; he gave it that name because the colour values are from Picabia's *I See Again in Memory my Dear Udnie* in The Museum of Modern Art, where Dine spent a lot of time from 1959 to 1961 when he was teaching art in a private high school nearby. Besides the Picabia in the museum, it is hardly surprising to realize that Dine also admired and learned much from Duchamp and Mondrian. Another important force in his development has been Barnett Newman, as is apparent in any number of pictures, among them the impressive *The Studio (Landscape Painting)*, 1963, huge, sumptuous (and more earthy to be sure) but related in scale and disposition. This alignment with Newman puts Dine, perhaps unexpectedly, in the same camp as some of the young abstract painters. Another American who has yet to be given his full due is Alfred Jensen, to whom Dine acknowledged his debt directly by titling one of his paintings *Picture of A. J.*, 1961. This picture has a small colour chart set plump in the centre of a roughly painted black field. The blunt placement of the image, the 'crude' handling of the black surround and the forthright character of the colours are related to Jensen's work. The colour chart in this painting is seen as though from a great distance but in sharp focus as through a telescope, a treatment of space and vision which Dine used frequently at that time. Here the colours do not follow their location on the spectrum; however, in the rainbow series, Dine does place the

colours in spectral sequence. In 1961 he presented an environment called *Rainbow Thoughts*, a black 8 × 10 foot room in which was suspended a 6 inch rainbow, lighted by a blinking bulb. Related to that environment is what might be called a 'Rainbow Room', a group of elegant paintings of rainbow colours in small, semi-circular form on black wood panels, also done in 1961. The rainbow figures frequently in other compositions, like *Rainbow*, 1962, a shower hose ending in a spray of coloured stripes, and in the toothbrush series, a particularly handsome example of which is the watercolour and collage *Rainbow Toothbrush and Tumbler*, 1962. Around three tumblers, drawn in pencil, the rainbow moves across the page: red-violet, violet, blue, green, yellow, orange, red, violet, with three actual coloured toothbrushes attached at the appropriate place on the spectrum. The identifying words which Dine sometimes includes in his pictures are treated in the same way as the other objects. He, like Ralph in Golding's *Lord of the Flies*, 'had learnt . . . that fundamental statements like this had to be said at least twice, before everyone understood them. One had to . . . drop words like heavy round stones.'

Related to the rainbows, colour charts and palettes are the studio tool pictures like *Brown T-Square* of 1962. The straightforward, deliberately non-pretty format reminds one of Dine himself when he says, with engaging belligerence, 'I'm a bourgeois guy.' With its thick T-square, adding to the squatness of the format, and its crusted, once juicy, red-brown paint, it is a sensuous, earthbound Mondrian. When Dine lets the materialist in himself go, he makes wonderfully vulgar and arresting images which are in direct antithesis, in terms of sensibility, to otherwise comparable examples of Jasper Johns's work, as the latter's *Painting with Ruler and 'Gray'*, 1960. Even this rather agitated painting is distinguished by Johns's nuances of values, his characteristically contemplative touch and aristocratic quality. In his hands the sandpaper at the left top and bottom of the picture becomes a refinement. There is something of Watteau in Johns, delicate, untouchable, remote, but many political and cultural revolutions apart.

What I have called Dine's 'materialism', his emphasis on things, on the matter of his art, its physical substance and brash assertiveness, is sometimes coupled with a kind of suave elegance which he has often seemed to distrust and work against. But there is a sweep and easy grace of drawing in such pictures as *Two Palettes (Sears Roebuck, Francis Picabia)* – so named because some of its images come from a Sears catalogue and some from a Picabia cover for *291* – or the seductive shapes and colours of the red, black and white robe-palettes and the sensuous freedom of line and rich glowing paint in *Two Palettes (International Congress of Constructivists and Dadaists, 1922) No. 1* (93), or the elegant studied refinement and meditative enclosure of *Self Portrait Next to a Colored Window*.

And there is another self to Jim Dine – a cerebral one which he strives hard to cultivate. Where Jasper Johns is by nature intellectual, Dine appears to be more basically intuitive, but he is not satisfied just to paint with his natural ease;

he *has* to paint with his mind, even if that sometimes means opposing himself. ('It would be easy to go to the studio every day and just *paint*.')

Dine's palettes, colour charts and other pictures with themes from art are as objective and at the same time as subjective as his ties, shoes and rooms; and they remain as closely knit to his immediate environment. We do not find in Dine the kind of social references to art that motivates some of Johns's work, like the satirical pieces, *The Critic Smiles* and *The Critic Sees* (with a mouth for eyes). This wider-ranging aspect of the subject has its ancestors, among them Daumier's gentle gibes at art, the artist and his public. It is within this tradition also that Lichtenstein's urbane humour functions, as in his 'Although he holds his brush and palette in his hand, I know his heart is always with me!' and 'Why Brad darling, this painting is a masterpiece! My, soon you'll have all of New York clamoring for your work!'

There is no room for such irony in Dine's choice of objects as subjects and in his head-on treatment of them. As we have seen, Johns, although less persistently than Dine, also takes motifs directly from his studio equipment; besides those already analysed are many more: 'devices', 'fields', *Canvas*, *Reconstruction*, *Drawer*, etc. But Johns's objects are never allowed to be as unequivocally themselves as Dine's are. Even in *Field Painting*, with well-mannered deliberation, Johns strips the objects (brushes, paint-cans, letters) of their fixed identity and cloaks them with the paradoxes of his mind as well as the quiet richness of his painting. As with his number and letter subjects, the more abstract the symbol and ubiquitous the object, the more concrete the image and the more individual the form in his 'painting of precision and beauty of indifference' which, unlike Duchamp's, do allow 'delight in the necessity of the artist's hand'.

In a less specific sense than this study has dealt with, Johns's famous flashlight is about art and about what art is. Johns appears to say with Duchamp that art is what the artist conceives and chooses it to be. But while Jasper Johns's flashlight is *Jasper Johns's* flashlight, not yours or mine or 'Mr Eveready's, it is not his only because he chose it but because of what he has done to it in terms of form and meaning as he works the surface, whether in plaster, sculpmetal or bronze. One version is mounted raised on a wooden base (a witty reference to ancient sculpture, a fragment of anatomy, a symbol of modern life). In another version the flashlight emerges from the modelled base as mysteriously as a head by Rodin or Medardo Rosso. No, Jasper Johns's flashlights are not ready-mades; they are startling new forms which slyly comment on the complex nature of art.

The subject of art about art has two other major facets: what might be called 'art in art', that is the incorporating of reproductions of older works into the new ones, as Rauschenberg and Wesselmann do, and 'art from art', that is the kind of translations made by Lichtenstein, Deem, Bacon and Jacquet, not to mention Picasso and a host of earlier painters.

Indeed, one might say that all art is 'about' art as well as about whatever else it happens to represent or evoke; but while Monet's waterlilies and Rembrandt's beef are certainly about colour, they are not so in the same way as the picture of a colour chart is. There is a difference of kind in the subject matter itself and there is a difference of degree of emphasis in the artist's approach to it. When he paints a picture of a palette or makes a cast of his paint brushes, the contemporary artist is pursuing the reduction and concentration which characterize so much of twentieth-century art. This deliberate limitation has provided the means for subtle enrichment and ambiguity – a complexity in reduction – which Rauschenberg describes as 'much to see but not much showing'.

Moreover, unlike Albers's paintings about the inter-activity of colour or Rothko's about its mysterious spiritual power, the new art treats the colour chart or name of a colour or colour itself as an object. Through isolating and fixing on objects and elements (and elements *as* objects) in his environment, the artist struggles to apprehend, and perhaps even control, the reality that faces him. Since he lives in a total reality which every day becomes more difficult to grasp, is it surprising that he often focuses on that particular segment of reality which he *can* hope to understand: the paraphernalia, properties and problems of painting?

The Image Duplicators:
Lichtenstein, Rauschenberg, Warhol

Since modern art begins its history of protest, ironically enough, with a second-hand image, Manet's *Déjeuner sur l'herbe* of 1863, one may wonder at the opposition aroused in many historians and critics by an extreme form of this same procedure in contemporary art. When Manet composed his *Déjeuner sur l'herbe* from an engraving by Marcantonio Raimondi after a lost painting by Raphael, he was not, on the face of it, departing too much from a long established tradition of making new art directly from old art. But two factors at least distinguish Manet's art from, say, Reynold's painting *Mrs Siddons as the Tragic Muse* in the weighty pose of Michelangelo's *Isaiah*, namely: the consciousness of modernity and the strong flavour of protest that one senses in Manet's position. If one cannot actually hear him say, 'Let us beat them at their own game and give them the unpalatable NOW in a tradition-soaked package,' still one cannot miss the conflict in his attitude towards tradition and the new.

Andy Warhol was hardly thinking of Manet when he stencilled a photograph of Marilyn Monroe on canvas, but his act is not so completely different as might be expected, given the intervention of a century of changing values. Of course there are many complex differences; my point is simply that the seed of the new attitude was sown a long time before Dada, and the historically mixed soil of protest and tradition continues to nourish our art.

Art comes from art, and art comes from nature. Even in abstract painting, what the artist sees, what he perceives and experiences with his eyes, impels his form. And what does the young New York artist see? Caught in traffic jams, packed in buses, subways, elevators, or spending a quiet evening at home, never has the human being been such a captive of the printed image, constantly changing and endlessly repeated: in books, newspapers and magazines, on the shifting world of the TV or movie screen, the blaring billboards, highway signs, giant lighted ads for hotels, theatres, stores – everywhere pictured products and pictured people beckoning, commanding and assaulting. These are the fields of Suffolk and the Fontainebleau Forest of our painters. Machine-made images in a machine-made world. Is the way Lichtenstein selects his images from the millions at hand so different from the way the landscape painter selected his picturesque view? Lichtenstein is not 'copying' his landscape any more than Constable was. It is the landscape itself that has changed, not the degree of the artist's creativity – which, in spite of all the redefinitions that art has undergone in the last hundred years, is still concerned with how the artist *orms* the raw material he chooses.

The subject of Lichtenstein's painting is not so much the subject of the selected comic or advertisement as it is the style in which those images are presented: brashly simplified and exaggerated, catching the eye immediately. His *Craig* is not about a young girl tenderly thinking the name of her lover (the word 'lover' probably interjects too much reality into the never-never land of comic romances); it is about comics, their conventions, style, artifice and sentimentality. Why do pulp-magazine romances continue to be called 'comics'? Because they are just that: funny, ridiculous. Some grown-ups take them instead of sedatives to go to sleep; other less grown-up adults take them instead of the real thing. A man of Lichtenstein's sensitivity and sophisticated humour could not be other than amused by the pretentious seriousness of comic romances (the witty comics Lichtenstein leaves alone). Even so, mockery is, I think, a peripheral factor in Lichtenstein's choice of subject matter. Like many artists before him, he wanted to do something so ordinary that it was outlandish; he wanted to show that art could be made out of something as crass as a comic. When the contemporary artist says that he wants to make a painting so 'strong', 'offensive' or 'despicable' that no one would want to hang it, he is voicing an impulse that has motivated much fine art of the distant as well as immediate past.

The desire to make art from something 'despicable' is not a whim on the part of our young artists, but a serious need to make art real again in their terms. In their willingness to get out on their own limb, the young painters in the United States are following the path set by the great innovators of the New York school. They dare to do something difficult, if not impossible. Lichtenstein says as much: 'I like to put myself in a kind of tight spot.' He does so by using the anonymous subjects and clichés of comics and industrial design for his serious and personal art which deliberately conceals its formal character

in its risky closeness to models which are as far removed as possible from normal aesthetic considerations.

The closer Lichtenstein's painting approaches its source, the more astonishing is its distinction from it. First, he reveals his individuality in his choice of subjects. His comics fall into two groups: the ideal girl of the popular romances, living on love but sexless as an IBM card, or the virile, what he calls 'fascist' heroes in violent battle. One actually *hears* the guns roaring and planes crashing in the bursting shapes and colours of those pictures and in the amazing quality of sound and action in their words: Voomp! Takka Takka, Blang, Varoom! Blam, Brattata.

Because Lichtenstein wants his motifs to be anonymous, he does not choose them from the most widely circulated serial comics but from single stories, preferably out-of-date issues which can be found in the well-stocked shops of the comic antiquarians on Times Square. He clips images which attract him for their formal and evocative possibilities and in so doing again reveals his individuality in the way he crops them and changes their format. From a firmly designed drawing, usually in colour, he constructs the carefully built-up painting, which looks like a comic but is no more a comic than Paulus Potter's cows are cows. The anonymous, machine-*like* character of Lichtenstein's painting fits his cool, noncommittal presentation of his subjects. He tells us that he likes the contradiction between the emotional subject and the unemotional technique; he must also like the ironical tension between real emotion and its comic travesty, between serious art and its silly source. He forges a refined and personal style from a vulgar and anonymous idiom.

It is not just that he enlarges the comic and puts it in a new context, but he gives it scale; he makes a monumental painting from a trifle. Comparing Lichtenstein's *I know how you must feel, Brad* (94) with its comics source (95), one sees how he proceeds. Eliminating inessentials, he dispenses with finger-nails and forearm muscle indications, cuts the number of lines throughout and more tellingly states and varies their curved or angular character. He changes the colours and gives them more force (from a dull red to a bright blue in the dress, from dirty yellow to brilliant gold in the hair), thus further idealizing the ideal girl of the comics; he intensifies the range and contrast of values; makes the flabby landscape background into a jagged, expressive pattern; transforms the vague rocket-like shape on the left into a neat vertical column (compare baroque portrait formulae) and realigns the whole into a quiet, steady vertical–horizontal–pyramidal structure. The head is squarely centred and over it the words float like a halo. The analogy to madonna compositions may be an art historian's fancy or possibly an unconscious allusion on the part of an educated painter or, considering Lichtenstein's cultivated humour, a deliberate quip at the icons of today.

Lichtenstein is interested and amused by the symbols and 'iconography' of the comics: the linear conventions for nose, mouth, eyes; the particular shapes

of eyebrows and forehead creases for different emotions (happiness, misery, confusion); the wavy think-balloons rising from the head by a series of bubbles, the talk-balloons by an arrow; exclamation points for speech; three dots for thought, etc. It is perhaps not too exaggerated to suggest that these formulae recall Seurat's dominants (descendants of the historic modes) – rising lines, light values and warm hues for gaiety and so on. Lichtenstein's resemblance to Seurat is sometimes noted on the basis of technique; however, Lichtenstein's dots are much smaller and completely uniform in size, shape and colour and they often do effect retinal fusion – orange through yellow and red, purple through red and blue. But there are more significant similarities between Lichtenstein and Seurat in style and content: expression of the everyday subject in a classic form, the lively combination of organic and geometric and of humour and gravity, the reliance on silhouette and line or edge, and the mechanical *look* of the painting.

In his painting of comics and advertisements Lichtenstein retains not only the appearance of the printing technique but also the commercial style itself, even exaggerating its mannered drawing. The slick black contours in '*I know how you must feel, Brad*' wittily parody the silly 'grace' of the pointed fingers, narrow waist, swelling hips and breast and the flowing blonde hair of the comic. But for all the mannerism in Lichtenstein's American beauty (who numbers the Comtesse d'Haussonville of Ingres among her ancestors), the total work is a powerful, commanding painting at least as far removed from the original comic as Seurat's paintings are from Chéret's posters.

Lichtenstein has made several quotations from other artists – from Picasso, from Picasso's translations of Delacroix, and from Mondrian among others. He has also made 'Lichtensteins' from ads for household products and holiday travel. With his classical bent it is not surprising that he has made drawings and paintings after photographs of ancient architecture. But all of these second-hand pictures are unmistakably Lichtensteins, including the much-discussed black and white painting from an illustration of a diagram by Erle Loran of a Cézanne portrait of Madame Cézanne. Surely one of the reasons that Lichtenstein chose that motif is because he was startled and amused by the discrepancy between the complex painting of Cézanne and Loran's simple diagram – from which Lichtenstein made a stark and impressive painting.

The interest of Lichtenstein, Rauschenberg, Warhol and many other artists in ready-made images stems not only from the abundance of such material around us but beyond that from the machine orientation of our environment. This interest is not uniquely contemporary – witness Monet's *Gare Saint-Lazare* series, Seurat's *Eiffel Tower* and Le Corbusier's 'machines for living'. Artists have long been fascinated by the technological aspect of our civilization and have used it as metaphor, tool and challenge; and now Andy Warhol says he thinks everybody should be a machine. The twentieth-century painters who have been particularly influential on the group we are discussing often

took their imagery or style from the industrial world: Duchamp and Picabia in their metaphorical machines and Léger with his crisp forms working like well-oiled pistons.

Léger's shapes resemble the machines themselves; Lichtenstein's paintings are intended to look machine-made, and he did in fact have some manufactured in porcelain enamel on steel, but from his personal, hand-made designs; whereas Warhol and Rauschenberg themselves use the machine process in the paintings they make with silk screens commercially produced from photographs. Apparently Warhol preceded Rauschenberg in this practice, although the latter had been moving in that direction and had gotten something of a related effect with his earlier transfers (*frottages*) from newsprint. (Parenthetically, Warhol painted comics – Superman, Popeye, Dick Tracy, etc. – in 1960 before and unknown to Lichtenstein.) Warhol's use of silk screen images is more mechanical, more 'pure' than that of Rauschenberg, who tends to treat them disrespectfully, as it were, more as a part of his 'palette'. Warhol uses them straight; Rauschenberg combines them freely with painting and drawing, as the cubists had done with collage. At first working only in black and white, Rauschenberg then combined the filters of the four-colour separation process as though these were exactly his choice from a rich and complex palette.

Mixing hand-made art with machine-made art, mixing photographs of reality with photographs of reproductions of paintings, Rauschenberg (96) ranges wider and freer than Lichtenstein or Warhol. He never makes a picture of a single image. He does not imitate ready-made images like Lichtenstein, nor does he re-present them as Warhol does; Rauschenberg consumes them. A hyper-responsive dynamo, he snatches the images and symbols of modern life as they flash by and converts them, superbly refined but still poignantly themselves, into pictorial and evocative energy. He has photographic silk screens made from news photographs (and some that he himself took) of our world of motion – trucks, ships, planes, space investigators, street signs, sports shots – and from postcards of the Statue of Liberty, display cards of oranges, pictures of mosquitoes and reproductions of Michelangelo, Rubens and Velazquez. These images form his urban and studio environment; they are the glass, bottle, pipe and guitar of cubist compositions and they tell as much about Rauschenberg's world as the cubists' iconography reveals of their more closed-in environment. Like Picasso, Rauschenberg forces the things to 'put up with' the pictorial life into which he transforms them; but, having himself brought the object back into painting in no uncertain terms, he now allows its mechanically produced image more life of its own than Picasso allowed the actual piece of rope or wallpaper.

Rauschenberg gives new power to the dynamic means of the cubists: he speeds up the simultaneous, multiple viewpoint befitting a more mobile observer and a faster changing world; his distortions in scale are more fantastic (the sparrow is larger than the Statue of Liberty); his shifts in space and meaning

92 JASPER JOHNS *Diver* 1962

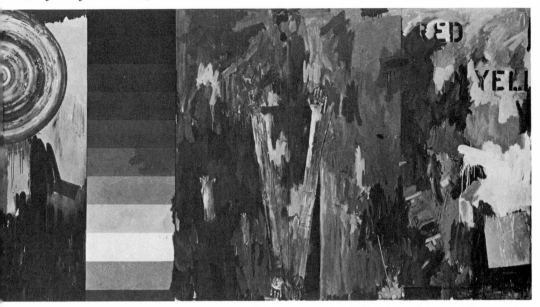

93 JIM DINE *Two Palettes (International Congress of Constructivists and Dadaists 1922) No. 1* 1963

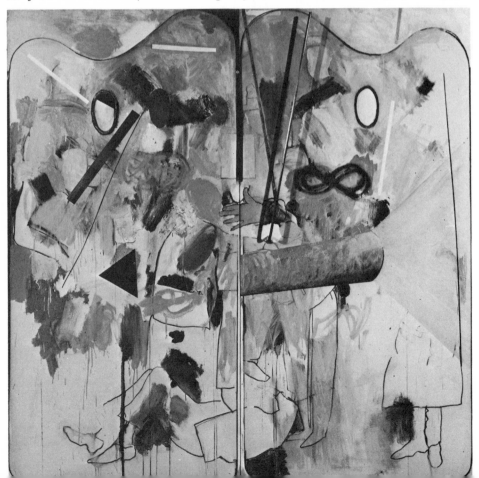

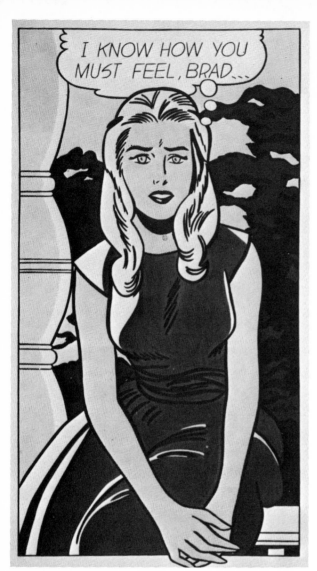

94 ROY LICHTENSTEIN
I know how you must feel, Brad 1963

95 Original comic for
I know how you must feel, Brad

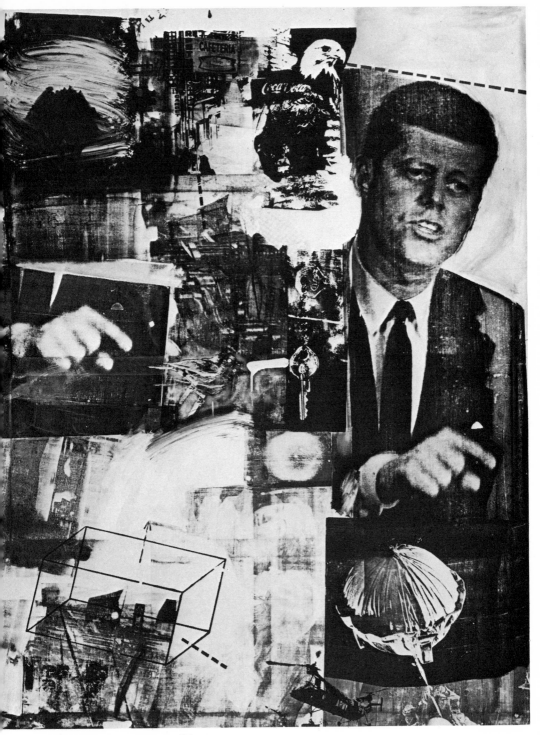

96 ROBERT RAUSCHENBERG *Buffalo II* 1964

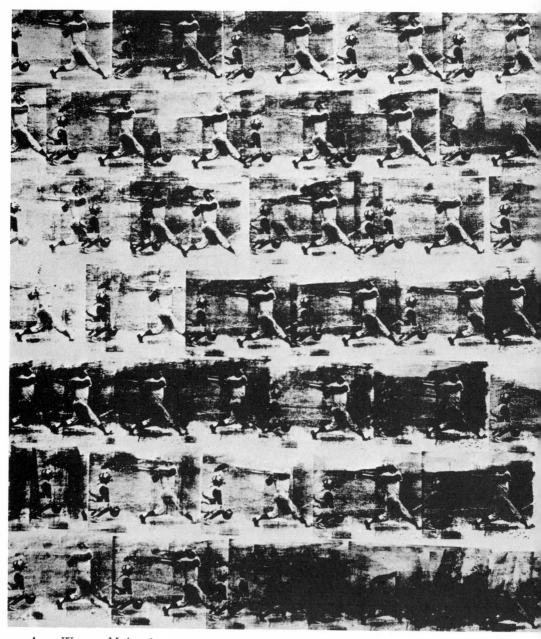

97 ANDY WARHOL *Maris* 1962

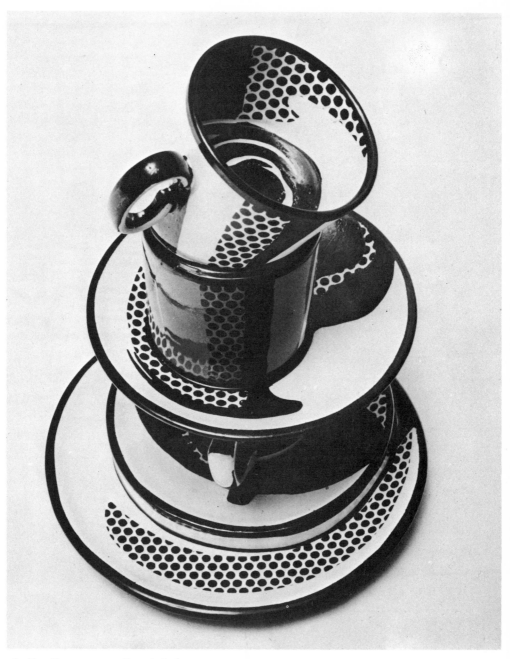

98 ROY LICHTENSTEIN *Ceramic Sculpture I* 1965

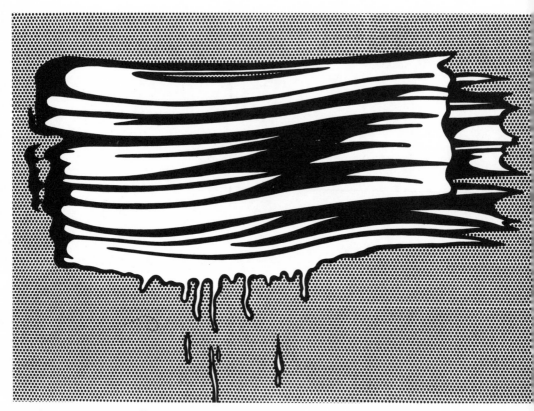

99 ROY LICHTENSTEIN *Yellow and White Brush Strokes* 1965

100 ROY LICHTENSTEIN *Modern Painting with Bolt* 1966

101 LARRY POONS *Away Out on the Mountain* 1965

102 NEIL WILLIAMS *The Lotus Eater* 1964

are more abrupt; and the dialogue between substance and illusion and between art and reality is ever more complex. Although his silk screen paintings are actually flat, in effect they are similar to his combines: the two-dimensional photograph of Kennedy in his familiar finger-pointing gesture is as startling and as physically *present* as the actual eagle is in *Canyon*. On the other hand, sometimes the most palpable image is the least 'real' one – as the Venus printed from a silk screen from a photograph of a reproduction of a painting. It cannot be entirely insignificant that the two paintings which appear most frequently in his work, Rubens's *Toilet of Venus* and the Rokeby *Venus and Cupid* of Velazquez, are figures whose backs are turned to us and whose faces we see only reflected in a mirror. Reality is veiled in the mirror reflections and in the whole field of second-hand images, reminding us that we live in a world of illusions – shadows of shadows of actuality. Much of the 'new realism' is far from realistic, dealing as it does with fantasy and the kind of illusion that our synthetic culture nourishes. Feeding on illustrated capsules, any one of the 7,156,487 subscribers to *Life* could tell you that the title for this article comes from Roy Lichtenstein's painting, *What? Why did you ask that? What do you know about my image duplicator?*

Besides those already noted, surely there must be other factors involved in the contemporary practice of image duplicating. Is there not a genuine feeling of affinity with commercial methods and design, a sense that 'This is my kind of world and I shall use what I want of it for my own work'? That, combined with the stimulus of a risky alignment – how mechanical can one get and still be an artist? Andy Warhol most dramatically marries the two worlds and his commitment to the machine is most outspoken. (When asked about some rolled canvases stacked against the wall of his studio, 'Those? Oh, they're just hand-made pictures!') Warhol is completely at home in the world of commercial art and entertainment; he understands its style, speaks its language, works to its music, loves its movies and, as everyone knows, makes astonishing films of his own.

Warhol wants his pictures to be artless, styleless, anonymous, painted without his interference (97). He solemnly denies that he makes any aesthetic decisions – a pretty piece of nonsense. He selects the image in the first place, determines the size of its enlargement, how many times it will be repeated on a given work, where it will be placed each time on the canvas, whether or not he likes accidental effects and irregularities, what the colour of the ground will be, how to group the colours in a composition of variously coloured panels. These are just a few of the aesthetic problems that the Warhol machine faces and solves. As Franz Kline said to the man who described Barnett Newman's paintings as too simple, 'Sounds very complicated to me!' Warhol's denial of the art in his art may be half pose and half genuine regret that it is not possible for an artist to rid himself of himself and become completely anonymous. If he is an artist, what he makes will be his art whether he does it with a machine or with his

finger-nails. The attraction of the anonymous to so many artists of this genera-
tion is one reason for choosing the common object and image. Warhol selects
the most mass-reproduced photographs of entertainment stars, personalities in
the news, commodities and disasters because they have been repeated so much
that they have lost their meaning. And so he repeats them again – and gives
them new meaning.

Whether consciously or not, Warhol and other image duplicators are making
a comment on the monstrous repetition our machines have bred: millions of the
same car, the same dress, the same soup can, similar offices and dwellings repeat-
ing the same unit layer above layer: the same number of windows in the same
pattern, the same number and distribution of rooms, filled with people sitting
at the same kind of desks, typing the same kind of letters or reading the same
paper or magazine, studying the same textbook, looking at the same TV
programme. How many of the same weapon to blow it all up?

Andy Warhol professes to like it. Perhaps he does. In any case it is one of the
things his pictures mean.

Another aspect of our environment which Warhol's and Rauschenberg's
work reflects is its movement, constant change and scattering of time. Warhol
has conveyed this quality in his work since 1961 but he also expresses its anti-
thesis: the serial soup cans, Coca-Cola bottles and movie stars repeated in a
regular rhythm, row on row, are static images rescued from time and motion.
A quality of absoluteness, of the suspension of time, is expressed in the slowly
drawn horizontal bands of *Blue Electric Chair*; and the film *Sleep* silently extends
time. On the other hand, Warhol often evokes the sensation of movement in
time, partly through overlapping the images and breaking their vertical align-
ment. The baseball players hit and run and the disasters flicker like the moving
frames of a film. Shifting time is evoked in the multiple portraits, composed of
several different photographs repeated, reversed and variously cropped. This
effect of time in sequence is heightened by the subject being at differing dis-
tances from the camera and there being, in some cases, a variety of background
colours. Warhol's colour is brilliant, peculiarly contemporary and commercial
at its best. The image of Marilyn Monroe, repeated twenty-five times in
gorgeous brazen orange, bluish-pink, yellow and green, forms horizontal bands
and stripes like boxes of Tide on an assembly line or an alphabet painting by
Jasper Johns. Warhol named several single portraits of the movie star *Grape
. . . Mint . . . Peach . . . Cherry Marilyn Monroe*, all very much 'artificial flavour
and colouring added'. The woman who admired a reproduction of a van Gogh
at Bloomingdales and asked the clerk to order it for her in green should have
asked Andy Warhol. He could do that – supply a picture in the customer's
choice of colour; at least it might amuse him to say that he would. But that
fancy does not minimize Warhol's distinguished power as a colourist. The blue
ground with black images in *The Texan*, that mysterious and impressive paint-
ing with its jagged shapes recalling the sombre compositions of Clyfford Still,

is like the acrid blue lights penetrating the black of an airfield at night. Besides using industrial colours, Warhol has made a further alliance with technology in painting pictures with actual light. *Blue Girlie* is in white paint, revealing nothing until strobe light is directed on it to produce a startling blue composition like a figure photographed in the depths of the sea.

Reference to Still and other abstract expressionists suggests that Warhol and many of his contemporaries might be called abstract objectivists, which would be no more ridiculous than some of the other names applied to them – and just as useless. I mention it only because the banality and omnipresence of the images they use more readily make way for an art 'dealing primarily with forms', as Picasso defined cubism. With cubist paintings one first sees forms which require considerable unscrambling to get them back to objects; whereas many people still have not seen the form for the objects in the new painting. The cubists stressed form by undermining subject matter and these contemporary artists reveal the insignificance of their subject matter by blatantly reproducing it. The latter procedure makes it more difficult for the spectator, but it is only a roundabout way of going to the same place.

Nonetheless, the things reproduced keep flashing back to our consciousness so that the tension between abstraction and subject can never quite be laid to rest – and is not meant to be. Present in cubism, that conflict is heightened in the new painting, as is the tension between anonymity and artistic individuality.

The whole struggle for the impersonal and anonymous on the part of so many contemporary artists is related to what T. S. Eliot wrote a long time ago: 'Poetry is not a turning loose of emotion, but an escape from emotion; it is not the expression of personality, but an escape from personality. But, of course, only those who have personality and emotion know what it means to want escape from them.'

Style as Object

Contradiction, paradox, irony have been key elements of the modern aesthetic from cubism to Duchamp to the contemporary painters and sculptors of the popular image. Roy Lichtenstein's work, from its initial conception to final execution, abounds in such contradictory combinations as vulgar and classic, witty and imposing, seductive and harsh, concrete and abstract, machine-made and unique.

At first Lichtenstein's wit was on a playful level; the function of *The Airplane* is whimsically thwarted as the machine is metamorphosed into a pigeon-toed, knock-kneed bull as helpless as Ferdinand. This early work, from 1951 when he had his first one-man show at Carlebach Gallery in New York, is obviously indebted to Matisse, Picasso and Duchamp; but the important factor for Lichtenstein's development is that, while profoundly admiring those masters,

he dared to treat them lightly. However, if one can disregard its amusing subject and consider it purely as form, this eclectic painting hints at the impressive sense of scale which characterizes all of Lichtenstein's mature work.

In the same year he also painted his first explicit translations of other art, including a parody on Leutze's *Washington Crossing the Delaware* two years before Larry Rivers's celebrated interpretation of the same nineteenth-century painting which used to be reproduced in every American history textbook. Lichtenstein's 1951 version of this popular subject *par excellence* is one of his proto-Pop pictures; others include *The Frontiersman*, a gentle dethroning of the American cowboy. However, while these works are 'Pop' in subject matter, they are only slantingly so in attitude towards the subject and not at all in form and technique. They are still in the cubist-Matisse mode which continued to engage Lichtenstein until about 1957, when he began painting abstract expressionist pictures, some of them in an open, loose style in which the quick linear movements and stains of colour leave much of the canvas untouched. By 1960 the thicker paint moved in wide ribbons of colour to form overlapping, squared-off planes, somewhat anticipating the spatial character of his well-known later paintings.

Within the abstract pictures Lichtenstein had incorporated some comic images, but it was not until the summer of 1951 that he made his first full-scale paintings from such subjects as Mickey Mouse, Donald Duck and Popeye. He was not aware that Andy Warhol had also made paintings from comics in 1960, when he was still a professional advertising artist. In fact, these two artists did not even meet each other until about the time of Lichtenstein's show at the Castelli Gallery in February 1962.

Before 1961 Lichtenstein had also tentatively used commercial imagery, specifically a bubble-gum wrapper; but it was only in 1961 that he fully accepted such advertising artifacts and the comics as a challenge for his serious paintings and set about developing an appropriate means of expressing his ambivalent attitude towards them. Like so many of the artists with whom he is associated, Lichtenstein admires certain qualities of comics and industrial advertisements, especially the immediate and compelling power of their close-up concentration and their brash, impersonal 'anti-sensibility' (his term). Working within their subject matter and technique, and even exaggerating their impersonal or slick style, he deliberately puts himself in a precarious and ironic position. He also makes things difficult for the observer, as was abundantly clear from the outraged reactions to his historic exhibition in February 1962, when the paintings based on these lowly sources were first presented.

Lichtenstein's paintings from comics are of two basic types: those with violent themes, of which *Blam* is a characteristic example, and the sentimental ones, like *Craig*, taken from comic romance books. In *Craig* the American dream girl (all girls and no girl) murmurs to herself her lover's name. In the actual comic from which the image was cropped she exclaims 'The Captain!',

which intriguing allusion Lichtenstein had to sacrifice to more important formal demands, replacing it with a shorter word that seemed to him sufficiently romantic. In the preceeding essay, I have analysed the significant pictorial changes which Lichtenstein makes even when, as in *Craig*, the final image might appear to be very close to the original comic. As a matter of fact, however, every single line is subtly changed and the whole beautifully integrated work is profoundly different from its trivial source.

The artist has said that he intentionally selects those comics in which the tension between the emotionally charged subject (whether violent or bland) and the impassive, mechanical style is most striking. Moreover, the fundamental unreality of these supposedly real-life situations attracts his ironic wit. In them and in the common-products paintings, such as the *Hot Dog*, he contradicts the banality of the object with the austere beauty of his form.

Lichtenstein also brings an individual character to the paradoxical relationship between volume and plane, and between space and surface, which has been a major concern of modern art since its beginnings. As Maurizio Calvesi has pointed out (in *Lichtenstein*, edited by A. Boatto and G. Falzoni, Rome, 1966), 'The image identifies itself with space ... there are no longer any full or empty parts, but only full parts.' However, it is a curiously flat fullness. Space is densely occupied by a series of planes suspended one after another like sheets of cardboard or stage flats. This is particularly true of the non-figurative or background elements; the figures are given somewhat more three-dimensionality by means of an extreme stylization of the linear symbols used in advertising and comics for rendering volume. His evenly coloured or uniformly dotted objects appear to be on the same continuous plane, interrupted only by white or black lines which imply solid forms without modelling them. Characteristically, Lichtenstein weds these formal contradictions of fine art, familiar from Matisse and Japanese prints, for example, with the commercial conventions in part derived from them.

That Lichtenstein handles all of his pictures as though they were abstractions, his primary concern being formal, becomes more obvious in the landscape series and explosions. He had several of these works industrially manufactured in steel, coated with porcelain enamel, evidencing his pleasure in the crisp, brilliant surfaces of machine-made objects. In *Wall Explosion II*, 1965, he translated the suspended stage-flat space of his painting with its interplay of two- and three-dimensionality into an actual construction of several coloured sheets of steel. This work is very close to his *Varoom! Varoom!* painting of 1943 which, in turn, is as close to Léger and Stuart Davis as it is to comics or commercial art. However, Lichtenstein has made use of the best elements of commercial art – and he has returned the best of it in his posters, such as the one he did for the Film Festival at Lincoln Center, autumn 1966.

The land, sea and skyscapes are particularly striking in their optical effects, which have always been present to some degree in his mature painting. In

many of them the black lines, which previously had separated colour areas, are eliminated, possibly in concession to the outdoor motifs. Some of the land-scapes, as the first sunsets in 1964, are executed in the dot and flat colour (oil and plastic paint) technique; some are in porcelain enamel on steel; some in layered plexiglass; and others in diffraction-grating, a material which separates light waves, thus producing three-dimensional effects and changing colour, moiré and other optical phenomena. Through the use of concealed motors, in some of the autumn 1966 work, he increased the dazzling kinetics of diffrac-tion-grating by setting into actual motion certain elements in the picture, notably the sea, or by revolving differently coloured light over it. All of the landscapes, even those in the traditional technique, shimmer as seductively as Monet's painted surfaces.

Because Lichtenstein so often coats his pictorial bite in 'honey and sugar' (not so much to catch flies, as Ingres did, but to confound them), the antithetical quality of his work is the more disquieting. Within the suavity of his style lurks harshness, even brutality. In response to this element, a student described Lichtenstein's lines as 'black slugs lying on a brightly painted surface'. His colours, particularly the reds and yellows, have a bitter tinge; and the Ben Day dots grow ominous as they become relatively larger – timid in *Blam*, assertive in *Craig*, overwhelming in *Ceramic Sculpture I* (98).

The ceramic cup-and-saucer compositions and the girls' heads inevitably call to mind Picasso's 1914 painted bronze *Glass of Absinthe*, where the cubist contradictions between plane and volume, and the multiple views, dislocation and fragmentation of the object are physically built into the work. Picasso made an actual object from his own explosion of the object. Lichtenstein, on the other hand, preserves, or reinstates, the intact three-dimensional identity of the object but then undermines it by decorating the surfaces of the volumes as though he were painting a cubist picture. Thus Lichtenstein paints the illusion of a painting on a three-dimensional object, while Picasso makes a three-dimen-sional object of a pictorial image. The paradoxes in both are multiple and involved, including of course the fundamental dialectic between art and reality. However, Lichtenstein conceals where Picasso had revealed the process from banal object to art; one would never come upon anything that looks like Picasso's piece outside a serious collection, but one could imagine finding a cup and a saucer or a girl's head which might *resemble* Lichtenstein's inventions in some bizarre arts and crafts shop or at one of the Times Square dispensers of kitsch objects, such as salt and pepper shakers in the form of female nudes.

The fact that one can even allude to such trivia arises from Lichtenstein's unmistakable pop flavour, his ironic disguising of his genuine aesthetic concern in apparent anti-sensibility and his painstaking craftsmanship in the appearance of mass-production. While the ceramic pieces were intended to look like industrially produced objects, they were actually made at the expense of great time and care in collaboration with the potter, Hui Ka Kwong. For some of the

cup and saucer compositions they used commercial moulds; for others they made their own. The mould for the girl's head was made from a plastic manni-kin which Lichtenstein reworked in clay. The cup and saucer pieces are unique,[1] while there are eight casts of the girl's head; however, all of the pieces are individual in colour, which is applied in part by means of ceramic decalcomania specially produced for Lichtenstein.

There is a similar tang to his *Brush Stroke* paintings (99), where the free-wheel-ing gestures and fortuitous drips of abstract expressionism are frozen in an industrial, machine-made style. Seen in the context of Lichtenstein's entire *œuvre*, this contradiction is thoroughly consistent. The true subject of a great part of his work, even when the ostensible subject has been a comic book situa-tion or a commercial product, has been pictorial style. Besides the outright quotations from Picasso and the adaptations of Mondrian's idiom, he has also incorporated allusions to other art styles within his explorations of comics and advertisements. In the cartoon paintings, lines and shapes often take on art nouveau or Hans Arp or Clyfford Still configurations. Much of his work, such as the monumental piece for Expo '67, is based on the interior décor and pictorial style of the 1930s (100); in fact, Lichtenstein heralded the art deco revival. The cups and saucers and girls' heads are about his own style as well as about cubism. Of his *Pistol* banner he has said, 'It is a play on the idea of a painting having a strong presence.' The brush stroke picture called *Big Painting 6*, exhibited at the 1966 Venice Biennale in the same room occupied six years before by Kline's paintings, is not so much the parody it patently appears to be as a worthy descendant of the abstract expressionist master's astringent energy and daring. But Lichtenstein eliminates the organic quality intrinsic in the work of Kline and the others he alludes to, and replaces it with an industrial, synthetic look. His stated intention in so doing is not to disparage the serious art styles which are the subject of so much of his work, but to depersonalize them. He runs them through a machine, as it were; and paradoxically they, like all the rest of his work, emerge in an extremely personal, exclusively Lichtenstein style.

8 *The Object in Jeopardy*

Mathematics and the New Abstraction: Hinman, Poons and Williams

The illusion of space and motion through colour, and the deliberate ambiguity and contradiction between space, volume and plane relations characteristic of cubism and most abstract painting, go back at least to Cézanne, and even the impressionists. For Cézanne, colour was a primary instrument to evoke, and at the same time deny, space and volume; and in the 'deliberate' impressionism of Seurat and the 'instinctive' impressionism (to use Signac's terms) of Monet and the others, the potentially kinetic power of colour was explored and engaged. Thus the new abstraction, represented by the work of Hinman, Poons and Williams, has its roots firmly planted in the viable soil of modern art.

Larry Poons's paintings (101), vibrant and dynamic but of an extraordinary sobriety and beauty, begin with drawings on graph paper on which he places progressions of dots or 'notes' (the musical analogy is almost inescapable in considering his work). One theme of notes falls in a certain place on each of the series of squares or parallelograms in which it appears – say, the first-theme notes are placed in the centre of the parallelograms and the second on their edge. The progressions move clockwise and again counter-clockwise. In painting, he first applies the ground colour, a uniform surface on the canvas, and then lightly pencils in the scheme, indicating the rhythmic distribution of dots or ellipses. Although any given element in a progression will be painted the same colour whenever it appears, Poons arrives at his subtle colour relationships through a trial-and-error method, overpainting all the dots several times before he finally decides that the painting does what he wants it to do. And frequently he discards paintings on which he has worked over a long period of time if they do not 'breathe', as he says – a lovely word for the way his coloured dots and their after-images move and beat rhythmically in and out of their expansive space. His earliest dot paintings, of 1962 and 1963, were relatively simple, the dots being single in their progressions and all of one colour (black on white, blue on gold, green on orange); but they become increasingly rich and complex. By multiplying the sequences he sets up a staggering number of alternate relationships; the parallelograms shift and interpose their directions

(this development may be partly an outgrowth of the fact that the ellipse, unlike the circle he first used, has a built-in axial direction); and the colours increase in number and become far more involved in their interactions. Painting the dots usually within a complementary relationship to the ground, he controls the way his colours reinforce or modify each other, call each other into being, set up vibrations and induce after-images whose illusory presence is as 'real' a part of the designed movement of coloured shapes in space as the painted ellipses are. Although the working diagrams of Poons may sound and even look 'scientific', those rhythmic designs, as well as the coloured relationships, are arrived at in large part intuitively and with as much lonely searching as we attribute to the existential heroes of abstract expressionism. To consider Larry Poons's sketches as mechanical drawings and his paintings as optical experiments is like regarding Maillart's bridges exclusively as remarkable feats of engineering and missing their breathtaking beauty. Poons is not a scientist; he is an artist – one who could say, along with Matisse, 'My choice of colours does not rest on any scientific theory; it is based on observation, on feeling, on the very nature of each experience.'

Poons's coloured rhythms can be powerful, noisy and insistent – shattering the space around them; or they can be serenely open, slowly expanding space, or austere and meditative, drawing the surrounding space into their depths. And they can combine these and many other expressive qualities. While they often suggest visual patterns in our mechanical world, as the indentations on an IBM card or flashing lights on switchboards, TV and city streets, they also, and more frequently, evoke natural images: light silently falling through layers of leaves, stars gleaming in the night-blue sky, rain splashing on the ground, swarms of gnats shimmering in the air, or water sparkling in the summer sun.

From the earliest pictures that Poons has preserved, *Art of the Fugue I* and *II*, 1958 and 1959, it is apparent that an independent talent was even then at work exploring the directions opened up by Mondrian in the *Victory Boogie-Woogie* paintings of his last years. Poons's dynamically interacting parallelograms, already present in the design of *Art of the Fugue II*, may also have something to do with the futurist lines of force but are less obvious and on the surface.

In Poons's *Away Out on the Mountain* of 1965 (101), the grey and ochre ellipses move almost imperceptibly in asymmetric rhythms within a great, shockingly magenta space. Some of the greys are tinged with green and others with violet; one of the ochres has been toned down almost to the ground colour. It is a painting which 'breathes' quietly, with 'much to see but not much showing'. The elegant, almost chichi character of the magenta field is counteracted by the relatively dry, rough texture of the ground surface. Sweet but acrid, it has the insistent flavour of a foxy champagne. This large, impressive painting has a kinship in form and spirit with the late Monets, which Poons admires.[1]

Where Larry Poons achieves the effect of moving space on a traditionally shaped canvas (he earlier used other forms), Neil Williams, for comparable

effects, relies in part on the directional thrusts engendered in the multi-edged canvas. His 1965 paintings called the *Paris Series* resemble surfaces of coloured blocks colliding and multiplying themselves like particles of nuclear energy. In this connection it is interesting to realize that, although Williams has little scientific training, having taken his degree at a professional art school rather than at a liberal arts college, he is, like many of his colleagues, very much interested in the philosophy of modern mathematics and physics, and his reading is largely in that field. In fact, he says that the idea for his first shaped canvas came to him while he was reading an essay by Heisenberg on the philosophical problems of atomic physics, from which I quote: 'All elementary particles are composed of the same substance, that is, energy. They are the various forms that energy must assume in order to become matter. . . . Energy is not only the force that keeps the "all" in continuous motion, it is also . . . the fundamental substance of which the world is made,' and referring to scission, 'Sometimes a great many particles originate in such a collision, and surprisingly and paradoxically the particles that originate in the collision are no smaller than the elementary particles that were being broken up. They are themselves again elementary particles.' I do not know that this particular passage has any direct significance to Williams but I find it relevant to his imagery, as I have indicated above.

Williams's flat planes of opaque paint produce an effect of transparency, of overlapping colour-filters; and, in the *Paris Series*, they also evoke the illusion of interpenetrating polyhedrons, as the white-edged triangular shapes appear to recede and advance. However, a plane which can be read, for example, as a blue side of a volume must also be read as one segment of the uniformly flat surface of a basic rectangle or parallelogram. Moreover, the white lines themselves, whose width is carefully adjusted to vary the speed of the adjacent planes, remind one (as do *passage* and other devices in earlier modern painting) that the picture is a continuous flat plane, thus contradicting the implied recession and advancement of individual shapes. These ambiguities are certainly no invention of Williams's; they are as old as cubism, but he, like Poons and Hinman, has constructed a very personal imagery within a universal ideology and style.

Williams's 1965 paintings, which owe much to Matisse, are a complex development of ideas implicit in his earlier pictures such as *Pesa Mignon*, painted in the spring of 1963, where the yellow and purple parallelograms read interchangeably and ambiguously as ground and figure, forward and back, with the complementary relationship between the two colours inducing further activity between them. However, the little strips of purple formed by the curved edges of the yellow parallelograms tend to check and reverse the thrust somewhat too much, and the slicing of the yellow lozenges by the edges of the canvas creates a troublesome disruption. But given the problem, its solution was all but inevitable. To restore consistency to the image and correspondence between the idea of thrust and the form of the work, the edges of the canvas had to give way

– which they soon did in the saw-toothed canvases, such as *Albatross*, of September 1963, his first multi-edged picture. Its painted parallelograms, deep ochre-orange and magenta connected and separated by bits of green, are now echoed in the very structure of the canvas, making the whole work of one piece, a unit of flight – a trajectory. The shadows often cast by the jagged, multiple edges become a part of the work and increase its sense of speed and energy. Thus we see that Williams's first use of the shaped canvas and its subsequent variations have evolved internally from his own work.

Williams's basic ideas were further developed in his next group of pictures which he called the *Transparency Series*, of which *The Lotus Eater*, 1964 (102), is the first example. Here the saw-toothed edges are reduced and simplified and the design of overlapping and implied-transparent rectangles has taken on a monumental character which continues to grow, along with the complexity of transparencies and contradictions already discussed. It is curious how much smaller *Albatross* looks than *The Lotus Eater*, which is actually three feet shorter.

While Neil Williams, in keeping his canvas flat, although breaking and multiplying its edges, avoids making 'objects', Charles Hinman stretches his canvases into actual three-dimensional constructions (103). Williams's work implies that matter is energy and Hinman's actual volumes contradict materiality in their buoyancy; they are shaped air. At least, that is the effect of the 1965 pieces; the slightly earlier ones have less of the billowing quality, but they too set up contradictions between illusion and fact, as all of Hinman's constructions do. In *Untitled*, of spring 1964, the long black foremost member appears to rush back towards the left at enormous speed because it is actually not a rectangle, its left side being considerably narrower than the right. The next plane immediately behind it, brick-red in colour, is also constructed of unequal sides and the section of it which emerges below the black slab appears to tilt up forward. It is as though Hinman had translated the ambiguous relationship of space and solids implied in cubist collages into actual space-occupying forms. In fact, that particular Hinman is astonishingly similar to Braque's *Clarinet*, 1913 (25), in the Nelson A. Rockefeller collection. With the considerable size of Hinman's piece, he has also fulfilled something of the vast scale implicit in Braque's beautiful collage, whose simulated wood-grain slice of paper swings into space like a great plank of wood. Hinman's *View Across Down to the Left and Right*, executed four or five months later, develops further the spatial incongruities implicit in the earlier work. The planned distortions make it impossible for the viewer to determine how the parts of the painting function in relation to each other with reference to the 'laws' of gravity and traditional geometry. Each of the three solids is constructed of differently coloured sides, avoiding parallelograms and equilateral shapes. Thus the bottom three-sided form, for example, has one white triangle and two rhomboids: the upper one yellow and the lower a robin's-egg blue. He further confuses us in our perception of volume and space relations by curving some of the sides; the blue 'plane' on

the bottom is really no plane, but a concave surface. Moreover, through changes of colour, he often gives the illusion of distinctly different volumes to a continuous surface, as on the front of *Occurrence* (103), where one has the impression that a change of plane occurs at the meeting of those two large, light, flatly coloured areas. Sometimes an actual change in plane does occur, as on the bottom right of *Occurrence*, but more often it only appears to. This free-standing sculpture-painting brilliantly exemplifies the contradictory way Hinman's work, as he says, 'seems to partake of the object-making of the sculptor and the illusion-making of the painter. I endeavour to cause these distinctions to fuse and become one concept.' The more one examines his work, the more it strikes one that he is giving three-dimensional existence to cubist implications.

Furthermore, Hinman's choice of colours imparts contradictory impressions of spatial location; a yellow which is actually behind a blue will appear to advance in front of it. And the way he stretches and shapes the canvas so that one plane slides imperceptibly into another, as on the right section of *Yellow/Green*, reinforces the analogy with cubist collage, supported in this particular example by the explicit and seductive guitar image. Forms frequently swell into breast-like projections. The voluptuous and erotic character of Hinman's work derives in part from the smoothly painted and tautly stretched flowing surfaces as well as from their basic forms. Sometimes their elegance almost approaches 'high fashion' – a kind of nouveau art nouveau. However, these objects are not only sensuously appealing, they are also intellectually stimulating, revealing a firm and inventive mind at work in the creation of this young man, who has said, 'Geometry, which is the basis of our knowledge of space, is full of mystery, and probably will always continue to open up new areas of thought and feeling.'

Hinman's constructions begin with a series of lively charcoal studies, rapidly establishing volumetric relationships, occasionally with the addition of large flat colour areas. The canvas structure itself, after he has built it, suggests more ideas to him which he pursues in further sketches that are halfway between the working diagrams of Poons and the more finished drawings of Williams, whose numerous sketches are in a variety of mediums: pencil, ink, watercolour, plastic paint and coloured pencil. After giving a schematic pencil drawing to his stretcher-maker, Williams continues working out a series of variations on each theme, exploring his ideas so thoroughly that many of the studies become complete and independent works.

In their finished paintings, all three of the artists have used the acrylic emulsion paints (water-soluble until dry then impervious to water) which help provide the clear, flat, impersonal surfaces which they usually seek. Liquitex, one of the most popular brands of acrylic paint, is used by Hinman and Poons, although the latter often mixes another substance with the ground colour in order to get a somewhat rougher surface. Williams did use Liquitex until, wanting even more intense colours, he switched to Dayglo, an oil-base 'fluorescent' enamel. Artists of this generation continue to experiment with materials – to make use of the

technological world in which they live. And they do so not only in the materials that they use but, more significantly, in the very images which they invent. However, as I have pointed out with Poons and to some extent with the others, their work also suggests natural origins and analogies. Poons's paintings evoke landscapes, Hinman's floating figures and swelling waves and sails, Williams's flashes of lightning or faceted surfaces of crystallized matter. Their titles sometimes allude to places or experiences in nature, as Williams's *Albatross*, the name of a motel where he often used to watch the stars blinking over the Pacific. Titles should not be taken too seriously, since they are, finally, only a means of identifying particular paintings and are often chosen at random from friends' suggestions; still, some individuality is revealed in their choices. Hinman's titles tend to be descriptive of the work: *Cascade, Vertical Waves, Dimensional Play, Yellow/Green*. Williams's are less direct: *The Lotus Eater*, the name by which a particular car-racer is known, refers to someone who is compelled to do what he does and can do nothing else. Larry Poons, who was one of the first to introduce poetry reading in a Village coffee-house he used to manage, chooses titles which have a poetic ring: *North East Grave* from a nautical chart, *Away Out on the Mountain*, a folk song, and *Tristan da Cunha*, 'the only island in the South Atlantic' (what that may lack in geographic fact it gains in poetic idea).

All three of these young Americans, then, have some concern with nature, with motion and speed, and with contradiction and ambiguity as basic conditions of life; and the work of all of them is somewhat oriented in mathematics, although with varying degrees of rationalism and intuition. Poons uses his arithmetical progressions as a musician or poet does; Williams is fascinated with the philosophical implications of mathematics and physics while Hinman, who constructs what might be called the malleable solids of modern geometry, says that he starts with geometry and strives towards 'the unknown from the known'. They all do that; from arithmetical and solid or plane geometrical relationships they make new art forms: images which did not exist before and which reflect the search of these contemporary artists, like that of Ryder and his inchworm, 'to find something out there beyond the place where I have a footing'.

Towards the Indeterminate:
Three Young Sculptors
(*Written in collaboration with Athena Tacha Spear*)

The work of Bruce Nauman, Jack Krueger and Alan Saret reveals several tendencies that are emerging with particular force at the present (i.e. 1968). Although in some respects Nauman's art appears to be most clearly rooted in the past, his interest in the unassertive and insubstantial and in exploring the self, body, identity and perception, are among the preoccupations which he shares with several other advanced artists. Some of his images, such as the

untitled crossed arms below a knotted rope and *From Hand to Mouth* (104), cast from parts of his own body, recall the early work of Jasper Johns and Robert Morris. Moreover, like these artists, he is a true descendant of Marcel Duchamp, particularly in his wit (most obvious in his puns and titles) which stems directly from the Dada master. Compare Nauman's *Device for a Left Armpit* and Duchamp's *Coin de Chasteté*. To Nauman as to Duchamp, the idea is at least as important as the visual aspect of the work. In *Six Inches of My Knee Extended to Six Feet* and *My Last Name Exaggerated Fourteen Times Vertically*, the titles unquestionably add to the meaning and originality of the images. Both of these later pieces provide a link between Nauman's Duchampian aspect and his earlier abstract sculpture – long, soft, curiously organic strips of fibreglass or rubber that stand or hang frail and lonely. The haunting extension of such abstract works suggests that Nauman may have reached his more overtly surrealist imagery through his own personal development rather than through direct outside influence. *Six Inches of My Knee* . . . and *My Last Name* . . . introduce an exaggerated elongation of known fragments of reality, which are altered almost beyond recognition through an unnatural stretching imposed upon them. One feels as though one is looking at the world through distorting mirrors, or as though one has been transferred to a strange planet where gravity and atmosphere obey different laws.

In his isolating and transforming of bits of reality into super-reality, in his body imagery, and his soft almost elastic forms, Nauman, like many other young sculptors, reveals his kinship if not direct indebtedness to Claes Oldenburg. But Oldenburg's transformations are primarily obtained through fantastic enlargement or through unexpected softening of hard objects; and the robust, overt sexuality of his imagery (as strongly present in his soft bathroom fixtures as in his knee piece) is of an order entirely different from the narcissistic, hothouse flavour of Nauman's body fragments. Also in contrast to Nauman's, Oldenburg's forms are substantial, sensuous volumes although often built of non-structural or ephemeral materials. The fragility which distinguishes Nauman's art is due less to the impermanence of the materials than to the evanescent character of his subjects, a quality underlined in the very fact that a large part of his work consists of photographs of the fugitive and the formless. Catching the numerous possible 'arrangements' of a pile of flour spilled on his studio floor, or the greasy spots of parts of the body pressed against glass (cf. Yves Klein's *Anthropometrics* and Jasper Johns's *Studies for Skin*) evidences a sophisticated and playful sensitivity. Further characteristic of his involvement with the insubstantial is Nauman's special interest in the negative form. In *Platform Made Up of Space Between Two Rectilinear Boxes on the Floor*, the negative void has been promoted into a positive and even solid shape, a contradiction which he exploits. And the *Neon Templates of the Left Side of My Body at Ten Inch Intervals* form a mould of the body through consecutive outlines of transverse sections in serpentine strings of neon. This piece, as indeed most of Nau-

man's work, is sculpture conceived as line – sculpture as linear continuity, a characterization that could also apply to Krueger's and Saret's work.

In its scale and concept, Krueger's sculpture (106) might have come from Barnett Newman's painting. His rectilinear contours of thin steel tubes do not simply define the edges of transparent planes; they 'declare space'. Striding in gigantic steps, they grace the void and structure it in a uniquely dynamic way. While all the sections of tube are joined in straightforward, right-angled relationships, the planes which they imply shift at subtly unpredictable angles to each other. Moreover, the fourth edge of each 'plane', if existent at all, contradicts the shape which the other three contours have led us to expect. A curve at the bottom of a hypothetical rectangle, for example, leaves the whole shape equivocal and half-open. This openness, which allows the structures to be interpreted both as planes and as continuous moving contours, accounts for their pronounced ambiguity. And the strictly linear nature of the works, which often causes one to see their closest and most distant parts as exchanging positions in space, contributes further towards a fluctuating perception. Thus, with only a pipe drawing lines as it moves through space, Krueger transforms a gallery or a street into a startling illusion of interpenetrating, immaterial volumes. His preparatory drawings aid the observer to grasp this new order of spatial existence. They are simple coloured crayon diagrams which in turn take on fuller meaning after the sculptures themselves have been experienced. Krueger had to adopt a personal and arbitrary kind of perspective in order to put down on paper his spatial visions.

If Krueger's work suggests Newman's space, Saret's recalls Pollock's. The multiple layers of wire screen (105), like the shimmering lines of paint, weave in and out, twisting and shifting, as they refuse to confine space or define bodies occupying it. Space is conceived as motion – silvery filaments of energy, indeterminate in form. The sensations and images which both artists evoke are nature's. Saret is a sculptor of the country: the swaying fronds of a willow tree; the sun shining on grasses tossed by the wind; balls of seaweed tumbling with the foam along the shore. Everything in Saret's work is growing, given to change, in process of becoming. Even those few pieces where the free exultant movement is somewhat reined in are still quivering with life. Claes Oldenburg has been here too. The young Saret has completely freed the chicken-wire which gave its vitality to Oldenburg's early plaster pieces.

Flexibility is the common denominator in Saret's choice of both form and material – wire mesh, felt, metal springs, soft plastic, wood-shavings, and predominantly chicken-wire. Some of the pieces, especially the ones with the square mesh, are permanently fastened into supple, curvilinear or rippling forms. But most are composed of simple units – thin cylinders, twisted shreds or long waving sheets of chicken-wire – piled randomly together and therefore of an indefinite and changeable form. To this latter category belong also the cut-out strips of felt, plastic and paper that can be hung or piled up in different ways,

and works like the wood-shavings which he shapes with a broom on his studio floor (cf. Nauman's *Flour Arrangements*).

The pale, hazy colours that Saret sprays on some of his pieces are as fleeting and tenuous as the forms and metal mesh on which they hover. Chicken-wire, in spite of its springiness and prickliness, is almost non-existent. It vanishes into the background like a fuzz of clouds, barely indicating its planes in space. In his coloured drawings, independent rather than preparatory, Saret expresses his predilection for immateriality and changing linear rhythms as forcefully as in the sculpture itself.

Linearity, undoubtedly a characteristic of all the work of these artists, reflects their concern with immateriality and indeterminacy: phenomena and experiences that are fugitive or barely perceptible, forms that are changeable and indefinite, materials that have little mass or weight. Underlying other more powerfully expressed currents throughout the century, this preoccupation has only now come to the surface. One might say that many young sculptors today build their tenuous forms with as little matter as possible in opposition to the primary structures which are so indisputably 'there'. Beside the large unyielding blocks which impose their material presence upon space, the younger artists, place emaciated, stringy or malleable creations of perishable or ambiguous nature, which lie modestly low on the floor, lean against the wall, or form space by occupying it with the least substance possible. However, to explain the recent work as a conscious reaction to the primary structures is to overlook the numerous anticipations of the new mode in the *œuvre* of the older artists. Oldenburg's limply hanging plastic and cloth works, Rosenquist's mylar and barbed wire constructions, Sol LeWitt's linear cubes, Carl Andre's flat floor pieces of a single, simple unit in repetition, Don Judd's floor and wall progressions, Robert Morris's early variable and recent free-form works, as well as the younger Eva Hesse's touching sculptures of hanging rope, string, papier-maché and rubber, are among the main threads uniting past and present. Moreover, the two superficially opposed generations are linked by a common involvement with reduction of subject, form and means. The younger Americans carry this tendency to an even further degree as they nearly eliminate the palpable and refuse utterly to be fixed.

Art = Idea ± the Object: Talking with Mel Bochner, 18 April 1972[2]

E.J. Why do you have such an aversion to the object; and what do you mean by 'the object'?

M.B. My aversion, if it is such, is aesthetic, although it might also be psychological. I don't like objects. I don't want to possess things. I don't want the responsibility for the existence of things. Carrying that a little bit further, I

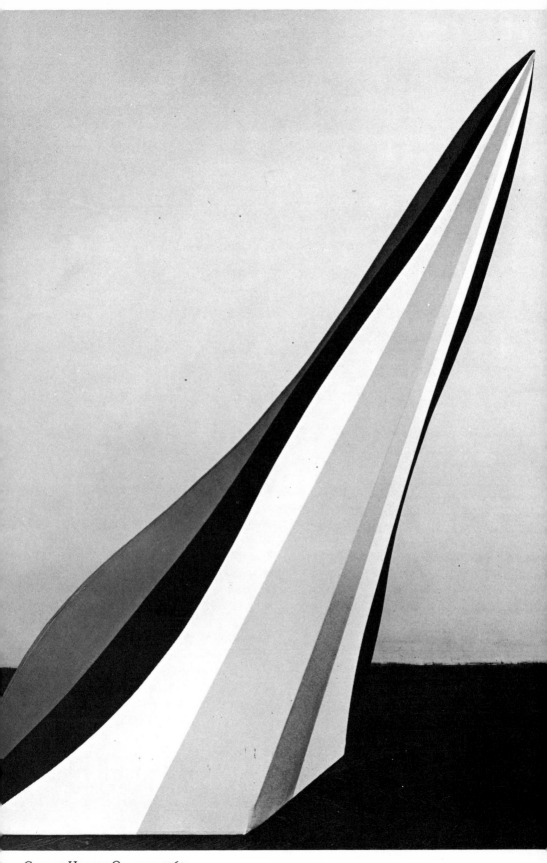

CHARLES HINMAN *Occurrence* 1965

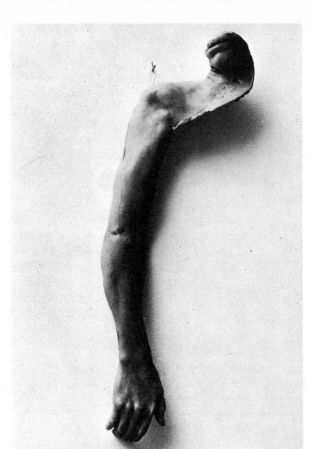

105 ALAN SARET *True Jungle: Canopy Forest* 1968

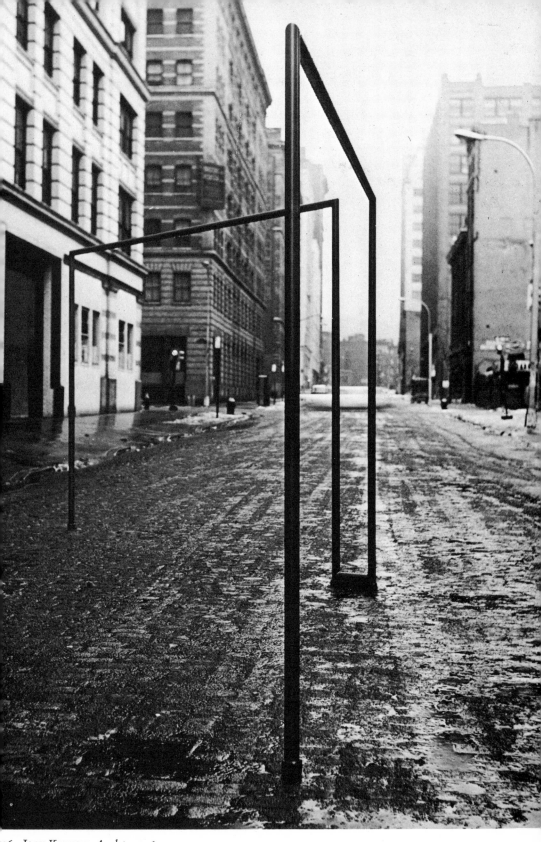

206 JACK KRUEGER *Appleton* 1967

EIGHT SETS "4-WALL"

108　MEL BOCHNER
Eight Sets '4-Wall' 1966

107　MEL BOCHNER *4 Orthogonal
Squares/Order 5* 1966

odds split (7's)

even split (8's)

o.s. (7's)

even split/drop (6's)

109　MEL BOCHNER
Split Sets 1966

don't want to have the responsibility for pieces of furniture which would be
the works of art that I had made.

E.J. You think that might be the reason why you don't make things?

M.B. Certainly it's on more levels than simply saying the aesthetic problem
is I don't like objects.

E.J. No, it's not just an aesthetic problem. It's almost a moral problem the
way you're setting it up.

M.B. It could have a tinge of moralism but I don't think it does for me. In
my art and life I have never valued objects. Their only value was a use value.
What interested me from the very beginning were the kinds of ideas, the kinds
of thinking involved in art.

E.J. Yes, but the idea made visible . . .

M.B. There is not a continuum from more object to less object. Something
is either an object or it doesn't exist, period. There's no question in that. But
during the early 'sixties when I began to think about art, the formula was really
'art = object'. The Johns and the Rauschenbergs and the Stellas were formative
things to my thinking. Everything about them tended to stress their physicality.
The surface, the support, and with Rauschenberg the found objects. I liked their
work very much. But it seemed to me that they didn't need all that para-
phernalia to get across. They were just as strong to me in my memory of them;
once I had the idea of the work, I possessed it.

E.J. But what, for example, is the idea of *Charlene* (21) that is existent without
the physical character of all that red paint and of the parasol and the Statue of
Liberty and all those other objects that are in it?

M.B. Well the confluence of all those objects could certainly be described.
The description can be experienced and the painting can be experienced. They
are simply two different experiences.

E.J. And it can be experienced visually in your memory.

M.B. It can be experienced visually in my memory.

E.J. What is the idea? Can you define it?

M.B. No. An idea doesn't necessarily have a verbal surrogate. You cannot say
the idea is A, B, C, D, E, F. I know what the experience was. And I can recon-
struct part of the intention.

E.J. Yes, but still, in order to convince me that you can reconstruct Rauschen-
berg's intention in *Charlene* and comprehend its idea, you have to be able to
define for me what it is in that work which is distinct from its physical existence.

M.B. It doesn't have to be anything distinct from its physical existence. And
I don't set up my art as being in distinction to anyone else's. It's all art and
everyone defines the characteristics of their own work. I disagree with state-
ments of the type: 'Everything that other sculpture has, my sculpture doesn't
have.' Or, 'I got rid of all those things and my art has other properties.' It
doesn't. Art is always about the same issues. Otherwise originality would be
equivalent to art. It is a false problem. All things that have physical existence

have the exact same *properties*. They have length, breadth, width, colour, surface, density and weight. So my work has all the same properties that a Judd or a Rauschenberg has. The dangerous thing in recent art has been the tendency towards reductivist thinking. You know, you take this away and you take that away and you have this, and you take a little bit more away, until you take it all away, and you have conceptual art. A long time ago I wrote, 'I don't like the term "conceptual art" because of the connotations of an easy dichotomy with perception which are obvious, and inaccurate.' What I know about Rauschenberg's work, for example, *Charlene*, I know about visually. And what you know about my work, you know visually. You have an idea of what my intention is from the evidence I leave. You can begin to reconstruct the intention. And that's really what interests me in art. Once you have that, you've obviated the need for the continuance of the object. It's what Wittgenstein said about philosophy: Imagine the problems of philosophy to be like a milkbottle and the philosopher to be like a fly trapped inside the milkbottle; he can see outside, but he can't get outside. And the role of philosophy was to be the ladder which the fly climbed to get out the milkbottle. Once the fly is out of the milkbottle, the milkbottle is forgotten. And so is the ladder.

E.J. But don't you think it is applicable also to earlier art, that what is really important is the intention, the concept, the non-material fact? A composition by Raphael, for example, has an intellectual basis which is simply put into a physical form, but it is not the physical form of it that is the important thing.

M.B. Agreed. I'm not taking a modernist or a reductive attitude. There's nothing that I could dream of doing that I would in any way consider progress in art. What could be more advanced or profound than Piero della Francesca? There is no development. A profound work of art is a profound work of art. It is not temporal. Art is always trying to do the same thing – be art.

E.J. But it always transcends physicality.

M.B. Yes, if you must, it always transcends its physicality. But I dislike very much that word 'transcend' because it means to be outside the limits of possible experience. That makes it non-sense.

E.J. I am just trying to understand your position: you simply want to make that non-physicality more evident – to release it completely?

M.B. I don't want the viewer to become involved with *specific* physical qualities in a work. It would be inappropriate to look at my art and like it for the formal properties or any of its secondary attributes. I have no feelings about pebbles or masking tape. They are expedient.

E.J. Are the materials interchangeable? Would you just as soon execute the piece called *Meditation on the Theorem of Pythagoras* (57), for example, with pebbles instead of hazelnuts? Would it matter if some forms were jagged and some round? Do you make visual choices of that sort?

M.B. I would like to have the physical and experiential aspects pared down to the point where they simply are a medium, through which the viewer can

reconstruct the intentionality. The process of how you think about my work is what's important to me. Like a theorem in geometry, one can do a demonstration of it here, or in Pittsburgh, or in New York. The steps of that demonstration are available at any time and they are always the same. If I count six pebbles on your pavement, it is the same procedure as counting six pebbles on a pavement in Italy. . . .

E.J. Yes, but when you isolate them and put them out as physical things, then they are physical.

M.B. Yes, of course they're physical.

E.J. They are very different when executed, or 'demonstrated', as you put it, from when they are only existing somewhere on a piece of paper as an idea. To be strict, your proposal alone should be sufficient for what you are doing.

M.B. No, that is the reductive viewpoint; I do not deny physicality. Try this out. . . . The first abstract thought in history must have occurred in either Sumeria or Egypt. It occurred when somebody realized that the geographer and the geometer were doing two different things. Originally the man who did geography, mapping the earth, and geometry, measuring the earth, believed the operations were identical. The Egyptians, you know, had the Pythagorean Theorem and most of Euclidean geometry. They applied it to measuring the land and drawing maps, re-establishing their territories after the river flooded. At some point, someone realized that if you drew a triangle on a piece of paper, you didn't have to pace out the distance from that tree to that rock and then back. You could represent it on a piece of paper. But the first abstract thought was the consciousness that two triangles on separate pieces of paper, derived from separate situations, had common properties. In other words, you didn't even need the paper.

E.J. Actually, that kind of thinking is reflected in Egyptian visual art; the wall painting, for example, is often analysed as a measuring and additive process. It's counting: four legs on each horse in sets of eight, three deep, are represented in clear, horizontal bands, one on top of another, disregarding visual appearance, but making the idea visible. And whatever you say about your work's not having tangible properties, or about its concerns not being texture, colour and so on, I say that there are some visual concerns which consciously or subconsciously operate when, for example, you place a row of numbers simply at your own eye level. But it happens (maybe as pure accident) that the eye level in those pieces has always been at such a perfect placement on the wall.

M.B. But don't you see that anywhere it would be, would be a 'perfect placement'? That term has no meaning.

E.J. But what it is doing is a visual thing.

M.B. Yes, what it is doing is a visual thing. It's dividing the wall.

E.J. But I don't see why, when you concede that there are some visual aspects of your work when you put it in some rooms in Spoleto or in the Modern, you won't accept that what is significant in the work of other artists, like

Mondrian, for example, *is* the idea and not the physical thing? And isn't it also a question of reduction, even though you don't want your work to be defined as reductive ... none the less, you have eliminated several of those physical aesthetic factors, while a few of them still remain, like placement and so on.

M.B. Placement functions at an almost zero degree. My eye level is different in every room that I walk into, yet it is always the same eye level. The room in Spoleto was very low; sometimes I actually bumped my head on the ceiling, so the eye level was very high. At the Modern it was almost in the middle of the wall. In every case it divides the wall in some kind of 'interesting' way.

E.J. You are eliminating the element of any possible choice. You don't have to worry about deciding whether it's going to be up here or down there. But Pollock didn't worry about that either when he started working, when he was swirling lines on. The line just went with the natural physical movement of his body, the way yours goes with the natural reaction of where your eye level is in a room.

M.B. He had an idea about the relation of the type of visuality which he was dealing with to the visuality of earlier art, like impressionism for example.

E.J. There is no recorded word that he ever said about impressionism.

M.B. He said it in his paintings. There are paintings like the white swirly ones ...

E.J. I couldn't agree more

M B. I think it was a brilliant leap to say, 'O.K., to hell with cubism, I'm going back to impressionism,' thereby just eliminating all those questions that everyone else was always concentrating on ... simply bypass Picasso. . . . Pollock *did* care about what colour he used. I *don't* care. When he got down to those black paintings, I think he was really making his best art. It doesn't bother me that they look like figures, because the other ones look like landscapes. What's the difference between looking like a figure and looking like a landscape? He was making different kinds of considerations, like the type of mark or its relation to the size of the canvas.

E.J. I agree with you. But you make decisions too.

M.B. Yes, I do. However, I do not want the focus of interest in my art to be what my relationship is to objectness. A more interesting thing would be what its relation is to literalness. There really isn't any transcendent meaning in the work. There is no spiritual meaning in the particular processes I use. The numbers mean nothing to me. I think there are more interesting aspects to my art than the fact that I didn't use standard art materials. They didn't interest me.

E.J. And numbers did interest you?

M.B. Numbers interested me because they're so available. Everybody counts things. Everybody measures things. It is our way of ordering the disorder around us. All of the operations I have incorporated are transparent. I didn't have to invent my eye level. Claes Oldenburg said, 'I made everything up when

I was six years old.' I haven't made anything up. It is all just there. I use it. Those numbers don't mean anything other than themselves. You could ask me what 'number' means, but I don't know.

E.J. It seems to me that numbers as they appear in your work 'mean' more than they do in Jasper Johns's, for example, because you use them in relation to each other to, as you say, count, measure, and order. . . .

M.B. The number piece I did at the Modern had to do with issues in my condition of being an artist: how is my mind working when I bring something into visibility? When I accepted the invitation to show there, I thought, 'What do I do when I first go into a space? I look around.' So I went there and I looked. Visually I cut a horizontal line, a scanning line through the entire space. The next thing I did was check the surface of the wall with my fingers. I touched the space mentally with my eyes by looking around and I touched the space physically with my hands. That was what the work was. The line was the record of my looking around and the numbers were the record of touching every single spot along that line. That's the literalness of it, the procedure made visible. [In a talk with students the day before our conversation, Bochner had described the piece he did at The Museum of Modern Art, *Three Ideas and Seven Procedures*: 'The three ideas were zero, number and line, which exist without physical embodiment. The seven procedures I formulate for myself as the way in which anything comes into visualization. First you have beginning, then adding, repeating, exhausting (which is coming to the end of a cycle), reversing, cancelling (which is a denial of progression), and stopping. I put a line of masking tape all the way around the space. Beginning with zero, I start to count – 1, 2, 3, 4, 5. Not counting anything, just counting intransitively, marking the tape, so that you will see that I have touched every point on that tape. I begin; that's the first procedure. The second procedure is I add. I begin with zero and I add one, which gives me number. Then I repeat that. 1, plus one; 2, plus one; 3, plus one; 4, plus one; 5. . . . I continue until I get to a natural stopping place which is the end of the tape. However, this being a line gives me something that is progressional, that has a beginning and an end, and I don't want either in my art because that is hierarchical. The only choice I have now is to reverse myself. This I do, starting again with zero and counting backwards over the whole line, cancelling out the first numbers by writing in red ink over black ink until I get back to the first zero. This closes the circle. A natural stopping place. My art is the explication of its own procedure of coming into being.'] I think what is radical about that work is that it does go back to a problem of the quattrocento, actually one of the earliest and most persistent problems in the history of thought – how to unify the discrete and the continuous.

E.J. So you do accept that such concerns have been basic concerns of some earlier art?

M.B. Of course, that's where I saw them!

E.J. What I am trying to get at is why you don't want your work to be a physical object that can be taken from one place and put some place else.

M.B. That might be a political concern.

E.J. Do you think that could be part of your generation? So many people nowadays relinquish possessions on moral grounds. And they want to be mobile; they don't want to be fixed and held. . . . But I'm sure it's more than that with you.

M.B. It's also that I had my own frustration with the initiation into fine arts skills. I have been around paint, brushes, canvas and stretchers and masonite and wood since I was six years old. I was an apprentice sign-painter. So when I went to art school the things that they were teaching were so basic; I couldn't believe that anybody did not know how to use simple tools! What baffled me was how those basic skills could lead to the making of art; they just led to the making of signs, billboards. . . . It seemed that all anyone talked about was craft.

E.J. What it amounts to is how you came to define art for yourself.

M.B. The emphasis in art school was on post-impressionist and Bauhaus design. It just didn't correspond to anything that I wanted to do. It was a training in dumbness. Then one professor, Robert Lepper, a very great man, said to me, 'You don't have to be dumb to be an artist.' And I said, 'That is not what everybody else is telling me.' One instructor told me, 'Your trouble is you read too many books. You are a pseudo-intellectual.' And I said, 'Well, what do you expect? I can't be a real intellectual yet, I'm only nineteen.' . . .

[Long discussion of Bochner's further education and other biographical data which he prefers not to have published.]

E.J. And so you took that first step. . . . You did these *Number Drawings* in 1965–6, reproduced here in the *Art in the Mind* catalogue.[3] . . .

M.B. These drawings have nothing to do with the making of objects; they are about the mental manipulation of numbers. In this one, for example [107], all four blocks start 0, 1, 2, 3, 4. In each block every line is different horizontally (except the first line) and different vertically. And so it's all the possibilities of changing just the relationships of those numbers. . . . These [108] all have 4 in the centre; once I had that essential, then everything had to be on a 7 × 7 grid. My first problem was discovering 7 × 7; the second was to decide what to do with the centre – how to deal with the centre, because 7 × 7 gives you a centre, whereas in 6 × 6 you wouldn't have a centre (because it divides in halves). The third question is the four quadrants. One thing you can do is fill each of these squares (A) with the same number, all 1, 2, 3, 4, counter-clockwise. Or (B) you can go 1, 2, 3, 1, 2, 3, 1, 2, 3, 1, 2, 3, and then 3, 2, 1, 1, 2, 3, 3, 2, 1, 1, 2, 3. Then I had another problem, what to do with the centre in each of the four quadrants. Well, there is the diagonal, and the diagonal (the 3s in B) solves it. Now, a rule is that these drawings must be symmetrical. So the fourth question was the type of symmetry. The type of symmetry in this (B) would be

like a folding symmetry; and the type of symmetry in this (C) is circular symmetry. In this one (B) it is a bilateral symmetry, and this (C) is identical, but in reverse ... they simply have 1, 2, and 3, 1, 2, and 3, 1, 2, and 3, but in rotation. In (D) the 4s extend out like a swastika. ... Here (E) it's 4s and 4 blocks. ... Here (F) it's very similar to this one, only I start in the centre with 4, then move out with 3, in two different procedures. In (G) I did a similar thing, only I made corner squares of 1s, of 2s, then 3s, then 4s, going around clockwise. Then (F), angles of 4s, angles of 3s, angles of 2s, going around the opposite way. ... And here (H) I tied the swastika back in on itself and made a number pretzel. ... They go on and on [109]. This [*odds split (7's)*] is a 7 × 7 square, taken apart on the diagonal and pulled out. ... It's a kind of amusement – just considering the number of possible approaches I might take on any problem. Other ones at this time deal with how to integrate two different systems – something I became concerned with a lot, later on. The thing was never to repeat.

[Discussion of Bochner's published art criticism and the recent work of those artists he had written about, including Sol LeWitt's wall drawings.]

M.B. Sol has an idea and it comes out looking beautiful. But the fact that it does, I maintain, is of secondary interest. It's like a natural phenomenon. It's like the grass there. It didn't set out, didn't have the intention, to be green because green is a beautiful colour. That grass is beautiful; but, you know, you can't talk to the grass about it.[4]

Notes

CHAPTER ONE

1 Picasso, quoted in Christian Zervos, 'Conversation avec Picasso', *Cahiers d'art*, Vol. 10, No. 10, 1935, p. 174; translated in Alfred H. Barr, Jr, *Picasso – Fifty Years of his Art*, London and New York 1946, p. 273.

2 Picasso, quoted in Françoise Gilot and Carlton Lake, *Life with Picasso*, New York 1964 (Harmondsworth 1966), p. 77.

3 Rainer Crone, *Andy Warhol*, London and New York 1970, p. 29.

4 Cézanne, quoted in John Rewald, *Paul Cézanne, A Biography*, New York 1948 (London 1974), p. 135, from Joachim Gasquet, *Cézanne*, Paris 1926, p. 205.

5 Cézanne, Letter CLXIX, to Emile Bernard, 26 May 1904, in John Rewald (ed.), *Paul Cézanne Letters*, London 1941, p. 237.

6 Cézanne, Letter CCXXX, to Roger Marx, 23 January 1905, in ibid., p. 248.

7 Picasso, quoted in Joseph A. Barry, *Left Bank, Right Bank*, New York 1951, p. 146.

8 Picasso, quoted in Zervos, op. cit., p. 178, translated in Barr, op. cit., p. 274.

9 Malevich, 'Suprematism', in his *Non-Objective World*, translated by H. Dearstyne, London and Chicago 1959, pp. 67–8.

10 Mondrian, 'De l'art abstrait, réponse de Piet Mondrian', *Cahiers d'art*, Vol. 6, No. 1, 1931, p. 42.

11 Kandinsky, 'On the Artist', translated by Ellen H. Johnson and Gösta Oldenburg, *Artforum*, Vol. 11, No. 7, March 1973, p. 78.

12 Judd, 'Lee Bontecou', *Arts Magazine*, Vol. 39, No. 7, April 1965, p. 17.

13 Morris, in 'A Duologue' with David Sylvester, recorded by the BBC in New York, March 1967, published in Michael Compton and David Sylvester, *Robert Morris*, exhibition catalogue, Tate Gallery, London 1967, p. 19.

14 Judd, quoted in John Coplans, *Don Judd*, exhibition catalogue, Pasadena Art Museum 1971, p. 32.

15 Stella, in Bruce Glaser, 'Questions to Stella and Judd', *Art News*, Vol. 65, No. 5, September 1966, pp. 58–9. An interview broadcast over WBAI-FM, New York, March 1964.

16 Rosenblum, *Frank Stella*, 'Penguin New Art' series, Harmondsworth 1971, p. 36.

17 Stella, quoted in William S. Rubin, *Frank Stella*, New York 1970 (London 1971), p. 58.

18 Newman, quoted in *United States of America Exhibition* catalogue, VIII São Paulo Biennial, 1965, n.p.

19 Rauschenberg, 'Painting relates to both art and life. Neither can be made. (I try to act in that gap between the two.)', quoted in Alan R. Solomon, *Robert Rauschenberg*, exhibition catalogue, Jewish Museum, New York 1963, n.p.

20 Duchamp, in a conversation with Emily Genauer, 'The Lively Arts', *New York Herald Tribune*, 4 December 1960.

21 Varèse, 'Music as an Art-Science', *Bennington College Alumnae Quarterly*, Vol. 7, No. 1, Fall 1955, p. 25.

22 Allan Kaprow, 'The Legacy of Jackson Pollock', *Art News*, Vol. 57, No. 6, October 1958, pp. 56–7.

23 From Oldenburg's Notebooks, 1961, published in his *Store Days*, London and New York 1967, p. 13.

24 Published in *Environments, Situations, Spaces*, exhibition catalogue, Martha Jackson Gallery, New York 1961, reprinted in longer form in Oldenburg, ibid., pp. 39–42.

25 See Bokris-Wylie, 'Mayday Ray Graduates Collage', *The Drummer*, 15 May 1973, p. 3.

26 Scull, quoted in David L. Shirey, 'Impossible Art – What It Is', *Art In America*, Vol. 57, No. 3, May–June 1969, p. 34.

27 Andre, quoted in Enno Develing, *Carl Andre*, exhibition catalogue, Haags Gemeente Museum, The Hague 1967, p. 40.

28 Oppenheim, in L. Hershman, 'Interview with Oppenheim', *Studio International*, Vol. 186, No. 960, November 1973, p. 196.

29 Andre, quoted in Lucy R. Lippard, *Six Years: The Dematerialization of The Art Object*, London and New York 1973, p. 47, from a symposium moderated by Dan Graham with Carl Andre, Robert Barry, Lawrence Weiner, Windham College, Putney, Vermont 1968, exhibition organized by Seth Siegelaub.

30 Morris, 'Some notes on the Phenomenology of Making: The Search for the Motivated', *Artforum*, Vol. 8, No. 8, April 1970, p. 66.

31 Schum, in *Land Art*, catalogue of films, 1969, cited in Lippard, op. cit., p. 94.

[32] De Maria, published in Gregoire Müller, *The New Avant-Garde*, London and New York 1972, pp. 150–57.

[33] Weiner, from 'Art Without Space', symposium broadcast 2 November 1969, WBAI-FM, New York, moderated by Seth Siegelaub, with Weiner, Barry, Huebler, Kosuth; quoted in Lippard, op. cit., p. 130.

[34] Kosuth, 'Introductory Note by the American Editor', *Art-Language*, No. 2, February 1970, quoted in Lippard, op. cit., p. 147.

[35] Huebler, in catalogue statement, Siegelaub's *January 5–31, 1969* show, cited in Lippard, op. cit., p. 74.

[36] Burgin, 'Situational Aesthetics', *Studio International*, Vol. 178, No. 915, October 1969, p. 119.

[37] Ibid., pp. 120–21.

[38] Andre, in a symposium moderated by Lucy R. Lippard, 8 March 1970, WBAI-FM, New York, with Huebler, Graham, Andre, Dibbets, quoted in Lippard, op. cit., p. 157.

[39] Barry, from 'Art Without Space' (see note 33), quoted in Lippard, op. cit., pp. 130–31.

[40] Bochner, from 'Problematic Aspects of Critical/Mathematic Constructs in My Art', lecture given at ICA, London, April 1971, cited in Benthall, 'Bochner and Photography', *Studio International*, April 1971 and in Lippard, op. cit., p. 236.

[41] From Klein's conditions of sale, quoted in *Yves Klein*, exhibition catalogue by McShine, et al., Jewish Museum, New York 1967, p. 19.

[42] Illustrated in ibid., p. 14.

[43] Graham, in his collected works, *Dan Graham*, London and Cologne 1972, n.p.

[44] Wegman, quoted in Liza Béar, 'Man Ray, Do You Want To . . . An Interview with William Wegman', *Avalanche*, No. 7, Winter/Spring 1973, pp. 40–41.

[45] Warhol, quoted in Stephen Koch, 'The Once-Whirling Other World of Andy Warhol', *Saturday Review/World*, 25 September 1973, p. 24.

[46] Beuys, quoted in W. Sharp, 'An Interview with Joseph Beuys', *Artforum*, Vol. 8, No. 4, December 1969, p. 44.

[47] LeWitt, 'Sentences on Conceptual Art', *0–9*, No. 5, January 1969, reprinted in Lippard, op. cit, pp. 75–6.

[48] Smithson, 'Fragments of an Interview with P. A. Norvell, April 1969', published in Lippard, op. cit., p. 89.

CHAPTER TWO

[1] Fritz Novotny, *Cézanne*, London 1961, p. 5 (first published 1937). I am indebted to John Rewald, Léo Marchutz, Fritz Novotny and other Cézanne scholars who have been helpful in correspondence and conversation regarding this watercolour.

[2] In the catalogue of the *Paul Cézanne* exhibition, Vienna, Österreichische Galerie, Oberes Belvedere 1961, p. 13.

[3] Particularly his ground-breaking *Cézanne und das Ende der wissenschaftlichen Perspektive*, Vienna 1938.

[4] To Joachim Gasquet, 30 April 1896, in Rewald, *Paul Cézanne Letters*, CXXIV, p. 199. My translation of this passage (in the preceding essay) is slightly different.

[5] Cézanne directly identifies his 'ideal of art' as 'a conception of nature', Rewald, ibid., CLXXX, to Roger-Marx, 23 January 1905, p. 248.

[6] Quoted in Rewald, *Paul Cézanne, a Biography*, p. 135. The passage comes from Gasquet, *Cézanne*, p. 205.

[7] Letter CLXIX, to Émile Bernard, 26 May 1904, in Rewald, *Paul Cézanne Letters*, p. 237.

[8] Reproduced in Adrien Chappuis, *Les Dessins de Paul Cézanne au Cabinet des Estampes du Musée des Beaux-Arts de Bâle*, 1962, no. 47, p. 39 of plates, Inv. 1934, 168.

[9] Venturi's original date was 1882–5; it is my understanding that 1883–5 will be used in the revised edition.

[10] Venturi's title; it is also called *Le Grand Pin à Montbriant*, as in the catalogue by Charles Sterling of the Cézanne exhibition at L'Orangerie, 1936, no. 71, pl. XXVIII.

[11] Reproduced in colour, Charles Sterling, *Great French Painting in the Hermitage*, New York 1958, pl. 86, p. 113.

[12] About 1885 for the Lecomte and about 1890 for the Leningrad are the dates which Rewald has recently arrived at for the revised Venturi catalogue which is being published by the New York Graphic Society. It seems to me that 'about 1885' for the Lecomte picture should be interpreted as 1883–5 and especially so if that date is to be maintained for the Hahnloser picture, *Vue de l'aqueduc au nord d'Aix*, V. 296, which is stylistically so thoroughly like the Lecomte painting. The Leningrad painting is given as late 1890s in M. Levinson-Lessing, *Catalogue of the Paintings of the Department of Western Art of the Hermitage Museum*, Leningrad 1958, no. 8963, pl. 363, p. 444; and as about 1890 in

Pierre Descargues, *The Hermitage Museum, Leningrad*, New York 1961, ill. p. 299; called *Pine-tree near Aix*.

[13] The long, rather narrow horizontal format is frequently used in the watercolours, whereas in the oils there is a marked tendency to square up the proportions, perhaps more in keeping with a 'classic' conception.

[14] Quoted in Alfred H. Barr Jr, *Matisse, His Art and His Public*, New York 1951 (London 1967), p. 120.

[15] *Le Grand Arbre*, not in Venturi; given as 1885-7 in the catalogue of the Columbia University Cézanne watercolour exhibition at Knoedler Gallery, New York 1963, no. 22. Reproduced in colour, *Time* magazine, 19 April 1963.

[16] Reproduced in colour, Georg Schmidt, *Aquarelles de Paul Cézanne*, Basle 1952, pl. 11. Venturi dated it 1885-90, but its stylistic maturity indicates that it must be placed at the outer limit of that date and it was so assigned (*c.* 1890) in the 1956 Cézanne exhibition in Aix, no. 72, catalogue dates by Douglas Cooper and Léo Marchutz; it is my understanding that it will also be given that date in the new Venturi. Another drawing of the same tree, V. 1494, at a slightly different angle and less finished than the others, was loaned by the Earl of Sandwich to the Arts Council Cézanne watercolour exhibition, cat. no. 29, 1946. Listed by Venturi as 'ancienne collection Bernheim-Jeune', and placed at 1885-90, it was acquired from Bernheim-Jeune by Halvorsen in 1920 and from him by Brown & Phillips in 1925. It is doubtful that the oil painting, *Le Grand Pin*, V. 669, 1892-6, now in the São Paulo Museum, is the same tree.

[17] Letter no. 195, to Theo, *The Complete Letters of Vincent van Gogh*, London and New York 1958, I, p. 360.

[18] Quoted in Lionello Venturi, *Cézanne, son art – son œuvre*, Paris 1936, I, p. 20.

[19] Meyer Schapiro, *Paul Cézanne*, New York 1952 (London 1953); 'Cézanne as a Watercolorist' in catalogue of the Columbia – Knoedler exhibition; and his lecture, 'The Humanity of Cézanne', delivered at the Art Institute of Chicago, 26 February 1952, on the occasion of the Cézanne exhibition.

[20] Theodore Reff, 'Cézanne: the logical mystery', *Art News*, v. 62, no. 2, April 1963, pp. 28-31, ref. p. 30.

[21] Acc. no. 62.38, then called *Landscape near Aix*, pencil and watercolour, 12¼ × 18⅞ ins. Purchased from Vollard, July 1936 by Alex Reid & Lefevre; sold to Oswald T. Falk, October 1936; included in Cézanne exhibition, Reid & Lefevre, June 1937, no. 33; purchased from exhibition by Mrs Chester Beatty; from her estate to Paul Rosenberg & Co., 1952; who presented it to Oberlin, 1962.

[22] Adrien Chappuis accepts Rattcliffe's figure of 90, while reminding us that Rewald gave 100 and Cooper only 50.

[23] Georg Schmidt, op. cit., p. 17.

[24] It was published with this date in the *Allen Memorial Art Museum Bulletin*, XX, 2, 1963, p. 70, and in the catalogue of the Columbia–Knoedler exhibition, no. 72.

[25] Alfred Neumeyer, *Cézanne Drawings*, New York and London 1958, no. 79, ill., text, pp. 58-9.

[26] *Cézanne*, exhibition, Reid & Lefevre, London 1937, no. 33.

[27] The best known oils of this motif are V. 452, Metropolitan Museum; V. 454, Courtauld collection; V. 455, Phillips Gallery. Venturi placed them all at 1885-7, but it is quite likely that their dates will be changed in the revised catalogue, V. 452 possibly earlier and V 454 later.

[28] In a letter to E. Johnson, 14 August 1963.

[29] Venturi, I, p. 162.

[30] Reproduced in colour, Schmidt, op. cit., pl. 10.

[31] In a sketchbook belonging to Leigh Block is a pencil drawing of the same subject as the Albertina watercolour; it is a lively little first thought in line, noting the view and forming the plan of the picture. Reproduced in John Rewald, *Paul Cézanne, Carnets de dessins*, Paris 1951. It is called *Vue de la vallée de l'Arc* (verso of *Enfant dormi*), 5th carnet p. XXII, pl. 46. According to Rewald, the drawings in that carnet are mostly from 1875-85.

[32] From the standpoint of biographical evidence also, Cézanne could easily have executed the watercolour at that time, since he was mostly in and round Aix in 1883-5 (as well as 1885-7); but to place the work, as has sometimes been suggested, from 1879-82 would be less easy since he was not in the area from March 1879 to November 1881 nor from March to October 1882.

[33] Venturi, I, p. 55.

CHAPTER THREE

[1] Henry T. Tuckerman, *Book of the Artists: American Artists Life*, New York 1882 (first published 1867), p. 511.

Notes

[2] George W. Curtis in the 'Editor's Easy Chair', *Harper's New Monthly Magazine* XLVI, March 1873, p. 612. Reprinted in Century Association, *Eulogies on John F. Kensett, Proceedings at a Meeting of the Century Association, Held in Memory of John F. Kensett, December 1872*, New York n.d., pp. 24–9.

[3] While today the tremendous number of museum and gallery exhibitions (including artists' cooperative shows) has made it unnecessary for the artist to exhibit in his studio, has not something of importance been lost in the modern method? Does the crowded cocktail party at which the painter occasionally appears eliciting excited whispers ('Is that the artist over there in the turtleneck sweater?' 'O, no, it can't be; I've heard he looks just like a business man!') really take the place of the artist's friendly conversation about his work in the ease of his own surroundings? Granted that a loft on Broadway now is a far cry from the studios of a hundred years ago, and granted that in 1855 the American artist and his patron and even the general public were more in accord as to the purpose and meaning of art than are the artist and public now, still the present chasm might be narrowed if today's artist opened his studio for a short time at fairly regular intervals. However, even assuming the artist's willingness and the complete desirability of such a practice, this half-serious suggestion would probably not be feasible for many reasons, not least of which is the artist's obligation to his dealer. (1975: See the first essay for my more recent thoughts on this problem.)

[4] Since this article appeared, a full-scale exhibition of Kensett's work has been circulated by the American Federation of Arts, selected by John K. Howat, who wrote the excellent catalogue, New York 1968.

Exhibited at the National Academy of Design prior to the sale, 24–9 March 1873, in Association Hall, Y.M.C.A., of *The Collection of over Five Hundred Paintings and Studies, by the late John F. Kensett*, Robert Somerville, Auctioneer. Fifty Kensetts were included in the Thomas Kensett sale, 22–3 November 1877, *Catalogue of the entire collection of paintings belonging to the late Thomas Kensett, Esq., Baltimore, comprising examples by American and foreign artists, selected by the late John F. Kensett, Esq., and formerly loaned to the Metropolitan Museum of this city*, The Messrs Leavitt, Auctioneers, New York 1877. Also in 1877 thirty-one Kensetts were included in *Robert M. Olyphant's Collection of Paintings by American Artists*, exhibited at The National Academy of Design and sold at auction, Chickering Hall, R. Somerville, Auctioneer,

18–19 December 1877, 'arrangements under superintendence of Samuel P. Avery'.

[6] Metropolitan Museum of Art, *Descriptive Catalogue of the Thirty-Eight Paintings, 'The Last Summer's Work' of the late John F. Kensett, Presented by Mr Thomas Kensett of Baltimore, Maryland, and the Three Paintings 'The Cross and the World' by the late Thomas Cole, presented by Vincent Colyer, Esq. of New York to the Metropolitan Museum of Art, 128 West Fourteenth Street*, New York 1874. (1975: Some of the paintings from this bequest were sold at Parke-Bernet, 24–6 October 1956.)

[7] Margaret Breuning, 'Kensett Revalued in the Light of Today', *Art Digest*, XIX, 1 February 1945, p. 10. Elizabeth McCausland, 'John F. Kensett, Painter of American Landscapes', *The Springfield Sunday Union and Republican*, 11 February 1945, p. 40. Later appeared a more ambitious article by Frederic W. Kilbourne, 'A White Mountain Artist of Long Ago', *Appalachia*, new series XVIII, 8, 1947, pp. 447–55.

[8] Century Association, op. cit., contains contributions by Daniel Huntington, Thomas Hicks, John Gourlie, Rev. Bellows, Rev. Osgood and George W. Curtis.

[9] Evidence for 1818 is supplied by two passports issued to Kensett, one in 1856 stating his age as thirty-eight, and the other in 1861 as forty-three. Tuckerman, op. cit., p. 510, writing five years before Kensett's death, gives the birth date as 1818; so does *The New American Cyclopaedia*, New York 1870, X, 137, for which the information may have come directly from the artist inasmuch as there is in the possession of J. R. Kellogg, grandnephew of J. F. Kensett, a letter to Kensett from the editor of *The New American Cyclopaedia*, C. S. Weyman, requesting biographial information, 7 April 1860. The Kensett papers belonging to J. R. Kellogg were indexed for him by Albert Ten Eyck Gardner, Archivist, The Metropolitan Museum of Art, in 1950.

[10] Three genealogies give 1816, as does the tombstone in Green-Wood Cemetery, Brooklyn. See Samuel Bradlee Doggett, *A History of the Doggett-Daggett Family*, Boston 1894, p. 192; George Frederick Tuttle, *The Descendants of William and Elizabeth Tuttle*, Rutland 1883, pp. 471–80; and a manuscript genealogy in the possession of J. R. Kellogg. If John F. Kensett had been born in 1818, not only would the sequence of issue be erroneous, but John F. would have been born only seven months after his sister Elizabeth. The inscription on the tombstone reads: 'John F. Kensett / Landscape Painter / Born March 22, 1816 / Died

December 14, 1872 / Blessed are the pure in heart for they shall see God.'

[11] Letter is in the Kellogg collection; it is to 'Uncle Fred and Grandmother Newbury' (his father's mother had remarried after his grandfather's death). It is quite possible that at some time in his life Kensett himself became confused about his birth date and thought himself younger than he was (if he gave it a thought), but with his gentle disposition he would surely pardon a meddling student for adding two years to his age.

[12] J. F. Kensett letter, quoted above, 27 June 1831, to Uncle Fred and Grandmother Newbury, Kellogg collection.

[13] Found in the attic of Kensett's mother's home, 668 Nostrand Street, Brooklyn, which J. R. Kellogg inherited in 1933, this Journal was presented by Harry S. Newman to the Whitney Museum of American Art and has now been turned over to the Frick Art Reference Library.

[14] The original painting by W. S. Mount is lost; Kensett's oil copy, *The Cottage Door*, is in the Suffolk Museum, Stony Brook, Long Island.

[15] From Draper, Toppan & Co, Draper, Underwood & Co, and S. S. Jocelyn.

[16] The Kensett Journals in the Kellogg collection contain entries on the following dates: 1–5 June 1842; 29 August–13 September 1845; c. 12 April 1847; 3–22 November 1847; 9 July 1856.

[17] To Thomas P. Rossiter, collection of The New York Historical Society.

[18] Algernon Graves, *The British Institution, 1806–67*, London 1908, lists the following Kensetts exhibited in 1845: 163. *Scene in Forest of Fontainebleau*; 167. *A Peep in Windsor Forest*; 179. *A Scene from Nature*; 433. *Watering Cattle*. In Algernon Graves, *The Royal Academy of Arts: A Complete Dictionary of Contributors and their work from its foundation in 1769 to 1904*, London 1905–6, IV, 318, are listed for Kensett in 1845: 324. *A Peep at Windsor Castle from St. Leonard's*; and 1279. *The Old Oak – Afternoon*.

[19] In 1843: 12. *Scene on the Wye, England*; 28. *Landscape*; in 1845: 24. *Outskirts of Windsor Forest*; 25. *The Mountain Stream*; 53. *Scene from Nature*; 58. *Foot Path in Burnham Forest*; 59. *A Peep in Windsor Forest*; 62. *Autumnal Scene*; 65. *Landscape – Afternoon*; in 1846: 108. *Northern Italy – A Scene of the Middle Age*; in 1847: 237. *The Rhine*, listed in Mary Bartlett Cowdrey, *American Academy of Fine Arts and American Art-Union*, New York 1953, II, *Exhibition Record, 1816–52*, pp. 212–13.

[20] *Ibid.*, I, pp. 146 (quoted by Baker from the *American Art-Union Bulletin* for 1849).

[21] *Ibid.*, p. 134.

[22] In 1845: 125. *Landscape, the Outskirts of Windsor Forest*; 133. *The Mountain Stream*; 140. *View near Richmond, England*; 226. *An Avenue in Hatfield Park, the Seat of the Marquis of Salisbury*; in 1847: 177. *Twilight View of Rome from the Borghese Garden*; 248. *Scene in Upper Italy in the Middle Age*, listed in Cowdrey, *National Academy of Design Exhibition Record 1825–1860*, New York 1943, I, pp. 274–5.

[23] Benjamin Champney, *Sixty Years' Memories of Art and Artists*, Woburn 1900, p. 59.

[24] Kensett Journal, 1 October 1840, Frick Art Reference Library.

[25] Champney, op. cit., p. 61.

[26] *Ibid.*, p. 70.

[27] Reference should be made here to a group of several hundred drawings which appeared on the market in the late 1940s as Kensetts, but which from chronological, and to some extent stylistic, evidence could not have been done by him. These drawings, often of considerable appeal in their own right, have now found their way to many private and public collections, including the Corcoran Gallery of Art, the Karolik Collection in the Boston Museum of Fine Arts and The Detroit Institute of Arts. The group in Detroit, numbering about 300 drawings, was studied by the curator, Paul Grigaut, who, before their acquisition in 1949, questioned their attribution to Kensett and proposed what appears to be an entirely likely attribution.

[28] Century Association, op. cit., p. 8.

[29] *Ibid.*, p. 26; also in George W. Curtis, op. cit., p. 611. For further material on this group of American artists in Italy, see George Willis Cooke (ed.), *Early Letters of George William Curtis to John S. Dwight*, New York and London 1898 (no specific Kensett references), and Madeleine B. Stern, 'New England Artists in Italy, 1835–55', *The New England Quarterly*, XIV, 1941, pp. 243–71.

[30] For many years (1852–66), Kensett had his studio and residence at the Waverley House, 697 Broadway, at the corner of 4th Street; before that at New York University (1849–51); from 1867–9 at 1193 Broadway, and from 1870–72 in the Association Building, Y.M.C.A., at the southwest corner of 23rd Street and Fourth Avenue.

[31] 'Mr. Kensett has lately returned from an excursion to the headwaters of the Missouri': 'Domestic Art Gossip', *The Crayon*, IV, August 1857, p. 252; see also December 1857, p. 377.

[32] That Kensett was in Europe in 1867 or later is based on the evidence of a photograph of him, in the Kellogg collection, on the back of which is printed 'Bingham / Médaille de 1re classe 1855–1862–1867. . . . Rue de Larochefoucauld, 58, Paris'.

[33] The date of the Colorado trip has often been given as 1866 (James T. Soby and Dorothy C. Miller, *Romantic Painting in America*, New York 1943, p. 137; Frederick A. Sweet, *The Hudson River School*, Chicago 1945, p. 86; Bartlett Cowdrey, 'The Return of John F. Kensett', *The Old Print Shop Portfolio*, IV, 1945, p. 135; John I. H. Baur, *The Coast and the Sea*, Brooklyn 1948, p. 23), but I have not been able to locate any documentation for this date, whereas there are drawings by Kensett in the Kellogg collection inscribed with names of places in Colorado and dated in July, August and September 1870. It is known that Kensett made his trip to Colorado in company with Worthington Whittredge and I believe it has been assumed that this referred to Whittredge's 1865–6 trip. However, Whittredge in his *Autobiography* (edited by John I. H. Baur, *Brooklyn Museum Journal*, 1942, p. 64) mentions two later trips to Colorado, one for the purpose of changing something in his painting *Crossing the Ford, Platte River, Colorado*. This picture, in the Century Association, is signed 'Worthington Whittredge 1868 & 1870'. It is thus possible to assume that he was in Colorado in 1870 and that it was on this occasion that he was accompanied by Kensett and Sanford R. Gifford.

[34] Editorial on the National Academy of Design exhibition, *The Crayon*, V, 1858, p. 147.

[35] Kensett refers to the end of the four years' civil conflict which had 'covered God's green fields with fraternal blood' in his comments as president, *VIth Annual Report of Artists' Fund Society*, 1865–6, p. 12.

[36] Kensett Journal, 3 June 1840, Frick Art Reference Library.

[37] The following four quotations are from Bryant's 'A Forest Hymn' and 'Lines on Revisiting the Country', both 1825. James Jackson Jarves called Kensett 'the Bryant of our painters' in his *The Art Idea*, New York 1864, p. 235 (and Inness 'the Byron').

[38] Published as a series of nine 'Letters on Landscape Painting' in *The Crayon*, vols I–II, 1855.

[39] S. G. W. Benjamin, writing in 1880, notes that 'before the great modern question of the values began to arouse much attention in the ateliers of Paris, Kensett had already grasped the perception of a theory of art practice which has since become so prominent', *Art in America, a Critical and Historical Sketch*, New York 1880, pp. 63–4.

[40] Volume for 4 October 1840 – 30 May 1841, Frick Art Reference Library.

[41] See Durand's *Sunday Morning*, 1839, and *Woodland Brook*, 1859, in the New York Historical Society and his *A Catskill Stream*, 1867, in the Brooklyn Museum, and Casilear's *River Scene, Catskill*, 1861, in the New York Historical Society. (In this sensitive painting, as in most of his, Casilear is very close to Kensett, but not quite equal in firmness of structure and authority of drawing in paint.)

[42] Kellogg collection, pp. for 1861–3 missing, 1864 is on a loose sheet.

[43] Reproduced in Edgar P. Richardson, *American Romantic Painting*, New York 1944, pl. 150 and in Sweet, op. cit., no. 129.

[44] This was one of four paintings by Kensett exhibited in Paris at the Universal Exposition of 1867 and later at the National Academy of Design. See the latter's 1867–8 *Catalogue of First Winter Exhibition including . . . the works from the American Art Department of the Paris Universal Exposition*, nos. 643, 650, 660, 674.

[45] Sale of pictures amounted to $125,769, not including the prices of frames, listed separately; with frame prices the figure is $136,312.62. This is the total of the individual items listed completely after each day's sale in the *New York Daily Tribune*, 25–31 March 1873. The only priced catalogue of this sale which is known, now in the New York Public Library (inscribed 'C Butler, 136 Mad Ave') is not completely priced and the total $137,000 written on it, probably by the owner of the catalogue, is apparently his estimate to include items which he failed to note, and probably frame prices.

[46] Manuscript, brief biographical note on J. F. Kensett, Kellogg collection.

[47] In the Whittredge *Autobiography*, John I. H. Baur (ed.), op. cit., p. 60.

[48] Mary Bartlett Cowdrey gives 1849 and 1850 in her *National Academy of Design Exhibition Record 1826–1860*, New York 1943, p. 274; but in accordance with the records of meetings of the National Academy of Design the dates should be 1848 and 1849.

[49] There is among the Kellogg papers a manuscript volume inscribed 'Cash Book, Fellowship Fund, National Academy of Design, Jas A. Suydam Treas.' which lists contributors and amounts from 1863 to 1866. It appears to have been used as a scrap book with items pasted on some of the pages; and several of the blank pages contain Daggett genealogical notes, written after Kensett's death.

[50] House of Representatives Document, 36th Congress, Ex. Doc. No. 43, *Report of the Art Commission*, 1860, p. 3.

[51] Ibid., p. 5. For a discussion of the Art Commission, see Charles E. Fairman, *Art and Artists of the Capitol of the United States of America*, Washington, D.C. 1927.

[52] Letter to Kensett, 26 October 1863, Kellogg collection.

[53] Editorial, *The Aldine*, VI, 1873, p. 48.

[54] A more complete list of artists present will be found in 'An Artist's Funeral', *New York Tribune*, 19 December 1872, p. 2. Kensett died suddenly on 14 December 1872, at his studio in the Y.M.C.A. building. He had contracted pneumonia from exposure in November while attempting to recover the drowned body of Mrs Vincent Colyer; but the immediate cause of his death was ascribed to heart disease. The funeral service was held at the Presbyterian Church, the body having first been placed in the library of the National Academy of Design. After the funeral the body was taken to the Marble Cemetery and later to Green-Wood where it now rests.

CHAPTER FOUR

[1] 'Je mets dans mes tableaux tout ce que j'aime. Tant pis pour les choses, elles n'ont qu'à s'arranger entre elles.' From Christian Zervos, 'Conversation avec Picasso', *Cahiers d'Art*, 1935, vol. 10, no. 7–10, pp. 173–8. The translation used here is that given in Alfred H. Barr, Jr., *Picasso – Fifty Years of His Art*, p. 272.

[2] From the same conversation with Zervos; this translation from Barr, op. cit., p. 273.

[3] Roger Fry, 'The Double Nature of Painting', *Apollo*, May 1969, p. 366. From a lecture delivered in French in Brussels, 1933 (abridged in translation by his daughter, Pamela Diamand).

[4] It has been called to my attention that Sidney Janis prepared an exhibition in which he presented an analysis and justification of the cubist method and identification of natural forms through photographs and graphic analyses of Picasso's *Seated Man*, of 1911, shown in the members' room of The Museum of Modern Art in connection with the Picasso show in 1939. Mr. Janis's exhibition, which unfortunately I did not have the privilege of seeing, was circulated by The Museum of Modern Art until 1943 when it was disbanded, and according to the Museum no longer exists.

[5] The glass is quite possibly of the same basic shape as the one which appears in Picasso's *L'Étagère*, 1912, where it is presented in a more nearly continuous profile view. Reproduced in Christian Zervos, *Pablo Picasso*, Paris 1932, ff., II, 310.

[6] Ibid. II, 87.

[7] Ibid., II, 253, 258, 259, 260, 262, 270.

[8] Ibid., II, 344, 349, 418, 757, 758, 759.

[9] For a valuable analysis of synthetic cubism see Winthrop Judkins, 'Toward a Reinterpretation of Cubism', *Art Bulletin*, XXX, 1948, pp. 270–78.

[10] Zervos, *Pablo Picasso*, III, 423, 427.

[11] Ibid. II, 213, 519, 522, 528. III, 157, 287. IV, 4, 114. V, 178.

[12] Fernande Olivier, *Picasso et ses amis*, Paris 1933, p. 168.

[13] For supporting evidence of the fan identification see Picasso's *L'Éventail*, 1910, reproduced Zervos, *Pablo Picasso*, II, 229. Looking at this painting, in which the fan is presented in a more immediately recognizable form, will make the identification of the Oberlin image clearer.

[14] Compare another Picasso of the same date as *The Glass of Absinthe*, spring 1911, called *Palette, Brushes, Book by Victor Hugo*, reproduced Zervos, II, p. 260. In this work Picasso's analysis of the book is no doubt more immediately recognizable, although possibly less refined than in the Oberlin painting.

[15] Reproduced in ibid. II, 342. See also 321, *La Bouteille de Marc (Ma Jolie)*, 1912, in which occurs a passage remarkably similar to the double scroll in the Oberlin painting.

[16] Miss Alice B. Toklas suggested (in correspondence) that certain of the picture's forms might be associated with a purple velvet sofa in Picasso's home at that time. This sofa is also mentioned by Fernande Olivier and it appears in a Zervos photograph of Picasso's studio at 11 boulevard de Clichy, published in *Cahiers d'Art*, vol. 25, II, 1950, p. 280.

[17] Zervos photographs in his 'Œuvres et images inédites de la jeunesse de Picasso', *Cahiers d'Art*, vol. 25, II, 1950. See pp. 280, 281. Picasso drawings: *The dining room of the artist, rue la Boétie*, Zervos, *Pablo Picasso*, III,

380 (room also contains two small round tables); *The drawing-room of the artist, rue la Boétie*, ibid., 427 (contains also small table with fringe); *The studio of the artist, rue la Boétie*, ibid IV, 78.

[18] See particularly *Allumettes, pipe, verre*, 1911, ibid. II, 284.

[19] Picasso in a statement first published in *The Arts*, III, 1923, pp. 314–29, 'Picasso Speaks'. 'Many think that cubism is an art of transition, an experiment which is to bring ulterior results. Those who think that way have not understood it. Cubism is not either a seed or a foetus, but an art dealing primarily with forms, and when a form is realized it is there to live its own life' (p. 323).

CHAPTER FIVE

[1] Quoted by Lee Krasner in an interview with Bruce Glaser, *Arts Magazine*, Vol. 41, No. 6, April 1967, p. 38.

[2] Pollock, as quoted by Lee Krasner in 'Who Was Jackson Pollock?' Interviews by Francine du Plessix and Cleve Gray, *Art in America*, Vol. 55, No. 3, May–June 1967, p. 51.

[3] Conversation with the author, 22 October 1971.

[4] Harold Rosenberg, 'The American Action Painters', *Art News*, Vol. 51, No. 8, December 1952, p. 22.

[5] Ibid., p. 23.

[6] Ibid., p. 48.

[7] Ibid., p. 49.

[8] Ibid., p. 48.

[9] Albert Camus, *The Fall*, London and New York 1956, p. 133.

[10] Quoted in Rudi Blesh, *Modern Art USA*, New York 1956, pp. 253–4.

[11] Pollock, quoted in Selden Rodman, *Conversations with Artists*, New York 1957, p. 82.

[12] Pollock, 'My Painting', *Possibilities*, 1, Winter 1947–8, p. 79.

[13] Rosenberg, op. cit., p. 23.

[14] See particularly 'Some Points about Action Painting, A Conversation between Thomas B. Hess and Harold Rosenberg', *Action Painting*, Dallas Museum for Contemporary Art, 1958.

[15] L. K. Pollock in 'An Interview with Lee Krasner Pollock by B. H. Friedman', Marlborough-Gerson Gallery, New York, *Jackson Pollock: Black and White*, March 1969, p. 10.

[16] Robert Goodnough, 'Pollock paints a picture', *Art News*, Vol. L, May 1951, pp. 38 ff. The picture Pollock painted, identified in the article as *Number 4, 1950*, is the work that he later named *Autumn Rhythm*, now in the Metropolitan Museum, New York. It is sometimes given as *Number 30, 1950*.

[17] Pollock, op. cit., p. 79.

[18] See Gertrude Stein, 'Composition as Explanation', and 'What are Master-pieces and why are there so few of them', in *What are Masterpieces*, London and Los Angeles 1940. 'If everyone were not so indolent they would realize that beauty is beauty even when it is irritating and stimulating not only when it is accepted and classic' (p. 29).

[19] 'The important thing is that Clyff Still – you know his work? – and Rothko, and I – we've changed the nature of painting.' Quoted in Rodman, op. cit., p. 84.

[20] 'An Interview with Jackson Pollock', taped by William Wright, 1950, quoted in Francis V. O'Connor, *Jackson Pollock*, New York 1967, p. 80.

[21] Ibid., p. 81.

[22] Lee Krasner Pollock in Plessix and Gray, op. cit., p. 51: 'Oh, he was angry, really mad, and he painted a picture, *Search for a Symbol*, just to show how disciplined he was. He brought the wet painting to the gallery where he was meeting Jim Sweeney and said, "I want you to see a really disciplined painting."' However, Pollock wrote a note to Sweeney, 3 Nov. 1943, 'Dear Sweeney – I have read your foreword to the catalogue, and I am excited. I am happy – The self-discipline you speak of will come, I think, as a natural growth of a deeper, more integrated, experience. Many thanks, – he will fulfill that promise – Sincerely Pollock.' Quoted in B. H. Friedman, *Jackson Pollock: Energy Made Visible*, New York 1972 (London 1973), p. 60.

[23] See photographs (as in Marlborough-Gerson, op. cit.) of Pollock's studio walls on which are hung large sections of canvas with several individual pictures painted on them. Most often the separate pictures were cut singly, but occasionally as a polyptych.

[24] Conversation with the author, 22 October 1971.

[25] Van Gogh, Letter 542, to Theo, *The Complete Letters of Vincent van Gogh*, vol. 3, p. 55.

[26] Quoted by Lee Krasner Pollock in Marlborough-Gerson, op. cit., p. 10.

[27] From letter CLXIX, to Emile Bernard, 26 May 1904, in John Rewald (ed.), *Paul Cézanne Letters*, p. 237.

[28] 'An Interview with Jackson Pollock', taped by William Wright, 1950, quoted in O'Connor, op. cit., p. 80.

[29] Quoted in Friedman, op. cit., p. 228.

[30] About his *The Spirit of the Dead Watching*, Gauguin wrote 'general harmony, sombre, sad, frightening, sounding to the eye like a death-knell, the violet, the dark blue and the orange yellow', quoted in John Rewald, *Gauguin*, New York 1938, p. 22.

[31] Quoted in Selden Rodman, op. cit., p. 80.

[32] From an imagined dialogue between the painter and the critic, Claude Roger-Marx, 'Les Nymphéas de M. Claude Monet', *Gazette des beaux-arts*, Series IV, Vol. 1, June 1909, p. 529, cited (in slightly different translation) in W. C. Seitz, *Claude Monet, Seasons and Moments*, New York 1960, p. 45. See also G. Geffroy, who quotes and explicates Roger-Marx's imagined dialogue in his *Claude Monet, sa vie, son œuvre*, Paris 1924, vol. 2, pp. 145–6.

[33] In an interview with Jackson and Lee Pollock published in the *New Yorker*, 5 August 1950, Jackson said, 'There was a reviewer a while back who wrote that my pictures didn't have any beginning or any end. He didn't mean it as a compliment, but it was. It was a fine compliment.' Quoted in O'Connor, op. cit., p. 51.

[34] 'An Interview with Jackson Pollock', taped by William Wright, 1950, quoted in O'Connor, op. cit., p. 81.

[35] Greenberg, 'The Present Prospects of American Painting and Sculpture', *Horizon*, October 1947, quoted in O'Connor, op. cit., p. 41.

[36] John Russell, *Sunday Times*, 9 November 1958, quoted in O'Connor, op. cit., p. 77.

[37] Pollock (answers to a questionnaire), *Arts and Architecture*, Vol. 61, No. 29, February 1944, p. 14.

[38] Lee Krasner Pollock interview, Marlborough-Gerson, op. cit., p. 8.

[39] Anthony Smith interviewed by Plessix and Gray, op. cit., p. 54.

[40] Alfonso Ossorio, ibid., p. 58.

[41] Conversation with the author, 22 October 1971.

[42] Pollock in the *New Yorker* interview, quoted in O'Connor, op. cit., p. 51.

[43] From questionnaire to Pollock, *Arts and Architecture*, February 1944, p. 14.

[44] Stuart Davis, 'The Cube Root', *Art News*, 1–14 February 1943, pp. 33–4.

[45] Pollock, loc. cit.

[46] From Pollock's application for a Guggenheim Fellowship, 1947, cited in O'Connor, op. cit., pp. 39–40.

[47] Robert Morris, 'Notes on Sculpture Part 2', *Artforum*, October 1966, p. 21.

[48] From *Alfred Stieglitz Presents Fifty-one Recent Pictures . . . by Georgia O'Keeffe*, The Anderson Galleries, New York 1924.

[49] Claes Oldenburg, 1961, notes in *Store Days*, p. 49.

[50] Robert Morris, 'Notes on Sculpture Part 3', *Artforum*, Summer 1967, p. 26.

[51] Stuart Davis, 'The Place of Painting in Contemporary Culture', *Art News*, Summer 1957, pp. 29–30.

[52] Now, in 1975, when realism is once again firmly ensconced, Diebenkorn is painting abstract pictures – as he has been doing for over a decade.

[53] This and following statements by Diebenkorn are quoted from letters to the author in 1958.

[54] When this essay appeared in 1958, Diebenkorn was still very little known on the East Coast (although he had been included in Oberlin's *Three Young Americans* show in 1955); now in 1975 he is a much admired 'old master'.

CHAPTER SIX

[1] 'Three Young Americans', Oberlin, Allen Memorial Art Museum, 8–29 January 1963.

[2] Unless otherwise indicated, all statements by Oldenburg come from his notebooks, including the phrase 'the poetry of everywhere'.

[3] From Oldenburg's original typescript, in English, for his 'Eftertankar', *Konstrevy*, Vol. XLII, No. 5–6, 1966.

[4] Conversation with the author, September 1969.

[5] It is difficult to avoid alluding to *Gulliver's Travels* in discussing Oldenburg's fantastic treatment of scale, even if one does not happen to know that he deeply admires Swift.

[6] Conversation, June 1969.

[7] Typescript cited in Note 3.

[8] Published in *Esquire*, Vol. LXXI, No. 5, May 1969.

[9] 1975: The original intention that it should circulate from one university to another not proving feasible, it remained in storage until now when it has been restored and installed in

the courtyard of Morse College at Yale, as an acquisition of the university's Art Gallery.

[10] 1975: The second one is now at the City Art Museum of St Louis and the third, and final, one is in the garden of a private collector in Philadelphia.

[11] 1975: Segal later did paint the figures in several cases, but apparently he still prefers to leave them white.

CHAPTER SEVEN

[1] These compositions are not to be confused with the china dinnerware designed by Lichtenstein and commercially available in a large edition of six-piece place-settings.

CHAPTER EIGHT

[1] 1975: This similarity became more marked in Poons's looser, less controlled-looking style after he abandoned the regulated dots and ellipses in 1967.

[2] Edited and revised by both M.B. and E.J. in October 1973.

[3] Allen Art Museum, Oberlin College, *Art in the Mind*, organized by Athena T. Spear, April 1970, one of the rare instances of a catalogue constituting an exhibition.

[4] Bochner's handsome drawings and paintings, exhibited recently at the Sonnabend Gallery, New York, and the New Gallery, Cleveland, startled some observers; but in my view his work has always been visually oriented, even though sometimes, perhaps, *malgré lui* (1975).

List of Illustrations

28 James Rosenquist, *Painting for the American Negro*, 1962–3. Oil on canvas, 80 × 210 (203·2 × 533·4). *Collection of the National Gallery of Canada, Ottawa.*

29 Andy Warhol, *Green Disaster No. 2*, 1963. Silkscreen on canvas, 106 × 79 (269·2 × 200·6). *Collection of Karl Ströher, Hessisches Landesmuseum, Darmstadt. (Photo: Rudolph Burckhardt)*

30 Chuck Close, *Phil (Glass)*, 1969. Synthetic polymer, 108 × 84 (274·5 × 213·5). *Collection of the Whitney Museum of American Art, New York (Gift of Mrs Robert M. Benjamin). (Photo: Kenneth Lester)*

31 Malcolm Morley, *S.S. 'Amsterdam' Entering Rotterdam*, 1966. Liquitex on canvas, 60 × 84 (52·4 × 213·5). *Collection of Marc Moyens.*

32 René Magritte, *The Therapeutic*, 1967. Bronze, height 63 (160). *Collection of William Copley. (Photo: Courtesy of the Alexandre Iolas Gallery, Paris)*

33 Meret Oppenheim, *Objet (Le Déjeuner en fourrure)*, 1936. Fur-covered cup, diameter 4⅜ (11·1), saucer, diameter 9⅜ (23·8), and spoon, length 8 (20·3). *Collection of The Museum of Modern Art, New York.*

34 Joseph Cornell, *Taglioni's Jewel Casket*, 1940. Velvet-lined wooden box containing glass ice-cubes, necklace, inscription, 4¾ × 11¾ × 8¼ (12 × 29 × 21). *Collection of The Museum of Modern Art, New York (Gift of James Thrall Soby).*

35 Joseph Beuys, *How to Explain Paintings to a Dead Hare*, 1965. *(Photo: Courtesy of the Galerie Alfred Schmela, Düsseldorf)*

36 Eleanor Antin, *100 Boots on the Way to Church*, Solana Beach, California, 9 February 1971, 11.30 am. Postcard. *Courtesy of the artist. (Photo: Philip Steinmetz)*

37 Michael Heizer, *Double Negative*, Virgin River Mesa, Nevada, 1969–70. 1,500 ft × 50 ft × 30 ft (45,750 × 1,525 × 915). *(Photo: Courtesy of Fourcade, Droll, Inc., New York)*

38 Richard Long, *England*, 1968. *(Photo: Courtesy of the John Weber Gallery, New York)*

39 Claes Oldenburg, *Soft Ladder, Hammer, Saw and Bucket*, 1967. Canvas filled with foam rubber, starched with glue, painted with Liquitex, mounted on wood, 110½ × 58¾ × 16⅞ (281 × 149 × 43). *Collection of the Stedelijk Museum, Amsterdam.*

40 Richard Serra, *Log Measure: Sawing Five Fir Trees*, 1970. Six red fir trees, 25 ft × 21 ft × 7 ft (762 × 640 × 213). *(Photo: Courtesy of the artist)*

41 Eva Hesse, *Right After*, 1969. Fibreglass, *c.* 5 ft × *c.* 18 ft × *c.* 4 ft (*c.* 152 × *c.* 549 × *c.* 122). *Collection of the Milwaukee Art Center (Gift of the Friends of Art).*

42 Robert Smithson, *Spiral Jetty*, Great Salt Lake, Utah, 1970. *Courtesy of the John Weber Gallery, New York. (Photo: Gianfranco Gorgoni)*

43 Christo, *Valley Curtain*, Grand Hogback, Rifle, Colarado, 1970–72. Span: 1,250 ft (38,125); height 185–365 ft (5,642–11,132); 200,000 sq. ft of nylon polyamide, 110,000 lbs. of steel cables. Project director: Jan van der Marck. *(Photo: Shunk-Kender, courtesy of the artist)*

44 Steve Kaltenbach, *Personal Appearance: Eye-disguise*, 1969. Mirror-coated contact lenses; performance, New York. *(Photo: Courtesy of the artist)*

45 Yves Klein executing *Anthropometrics* in the International Gallery of Contemporary Art, Paris, 9 March 1960. (*Photo: Shunk-Kender*)

46 Jasper Johns, *Target with Plaster Casts*, 1955. Encaustic and collage on canvas with plaster casts, 51 × 44 × 3½ (129·5 × 11·7 × 9). *Collection of Mr and Mrs Leo Castelli.*

47 Robert Morris, *I-Box*, 1963. Mixed media, 19 × 12¾ × 1⅜ (48·2 × 32·4 × 3·5). (*Photo: Courtesy of the Leo Castelli Gallery, New York*)

48 Chris Burden, *Movie on the Way Down*, performance at Oberlin College, Oberlin, Ohio, 1 May 1973. (*Photo: Athena Tacha*)

49 William Wegman, *Reading Newspaper*, 1973. Photograph, edition of ten, 12 × 10⅞ (30·5 × 27·6). *Courtesy of the Sonnabend Gallery, New York, and the artist.*

50 Andy Warhol at the Factory, 1966. Left to right: Benadetta Barzini, a friend, Warhol, Lou Reed, Sterling Morrison. (*Photo: Stephen Shore*)

51 Gilbert and George, *Singing Sculpture*, 1971. *Courtesy of the Sonnabend Gallery, New York.*

52 Duane Hanson, *Artist Seated (Mike)*, 1971. Polyester fibreglass, polychromed in oil, life-size. *Collection of Byron Cohen.*

53 Newton Harrison, *Portable Orchard: Survival Piece No. 5*, 1972. *Collection of the California State College, Fullerton, California, and reproduced by courtesy of the artist.*

54 Newton Harrison, *Drawing for Portable Orchard*, 1972. *Courtesy of the artist.*

55 Athena Tacha, *Dripping*, 1969, from the *Phaenomena* series. Silicone fluid in plexiglass cylinder, height 12 (30·5), depth 12 (30·5). *Collection of Albrecht and Agnes Saalfield, Greenwich, Connecticut.*

56 Agnes Denes, *Dialectic Triangulation: A Visual Philosophy*, 1970. Aesthetograph, 30 × 40 (76 × 101·5). *Courtesy of the artist.*

57 Mel Bochner, *Meditation on the Theorem of Pythagoras*, 1972. Forty-seven hazelnuts arranged around a white triangle drawn in chalk on the floor, 17½ × 16 (44·5 × 40·5). *Collection of the Allen Memorial Art Museum, Oberlin College, Oberlin, Ohio. (Photo: Courtesy of the Sonnabend Gallery, New York)*

58 Sol Lewitt, *49 3-Part Variations on 3 Different Kinds of Cubes*, 1968. Baked enamel on aluminium, 49 units, each 23½ × 8 × 8 (59·7 × 20·3 × 20·3.) *Collection of the Allen Memorial Art Museum, Oberlin College, Oberlin, Ohio.*

59 Paul Cézanne, *The Basket of Apples*, c. 1895. Oil on canvas, 25¾ × 32 (65·4 × 81·2). *Courtesy of the Art Institute of Chicago.*

60 Paul Cézanne, *The Large Bathers*, 1898–1905. Oil on canvas, 82 × 99 (208·4 × 251·5). *Collection of the Philadelphia Museum of Art, The W.P. Wilstach Collection.*

61 Paul Cézanne, *Mont Sainte-Victoire*, 1904–6. Oil on canvas, 28⅞ × 36¼ (73·3 × 92). *Collection of the Philadelphia Museum of Art, The George W. Elkins Collection.*

62 Paul Cézanne, *Pine Tree at Bellevue*, 1883–5. Pencil and watercolour, 12¼ × 18⅞ (31 × 48). *Collection of the Allen Memorial Art Museum, Oberlin College, Oberlin, Ohio.*

63 Paul Cézanne, *Le Grand Pin et les terres rouges* (V. 459), *c.* 1883–5. Oil on canvas, 32⅛ × 39⅜ (81 × 100). *Lecomte Collection, Paris. (Photo: Musées Nationaux)*

64 Paul Cézanne, *Grand Pin et terres rouges* (V·458), *c.* 1890. Oil on canvas, 28¾ × 36¼ (73 × 92). *Collection of the Hermitage, Leningrad.*

65 Paul Cézanne, *Study for a Tree* (V. 1024), *c.* 1890. Watercolour, 10⅞ × 17⅛ (27 × 43·5). *Collection of the Kunsthaus, Zurich.*

66 John F. Kensett, *Lake George*, 1869. Oil on canvas, 44 × 66½ (111·7 × 169). *Collection of the Metropolitan Museum of Art, New York.*

67 John Marin, *Study of the Sea*, 1917. Watercolour, 16 × 19 (40·6 × 48·2). *Collection of the Columbus Gallery of Fine Arts, Columbus, Ohio (Gift of Ferdinand Howald.)*

68 Pablo Picasso, *The Glass of Absinthe*, 1911. Oil on canvas, 15⅛ × 18¼ (38·4 × 46·3). *Collection of the Allen Memorial Art Museum, Oberlin College, Oberlin, Ohio.*

69 Pablo Picasso, *The Glass of Absinthe*, 1911. The photograph has been partially painted over to isolate the identifiable objects.

70 Jackson Pollock, *Number 1*, 1948 (detail). Oil on canvas, 68 × 104 (172·7 × 264·2). *Collection of The Museum of Modern Art, New York.*

71 Jackson Pollock, *Number 1 (Lavender Mist)*, 1950. Oil enamel and aluminium paint on canvas, 87 × 118 (221 × 300). *Collection of Alfonso A. Ossorio and Edward F. Dragon, East Hampton, New York.*

72 Claude Monet, *Waterlilies, c.* 1910. Oil on canvas, 78¾ × 236¼ (200 × 600). *Collection of the Kunsthaus, Zurich. (Photo: John Reed)*

73 Joseph Cornell, *Sun Box (Fox Block)*. Box with objects, 9¼ × 14 × 4¼ (23·5 × 35·5 × 10·8). *On extended loan to the Allen Memorial Art Museum, Oberlin College, Oberlin, Ohio.*

74 Georgia O'Keeffe, *Red and Pink Rocks and Teeth*, 1938. 21 × 13 (53·3 × 33). *By courtesy of the Art Institute of Chicago.*

75 Stuart Davis, *Little Giant Still Life*, 1950. Oil on canvas, 33 × 43 (83·8 × 109·2). *Collection of the Virginia Museum of Fine Arts, Richmond.*

76 Donald Judd, *Untitled*, 1967. Blue painted galvanized iron, 5 × 25½ × 9 (12·7 × 64·8 × 22·9). *Collection of the Allen Memorial Art Museum, Oberlin College, Oberlin, Ohio.*

77 Robert Morris, *Untitled*, 1967. Felt, 12 ft × 6 ft × ⅜ (365·8 × 183 × 1). *Private collection.*

78 Stanley Landsman, *Pinocchio*, 1967. Chromium–plated polished plate glass, wood, light bulbs, 78¼ × 27½ × 24⅛ (198·8 × 69·8). *By courtesy of the artist. (Photo: Rudolph Burckhardt)*

79 Will Insley, *Wall Fragment*, 1967. Liquitex on masonite, 8 ft × 8 ft 8 ins. (243·8 × 264). *By courtesy of the artist. (Photo: George Roos)*

80 Richard Diebenkorn, *Woman by a Large Window*, 1957. Oil on canvas, 70⅞ × 65 (180 × 165). *Collection of the Allen Memorial Art Museum, Oberlin College, Oberlin, Ohio.*

List of Figures

Index

Figures in the text are indicated by bold type; other illustrations are in italics